HONORÉ DAUMIER

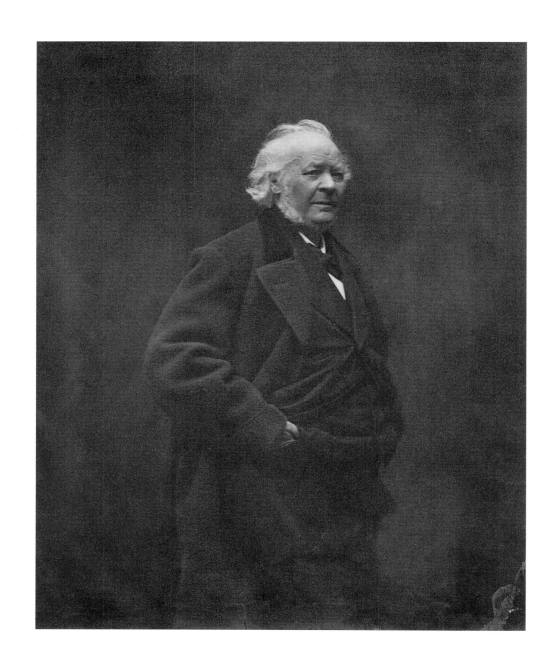

Honoré Daumier

BRUCE LAUGHTON

YALE UNIVERSITY PRESS
NEW HAVEN AND LONDON

TO DORIS

Set in Bembo by Best-set Typesetter Ltd., Hong Kong
Printed in Hong Kong

Library of Congress Cataloguing-in-Publication Data

Laughton, Bruce
 Honoré (1808–1879)/Bruce Laughton.
 p. cm.
 Includes bibliographical references and index.
 ISBN 0-300-06945-6
 1. Daumier, Honoré, 1808–1879. 2. Artists – France – Bibliography.
 I. Title.
 N6853.D3L39 1995 96-21441
 760'.092 – dc20 CIP

Frontispiece: Honoré Daumier; photography by Etienne Carjat (gelatin silver print) c.1861

CONTENTS

PREFACE AND ACKNOWLEDGEMENTS

This book has turned out to be a 'Life and Work' of Daumier without my quite expecting it. The project originated with a suggestion made by Asya Chorley, around 1991, that I write a book on Daumier's watercolours, as a kind of sequel to my previous book on Daumier and Millet drawings for those who had read it, and as independently accessible to the general reader for those who had not. It seemed to be a fairly straightforward task until I began to be fully aware of what Daumier had made of that particular medium. Watercolour has historically been associated with private collectors, connoisseurship and also to some extent, unfortunately, with amateur practitioners. Even the levels of achievement reached by the great professionals from Turner to Cézanne have tended to be overshadowed, in the public eye at least, by their activities as painters in oils. Is this the case with Daumier? So unusual is the relation between his activities in all media that it took me some time to work out just what place watercolour does occupy in his *œuvre*, and why he took it up eventually as a relatively late development. This in turn led to consideration of just what he made of lithographs, since the sources of his first watercolours came from there, and then of what he made of oil painting, after his first conventional essays in that medium were laid aside. As I began to take stock of the mental lumber about Daumier that I had accumulated over more years than I care to remember, the possibility began to emerge that the relation between Daumier's media and his meanings might be unravelled, and then stitched together again in the form of a working biography (we know remarkably little about his 'other' biography). The result is a new book on Daumier, the outline of which is explained, I hope, in the Introduction and the structure explained by the chapter headings.

In the middle of my most recent researches an important event took place: the Frankfurt–New York exhibition entitled *Daumier Drawings*, which opened in Frankfurt-am-Main in the fall of 1992. I shall always be deeply grateful to its organisers, Colta Ives, Margret Stuffmann and Martin Sonnabend for making this marvellous opportunity for visually reassessing Daumier happen at just the right time, not to mention the friendliness and hospitality which I received at the Städelsches Kunstinstitut in Frankfurt. I have been fortunate in being able to discuss with them a number of matters arising out of that exhibition, and also in meeting other colleagues at the useful and stimulating colloquium that was held at the Metropolitan Museum of Art in New York in the spring of 1993. My correspondence with Michel Melot on the subject of Daumier has continued since then, and I am particularly indebted to him for keeping a critical eye on my research.

The number of museum and print room curators who have been helpful to me over the years is too large for everyone to be acknowledged adequately, yet without wishing to be invidious I would like to mention the opportunities given me to make technical examinations of the watercolours during my most recent visits to the Walters Art Gallery, Baltimore; The Baltimore Museum of Art; the Victoria and Albert Museum and of course once more the Cabinet des Dessins at the Louvre Museum, this time in conjunction with their Drawings Conservation Department. Many museums have been particularly helpful in the examination and documentation of oil paintings; again I can acknowledge only some of those who have been of most recent assistance: The National Gallery, London; the Municipal Museum of Soissons and the Musée d'Orsay, Paris; the Cleveland Museum of Art, and the Hermitage Museum in St Petersburg. I particularly wish to acknowledge the continued support of the Advisory Research Committee of

Queen's University, Canada, which has awarded me four successive grants to assist in travel for this particular project over as many years. I am also grateful to Mrs Stefanie Maison, once again, for giving me access to the archives of the late K.E. Maison, and for permission to reproduce some of his photographs of works whose owners cannot be traced. In addition to the persons named above, I would also like to acknowledge the assistance of the following individuals: Kenneth Bé of Cleveland Museum of Art; Laure Beaumont-Maillet of the Bibliothèque Nationale, Paris; Eve Boustedt of Sotheby's; Peter Bower, London; Philippe and Sylvie Brame, Paris; Thea Burns of Queen's University, Kingston, Ontario; Asya Chorley, London; Melanie Clore of Sotheby's; Jean-Pierre Codaccioni of the Bibliothèque Municipale, Marseilles; Jane Corbett of Queen's University, Kingston, Ontario; Josè-Louis de Los Carlos of the Petit Palais, Paris; Arianne de la Chapelle of the Louvre Museum, Paris; Georges de Batha, Geneva; Patrick Dudragne, Paris; Jay Fisher of Baltimore Museum of Art; François Fossier of the Bibliothèque Nationale, Paris; Kate Garmeson of Sotheby's; Alison Garwood-Jones of Queen's University, Kingston, Ontario; Melanie Gifford of the Walters Art Gallery, Baltimore; Vivian Hamilton of Glasgow City Art Gallery; Robert Herbert of Mount Holyoke College; John Herring, New York; Vojtech Jirat-Wasiutynski of Queen's University, Kingston, Ontario; William Johnstone of the Walters Art Gallery, Baltimore; Catherine Legrand of the Louvre Museum, Paris; James Leith of Queen's University, Kingston, Ontario; John Leighton of the National Gallery, London; Georgeanna Linthicum Bishop of Baltimore Museum of Art; Katherine Lochnan of the Art Gallery of Ontario, Toronto; Bernard and François Lorenceau, Paris; David McTavish of Queen's University, Kingston, Ontario; Mrs Henry B. Middleton, New York; Gael McKibbon of Portland Museum of Art; Elizabeth Miller of the Victoria and Albert Museum, London; José Mugrabi, New York; Michael Pantazzi of the National Gallery of Canada, Ottawa; Kelly Park of the J. Paul Getty Museum; Michael Parke-Taylor of the Art Gallery of Ontario, Toronto; Lori Pauli of the National Gallery of Canada, Ottawa; Abigail Quant of the Walters Art Gallery, Baltimore; Barbara Ramsay of the National Gallery of Canada, Ottawa; Barrie Ratcliffe of Laval University; Vera Razdolskaya of St Petersburg University; Robert Schmit, Paris; Douglas Schoenherr of the National Gallery of Canada, Ottawa; Arlette Sérullaz of the Louvre Museum, Paris; Rachel Shain formerly of Queen's University, Kingston, Ontario; Helga Stegemann of Queen's University, Kingston, Ontario; Mrs A.J. Ströllin, Lausanne; John Sunderland of the Witt Library, Courtauld Institute of Art, London; Moira Thunder of the Victoria and Albert Museum, London; Mrs Vera Neumann, Geneva; Françoise Viatte of the Louvre Museum, Paris; Pauline Webber of the Victoria and Albert Museum, London; Hilary Williams of the British Museum, London.

Kingston, Canada
May 1995

INTRODUCTION

In Daumier's lifetime the audience and clientele for his oils and watercolours was small, relative to his fame as a cartoonist. His political lithographs were well known as early as 1832, and he became famous as a social satirist by the 1840s among practically all classes of citizens in France. However, before the 1848 revolution only his close friends knew that he painted in his spare time. As an *artiste-peintre* (as opposed to an *artiste-lithographe*) he enjoyed a sudden spell in the limelight when he was a finalist in the abortive state competition for an official painting of *La République*. The competition dragged on through 1848, and he received two state commissions for religious paintings in 1848 and 1849. Afterwards he showed a few works at the Salon during the Second Republic, but there were no more state commissions after the rise of Prince Louis-Napoléon to power. It is unclear whether or not he was making any watercolours for private sale earlier than the mid-1850s. His drawings on paper, such as still survive, seem to have been more often related to ideas for oil paintings. The emergence, then, of a significant body of work by Daumier in the traditional French medium of watercolour points to two possible conclusions. One is that, at a period to be determined, there was a clientele (however small at first) who began to recognize his special qualities as an artist-draughtsman in this medium and encouraged him to continue with it by the simple expedient of buying his work. The other possibility is that Daumier himself began to find that a combination of techniques, employing black chalk or conté-crayon, pen and monochrome washes and touches of watercolour, could produce more complete expressions of his intentions than he could easily manage in oils. This body of work emerges parallel with his *œuvre* in oil painting, and in some ways develops ahead of it, or at least with more technical confidence, until about the mid-1860s. The arrangement of the chapters which follow is partly chronological, on the assumption that the general reader may appreciate some structure and shape being given to Daumier's life and career, and partly thematic, because certain ranges of subject matter seem to have lent themselves especially to expression in the watercolour medium and other, different, ranges of subject matter may be discerned as preoccupying Daumier in his later oil paintings.

Another surprising activity, which first occurs very early in his career, is clay modelling. If he had ever been known as a sculptor in his lifetime his work might have been observed by the public with startled curiosity – and indeed his statuette of *Ratapoil* (fig. 188), known to Jules Michelet in 1851, was regarded by the radical historian with admiration – but he would probably not have been able to make much of a living out of it. He apparently sculpted whenever he felt the need, with no set pattern (Degas, a parallel case, was a more consistent painter-sculptor). Daumier began by modelling a group of small expressive heads of politicians, bordering between reality and caricature (fig. 7). His reason for doing this seems to have been only to help him draw: not from life but the projections of his mind and memory. Just why Daumier was so productive in all the nineteenth-century media (except etching and pastel), and how his creative processes interrelated in each, has never been completely explained. His career was an amazing mixture of constant struggle with material circumstances combined with a creative independence ahead of his time.

Twentieth-century Daumier literature has tended to polarize somewhat between the view that his strongest claim to a major position in the history of art lies in the cumulative achievement of his 4,000 lithographs which (together with his wood engravings) maintained a critical commentary on the society in which he lived over a period of forty years,

and the view that this activity should be seen as purely ancillary to his achievement in the traditionally 'higher' media, namely drawings and paintings produced as 'fine art' for the consumption of connoisseurs and public patrons. Reconciliation of the tension between these two extremes is usually attempted in the form of totalizing biographies, on the theme of 'Daumier and His World', 'Daumier, Witness of His Time' or similar, stressing the uniqueness of the individual. (It is significant that his first biographer, Arsène Alexandre, entitled his book *Daumier – l'homme et l'œuvre* in 1888 and then devoted thirteen out of fourteen chapters to Daumier the lithographer). Another approach to Daumier has been to isolate certain aspects of his output and publish selections which are visually pleasing and coherent – Jean Adhémar's and K.E. Maison's respective selections of the drawings and watercolours on their own fall into this category, as do editions of selected lithographs such as the classic volume on *Les Gens de Justice* by Julien Cain. The only trouble with such selections is that they are exclusive of larger questions.

One object of this book is to show the connection between Daumier the lithographer and Daumier the artist and, by examining the unfolding sequence of his life alongside his production of work, to show that he remained the same artist (not just the same person) throughout every shift in medium and process. This is not the same thing as arguing that there is no *difference* between the cartoonist and the draughtsman-painter: there is of course a profound difference in the demands of the markets which each activity served. The differences in what was expressed in each became even greater with the deepening perceptions of the artist himself. Daumier possessed no private income or parental support when he began his career, and for the first twenty years of it his market was that of popular journalism. Part of his earnings continued to come from this source for the next twenty years after that (roughly 1850 to 1870), except that there is enough work in oil and watercolour datable to this period to indicate that he was simultaneously attempting to cultivate a second market consisting of private patrons, or *connoisseurs*. This is confirmed by the evidence of some surviving account books (*carnets*) which are published here in an Appendix. The question of 'finish' in relation to the requirements of such purchasers will arise in the course of discussion, and it will appear that this was considered particularly important for the small-time *connoisseurs*, so to speak, who began to buy his watercolours. His oil paintings, on the other hand, after his state commissions ceased, range between a rather spectacular lack of conventional finish and evidence of laborious overworking. Daumier's 'late style', which was not only unique but produced in isolation from a changing world, is particularly addressed in the last two chapters. K.E. Maison was the first scholar to grapple seriously with the problem of the physical condition of Daumier's paintings as they affect our reading of his work. In his now celebrated *catalogue raisonné* he attempted to deal with the problems caused by later additions (sometimes to the owners' chagrin), and in this context the reader should immediately be warned of the number of 'marginal Daumiers' on canvas or panel which have been completed by other hands, quite apart from out-and-out fakes which are sometimes quite insulting in their crudity of execution.

The relation of this book to my previous one on Daumier and Millet drawings is that there I was searching, whether or not successfully, for some insight into the creative process of two artists by comparing their use of drawings in developing their ideas. Here, in researching Daumier as a whole I became curious, first, about why he chose to work in watercolour at all, and what he made of this medium, and then about the variety of techniques that he tried with oil paints. There is an obsessive quality to his work in watercolour in particular: what caused him to hack and scratch away so compulsively at these images, repeat them, reverse them, modify, transform and enrich them?[1] Few other artists have left so vast a body of incontestable evidence of their graphic powers in prints – in Daumier's case both in the lithographs that he drew directly upon the stone or zinc plate, and in his designs for wood engravings (some drawn in pen and watercolour)

which were expertly cut by contemporary craftsmen. For seekers of images upon which to base fake drawings, Daumier's graphic lexicon has been a forger's paradise. Consequently, attempts to set up an *œuvre* or canon of Daumier's drawings – from the first scholarly accumulations by Klossowski and Fuchs, to the lifetime researches of Jean Adhémar, and the revisions to the canon made by Maison's essential *catalogue raisonné* – have all been held up to question at various points. The subject can be a minefield for the would-be attributionist. The marvellous facility of Daumier's lithographs appears apparently effortless because the initial groping, errors and corrections were obliterated before the lithographic chalk was applied.[2] The original drawings left on paper, for whatever projects, display varying degrees of success, and the amount of struggle that was really involved in Daumier's imaginative invention is open to conjecture. There must be a certain level of ineptitude of which only a forger is capable, and it is this grey area between the 'real' Daumier process and that created by the market about which it is so hazardous to pontificate. In the present volume we will navigate the minefield once more in an effort to demonstrate Daumier's real achievement.

Before proceeding to an account of Daumier's life and work, the following two sections may be of interest to present day collectors of drawings and watercolours.

Copies after lithographs

A significant number of hand-drawn copies after Daumier's lithographs, made in pencil or black chalk and sometimes with watercolour added, have appeared from time to time, produced by owners wishing opinions on their authenticity. Some are even in museums. They are usually after Daumier's most popular subjects which would be well known to anyone collecting his prints. The sources of these copies can easily be found in Delteil's illustrated catalogue. Some of them are very close to the 'original' prints indeed, and obviously made with great care, reproducing every line in the print. My present view is that such copies were not necessarily made with the intent to deceive, but rather as *copies* made for the copyist's edification or pleasure, probably in the nineteenth century. Their early date sometimes convinces the owners that they have something very rare. It is of course possible that Daumier himself was occasionally asked to make such copies, but the only cases in which I have found this to be likely are not copies but adaptations, as in figs. 14 and 16 discussed in chapter 1. Copies are to be distinguished from forged drawings, very often purporting to be 'studies' for known works, but clumsily put together from different sources including wood engravings.

Watermarks

A good deal of work could still be done on the watermarks to be found on some of Daumier's papers, if only to discover whether, by systematically acquiring good quality laid papers for his drawings, he was consciously aiming at a particular kind of *connoisseurs'* market. He would never have been well off enough to lay in large stocks of preferred kinds of special papers,[3] but being positioned so closely to the printing trade it is perfectly conceivable that he accepted good papers whenever they were offered to him. Paper made by Canson was as common in France as Whatman was a familiar paper maker in England, and the name was likewise applied generically, as in Cherpin's description of the paper Daumier used to make his account books. One lithograph of a lawyer, datable from the print published in *Charivari* on 25 September 1847 (LD 1661), and now in the Reserve Collection of the Cabinet des Estampes in the Bibliothèque Nationale, is printed on a special pinkish paper with a watermark at the left edge, DE CANSON FRERES.

I have not found this used for any of his drawings or watercolours, however.[4] Watermarks found in those drawings which I have been able to examine closely enough are as follows:

HALLINES (associated with a crown, and the initials HP)

1) HALLINES appears below a crown with initials HP, on MD 601, *The Grand Staircase at the Palais de Justice*, c.1860–1864. (Baltimore, Walters Art Gallery.) Watercolour reproduced here as fig. 91.
2) Part of crown with initials HP appears on MD 162, *Four Spectators ('At the opera')*. Drawing begun in charcoal, faint wash, 'improved' later. (Montreal, Museum of Fine Arts.)
3) HP on a shield with heraldic bend appears on a two-sided sheet: *Lawyer and Client*, black chalk and wash; *Man Reading*, black chalk, 1850s. Ex Maison.
4) HALLINES appears with part of a fleur-de-lis on MD 654, *The Advocate* (lawyer with client in court), charcoal and pen drawing, 1860s. (London, Victoria and Albert Museum.)
5) . . . LLI . . . appears on MD 5, *Man's Head*, with watercolour tests on verso, 1860s. (London, British Museum.)

HUDELIST

1) Appears on MD 682, *The Lawyers*, c.1867–1870. (Baltimore, Walters Art Gallery.) Watercolour reproduced here as fig. 129.
2) HUDELIST appears at edge of paper, letters partly cut off, on MD 750, *Centaur Abducting a Woman*, pen and wash, c.1860–1870. (Paris, Louvre.)
3) HU.ELI..(?) appears on MD 719, *Two Bathers*, c.1865–1870. (Baltimore Museum of Art.) Watercolour reproduced here as fig. 156.
4) . . . ST appears on MD 649, *A Barrister Pleading*, charcoal, c.1855–1865. (London, Victoria and Albert Museum.)

A 'Pot' Design

1) Appears on MD 298, *Third Class Railway Carriage*, c.1864. (Baltimore, Walters Art Gallery.) Watercolour reproduced here as fig. 138.
2) Small fragment of ring on 'pot' appears on MD 227/256: recto, *Man Carrying Bucket*; verso, *Woman Guiding Her Child*; both charcoal on blue laid paper, c.1855–1865. (London, British Museum.)

WHATMAN

1) WHATMAN/1852 appears on MD 587, *Two Lawyers*, black chalk, pen and wash on thin wove paper, c.1852–1855. (London, Victoria and Albert Museum.)
2) J WHATMAN / TURKEY MILL / 1869 appears on MD 390a, *Three Connoisseurs in a Saleroom*, after 1869. (Chicago of Art Institute.) Watercolour reproduced here as fig. 80. TURKEY MILL was the mark used by the Hollingworth brothers from 1805 onwards, controlling a large export business. It has been suggested to me, however, that this might be a late example of a fake Whatman paper, perhaps produced in France or Austria.

Any further information on the subject of watermarks with which readers can provide me will be gratefully received and acknowledged.

Chapter 1

DAUMIER'S EARLIER CAREER, UP TO 1848

Honoré Daumier was born in Marseilles on 26 February 1808. His family background was unusual for an artist. His father, Jean-Baptiste, was a highly intelligent artisan who had developed his family trade of glazier into his own picture-framing business; he was also a poet who had educated himself in literature (one of his favourite authors was Jean-Jacques Rousseau).[1] Although born in the city he had a love of the countryside, and his wife owned a small cottage in the hills ouside. She had spent her childhood in Entrevaux in the Basses-Alpes, while Jean-Baptiste's father had come to Marseilles from Béziers, in the region known as the *méridional*. Jean-Baptiste was taken up by literary circles in Marseilles, and he gave readings of his pastoral poems inspired by the style of the Abbé Delille. His poems were followed by an ambitious five-act tragedy, *Philippe II*, inspired by Racine. For this he was lionized, and he decided to abandon his trade and move to Paris in April 1815. Being an ardent Provençal monarchist he could hardly have arrived at a worse time, as this was in the middle of Napoleon's 'Hundred Days'. However, he gained an introduction to Alexandre Lenoir, painter, archaeologist and founder, during the *Directoire* (1794–1799), of the Musée des Monuments Français. Lenoir, having saved many historical monuments from vandalism in the churches during the Terror, had good contacts with the French royal family, and these he used to further Jean-Baptiste's literary career by a series of judicious introductions, culminating with the presentation of an ode to Louis XVIII in 1818. But although *Philippe II* was eventually put on at a small theatre and achieved a respectable run, its author did not appear to make much money out of it. His family, then consisting of his wife and three children including Honoré, had joined him in Paris in 1816. Frequent changes of address suggest that they lived in varying if not straightened circumstances. Although Daumier *père* continued to publish poems with modest success until at least 1830, by 1832 it was noticed that Honoré was the sole supporter of his parents (and, by implication, of his two surviving sisters).[2]

It is not surprising to find, therefore, that Honoré Daumier's own formal education was brief. His father evidently tried to place him as best he could. At the age of thirteen he was taken on as errand boy for a bailiff at the law-courts, and not long afterwards was employed as an assistant in Delaunay's bookshop in the lively complex of the Palais Royal. According to his early biographers he was already visiting the Louvre at this point, making drawings after the antique, and his insistence upon drawing prompted Jean-Baptiste to send him to Lenoir for some lessons, around 1822.[3] The story goes that Lenoir, as a traditional academician, set the young man to draw after plaster casts of ears and noses, a training to which Honoré, already possessing an excellent visual memory for such details, strongly objected (to his parents' dismay). This arrangement did not last long, and one can only speculate that some of Lenoir's more viable enthusiasms, for example antique sculpture and Flemish baroque painting, rubbed off on his young pupil none the less. Although the Musée des Monuments Français had been abolished by decree in 1816 (and many of its monumental effigies sent back to the churches whence they came), Lenoir himself retained in his possession a collection of sixteenth-century portrait drawings and about 200 painted portraits. These had been collected for their physiognomical characteristics in an age when it was widely believed that mens' motives could be interpreted, at least in part, through a study of their features.[4] Daumier was to become the artist most able to support such a belief in his own time. His training with

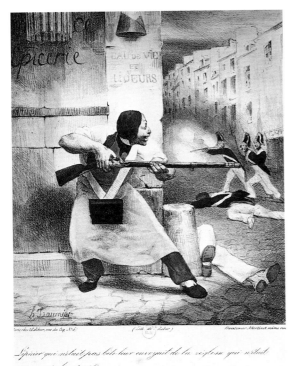

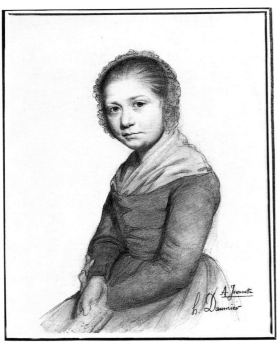

1. Daumier: *L'épicier qui n'etait pas bête...(The grocer who was no fool...)*. Lithograph, published by Hautecœur Martinet 1830. LD 7.

2. Daumier: *Portrait d'une jeune fille (Portrait of a Young Woman)*. Black chalk and stump, 28.6 x 22. Inscribed *A Jeanette* and signed. Vienna, Graphische Sammlung Albertina. MD 193.

Lenoir did not proceed, however. At various times between 1823 and 1828 he attended the life classes of Suisse and Boudin, who provided models at a modest fee *per diem* for drawing without instruction, which would indicate some desire to become an artist by profession. He met other art students there with whom he would keep in touch, who were later to become 'the men of the 1830s': these included the painter Philippe-Auguste Jeanron and the sculptor Auguste Préault. Daumier's financial circumstances could not sustain such aspirations, however. In about 1825 he was apprenticed to the publisher and lithographer Zépherin Belliard for some five years, preparing stones and helping Belliard with his work, though without much respect for his master. Belliard was a respectable bourgeois portraitist, and can hardly have encouraged his apprentice to draw cartoons, although this was the direction that Daumier's path was now going to follow.

Most of Daumier's earliest surviving works are lithographs. Whilst still an apprentice he took some early cartoons to the printseller Achille Ricourt, who encouraged him and is reported to have said later 'Vous avez le geste, vous'.[5] Ricourt published one or two of these in the caricature journal *La Silhouette*, of which he was then editor.[6] During the years 1830 and 1831 Daumier got a number of his lithographs published as separate prints for sale, some for the firm of Hautecoeur Martinet, and some for La Maison Aubert, a caricature gallery opened in December 1829 in the Passage Vero-Dodat near the Palais Royal. This was run by Gabriel Aubert and his brother-in-law Charles Philipon, who a year later founded his famous republican weekly journal *La Caricature*. Philipon was a person of vision and influence who may be said to have been the main inspiration behind Daumier's first career as political satirist, as we shall see. A good example of Daumier's first style of drawing is the lithograph (fig. 1) given the caption *L'épicier qui n'était pas bête . . . (The grocer who was no fool . . .)*. Published by Hautecoeur Martinet in 1830, the reference is plainly to the 'July Days', when the Bourbon regime of the Restoration was finally overthrown by a popular uprising that cut across class barriers: hence Daumier's choice of the grocer as victorious participant, shooting down the remnants of the royal guards at a street corner, probably near the Louvre Palace. The style is terse, incisive and neat, employing fine contours within which shading in parallel hatching defines the forms to give an effect of shallow relief. This technique derives directly from the lithographs of Charlet and Raffet, while the compositional arrangement of the street corner happens to be reminiscent of a lithograph of a London beggar (entitled *Pity a Poor Old Man*) made by Géricault about 1820.[7] Details like the foreshortening of the man's legs behind the bollard, and the hands of the grocer holding his ancient rifle, already indicate a professional level of competence, although Daumier would soon do better still. One of his very few original drawings that can be firmly dated to the early 1830s, a portrait of the young lady to whom it is dedicated (fig. 2), shows the same kind of innocent representational talent put to quite different ends. Somewhat Corot-like in its direct, unaffected sentiment, it gives some indication of what Daumier could have done had he followed this route of middle-class portraiture. Arguably he was too inventive to have been satisfied with it for long. The printseller and publisher Gabriel Aubert began to stock his lithographs in single sheets from September 1830. Now the influence of Philipon began to show, and Daumier's talent, spurred on by the excitement of a virulent political campaign against the new regime of King Louis-Philippe, really took wing. Calculated visual insults suceeded one another, executed with skill and ferocity. The 'liberal' king with his pear-shaped head[8] was represented in various scatological poses: slow, treacherous, dealing out a substance recognizable as shit, and surrounded by aggressive conservative politicians, out for their own aggrandizement and the suppression of the people. In February 1832 Daumier was tried for libel, along with Philipon and Aubert as publishers, for his single sheet lithograph entitled *Gargantua*. In this, King Louis-Philippe is shown as a giant enthroned before the city of Paris, fed by the starving

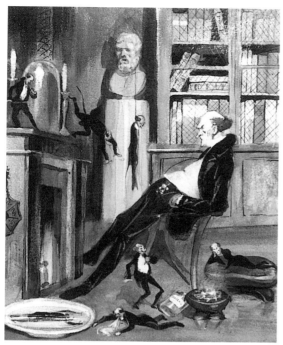

3. Daumier: *Misanthropie (Misanthropy)*. Pencil, pen and ink, brown wash and gouache, 25 x 20. Private collection, Paris. Ex Maison.

masses who haul panniers of food up to his mouth in continuous succession, while from his posterior honours and concessions fall to politicians gathered outside the Palais Bourbon, in the form of toilet paper. Daumier was convicted, fined, and given a suspended sentence of six months imprisonment. This sentence was reimposed when he was arrested the following August for yet another subversive print, *Les Blanchisseurs*, which shows three important members of the government – J.-C. Persil, the procurator general; the Comte d'Argout, minister of the interior; and Marshal Soult, president of the Council – at the strange task of trying to wash the colours out of the *tricolore*. It was given the legend 'The blue goes alright, but this devilish red sticks like blood'. However, Philipon had already taken Daumier on to his regular staff of cartoonists for *La Caricature*, and the young man's career was fully launched by the time he went to prison.

It is possible that Daumier hoped to straddle both the fields of journalistic production and of fine art at this early date, but there is little evidence of his succeeding. The recent discovery of a monochrome wash drawing which was made for reproduction in *Charivari* in 1833 as a 'painting' may indicate his aspirations. *Misanthropie (Misanthropy)* executed in pencil, pen, brown wash and gouache (fig. 3), was one of a group of such drawings made by Daumier in the mental home of Dr Pinel whilst serving part of his sentence there as a political prisoner. They were published in *Charivari*, but all the originals had been thought lost until recently.[9] This lugubrious fantasy, very neatly articulated with clear contours drawn in pen, lent itself to a literal transcription by the lithographer. The following year, on 9 October, *La Caricature* announced that a watercolour by Daumier called *Un Cabaret de village* would be reproduced, but it never appeared.[10] This no doubt led Jean Adhémar to conclude that other early lithographs of genre scenes, such as *Le Malade* (*The Illness*) and *La Bonne Grand'Mère* (*The Good Grandmother*), published in *La*

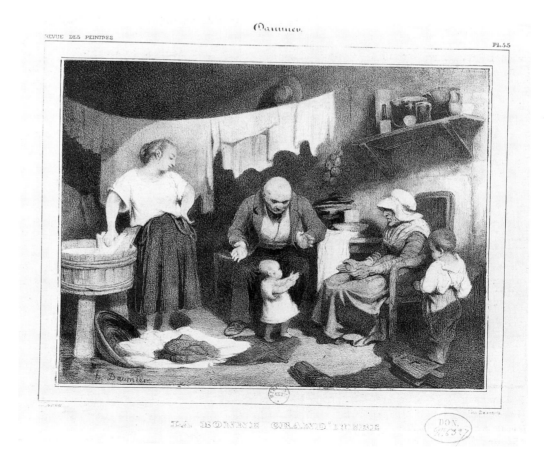

4. Daumier: *La bonne grand'mère (The Good Grandmother)*. Lithograph by Delaunois, from *La Revue des Peintres*, 1835. Paris, Bibliothèque Nationale. LD 254.

5. Monnier: *Chez Monsieur le Curé (At The Vicar's House).* Pencil, watercolour and gouache, 21.5 x 28.2. Paris. Louvre.

7. opposite page, Daumier: *François Guizot.* Bronze cast from clay, 22.1 high. Los Angeles, Armand Hammer Daumier and Contemporaries Collection, UCLA at the Armand Hammer Museum of Art and Cultural Centre.

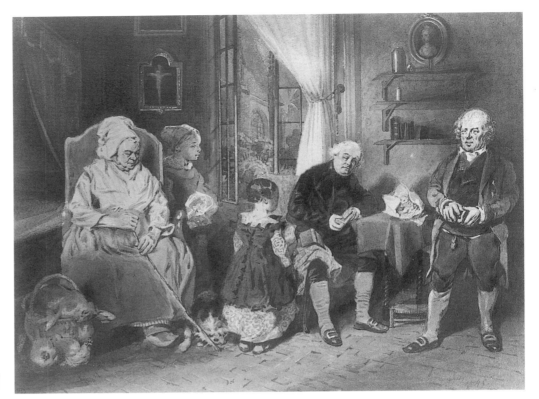

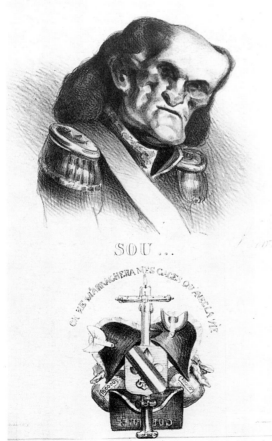

6. Daumier: *SOU...(Marshall Soult).* Lithograph, published in *La Caricature,* 28 June 1832. LD 66.

Revue des Peintres in 1835 (fig. 4), must also be reproduced from watercolours.[11] However, there seems no reason to believe that monochrome wash drawings would not have done just as well, and in French terminology the term *aquarelle* is used to cover both coloured and monochrome wash drawings using a brush. *La Bonne Grand'Mère* is a lithograph after Daumier by Delaunois. Daumier's signature, as artist, appears on the plate, and the carefully modulated variations of tone in the print produces an effect of 'pictorial' lighting. This work is plainly celebrating a moral theme concerning the deserving poor. Although treated with a somewhat superficial, Greuze-like sentiment at this stage, the theme of the working-class grandmother is one which Daumier would return to later, with greater vivacity and earthiness. Adhémar concluded that such works were not found saleable by Daumier and that he returned exclusively to caricature after 1835. The type of popular art to which they belonged was not uncommon, however. Daumier's slightly older contemporary, Henry Monnier, was producing watercolours of genre scenes, based on monochrome washes with colour tints and dark accents added, from the late 1820s onwards.[12] Monnier's drawing *Chez Monsieur le Curé (At the Vicar's House)* of 1845 is a good example of his rather darkly satirical genre pieces with their subjects taken on the whole from the lower middle class and peasantry (fig. 5). His technique, together with the example of Charlet, could have formed a model for Daumier's earliest independent watercolours. Given so few surviving examples, however, it is impossible to discuss Daumier's further development as a draughtsman from 1830 to 1848 without returning to his career as a cartoonist and a closer look at the development of his lithographs.

If Daumier's debut as a 'fine artist' was hesitant and imitative, his rise as a cartoonist between 1830 and 1835 was meteoric. Around the time that he had begun working for Philipon as a full member of the *La Caricature* team, in about February 1832, his editor commissioned from him a series of *portraits-chargés* (caricatured portrait busts) in clay of the deputies in the legislative assembly. (Philipon had previously announced his intention

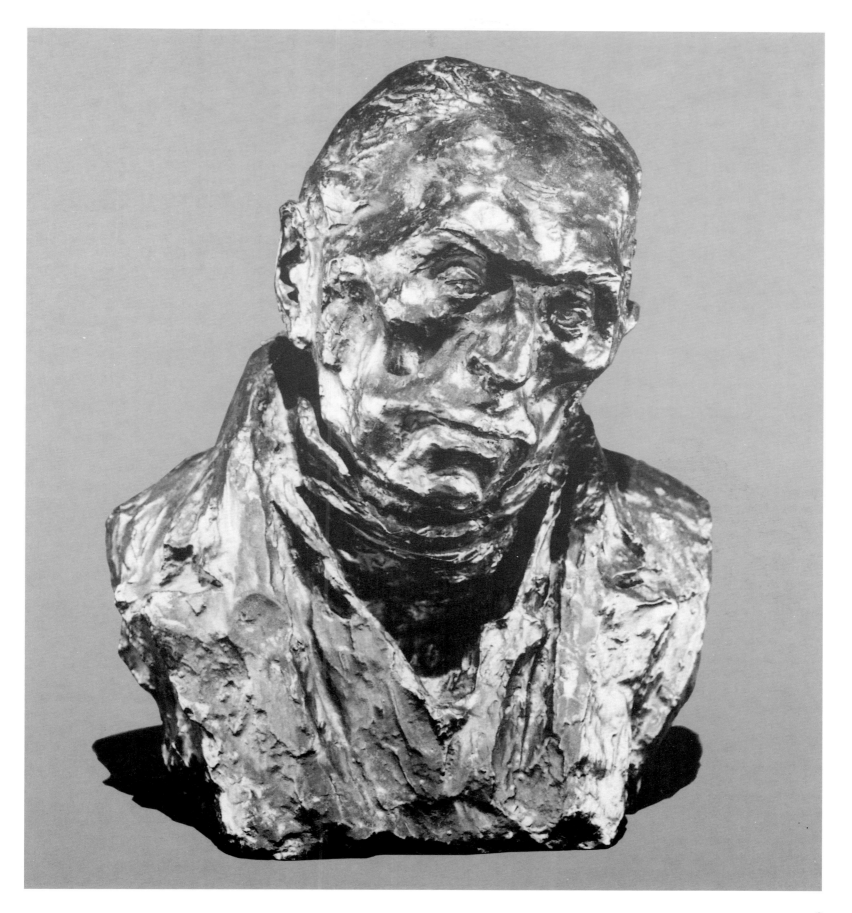

of finding a sculptor to do this).[13] At the same time, and perhaps using his clay busts as sources of inspiration, Daumier began his series of lithographs of the same individuals for publication, each recognizable by some signs of family or career status but with name abbreviated or disguised. It is not always possible to match up sculpture with lithograph in every case, but what is clear is a marked increase in plasticity in Daumier's drawing. An early case in point, for which a clay bust has not been found, but which is nevertheless drawn in a markedly sculptural style, is the bust of Marshal Soult (fig. 6). The marshal's 'insignia' include a sash of honour across a fleur-de-lis, his military hats, and bags of money. This was published in *La Caricature* on 28 June 1832, one of four such busts which appeared before the artist's arrest. The roughly gouged planes of the subject's craggy face and jutting jaw give the sense of its being made, in modern analogy, by a jackhammer cutting into rock. After Daumier's release from prison in 1833 more deputies appeared in *La Caricature*, some of them as full-length figures. A larger number, however, were published in *Le Charivari*, Philipon's new daily satirical journal, the first number of which had been issued on 1 December 1832. It seems unlikely that Daumier would do anything so tame as to 'copy' his sculptural models: more likely that they represent his initial researches into character. One of the most sophisticated in the series, that gives a sense of real psychological insight, is the bust of François Guizot, reproduced here from a photograph of a bronze cast which accentuates the sculptural forms (fig. 7). This bust appears to have been the direct source for a lithograph published in *Charivari* on 3 May 1833, although there the head is seen in profile from the left, and also for the head of a full-length figure of Guizot sitting in the Chamber, published in *La Caricature* at the end of the year (fig. 8). This austere character had been a professor at the Sorbonne before becoming secretary of the interior in 1814. He survived the Bourbon Restoration and served in Louis-Philippe's parliament from 1830 to 1848, with a gloomy but unbending and authoritarian loyalty until the king's downfall: he followed him into exile. At the time of this portrait, Guizot was minister of public instruction. A subjective reading is surely demanded of this face with its averted eyes: did Daumier feel, for once, slightly in awe of this man's lofty boredom with the stupidities of governmental administration?

Much has been written about the great lithographs through which Daumier and Charles Philipon pilloried the sovereign regime of Louis-Philippe, his ministers and parliament from 1831 to 1835. Philipon and his staff on *La Caricature* and *Charivari*, writers and artists, formed a team which conducted an organized political campaign over this period. Their performance was humorous (sometimes), noisy and aggressive, as expressed in one of Daumier's designs for wood engraved headpieces for *Charivari* in November 1833 (fig. 9). The engraver's translation of Daumier's original drawing is crudely done in this case, but the personae are clear enough. Philipon bangs the drum in the centre, flanked by his brother-in-law, Gabriel Aubert, on his right and Daumier with the tambourine on his left, surrounded by all the artists and lithographers who collaborated on the journal. Daumier represents himself as the youngest looking member of this gifted and wicked team. These consistently subversive portrayals of Louis-Philippe as a barbarous, revolting, pear-shaped parody of a monarch, resulting in several indictments for criminal libel, are well known. During Daumier's six-month sojourn in St Pelagie prison and the mental establishment where he completed his sentence, he met many old friends including painters and intellectuals who were enemies of the current regime – and this has been referred to ironically as his 'University Period'. The community included republican artists like Philippe-Auguste Jeanron and the sculptor Auguste Préault, both of whom had met him before as students in the Atelier Suisse and in the Atelier Boudin. However, Daumier cannot have had as much time to study in these fine art establishments as they did, and Jeanron is said to have given him painting lessons in prison. The relation between the 'fine artists' and the artist employed by the newspaper trade is

8. Daumier: *François Guizot*. Lithograph, published in *La Caricature*, 13 December 1833. LD 74.

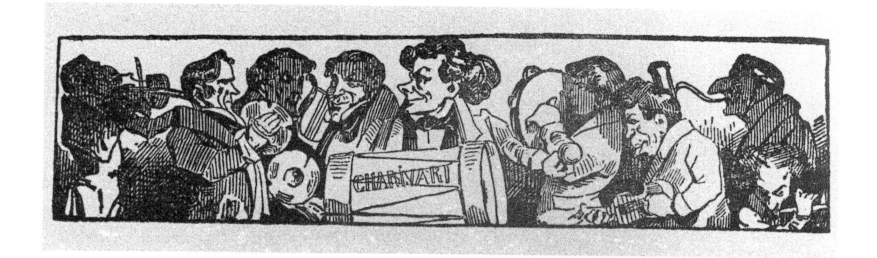

9. Daumier: *L'Orchestre de Charivari (The Charivari Orchestra)*. Wood engraving, 1833. Bouvy 6.

significant. It will become clear that Daumier quietly pursued his education in the history of art and developed his draughtsmanship in the ensuing decades, but his early efforts at painting must have been much curtailed.[14] What earned him his daily bread during the 1830s and 1840s was his power to draw cartoons that could be instantly understood by everyone, whether their targets were political or social.

At the height of his campaign Philipon launched an ingenious subscription scheme called *L'Association Mensuelle*, to avoid the government censor's prohibition and also help to pay his fines. This scheme provided private subscribers with one large, separate, 'original' lithograph per month – invariably on a political theme. All Philipon's staff of cartoonists contributed to the series, but Daumier's prints became the most notorious of all. Two are illustrated here. *Liberté de la presse* (*Liberty of the Press*), which was given the legend *Ne vous y frottez pas!* (*Don't rub them up the wrong way!*), appeared for the month of March, 1834 (fig. 10). On a mound in the foreground stands a brawny worker in printer's cap and apron, fists ominously clenched. In the background on the right,[15] the recently deposed king, Charles X of the house of Bourbon, lies on the ground knocked out and attended by anxious royalists. (The reference is to the recent revolution of 1830.) On the left, the newly arrived king Louis-Philippe, of the supposedly liberal house of Orleans, attired in bourgeois garb and his famous grey felt top hat with cockade, advances waving his umbrella threateningly. .He is pushed forward by his procurator general, Persil, but restrained by Deputy Barrot, Prefect of the Seine and a member of the left opposition. This explanation was given by Philipon in a subsequent issue of *La Caricature*, and he described it as one of the finest political studies made in France, done in the English [caricaturists'] manner.[16] The compositional arrangement is certainly in the English manner, but the vigorously drawn figures, with tough, springy contours and uncomplicated tonal shading giving a colouristic effect, is identifiably Daumier's own. Four months later he produced an even more striking image (fig. 11) concerning a very recent event, entitled *Rue Transnonain, le 15 Avril 1834* (*Rue Transnonain, 15 April 1834*). This refers to a particularly horrible series of murders which had taken place in the workers' quarter of Saint-Martin (now the area rebuilt around the Pompidou Centre), after a day of insurrection, riots and barricades. A troop of the National Guard, fired upon from an upper window of an apartment building in the rue Transnonain, were apparently let into the house whereupon they massacred most of the inhabitants inside, men, women and children.[17] Daumier has condensed a series of incidents which took place in rapid succession on several floors, into a single scene. The overturned chair sets the immediate sense of disorder, dominated by the cadaver of the worker in his

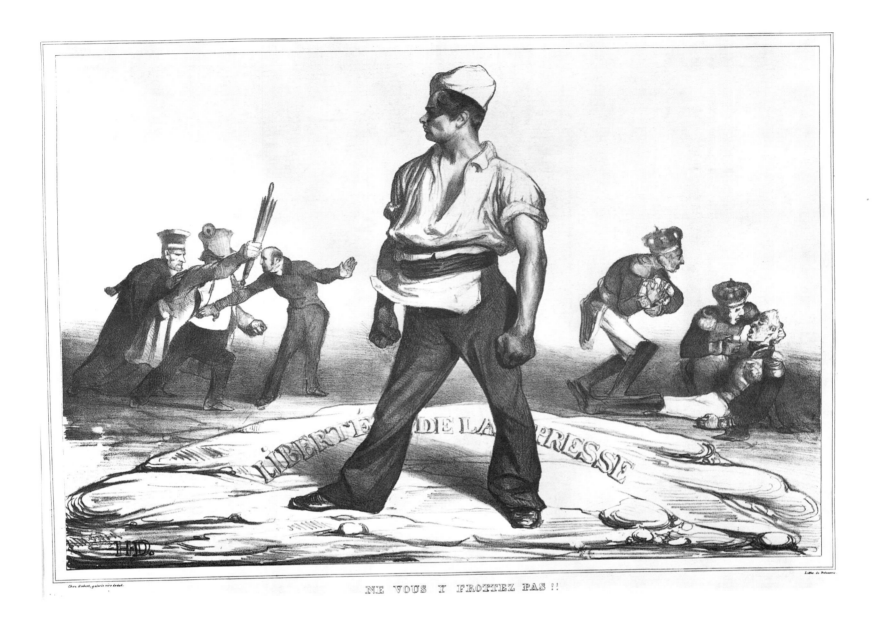

NE VOUS Y FROTTEZ PAS !!

10. Daumier: *Liberté de la presse (Liberty of the Press).* Lithograph, published March 1834. Paris, Bibliothèque Nationale. LD 133.

nightshirt, collapsed on his back and lying across his dead baby in pools of dark blood. The upturned head of an old man, with jaw collapsed in death, protrudes into the picture at the bottom right, while the foreshortened corpse of a woman lies in the shadows to the left. This dramatic presentation, highly pictorial in its baroque chiaroscuro with deep blacks reminiscent of Goya's *Disasters of War* prints, comes entirely from Daumier's imagination, fired by the written accounts. Its stark 'realism' is from his mind and memory – of course we cannot know from what several sources, but the resemblance of the men's heads to some of Géricault's painted studies of dismembered corpses, made in the morgue at the time he was planning the *Raft of the Medusa*, is striking.

This 'pictorial' aspect of the *Rue Transnonain . . .* is relatively unusual for Daumier's lithographs, and although similar effects did occur in his genre prints for *La Revue des peintres* mentioned above, this was not the way that his style for daily cartoons would develop through the 1840s. After the government's suppression of all political caricature in 1835, which obliged Philipon and Aubert to reorganize *Le Charivari* and (after a period of closure) *La Caricature* into popular journals concerned with social manners, Daumier developed a new system of drawing with which to keep up his production for the new

12

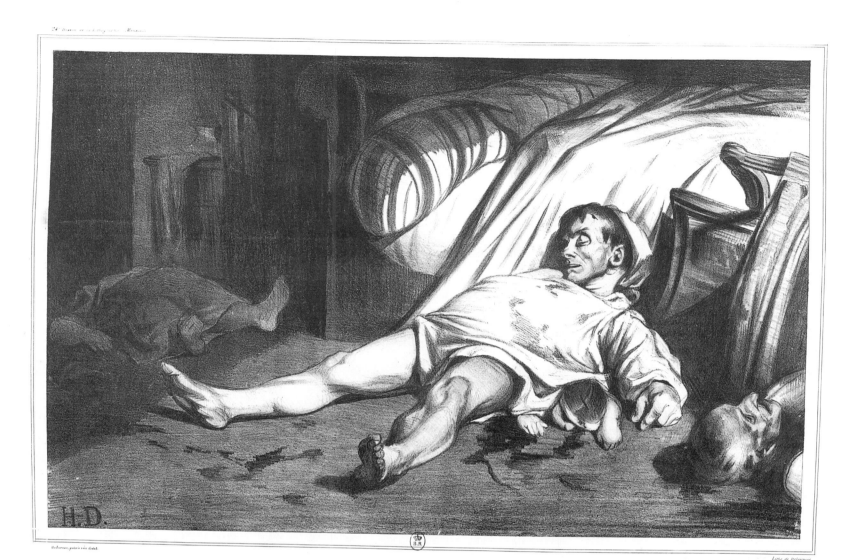

RUE TRANSNONAIN, LE 15 AVRIL 1834

11. Daumier: *Rue Transnonain, le 15 Avril 1834 (Rue Transnonain, 15 April 1834).* Lithograph, published July 18, Paris, Bibliothèque Nationale. LD 135.

market.[18] The survival of an account book which records, in very rudimentary note form, all his orders for lithographs and designs for wood engravings delivered between November 1837 and September 1840, has enabled us to see the pattern of Daumier's activity at this time very clearly.[19] In the first ten months covered by this account book (now known as *Carnet I*) he was producing almost nothing but lithographs, for which he was paid 40 francs per stone. He produced between five and ten of these per month, and his average monthly takings were 328.5 francs. Then from September 1838 we find him drawing more of his designs on wood blocks, to be engraved by others.[20] This coincided with a new vogue for wood engraved illustrations, which hit its full stride in 1839. The usual prices for wood blocks (he refers to them as 'bois' in his account book) were from 20 to 30 francs, but they could fetch up to 55 or 65 francs for more elaborate designs. Likewise, exceptionally important lithographs, such as the one he drew for *Charivari* on 29 December 1838 (fig. 12) could bring in as much as 125 francs. This elaborate 'Parade' of the editor and staff of *Charivari* as *saltimbanques* (roving entertainers), was drawn on the stone entirely with a pen. Young Daumier himself, tousle haired and shouting, appears on the steps leading up to the stage, urging the crowd into the subscriptions office.[21]

13

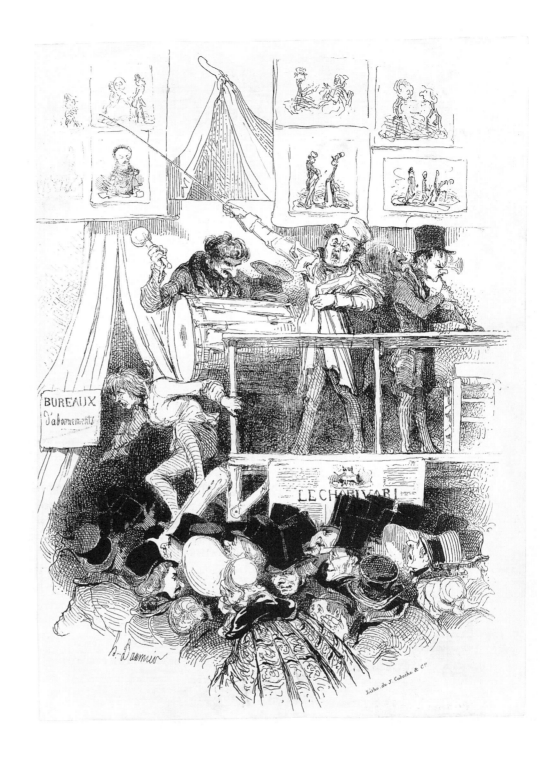

12. Daumier: *Parade de Charivari (The Charivari Parade)*. Lithograph, published 6 January 1839. New York, Metropolitan Museum of Art, The Elsiah Whittesley Collection, The Elsiah Whittesley Fund, 1992. LD 554.

Instrumental in his increased production of wood block designs from now on was Monsieur Dutacq, who became the new owner of *Charivari* in February 1839. At this time, in addition to a full-page lithograph which appeared regularly on page three, the other three pages of the journal were embellished with smaller engraved illustrations and ornaments. Daumier is said to have received a new contract from Dutacq on 2 February, offering him 50 francs per lithographic stone (instead of 40) and 2,000 francs down against the next 200 prints in exchange for a monopoly of his work.[22] However, the only reference to this in Daumier's accounts is a faint note in pencil made on 1 March, which

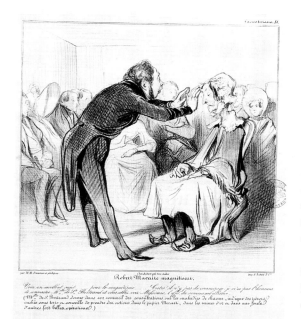

13. Daumier: *Robert Macaire magnétiseur (Robert Macaire, Hypnotist)*. Lithograph, published 26 August 1838. New York, Metropolitan Museum of Art. Gift of Edwin De T. Bechel, 1953. LD 443.

14. Daumier: *Robert Macaire*. Watercolour, 13 x 10. *c.*1855-60. Collection unknown. MD 76.

reads 'retour des 2000'. Lower down, however, he writes 'Le 9 Mars touché 1000fr', which would indicate the receipt of this sum. What remains curious is that with one exception – he was paid 50 francs apiece for six lithographs in August 1839 – nowhere in this account book is there any sign of his fee per stone being raised. They remain at 40 francs up to September 1840. Be that as it may, his average monthly income increased overall from 1838 through to 1840. During the ten months from September 1838 to June 1839 his average income rose to 484 francs per month. In this period we find more designs for wood blocks, and many new series of cartoons for *Charivari*. Over the third period of ten months, from July 1839 to April 1840, his average income peaks at 687 francs per month. During the last five months recorded, Daumier's average monthly income evens out at 523 francs a month over that short period.[23] A significant part of this income was now provided by designs for wood engravings, although his lithographic cartoons were more the cause of his increasing fame. To complicate matters, there exists an autograph letter signed by Daumier on 30 September 1843, in which he agrees to a reduction in his price for lithographs from 50 francs back to 40 francs after the departure of M. Dutacq.[24] Thus at some point after September 1840 he did receive 50 francs per stone, which would have made him much better off for two or three years.

The first and most famous of Daumier's cartoon series was the *Robert Macaire*. The character of 'Robert Macaire' had been created by the actor Frédéric Lemaître and his company at the Folies-Dramatiques on 14 June 1834. Charles Philipon was instrumental in getting Daumier to develop this subject for *Charivari*. He managed to portray Macaire as an instantly recognizable personage, yet one who appeared in many different professional disguises, remaining a rascal and an imposter in all of them. Macaire came to symbolize a basically self-seeking and unscrupulous entrepreneur in all walks of life, and many saw him as a reflection of the morals of the business world which was then taking over the governance of France. All of the *Macaire* plates published in *Charivari* are inscribed *Ch. Phil. invt. H. D. lith*, or *par MM. Daumier et Philipon*, and like variations. Daumier drew one hundred 'Robert Macaires' in his first series, the prints being published between 20 August 1836 and November 1838, and so popular did they become that they were later issued as a separate album in 1839. Moreover, a second series of twenty was drawn for *Charivari* between October 1841 and October 1842, again acknowledging both Daumier and Philipon. *Robert Macaire magnetiseur (Robert Macaire Hypnotist)*, drawn in August 1838 (fig. 13), is an excellent example of their collaboration. The visual apprehension of hypnosis by the viewer is instantaneous: the expression of Macaire's profile; the outstretched hands exuding power from the fingertips; the old woman's face asleep with the tell-tale dropped jaw (actually she is recognizable as Macaire's male assistant, Bertrand). The springy tension of the mesmerizer's bodily stance, like an actor on stage, and the thinly drawn gaping faces of the audience seated around – all this is Daumier's contribution. The text, Philipon's contribution, is not bad either – it makes a good story:

> here is an excellent subject . . . for mesmerism . . . certainly there has been no prior gossip, [since] I do not have the honour of knowing Mme. de St. Bertrand, and you are going to see, Gentlemen, the effects of somnambulism . . .
> (Mme. de St. Bertrand gives, in her sleep, opinions on the defects of everyone, indicates buried treasure under the earth and advises action to be taken in the matters of the Mozart manuscript, in the gold mines and in a host of other very attractive operations.)

This is but one aspect of the legendary character of Robert Macaire, built up over the years to personify an exploiter of human greed and gullibility, wherever these could be found in French society. Such inventions must have been continually discussed by

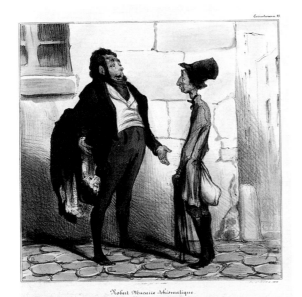

15. Daumier: *Robert Macaire schismatique (Robert Macaire, schismatical)*. Lithograph, published 16 March 1837. New York, Metropolitan Museum of Art. Gift of Edwin De T. Bechel, 1953 LD 389.

Daumier and Philipon. The fundamental character of Macaire, however, his *reality* as a person, seems to have remained in people's minds from the visual image after the specific social contexts of the satire had been forgotten. A strange case in point is the existence of two watercolours of Robert Macaire and one of his assistant Bertrand, exhibited in one frame in 1888 together with a watercolour of the actor Bocage.[25] Both busts of Macaire, and the bust of Bertrand, are near-replicas of specific lithographs: shown here is the bust of Macaire hatless (fig. 14) with a lithograph (fig. 15) – this particular print has been hand-coloured at a later date – and Macaire with hat (fig. 16) as in the lithograph (fig. 17) *Brevet d'invention . . . (Inventor's Patent . . .)*. In both cases the original texts by Philipon, on Robert Macaire proposing to found a new religious sect and setting up the phony invention of bituminous powder, respectively, have been ignored by the collector who requested the drawings, together with the entire pictorial setting. Only the disembodied bust of this battered and now rather sad-looking rogue has been requested, as though for a private portrait gallery. If Daumier made these watercolours himself he could have been responding to a commission made some years after the lithographs were made. Alternatively, they may not be by Daumier at all.[26] Personally I think the attribution is possible, given that they were made during the time-span of Daumier's overlapping career as a watercolourist, where being tied to a specific text was no longer necessary. In such a context the 'resurrected' Macaire watercolours could be dated perhaps to the later 1850s, when the artist was experimenting with remaking some of his best known images for sale in a fine art medium.

Throughout the remainder of the 1840s, therefore, the best evidence for the development of Daumier as a draughtsman – and hence as an artist as a whole – lies in his lithographs. *Les Bas-bleus (The Bluestockings)* was a new series commenced in January 1844 which became popular enough, after publication in *Charivari*, to be republished separately 'sur blanc', that is on separate sheets of blank, white paper as a separate set.[27] The woman standing up in the theatre gallery (fig. 18), is a commanding figure made cruelly plain in appearance by her thinning hair, needle-nose and glasses, yet her dress is rendered with the richest black of which the lithographic crayon is capable. A caption will tell us that she is a female author, called upon at the end of a performance at the

16. Daumier: *Robert Macaire* (with hat). Watercolour, 13 x 10. *c.*1855–60. Collection unknown. MD 75.

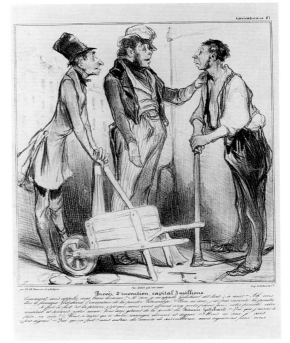

17. Daumier: *Brevet d'invention… (Inventor's Patent…)*. Lithograph, published 19 August 1838. New York, Metropolitan Museum of Art. Gift of Edwin De T. Bechel, 1953. LD 442.

18. Daumier: from the series *Les Bas-bleus (The Bluestockings)*. Lithograph, published 17 March 1844. Paris, Bibliothèque Nationale. LD 1237.

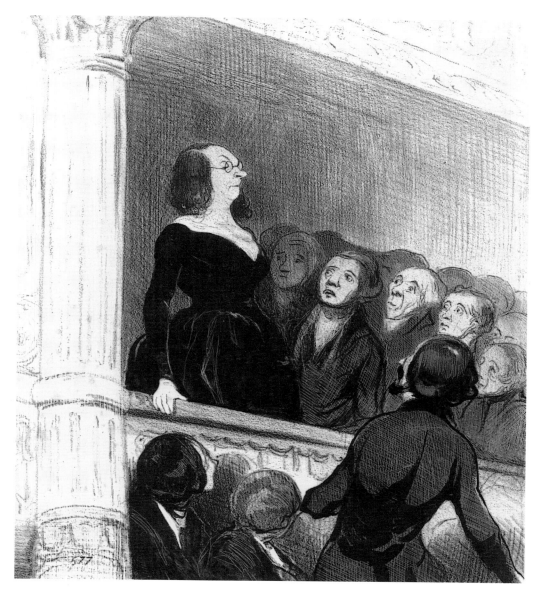

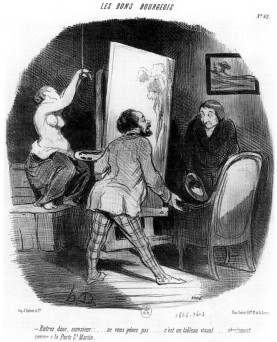

19. Daumier: from the series *Les bons bourgeois (The Good Bourgeois)*. Lithograph, published 5 January 1847. Paris, Bibliothèque Nationale. LD 1538.

Odéon and who now reveals her gender. The irony is that if the figure were a man its slight eccentricity would have excited no remark. But the males and their expectations are satirized too, by their expressions, by the relatively wan greys of their clothes, and by the grouping of their weaker forms which slide away to the right.[28] In fact the story is told here virtually without a caption, albeit *Charivari*'s staff of hack copywriters were happy to provide one for its readers.

An increasing mastery of tonal control on the lithographic stone, manipulating the grey-scale from the deepest blacks up to the whiteness of the paper itself, giving effects of light and atmosphere comparable to Corot's achievements with oil paint, is the hallmark of Daumier's development as an artist throughout the 1840s. This can be shown in a simple series of selected examples, of both indoor and outdoor scenes. Theatrical lighting, as in the *Bas-bleus* scene, can be counted a baroque device, which forms one strand of Daumier's artistic vocabulary. The artist receiving an unexpected visitor in his studio (fig. 19) is rendered both with baroque lighting and with a baroque pose for the model. So grotesque is the pop-eyed visitor's expression here that Daumier's other allusions could easily go unnoticed. The artist's pose is as affected as that of his suspended

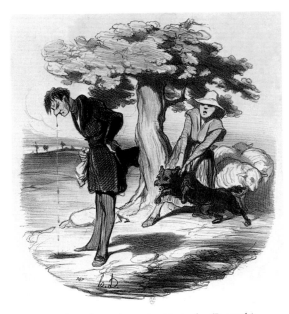

20. Daumier: from the series *Pastorales (Pastorals)*. Lithograph, published 9 May 1845. Paris, Bibliothèque Nationale. LD 1388.

21. Daumier: Unpublished lithograph, inscribed *Bouderie conjugale (Marital Sulks)*. 1847. Paris, Bibliothèque Nationale. LD 1561.

model, who seems to be a Repentant Magdalene;[29] her arms are literally suspended and so is her movement, though it is only the latter fact that catches the visitor's limited (bourgeois) viewpoint. At least he can understand the explanation of the popular entertainment mode to which the viewer is referred in the caption – the legal loophole allowing the public display of nudity if it remains immobile. The *plein air* type of landscape hanging on the wall behind might be a dig at Corot or Daubigny, both these artists being friends of Daumier's by 1846.[30] The same deep blacks of the interior scenes are found in a landscape from the series *Pastorales* of 1845 (fig. 20), where they enhance the elegant silhouette of the bourgeois who has just been punched on the nose, and the ferocious black dog belonging to the country maid whose virtue has just been essayed. The sense of distance from the solid foreground to the river in the background is achieved by tonal gradations, although the curiously cut-off top of the tree seems to be caused by the necessity for the figures to fill most of the space; a problem that Daumier has not successfully overcome. A slightly later lithograph of 1847 does convey the feeling of light and space with total consistency (fig. 21). Here the problem of the tree-figure

18

22. Daumier: Unpublished lithograph, inscribed *Un propagandiste (A Female Propagandist)*. 1849. Paris, Bibliothèque Nationale. LD 1930.

23. Benjamin (Benjamin Roubaud, 1811–47): *Les jolies femmes de Paris: 'Divertissement matrimonial...' (Pretty Women of Paris: 'Marital distractions...')*. Lithograph published in *Panthéon charivarique c.*1840.

scale has been avoided by pushing the vegetation well into the background behind the figures. It is not, of course, quite clear why this couple are sitting out there sulking, and as the lithograph was not published we lack an explanatory storyline; however, the psychological distancing of this speechless pair should give any reader the chance to make up their own caption. (Daumier may have enjoyed seeing what his writers produced.)

An increasing freedom and fluency of line in lithography undoubtedly came to Daumier through continuous practice over two decades of trying to meet deadlines for his publishers, to earn his living. But although we are now reaching a point where he made his first major attempt at a career change, it should not be assumed that there was a corresponding falling off of power in his cartoon images, especially when he had a telling political point to make. One of his most interesting satires on the women's movement – if indeed satire was the real intention – is the revolutionary print *Un Propagandiste (A Female Propagandist)*.[31] The panoramic landscape is handled with even greater mastery than the previous illustration: all the seeds of Daumier's understanding of space in watercolours and oils are here (fig. 22). The low viewpoint gives the woman propagandist a Napoleonic stature, and the wind blowing out her garments is reminiscent of the wind of change blowing out the curtains of the Jeu de Paume hall in J.-L. David's *Oath of the Tennis Court*. The young woman looking up at her seems to be fluttering with hope (the message is a socialist one, issuing from the women's clubs of Paris in 1849), and the scene is filled with light and air. The agitated lines may be somewhat hard and spiky, but the image we are left with goes far beyond the ordinary requirements of caricature. It is both explicit and implicit, depending, perhaps, on the expectations of the reader. Ironically, while the implied reference to David remains probable, Daumier's starting point for his image of the wind-blown young woman could have been a perfectly anodyne cartoon by Benjamin Roubaud of a young woman with her husband 'watching the sunset from the hill of Montmartre' (fig. 23). He seems to have lifted the idea of the blown skirt, the stretched-out sash, and the panoramic viewpoint from his contemporary's charming 'matrimonial diversion' published in an album, *Panthéon charivarique*, in 1840; but in so doing he has completely overturned the social meaning of his original, and both literally and figuratively reversed the direction of the wind.

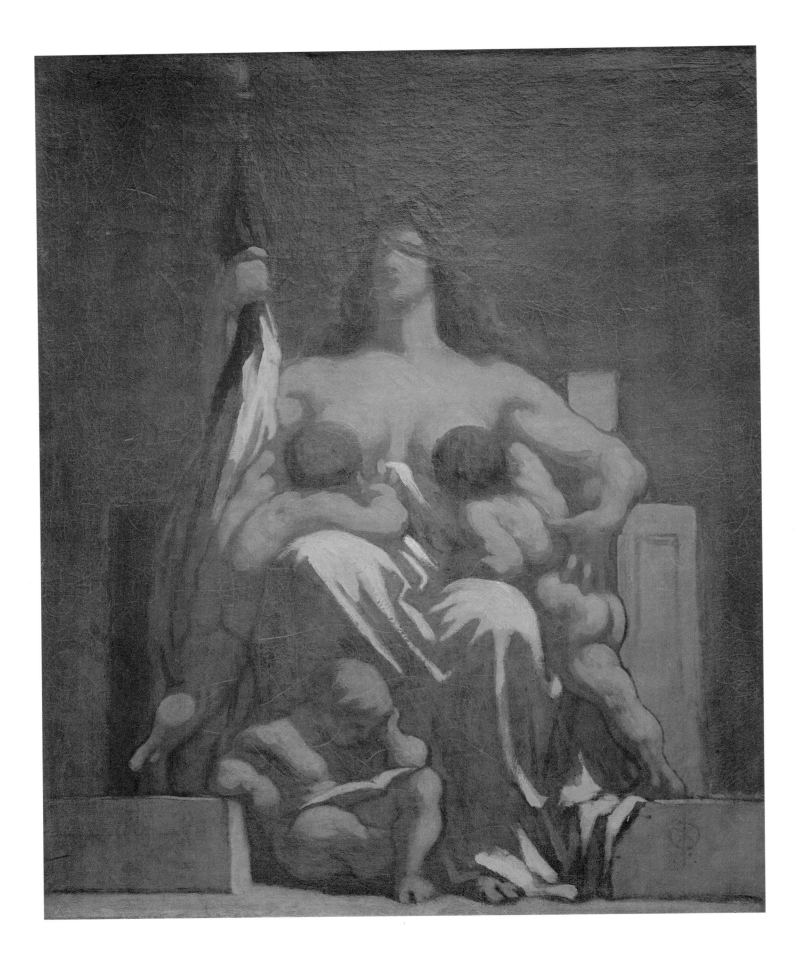

Chapter 2

DAUMIER AS *ARTISTE-PEINTRE*, PART I (1848–1852)

Daumier was evidently feeling triumphant at the outbreak of the February revolution in 1848, and his cartoons showing the occupation of the Louvre Palace by the common people, and the abdication and flight to England of Louis-Philippe, no longer carried the vicious overtones of the 1830s. At first the advent of the new regime, unstable though it proved to be, worked to his advantage as an artist – and by now some did consider him as an artist.[1] Nevertheless, when he entered the state competition for an allegorical painting of the republic and was short-listed for the prize, he no doubt took many people by surprise (fig. 24). This heroically proportioned, Michaelangelesque figure breast-feeding two enormous boys is a far cry from his cartoons of sharp-tongued 'femmes d'esprit'. This figure seems more in the tradition of Delacroix's allegory of *Liberty at the Barricades* of 1830. She is not quite so belligerent but, like Delacroix's figure, she is a 'Marianne' – a woman of the people. Her breast-feeding makes her look like a figure of Charity,[2] but the improbable age of her sons is further compounded by the device of a third child reading a book at her feet. The 'double goose-foot' mark inscribed in a circle on the stone at lower left, which resembles a sign used by stone-cutters' guilds, was actually Daumier's chosen rebus for this competition in lieu of signature (the entrants were supposed to be anonymous). All this suggests that Daumier took his republican allegiance very seriously in 1848, and may have associated himself with the educated working class, as represented by the printing trades who worked closely with journalists but whose social status straddled the gap between bourgeois and proletariat. In this oil painting Daumier does not seem to be completely at home with the medium. It is rather heavily executed in flat tones, with chiaroscuro modelling giving the effect of soft forms like putty or clay. However, he was placed eleventh in the competition and might have painted a life-size version if the whole scheme had not come to a premature end.

The existence of the *République* sketch begs the question: how much had Daumier painted in oil before 1848? The relative dullness of its execution (as opposed to the originality of its conception) would suggest the answer 'not much'. K.E. Maison catalogues nineteen extant paintings which he places before or up to 1848, but the dates assigned to them are purely speculative. There are a very few obviously early efforts such as *L'aquafortiste* (see chapter 1, note 14), and some small paintings on panel which are in effect drawings made with the point of the brush and then toned. *Ouvriers dans la rue* (*Workmen in the Street*) in the National Gallery of Wales (fig. 25) is one such case. The contours are drawn in black and the areas between tinted with variations of white and dark brown, not unlike a watercolour technique.[3] There seems to be no specific reason to date this much before 1848. The subject, in which workers cross the path of a top-hatted bourgeois, could well relate to the revolution of the 'February Days', with Daumier the cartoonist of manners suddenly able to turn back to the people of his local quarter – the workers in the streets on the Ile Saint-Louis. But this is a draughtsman's painting, and we have to look further on for evidence of Daumier learning his oil painting technique from the avant-garde painters of his day, like Delacroix or J.-F. Millet. The latter he met in about 1847, and it was perhaps Millet who most likely moved him in a more painterly direction, especially in his smaller scale, more intimate works.[4] A smallish painting entitled *La sortie de l'école* (*Children Coming Out of School*) (fig. 26) is an example of Daumier's early difficulties with painting, and also of how he could

24. Daumier: *La République (The Republic)*, 1848. Oil on canvas, 73 x 60. Paris, Musée d'Orsay.

take up an abandoned work again at a later date. Like the *Workmen in the Street*, it is painted on a primed wood panel over which a brownish ground layer has been thinly spread. But in this case the artist has attempted to render his figures in large areas of differentiated tones and bright local colours, rather than stressing their contours. In the first phase of painting he was not altogether successful. The three children at the bottom of the steps on the left, who might have stepped out of the shadows of a scene by Breughel in their little white caps, are lively in movement but a bit doll-like in their features, as though the artist could not get his brush round the details. These figures have not been retouched. The children's heads on the right, however, and their caps and shawls, have been repainted with a more liquid, fatty paste reminiscent of Millet's *manière fleurie* style (as it was called) of the mid-1840s. Daumier seems to have adopted it some time afterwards, and his later intervention here pulls together his image of busy, chattering schoolchildren rushing out to play. A group of small paintings of bathers by the river is dated by Maison to the period just preceding 1848.[5] This seems plausible, both stylistically and because of Daumier's increased interest in landscape, already noted in his lithographs. In the series *Tout ce q'on voudra*, for example, which began in March 1847, there are several drawings of summer trippers along the reaches of the Seine and its tributaries, beyond the confines of the city. However, whereas the cartoons specifically deal with the leisure pursuits of the bourgeois, a painting like *Les baigneurs* (*The Bathers*) is conceived in a different light, both technically and in terms of content (fig. 27). The dark red tone of the panel glows through colours that have become transparent in the shadow areas, in contrast to the very white sky with touches of pale blue and pink, rather clumsily painted. These Breughel-like young men and boys, lazily undressing and entering the water, have an unaffected, natural gawkiness which spells out a working class and un-bourgeois milieu. They are shown bathing in the nude because that was how they did it, before swimming for both sexes (trunks for the men and elaborate bathing costumes for the women) became a fashionable exercise for the middle classes.

25. Daumier: *Ouvriers dans la rue (Workmen in the Street)*. c.1846-48. Oil on panel, 11.5 x 16.5. Cardiff, National Museum of Wales. MI 4.

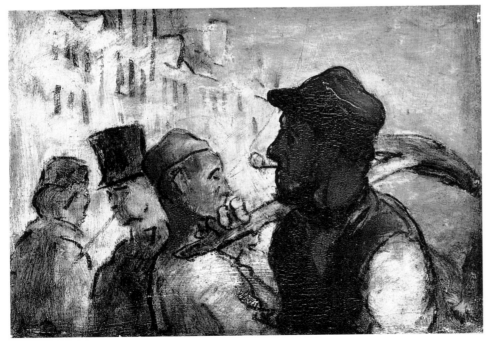

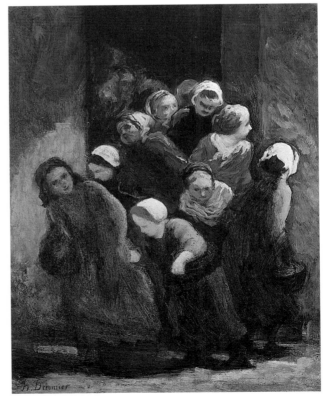

26. Daumier: *La sortie de l'école (Children Coming Out of School)*. c.1846-47 and c.1852-55. Oil on panel, 40 x 31. Present collection unknown. MI 12.

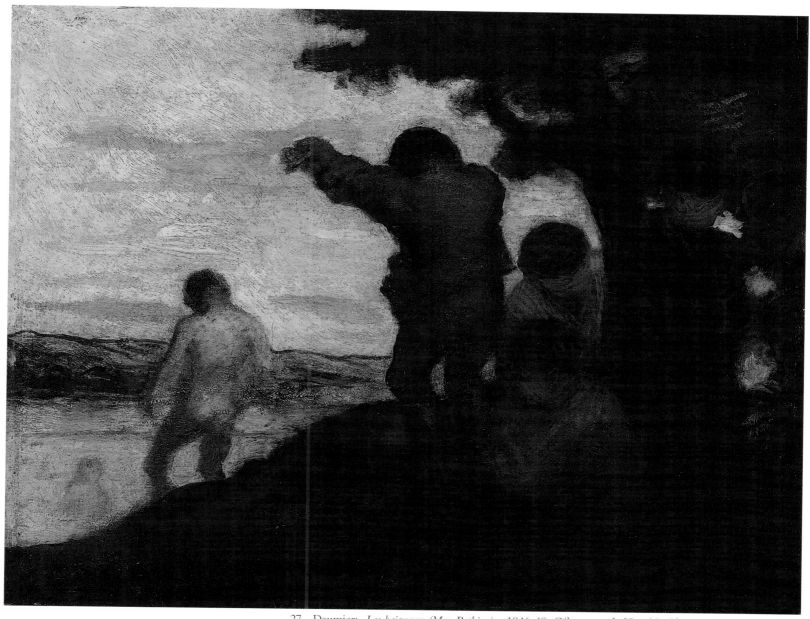

27. Daumier: *Les baigneurs (Men Bathing)*. c.1846–48. Oil on panel, 25 x 32. Glasgow City Museums, The Burrell Collection. MI 17.

These are surely the direct relatives of the mother-figure of *La République*, and should be compared to the boys feeding at her breasts.

Another motif of bathers which seems to begin quite early in Daumier's painted *œuvre*, and then persists, is family bathing in the Seine *within* the city of Paris, on the sandy rubble below the *quais*, where the horses were watered and much of the heavy laundry done. Children often feature in these groups, and in *Au bord de l'eau (At the Water's Edge)* young girl paddlers and washerwomen appear together (fig. 28). This little painting has been given various dates by different commentators, but I am inclined to think that it relates to *La République* in style and intent, although the glowing colours and transparent

Daumier: *La République (The Republic)*. Detail of fig. 24.

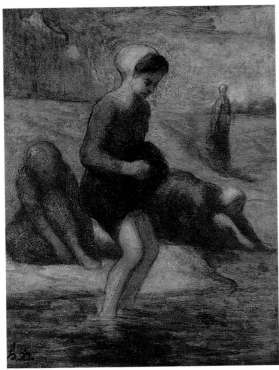

28. Daumier: *Au bord de l'eau (At the Water's Edge).*
*c.*1849-52. Oil on panel, 33 x 24. Troyes, Musée de
l'Art Moderne, Collection Pierre Lévy. MI 11.

glazes point to a better understanding of Delacroix than we have previously seen. From 1848 to 1852 Daumier developed rapidly as a painter, and even if this small, intimate work is only a byproduct compared to his Salon pieces, it nevertheless represents a new level of achievement. This brings us to his more official activities as *artiste-peintre* during the brief life of the Second Republic.

In 1848–49 Daumier was awarded two state commissions for religious paintings, at 1,000 and 1,500 francs respectively.[6] The first of these contracts, for a *Mary Magdalene in the Desert*, was paid in two instalments of 500 francs each, on 29 September 1848 and 26 May 1849, although the picture itself turned out to be Daumier's most notorious case of non-delivery. The state finally accepted his great gouache of *Silenus*, which he had exhibited at the Salon in 1851, in lieu – in 1863. The second painting, *Martyrdom of Saint Sebastian* (fig. 29), he did complete by 1852.[7] He was paid 600 francs on account on 11 April 1849, and the balance of 900 francs on 30 June 1852, at which time it must have been delivered. It had been requested by M. Liance, mayor of Lesges (Aisne), for his village church, of which he was a benefactor.[8] This very large canvas then languished forgotten for 125 years, until it was rediscovered *in situ* by Jean Adhémar and Pierre Angrand in 1978, after Angrand had located correspondence between the mayor of Lesges and the ministry of the interior in a dossier in the Archives Nationales.[9] In the same year Mme Hélène Adhémar independently identified a small and lively *esquisse* for this composition in St Ouen.[10]

The technique of the *Martyrdom of Saint Sebastian* appears to derive from that practised by Thomas Couture. The ground appears to have been toned a dark brown colour, and parts of the *ébauche* underdrawing in black are still visible to the naked eye. On this, half-tones have been put in with an opaque grey mixture, probably consisting of cobalt blue, earth red, black and white (a similar tone and colour to the half-tones found in *La République* of 1849). Thick, opaque lights have then been added with Naples yellow, white, and some pink (on the cherub) for flesh tones. The sky is a pale grey half-tone, streaked with pink, yellow and blue, acting as a lugubrious background for the succouring women (they look more like mourners) who are approaching the wounded martyr. His loincloth is white – the highest light – splashed with thick drops of red blood which has been running down from the wounds in his torso made by two vicious black arrows. Saint Sebastian's head is very strongly modelled, with black hair and black eyes. His hands are tied back to a thick tree trunk, gnarled in a way reminiscent of J.-F. Millet's painting of *Oedipus tied to the Tree* which Daumier would certainly have seen at the Salon of 1847. The strangest part of the painting, however, is the very solid angel-putto flying above the saint's head.[11] This putto is carrying a green palm frond or branch, which by its position might have been metamorphosed from an arrow just pulled out from near the saint's armpit, although the palm branch itself is a symbol of Christian martyrs in general.[12] A martyred saint, however, is usually depicted holding the palm branch rather than being given it, as here. One could even speculate that this unusual piece of iconography carries a veiled reference to *Charivari* and its editors, since the slender branch is carried by the cherub as if it were a very large quill. Overall, this exceptionally large canvas is charged with dramatic effect within a stable composition, and the lighting is strongly reminiscent of Spanish baroque painting. A very similar dark brown toned ground was employed for a large *ébauche* of a subject of Daumier's own invention, *Le Fardeau* (*The Burden*, fig. 90) which was probably begun about the time that the *Martyrdom of Saint Sebastian* was finished. This will be discussed in chapter 5.

A small sketch for the *Martyrdom of Saint Sebastion*, a panel now in the Musée d'Orsay (fig. 30), is in brighter colours than the big canvas. The sky is blue, Saint Sebastian's loincloth is red, there is more light on the flesh colours of his limbs and more reflected colour in the shadows. The cherub holds the palm frond in his hand, but there are no arrows, no blood and no approaching women: the whole effect is lighter. There is more

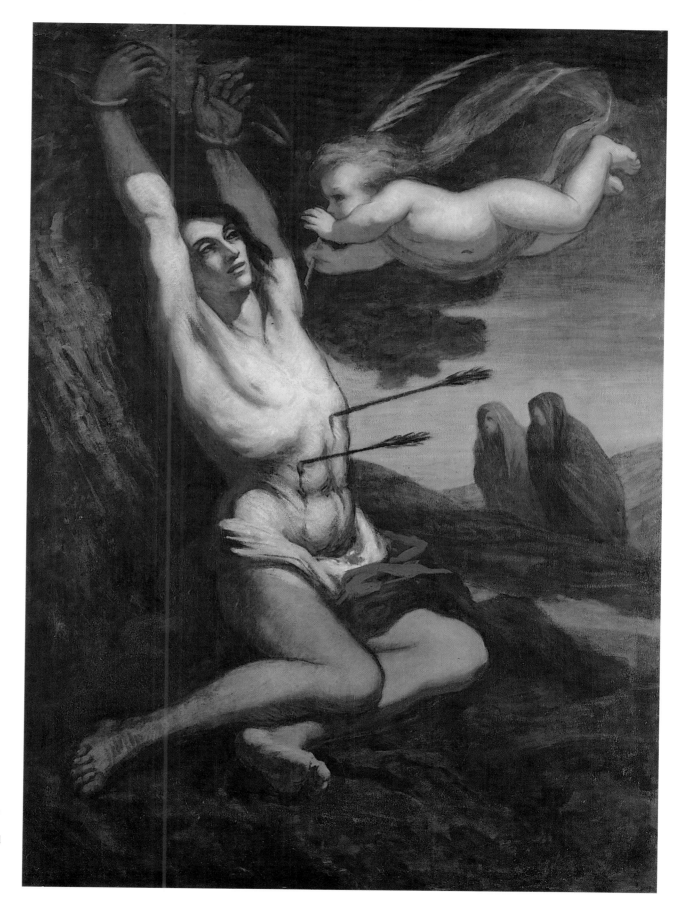

29. Daumier: *Le Martyre de Saint Sébastien (Martyrdom of Saint Sebastian)*. 1849–52. Oil on canvas, 140 x 220. Soissons, Musée Municipale des Beaux-Arts. Ex Maison.

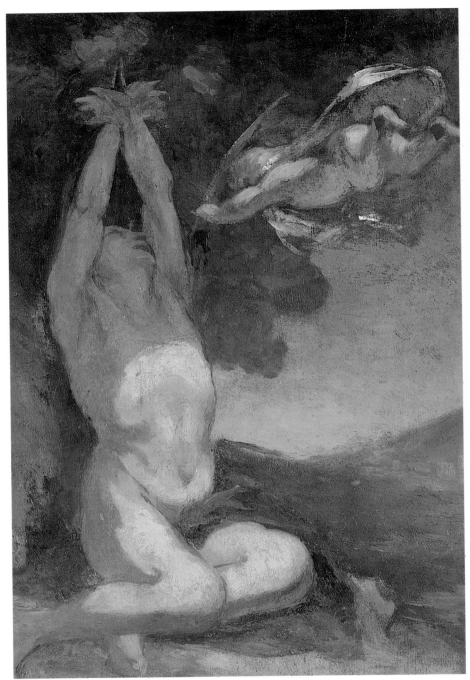

31. Daumier: *Le Meunier, son fils et l'âne (The Miller, his Son and the Ass)*. 1849. Oil on canvas, 130 x 97. Glasgow City Museums, The Burrell Collection. MI 23.

30. Daumier: *Le Martyre de Saint Sébastien (Martyrdom of Saint Sebastian)*. Sketch. 1849-50. Oil on panel, 32 x 22. Paris, Musée d'Orsay (RF 1994.18).

evidence of a debt to Millet's technique in the paint handling than to Couture's. Evidently at this stage Daumier was more willing to experiment on a small scale than on a large one, and so in his full-scale canvas he adopted a more traditional chiaroscuro. His oil sketch for his other religious commission, a figure for the *Repentant Magdalene* which should also date to about 1849,[13] is more monochromatic and reminiscent of the religious realism of Spanish painters such as Ribera and Zurbaran.[14] Both sketches exhibit a freedom of touch probably inspired by Delacroix as well as Millet.

Thus within a year Daumier had adopted a neo-baroque mode for his public painting style. This is confirmed by the painting he entered in the Salon in 1849, *The Miller, his Son and the Ass* (fig. 31). The group of three large girls in the foreground, treated with

a sculptural plasticity, take over the picture completely. They are composed like the terracotta bacchante groups of Clodion, although their baroque gestures are here translated into a kind of ribaldry more appropriate to the women of the Paris street markets, as they mock the wretched, status-conscious subjects of la Fontaine's fable in the background.[15] Although the colours of this painting are now much darkened, it is doubtful whether they were ever particularly bright: the women's figures may be seen as Rubensian but the colours are cooler. The fruit in the basket on one girl's head on the left is made into a fine still life: the paint handling there anticipates Manet or Fantin-Latour. We can also find Daumier's 'first baroque style' comparably in his lithographs and his drawings on paper around 1848 to 1852. One of the best examples is a large charcoal drawing of the death of Archimedes (fig. 32) which, although totally different in purpose from a lithograph like *Un propagandiste* (fig. 22) is nevertheless manifestly by the same hand. This violent image, in which the mathematician of Syracuse is just about to be slaughtered by a Roman soldier whom he has rebuked for trampling on his diagrams, is given wider intimations of massacre by the scattered corpses that appear in the background (drawn on a piece of paper which has been added to the sheet to enlarge the composition).[16] The whole scene might be a metaphor for the troubles of the Second Republic from 1849 through to 1851, when Prince Louis-Napoléon at first infiltrated

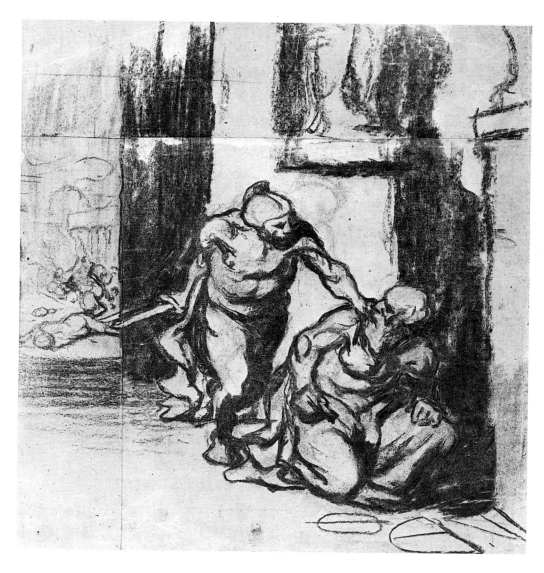

32. Daumier: *La mort d'Archimède (The Death of Archimedes)*. 1848–50. Brown and black charcoal, 42.6 x 38.9. Budapest, Szépmüvészeti Museum. MD 811.

and then gained supreme power over the French parliamentary system. We know from the tenor and subject matter of his cartoons during this period that Daumier foresaw the end, and this is even clearer in his private works. The large drawing *Tête d'expression* (*Expressive Head*) may have been part of a larger composition (the sheet has been arbitrarily cut) or it may be a kind of parody of a seventeenth-century *Tête d'expression* (fig. 33).[17] Either way Daumier's intention is clear: this is an old man's head expressing anxiety and fear, and it is drawn in brown ink with a brush. It must relate to some aspect of the 'refugees' or 'riot' subjects which Daumier is known to have been working on, both in drawings and paintings, about 1849, when French society was still riven by factional civil war, and large numbers of deportations were taking place. Being in monochrome we do not think of it as a 'watercolour', but it is related to the brush drawing techniques that Daumier was developing.

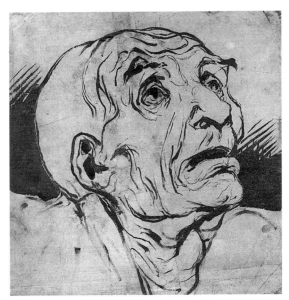

33. Daumier: *Tête d'expression* (*Expressive Head*). 1949-51. Brush and brown ink, 36 x 32. London, British Museum. MD 29.

34. Daumier: *Les Fugitives* (*Fugitives*). *c*.1849-52. Oil on panel, 16 x 31. Private collection (on permanent loan to the National Gallery, London). MI 27.

The small panel known as *Les Fugitives* (*The Fugitives*) belongs to a group of works concerned with refugees or deportees (fig. 34), which Daumier produced in drawings, in two clay reliefs, and as paintings, beginning probably in 1849 and continuing into the 1850s. This panel is thought to be the earliest of three genuine oil versions, and it was likely done about the same time as the first clay relief. But whereas the relief represents a slow moving procession of nude figures carrying burdens as though crossing a stage (like Delacroix's fugitives in his hemicycle of Attila),[18] in the painting a line of clothed refugees heads diagonally out into space, disappearing over the horizon of a bare mountain landscape. Daumier uses the counter-action of the wind against the figures as a symbol of adversity. The evening sky gleams white and cold beyond the heavy dark clouds overhead. The people, although all with their backs towards us, have some sense of being individuals: there are rhythmic colour variations between shawls, jackets and cloaks, from pink to white to black to red, grey and blue and so on. This colour system bears little resemblance to the brilliant primaries of Delacroix's Bourbon Palace murals,

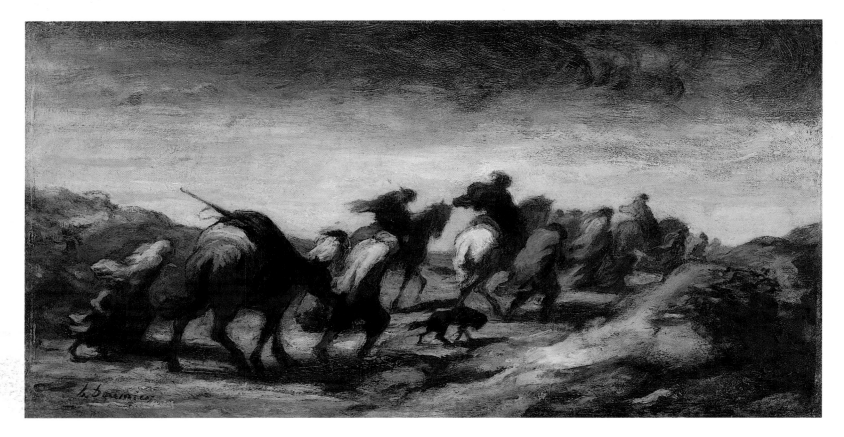

although Daumier was not above borrowing figures from them. His chromatic range here is cooler, with sharper tonal contrasts, more luminous and glittering.[19] Such colours, taken together with the incisive drawing of the figures, are more akin to some of the cabinet paintings done by Goya around 1793 to 1794 (one thinks of Goya's *Attack by Robbers*, or the *Shipwreck*).[20] And like Goya in such works, Daumier must have been painting to please himself rather than aiming at a wider public. He painted differently for the Salon.

The most important Salon to be held while Louis-Napoléon's rise to power was taking place was the one planned for 1850 but not actually opened to the public until January 1851. Here Gustave Courbet, already well known, showed nine works including three major canvases, of which his *Burial at Ornans* caused the greatest stir – the sophisticated but anxious Parisian public thought the peasants of Ornans were burying the bourgeoisie. J.-F. Millet, not quite so well known but now on close and friendly terms with Daumier, showed two paintings, of which his *Sower* caused the greatest alarm because, in the eyes of some conservative critics, he committed the error of portraying a peasant as too heroic in his pose, and consequently menacing to the establishment. Daumier himself sent in three works to this Salon, two in oil and one which is technically a watercolour with

35. Daumier: *L'ivresse de Silène (The Drunkenness of Silenus)*. 1848-50. Charcoal, brown chalk, sepia wash and gouache, 43 x 61. Calais, Musée des Beaux-Arts et de la Dentelle. MD 762.

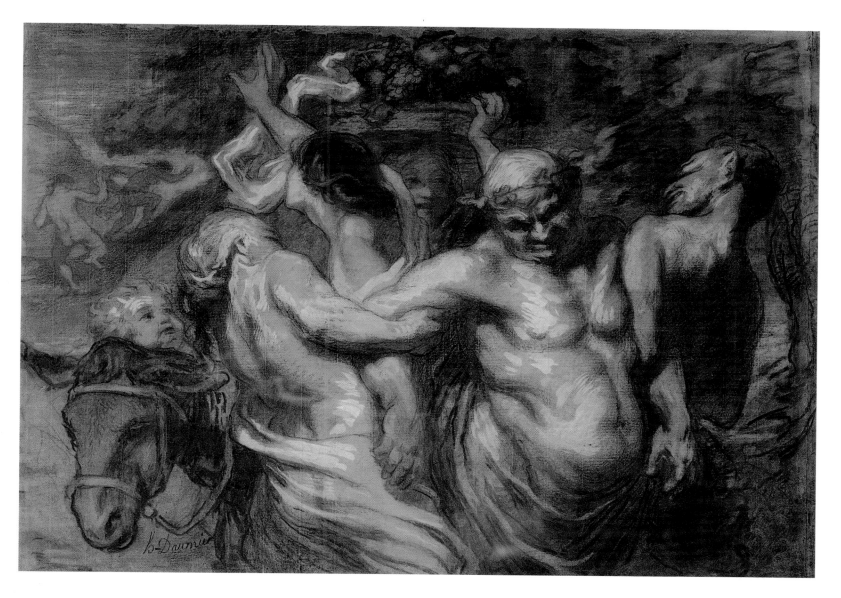

36. Daumier: *Deux nymphes poursuivies par des satyres (Two Nymphs Pursued by Satyrs)*. 1850, with later additions. Oil on canvas, 128.2 x 96. Montreal, Museum of Fine Arts. Legs Adeline van Horne Bequest. M I–32.

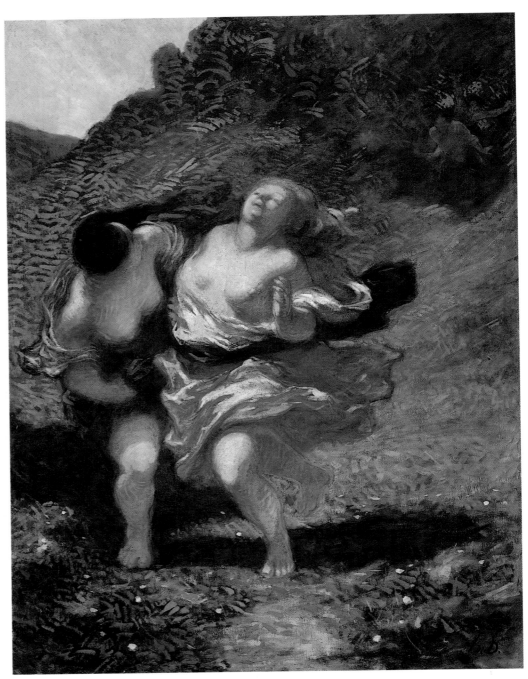

37. Daumier: Étude pour *Deux nymphes poursuivies par des satyres* (Study for *Two Nymphs Pursued by Satyrs*). 1849–50. Watercolour, 20.4 x 22.7. Rotterdam, Boymans-Van Beuningen Museum. MD 215.

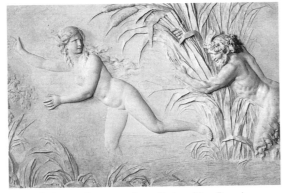

38. Clodion: *Pan poursuivant Syrinx (Pan Pursuing Syrinx)*. Detail of décor for Hôtel de Claude Besenval, 1782. Stone relief, 104 x 323 x 23. Paris, Louvre.

gouache and mixed media, but when framed is as strong as any oil painting. This last is *The Drunkenness of Silenus*. The highlights in white gouache which Daumier has added to the foreground figures give a sculptural effect like high relief (fig. 35), and the spiralling group of dancing figures is again reminiscent of Clodion's rococo style. The orange-terracotta colour of the ground tone on which the artist has placed his successive layers of drawing in charcoal and various chalks increases the similarity to a clay-coloured relief. The iconographic source of the design comes from Rubens, or more specifically from an engraving by Nicholas Delaunay the Elder after the Rubens/Van Dyck *Triumph of Silenus* in the National Gallery, London. Daumier, however, has changed the mode of the design from a ceremonial baroque bacchanale to a strangely contradictory one: when

we examine the spiralling figures more closely we see that each of them is pulling against everyone else, and the woman who should be crowning Bacchus has turned away from him to wave at two minor characters off for a romp in the woods. She looks, in fact, as Delacroix's *Liberty* might look if we could see her from the back — but is hardly a figure of triumph from this angle. So why is everything reversed? The resemblance of Silenus's face to Dr Louis Véron, supporter of Louis-Napoléon and editor of the conservative newspaper *Le Constitutionnel*, has been noted.[21] It would seem that while Daumier was anxious to appear like a regular Salon artist working in a neo-baroque style on the one hand, the politically aware cartoonist was never far away.

It is probably a little harder to attribute political significance to the other Salon exhibit which can be definitely identified, namely *Deux nymphes poursuivies par les satyres* (*Two Nymphs Pursued by Satyrs*). The brilliant colours of these semi-attired women galloping towards us are comparable to Fragonard's, particularly in the orange and yellow notes of the fluttering skirt (fig. 36). Their proportions, however, are similar to Rubens's females, and this heaviness was mistaken for vulgarity by the critic Philippe de Chennevière, who thought Daumier's work at best suitable for decorating a cabaret.[22] The criss-cross strokes of blue and green which now overlay the grass and vegetation, and the hatched strokes in certain flesh areas, look as though Daumier may have reworked the painting at a later date. This technique is remarkably like that of Delacroix in his murals in Saint-Sulpice, which were not unveiled until 1863. We must conclude, therefore, that Daumier was still not finding oil paint his most natural medium in 1850. His first idea for this picture, a drawing shaded in with grey wash, is much lighter in touch even if it is rather messy (fig. 37). The compositional relationship of the nymph in the foreground to the pursuing satyr is not unlike a detail of a relief by Clodion of *Pan pursuing Syrinx* (fig. 38), and it will be seen that this lightness of French rococo comes to form one distinct strand in Daumier's development as an artist. However, although one or two critics wrote favourably of his work, he sent no more paintings to the Salon until 1861, by which time his circumstances had changed. Perhaps he felt that the general public could not accept him as an artist, or else his economic situation simply forced him to continue earning his living as a cartoonist. How he slowly began to find new spaces in which to operate will be the subject of the next chapter.

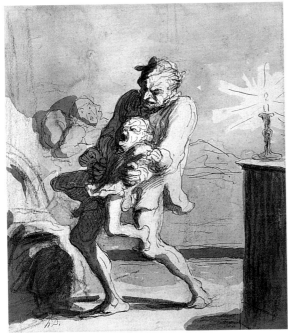

39. Daumier: *Scène de ménage (Fatherly Discipline)*. 1851–52. Black chalk, pen and grey wash, 25.3 x 20. The Art Institute of Chicago. MD 693.

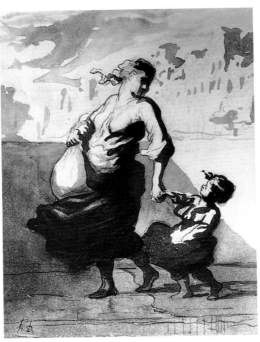

40. Daumier: *Femme et L'enfant passant sur un pont (Woman and Child Crossing a Bridge)*. *c*.1855. Black chalk, pen and grey wash, 29 x 22. Paris, André Bromberg Collection. Ex Maison.

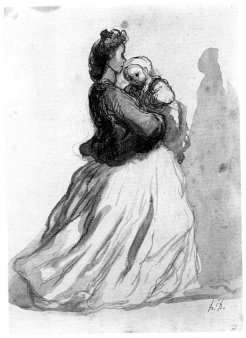

41. Daumier: *Femme emportant son enfant (Woman Carrying a Baby)*. 1855–60. Black chalk, pen and grey and brown wash, 24.5 x 17.4. Washington D.C., National Gallery of Art, Chester Dale Collection. MD 233.

43. Gavarni: *Jeune fille balayeuse (Young Girl with Broom)*. Pen, brown ink and watercolour, 19.3 x 14. Paris, Louvre (RF 31,403).

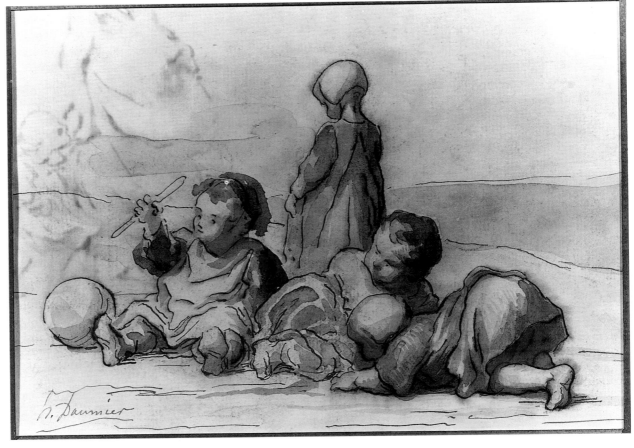

Chapter 3

CHANGING DIRECTION: DAUMIER'S WATERCOLOURS, *c*.1850–1860

The existence of a few early monochrome wash drawings by Daumier is not sufficient evidence, unfortunately, to show that he took an active part in the revival of the art of watercolour in France in the 1820s and 1830s.[1] French artists such as Géricault, Delacroix and Charlet, who had been influenced by the English tradition of watercolour after the Continental blockade was over and travel between the two countries was again possible, used this medium both for *plein air* studies and for compositional sketches in the studio. Daumier, however, at that time was being driven by his fame as a black-and-white draughtsman into quite another area of production. The fact remains that none of his light, *plein air*-looking wash drawings using chromatic hues can be dated with any certainty before 1860. Adhémar, Maison and others have attempted to date some of his finished watercolours of advocates, drinkers in taverns and various indoor scenes to the 1850s, on the assumption that these subjects, popular with the public who followed his cartoons, might have been his first attempts at producing works for private sale. However, it should be noted that most of these are in monochrome or near-monochrome. *Scène de ménage* (*Fatherly Discipline*) is a case in point (fig. 39). The exasperated father trying to quiet his child in the middle of the night is related to several lithograph series about unruly children, and the vigorous, spontaneous drawing style has been plausibly compared to the style of the series *Les Enfantillages* (*Childishness*) of 1851 to 1852.[2] This drawing, however, in black chalk, pen and grey wash, has more substance to it than the cartoons and needs no caption. Comparable drawings in this style, which I would still call Daumier's 'first baroque style' and argue that it lasted into the mid-1850s, are the recently discovered *Woman and Child Crossing a Bridge* (fig. 40);[3] *Woman Carrying a Baby* (fig. 41); and *Four Children Playing* (fig. 42). All these sheets, and several others like them, are essentially drawings in pen and monochrome wash (either brown or grey, occasionally both), in which the white paper support is allowed to shine through for the light areas. The use of a pen in conjunction with watercolour is also found in the work of Daumier's contemporary Gavarni, one of the most popular and talented illustrators of the nineteenth century.[4] Gavarni's drawing of a little housemaid or street sweeper (more probably the latter) is undated, but it seems to belong to his realist mode of the 1840s (fig. 43). His sharp, rather ruthless observation here is different from Daumier's, but the technique is comparable to the *Woman Carrying a Baby* (fig. 41). The ink used is brown ox-gall, and the watercolour touches are in brown, grey, purple, ochre and pink. This method of using transparent washes is exemplary of traditional French watercolour technique, and this must have been the route by which Daumier reached true watercolour later on.

The domestic subject matter of these pen-and-wash drawings is an aspect of Daumier's private world, of which the readers of *Charivari* were probably not aware. In 1846 he had married a young woman, Marie-Alexandrine D'Assy, known affectionately as Didine, who was fourteen years his junior.[5] The couple remained childless, but Daumier's older surviving sister had had an illegitimate child two months before they got married, and the likelihood is that children were never far away from his establishment on the Ile Saint-Louis.[6] The population of this small island, next to the more prestigious Ile de la Cité, included quite varied income groups living within its tall apartment houses of rather faded grandeur. In the houses along the quays were found small business men, such as

42, left. Daumier: *Quatres enfants jouant (Four Children Playing)*. 1855-60. Black chalk, pen and brown wash, watercolour 15.3 x 21.2. Detroit Institute of Arts. MD 253.

wine and fuel merchants dealing with materials brought into Paris by barge traffic, professional people such as the veterinary surgeon Monsieur Thibault who was Daumier's landlord, and also a bohemian set of writers and artists. A large proportion of low income, working-class families were to be found in the houses further back, and these included a legion of washerwomen who took their laundry bundles down the steep flights of steps from the quays to the sandy and pebbly shores of the Seine, right below the Daumiers' windows at 9, quai d'Anjou. The theme of a single washerwoman and her child became a sort of leitmotif, which appears in about a dozen of Daumier's oils and a number of his drawings (fig. 40). Mother and child groups also appear in outdoor settings associated with markets – fig. 41 is probably related to one of these. This range of subject matter is sometimes known as 'Daumier's Republic', meaning the private, semi-working class environment where he lived. That he enjoyed watching children playing is obvious from fig. 42. The absolutely natural gestures of these toddlers, who have been parked somewhere to play together by their mothers, are acutely observed, and their unified relationship as a group is achieved by two related means: a continuous flow of pen lines with echoing shapes from the large ball on the left to the child's foot on the right, and the strongly accented shadows drawn in with a brush, which create a sculptural solidity of form. Most of the tones are established with brown ink wash, but there are some touches of pink and blue, as on the child's ball, which indicate a transitory stage in the artist's use of watercolour.

Daumier's works on paper that can be dated to the 1850s show no definite pattern of production. It is evident that he had to revert to relying on his work as a cartoonist as his primary source of income after his state commissions for paintings had dried up by 1852. He produced between 110 and 125 prints a year throughout the 1850s decade, and this activity must have given him little time to do much else, or at least little opportunity to carry major projects through. Théodore de Banville's account of a visit to Daumier's studio in about 1848 mentions cartons bulging with 'drawings', so stuffed that they could never be shut, but he does not say what kind of drawings.[7] Another visitor, Poulet-Malassis, recounts seeing many canvases as well as a wax relief in Daumier's studio in 1852,[8] but again there is no specific mention of watercolours. All we know is that Daumier clearly saw himself as an artist by this time, but a private artist pressured by other deadlines, and one who had great difficulty in 'finishing' the numerous pictures that he began. When his *œuvre* in oil paint is examined, a degree of heavy handedness can hardly be denied in many of his canvases, although he became more fluent with this medium as time went on. (He did not sell many, though.) The one common thread that runs through Daumier's work in all media is his drawing ability, meaning his lucidity of expression in line and his grasp of space and light: as we have already seen, he seems able to *suggest* colour in black and white. It is therefore worth examining what he does, purely as a draughtsman, in the 1850s.

Daumier seems to have been equally happy with almost any drawing tool, whether it was a stick of charcoal, a piece of black chalk or a conté-crayon, a pen, or the end of a brush.[9] One of the most remarkable hybrids between painting and watercolour wash drawing is the large canvas of three reclining women (fig. 44). On an opaque ground-tone of 'battleship grey', Daumier has drawn his three nude females apparently using both charcoal and black chalk, then used a large brush to put in warm grey washes and some black contours. He has also accentuated the modelling with strokes of white chalk across the forms. The entry in K.E. Maison's catalogue of Daumier's drawings suggests that the artist had 'never before drawn in this technique nor on this scale'.[10] He surely confuses the technique with Daumier's experiments in painting in oils, for which this work was obviously intended to be a beginning. (A comparable canvas would be the even larger *Ecce Homo* in Essen, fig. 82, from the late 1850s, which is drawn with a brush almost entirely in monochrome.) Certainly Daumier got carried away by his task of

44. Daumier: *Trois femmes couchées (Three Women Reclining).* Black chalk or charcoal, white chalk, grey and black wash on canvas, 94 x 140. Paris, Louvre (RF 31,431). On loan to Musée d'Orsay. MD 213.

Daumier: *Ecce Homo!* Detail of fig. 82.

45. Daumier: *L'émeute (The Riot)*. 1848-50. Charcoal, grey and sepia wash, black chalk and gouache, 58 x 43. Oxford, Ashmolean Museum. MD 735.

46. Daumier: *Camille Desmoulins au Palais Royal (Camille Desmoulins at the Palais Royal)*. 1848-50. Black chalk, pen and wash, watercolour and gouache, 55.7 x 44.8. MD 737.

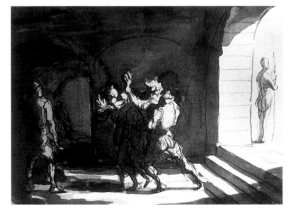

47. Daumier: *Scène de prison (Prison Scene)*. 1855-60. Black chalk and grey wash, 19 x 26. Marseille, Musée des Beaux-Arts. MD 706.

drawing, which he simply did not distinguish from painting. The three women of voluptuous proportions seem to be in idle conversation, apparently unconscious of their nudity. There is the vaguest indication of a sand-dune which they could be lying against, and a dark sea and horizon line to the right. The final contours are made with black greasy chalk and white chalk, giving a very sculptural effect of relief. The brushed paint was applied very wet, in spreading blotches and splashes – the only possible comparison would be some late unfinished canvases by Degas, thirty years later!

The strange sense of internal muscular energy in those figures is found again in a totally different image (fig. 45) drawn probably about the same time, on paper: the unfinished drawing known as *L'émeute (The Riot)*. In so far as these struggling naked figures are conjured out of Daumier's empathetic imagination, one wonders whether the three nude women were not imaginary too. The catalogue of the Arsène Alexandre sale described the drawing only as a 'composition dramatique', although it has since been associated with a commission to illustrate Henry Martin's *Histoire de France*.[11] It seems, however, to be a more universal allegory about the destructive forces of man rather than recorded history; something from Daumier's inner world. Another drawing which certainly was intended for Martin's *Histoire de France* is the more elaborately finished fig. 46, *Camille Desmoulins au Palais Royal (Camille Desmoulins at the Palais Royal)*. Camille Desmoulins, a young extra-parliamentary agitator in 1789, had been a leader of the left-wing club of the Cordeliers, one of many revolutionary clubs in existence at that time.[12] The Palais Royal was the seat of the Duke of Orleans (father of Louis-Philippe, later to become king of the French after the 1830 revolution), then leader of a faction of French nobles conspiring against Louis XVI. Its gardens had become commercialized and turned into a popular pleasure resort, which in turn became a centre for democratic agitators.[13] Daumier's watercolour illustrates the well-known story of Desmoulins haranguing the mob here, waving pistol and sword and telling them to tear leaves off trees to make cockades for their hats.[14] The style is rather English, recalling Rowlandson in the figures and the colouring,[15] and the elaborate technique, which includes black chalk, pen,

watercolour and gouache, puts this work in the category of 'watercolour painting' trying to compete with oil. It remains unique in Daumier's *œuvre* as a specific historical illustration in an old-fashioned style, but his theme is expressed with the passion of a true Republican. Not surprisingly, it was never published.

Scène de prison (*Prison scene*) must also have political overtones, though the subject is not explicit (fig. 47).[16] Both Adhémar and Maison have suggested that it might be a stage design, and its suggestion of Roman helmets might possibly link it to a series of projects for classical costumes in a satirical mode which Daumier made for the Porte-Saint-Martin theatre in 1853.[17] The intention here, however, does not seem to be comic. Behind the central group of the prisoner being dragged out of the sunlight, two cadavers are stacked against a wall, whilst a jailor drags away a third by its feet. It could be a scene from a baroque opera. The loose, rococo drawing style is very difficult to date, but the grey ink monochrome washes, applied heavily one over the other while still wet, is a technique most often found in the 1850s.

Although Daumier was involved in a scheme, projected by a group of Barbizon artists in 1855, to illustrate the *Fables* of la Fontaine,[18] such illustrations do not form a large part of his drawings at that time. Scenes of the proletariat at home and at work, such as figs 48, 50 and 51, occur more frequently, as studies of expression and of effects of indoor chiaroscuro lighting. *La soupe* (*The Soup*), showing a family eating before a smoking fireplace while the mother breast-feeds her child at the same time as drinking her soup, has been seen by many commentators as Daumier's grim exposé of the hungry working class (fig. 48). At the same time there is a certain classical grandeur in the proportions of

48. Daumier: *La soupe (The Soup)*. 1853-57. Black chalk, watercolour, pen and ink, 28 x 40. Paris, Louvre (RF 5188). MD 698.

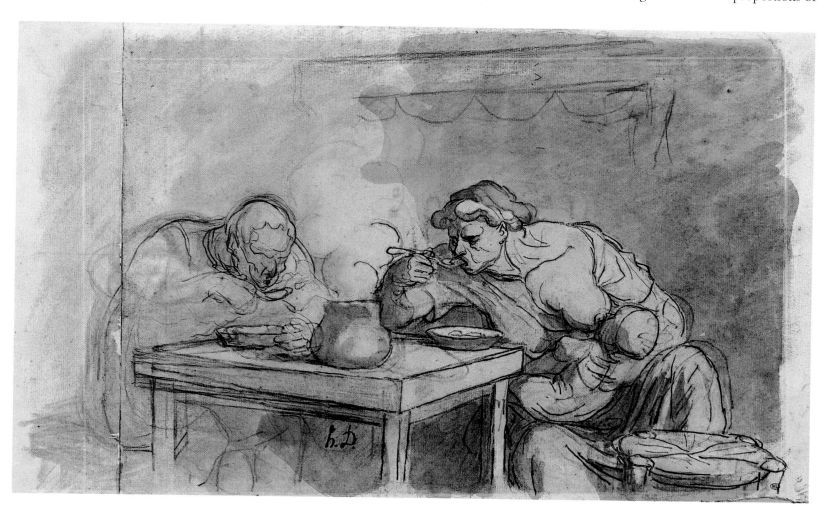

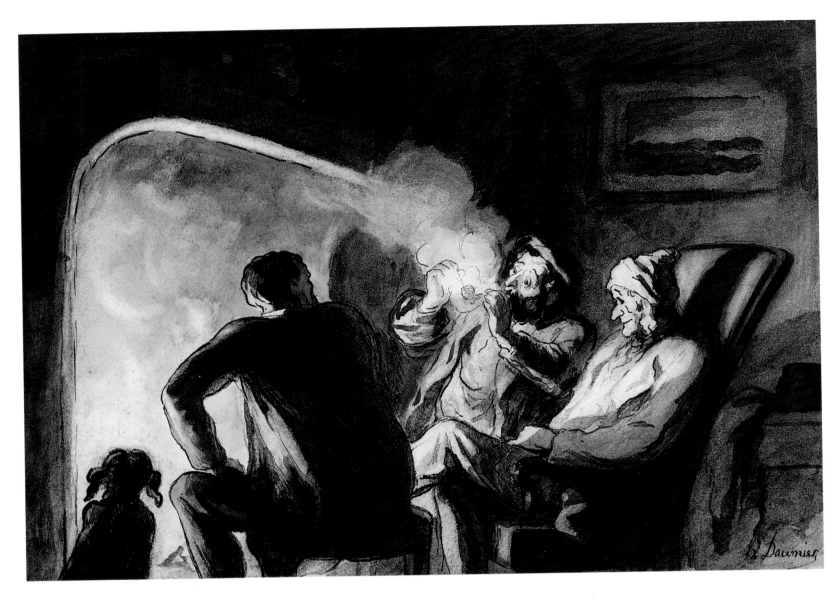

49. Daumier: *Trois chasseurs se chaffant (Three Hunters by the Fire)*. Mid-1850s. Charcoal, pen and ink and watercolour with gouache, 25 x 35. Ex Esnault-Pelterie Collection. MD 322.

50. Daumier: *Le forgeron (The Blacksmith)*. 1855-58. Black chalk, pencil, and grey wash with gouache, 34 x 24. Paris, Louvre. Ex Claude Roger-Marx Collection. MD 269.

51. Daumier: *Le forgeron (The Blacksmith)*. 1855-58. Black chalk and watercolour, 35 x 25. Private collection, New York. MD 268.

53. Daumier: *Oui, Mme Fribuchon...(Yes, Mrs Fribuchon...)*. Lithograph, published 17 March 1852. Paris, Bibliothèque Nationale. LD 2263.

the seated woman; at the same time again there is a certain comic element in the way the soup is being splashed about all over the place. Daumier's meaning is multifaceted. Another smoky interior which was probably executed in the 1850s is fig. 49, *Three Hunters by the Fire*. It is difficult to tell what class of family this is, but the huge fireplace might belong to an old farmhouse, a setting reminiscent of Courbet's well-known canvas *After Dinner at Ornans* (which was exhibited at the Salon of 1849, where Daumier had also been represented). The landscape painting hanging on the wall suggests some level of culture, in the same way that Courbet's group were listening to a violinist. The wide tonal range in this watercolour is achieved by successive monochrome washes, but certain colour tints, pink and blue, are now being added for decorative effect. Similar overlaid layers of tone, applied wet and running into each other, are found in the uncompleted *Le forgeron (The Blacksmith)*, which has considerable pentimenti adjusting the length of the man's legs (fig. 50). A second version (fig. 51) resolves the problem. Now the blacksmith is delineated as a tall, commanding figure brilliantly illuminated by the furnace fire. The highlights are achieved by reserved areas of untouched white paper, and all the brush strokes and washes are confidently controlled. I believe that Daumier was developing this technique of applying a few colours over basic monochrome washes

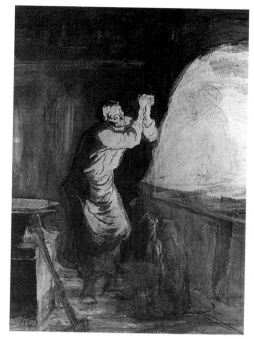

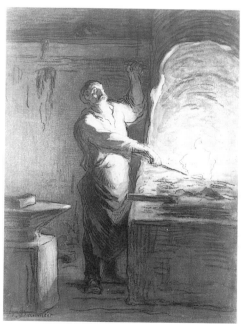

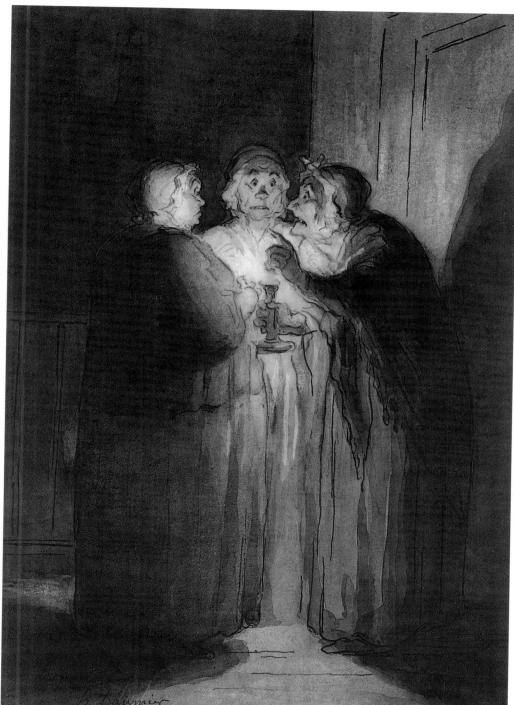

52. Daumier: *Les trois commères (Three Gossiping Women)*. 1858–62. Charcoal, pen, watercolour and gouache, 26 x 18. MD 697.

during the 1850s, seeking to recreate in watercolour the luminosity he had already achieved in his lithographs. Sometimes he even made a reprise of the same subject, as in his famous image of *Les trois commères (The Three Gossiping Women)*. This group (fig. 52) repeats the design of a lithograph published in 1852 (fig. 53), which was given a legend beginning *Oui, Mme Fribuchon . . . (Yes, Mrs Fribuchon . . .)*. Although the features of the individual women have changed somewhat in the watercolour, the intensity of expres–

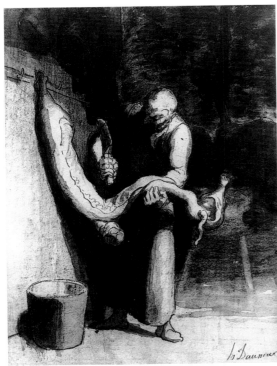

54. Daumier: *Le boucher (Butcher with Meat Cleaver)*.
1856–58. Charcoal, black chalk and watercolour, 29.5 x
21.5. Private collection. MD 263.

sion remains: it does not really matter what they are saying, but rather the sense of
hearing persistent whispering late at night is conjured up for every viewer's sometime
remembered experience. In the lithograph, the illumination is created by reserving the
white paper in the centre; in the watercolour, graded washes create flickering shadows,
and the patches of light are intensified by adding white gouache. Daumier puts the final
touches to the facial expressions and the hands with a pen, and also points up the nuances

55. Daumier: *Le charcutier (Pork Butcher in Market Stall)*.
1856–60. Black chalk, pen, and watercolour, 27 x 19.
Winterthur, Oskar Reinhart Collection. MD 265.

of modelling with a brush. Thus, in the watercolour he has not only transformed the scene through the new medium, but strengthened and deepened the realization of his whole image. It would seem that he was now redirecting his creative energies towards making independent drawings.[19]

Another connection that can be found between Daumier's lithographs in the 1850s and his evolving watercolours concerns the subject of butchers. Familiar with all the Paris *métiers*, he drew a butcher with a tray of meat on his head in a cartoon of 1839.[20] Later he drew a rather repulsive butcher's shop as viewed supposedly by Victor Hugo in Germany, and in 1855 he made a couple of cartoons about butchers using makeweights.[21] It is in a series of lithographs of 1857 to 1858, however, that butchers enter his iconography in a big way. Historically, Paris butchers had become a very powerful guild, operating both from market stalls and in their own shops. They were limited in number by ordinance, and often amassed great fortunes as a result.[22] 'Messieurs les Bouchers', a series of three prints published on 26, 27 January and 14 February 1858, anticipates a decree of 24 February 1858 which changed the regulations, ending the limitations on the number of butchers' establishments, and suppressing the privileges which had enabled them to set prices. Daumier also drew eight prints during 1857 and 1858 in the series 'Actualités', representing butchers as somewhat histrionic characters not unlike advocates! Women shoppers are shown regarding them with fear and distrust.[23] In a very unusual procedure, he turned one of these cartoons into an oil painting, probably by making a tracing of it: perhaps this was done at the behest of the painting's first owner, Daumier's sculptor friend Geoffroy-Dechaume.[24] Another motif that occurs in the cartoons, of a butcher lifting a carcass on a pole, was separately treated in a watercolour now in the Fogg Museum.[25] This watercolour and its pendant, *Le boucher (Butcher with Meat Cleaver)* are both highly finished and signed in full (fig. 54), so we can assume that they were made for sale. *Le boucher* is a particularly gruesome image. This person seems to have a ferocious enjoyment in his task, and Daumier puts a spot of red blood on the bone protruding towards us as if to point up a kind of horror. Daumier made two versions of this – one must have been traced from the other – although the less finished study, which for some reason dissatisfied the artist, lacks the bucket for collecting offal.[26] It is an open question which of the two images is the more sinister in effect.

More pleasant in its setting, but with the butcher's expression nearly as grim, is *Le charcutier (Pork Butcher in Market Stall)*. This is a very fresh, directly painted watercolour in grey wash and touches of blue, pink, and yellow over black chalk and pen (fig. 55). This kind of *plein air* effect anticipates the impressionist market scenes of Camille Pissarro, although Daumier undoubtedly painted it in his studio. Comparable in freshness is another outdoor scene, *Le marché (The Market)*. These graceful and dignified figures of women and children going about their business in the vegetable market (fig. 56), which bear some resemblance to Daumier's groups of washerwomen begun earlier in the decade, are another facet of 'Daumier's Republic'.

In March 1860 there occurred an event which was to alter the course of Daumier's career: he was sacked from *Charivari*. Later commentators have differed in interpreting the editors' reasons for this, and in estimating whether or not Daumier accepted the situation equably. Baudelaire was in no doubt: 'Think of Daumier, free and kicked out of the door of *Charivari* in the middle of the month', he wrote to Poulet-Malassis in April.[27] Baudelaire immediately wanted to find work for him as an illustrator, while recognizing that his 'other occupation' was that of painter. When Daumier returned to *Charivari* three years later, readers were simply informed that he had left to devote himself to full-time painting, but that explanation could well have been face-saving on the part of the journal. Daumier's lithographs from 1855 to 1860 had maintained their vigour for the most part, and there was more likely a political reason for his sacking. On 14 January

56. Daumier: *Le Marché (The Market).* 1857-60. Black chalk, wash and watercolour, 25 x 17.5. Private collection. MD 531.

1858 there had been an assassination attempt on Napoleon III, following which the government started a new wave of repressive censorship against the Republicans and the press. An editorial in *Charivari* of 13 April 1860 entitled 'L'abdication de Daumier' referred to the inconstancy of the public and a number of signed and anonymous letters threatening to abandon them if they insist on publishing Daumier's 'abominations', meaning his cartoons criticizing the domestic and foreign policies of Napoleon's government.[28] This dual aspect of Daumier's character – the politically involved journalist-cartoonist and the artist-dreamer – cannot be ignored: he was that kind of person. During his absence from *Charivari* he was extremely short of money, and letters from J-F. Millet to his agent Alfred Sensier indicate that the Daumiers moved three times and were hard to find. It is now known that the first address to which they moved, a rather cramped dwelling at 48, boulevard Rochechouart on the edge of Montmartre, had – of all people – a Monsieur Thibault listed as its *locataire* in 1862.[29] If this person was the same Monsieur Thibault as the proprietor and landlord of 9, quai d'Anjou, where records of Daumier's paying his rent of 300 francs a quarter discontinue after August 1860 (see *Carnet II* and p. 163), we could speculate on the possibility that Thibault let him off paying for a time and then found him this much cheaper place to live while taking the lease in his own name.[30] Daumier is next heard of living at 26, rue de l'Abbaye, from which address he signed a new rental agreement for an apartment with a studio at 20, boulevard Pigalle in December 1863 – by which time he knew he was reinstated with a new contract with *Charivari*. In 1864 the boulevard Pigalle was united with the contiguous boulevard de Clichy: the house then became 36, boulevard de Clichy without Daumier changing his location again, a fact which has sometimes caused confusion. This studio he kept until his final move out of Paris to Valmondois in 1872.[31]

Although Daumier's friends had tried to find him work with other journals during the interim they did not succeed until 1862, when he produced twelve excellent lithographs for the literary and critical journal *Le Boulevard*[32] and began drawing designs for wood engravings for another weekly, *Le Monde illustré.*[33] The former contract was probably due to Baudelaire, who wrote extensively for *Le Boulevard*. The editor, Étienne Carjat, employed a number of different draughtsmen as well as being an artist and photographer himself, but he made a particular fuss about Daumier's contributions, which he used as a selling point for the magazine. He drew a full-page *portrait-chargé* of Daumier himself for a specimen number which appeared on 1 December 1861, holding a painter's palette and maulstick,[34] and announced the collaboration of 'Le spirituel dessinateur qui a écrit à la point du crayon la fine et amusante satire de ces trente dernières années' in an early number.[35] Would-be readers were informed that although all the world knew of the cartoons which had ensured his popularity, nevertheless many naïve people (and were they only naïve?) could not believe that Daumier was truly a painter. Daumier had assured them of two large *drawings* (my italics) a month. Some of the lithographs in this series relate directly to watercolours produced for private clients (these will be discussed in the next chapter). Plainly, Daumier was intended to be shown as 'arrived' on the fine art scene. Two of his account books, *Carnet III* and *Carnet IV*, which both commence in 1864, one recording titles of lithographs and the other sales of drawings and paintings, provide further evidence that he consciously pursued a dual career from that time on, if not earlier (see Appendix).

It is difficult to surmise exactly which watercolours Daumier was producing immediately prior to his severance from *Charivari*, and art historians differ widely in their dating, which is always speculative concerning this period. Stylistic considerations, however, would suggest that an increasing depth in shadows characterizes his new technique, and that his chosen subjects in the late 1850s varied between celebrating the more baroque pleasures of life on the one hand, and a somewhat sardonic look at human behaviour on the other. Such dualistic attitudes might have produced, simultaneously, such works as

Le chanson à boire (*The Drinking Song*) and *Deux Buveurs* (*Two Drinkers*). The first version of the drinking song (fig. 57) contains nine heads with such expressive countenances that they could be compared to the open-mouthed stone *mascarons* on the Pont Neuf. (These neo-baroque grotesque heads were a phenomenon which Daumier probably passed every day.)[36] The hedonistic bulging forms and ruddy faces show unbridled enjoyment of their wine, and this scene might be considered a modern counterpart to the baroque imagery of Daumier's earlier masterpiece *The Drunkenness of Silenus* (fig. 35) of 1850 – which, we noted earlier, he traded off to the government around this time in final settlement of a state commission accepted in 1849. The picture had quite recently been once more in the public eye, for a wood engraving after it by Trichon was reproduced in *Le Temps* on 8 July 1860, accompanying an article on Daumier by Edmond and Jules de Goncourt. The art editor of *Le Temps* at that time was Daumier's contemporary and friendly rival, Gavarni, and in view of Baudelaire's efforts noted above we might assume that this was a case of cooperation between friends trying to help him.[37] The figures in *Le chanson à boire* appear to be workers wearing overalls or aprons. In a second version (fig. 58) he has extrapolated the four foreground figures for more specific characteriza-

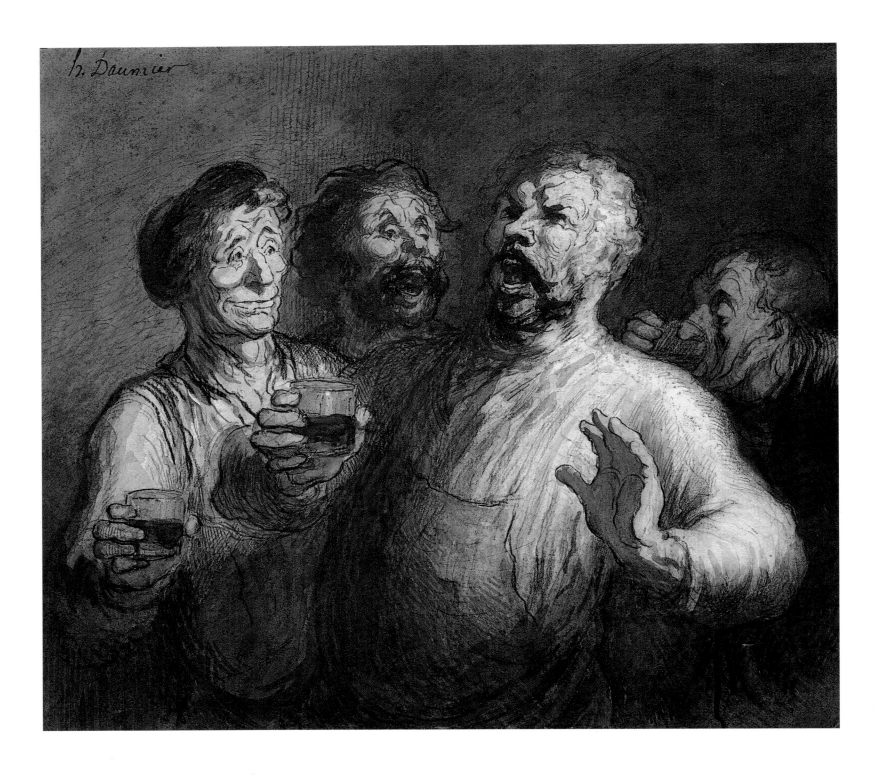

58. Daumier: *Le chanson à boire (The Drinking Song)*.
1860–63. Pencil, black chalk, pen, and watercolour.
Williamstown, Sterling and Francine Clark Art
Institute. MD 330.

tion, concentrating on the roaring voice of the lead singer, as it were, his open mouth
echoed by that of the hairy ruffian standing at his shoulder, and causing an expression of
quizzical amusement in the face of the spectator on the left. The man drinking on the
right sinks further down into the shadows, while on the left two hands grasping glasses
of plum-coloured wine develop into hefty fists.[38] An unsigned wood block engraved
after the first version, not published in Bouvy's catalogue of the engravings, was fairly
recently discovered and is now in the Armand Hammer Daumier Collection.[39] It was
apparently never printed, but the style is like the engravings which began to appear in *Le*

44

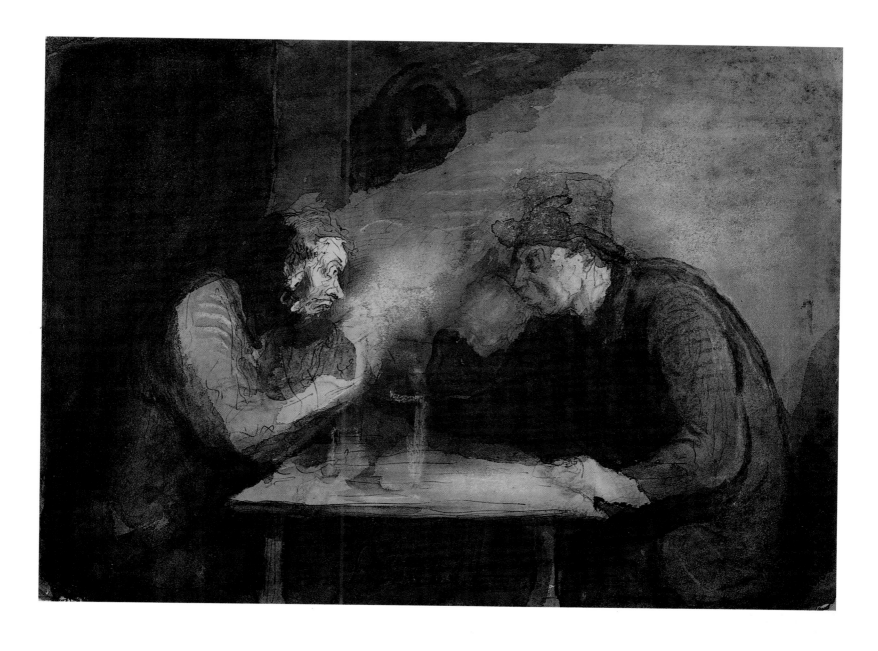

59. Daumier: *Deux buveurs (Two Drinkers)*. 1860-64. Pen and ink wash, watercolour and white chalk, 17.5 x 24. Collection Neumann, Gingins, Switzerland. MD 315.

Monde illustré from 1862, and if this block was an earlier trial piece left unused, it might point to a date for the watercolour of about 1860.

Daumier reveals quite a different mood in *Deux Buveurs*, in which the protagonists are having an argument across a table in a cavernous bar. There are two versions (figs 59 and 60), which relate to each other in a way rather similar to the two versions of *Le chanson à boire*. The first is a moody, darkly satirical, groping and blotchy watercolour, in which the two figures stare at each other across a table with almost hypnotic effect. The forms are not completely resolved, and an attempt has been made to introduce a harsh lighting effect by the addition of white gouache or chalk. Margret Stuffmann suggests that this shows Daumier 'struggling to rethink his position as an artist' in about 1860.[40] The sequel is, I believe, the recently discovered watercolour (fig. 60) in which the two men seem to have suddenly sprung to life and started verbally attacking each other. Grey watercolour washes, well controlled, with touches of blue and pink and alizarin crimson are laid over an elaborate underdrawing in pen (compare the hand holding the glass to those in *Le chanson à boire*), and occasional highlights in white gouache on the hair and shoulders

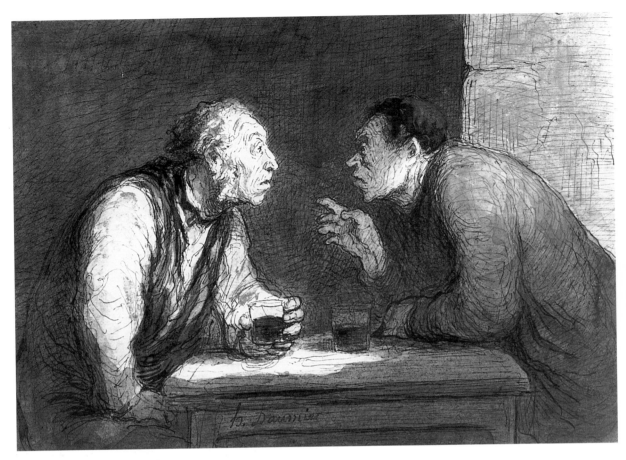

61. Gavarni: *Gibier de potence (Jailbird)*. 1847–51. Pencil, pen and red ink and watercolour, 34 x 21. Paris, Louvre (RF 812).

60. Daumier: *Deux buveurs (Two Drinkers)*. 1860–64. Pen and ink wash, watercolour and gouache, 18.4 x 25.4. Christie's London, 29 June 1992 (1). Ex Maison.

of one of the men. This drawing has been highly worked up as a finished piece for a client, surely, and ushers in the next phase of Daumier's independent career as an artist in watercolour. Gavarni's assistance has just been mentioned; it is quite likely that at this point in time Daumier was once more taking note of his skill, although the approach to life of the two men was quite different. Gavarni's lightness of touch – and quite often light-hearted subject matter – concealed a rather acerbic observation that was more objective and cooler than Daumier's. During his time spent in England, from 1847 to 1851, Gavarni studied the poor in London and also peasants and itinerants in the countryside. The watercolour bearing his inscription *Un mauvais quart d'heure* (fig. 61) implies the possibility of a nasty encounter with this vagrant in the countryside, who turns out to be a jailbird, as the given title, *Gibier de potence*, further informs us. Characteristically Gavarni drew with touches of his sable brush in burnt umber, grey, bright blue and red over a light underdrawing in pencil; although Daumier did not use pencil, these are the sorts of colours he would adopt in the 1860s.

An outstanding watercolour, often dated about 1860, is fig. 62, *L'orgue de Barberie (The Barrel Organ)*. If it were done just after Daumier's sacking from *Charivari*, it could even symbolize the artist himself being thrown on to the street[41] and joining the street entertainers – a class of social outcasts. There are (again) two versions of this, in one of which the organ grinder's head has been completely scraped out.[42] The oppressive stone portico, in the deep shadow of which several of the spectators stand, has prison-like associations which might be echoed by their solemn expressions. The blue-smocked farmer and his wife on the left also look sad; only the small boy in front, ear cocked to the music, seems actively absorbed by the performance of the singers. Their expressive

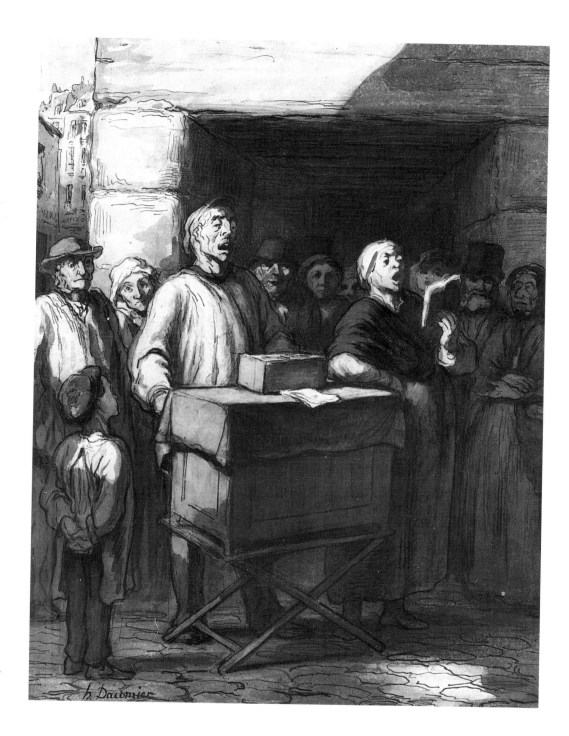

62. Daumier: *L'orgue de Barbarie (The Barrel Organ)*. 1860-64. Black chalk, pen, watercolour and gouache, 34 x 26. Paris, Musée des Beaux-Arts de la Ville de Paris, Petit Palais. MD 350.

open mouths create that ironic silence only found in pictures. The brightly lit buildings in the distance strike the only cheerful note. Daumier's own emotional involvement with his subject is most noticeable here, although what he records is undoubtedly a realistic picture of people of his time.[43]

63. Daumier: *Le dessinateur (The Draughtsman)*. 1852-55. Oil on panel, 14 x 13. Ex Florence J. Gould. MI 63.

Chapter 4

DAUMIER AS *ARTISTE-PEINTRE*, PART II (AFTER 1852)

A very small oil painting on panel, only about 5½ inches high, represents an artist drawing (fig. 63).[1] He appears to be alone in a studio hung with paintings, and is totally absorbed in his occupation. Daumier made several other representations of artists in their studios, either actively engaged in their tasks or showing their work to visitors. This particular painting makes the viewer feel *de trop*, an interloper; the artist's crayon is poised at a moment of private thought. K.E. Maison puts this work amongst a group of three small paintings of artists at work which he dates '1852/55', presumably on the assumption that Daumier was now attempting to continue his career as a painter following his recent successes at the Salon (which, however, did not continue with the advent of the Second Empire). I wonder, on the other hand, whether the deep, Rembrandt-like colours and chiaroscuro should not suggest a date of *c*.1860 to 1863, putting this work into the context of the present chapter. It gives a profound sense of introspective enquiry regarding the creative process: the artist appears indifferent to the beholder. What has happened to the artist of 1851 and 1852? We have just considered his strategy during the intervening period, when he apparently sought a new clientele for his small-scale watercolours while continuing to rely on his work as a cartoonist for his main source of income. This strategy perforce changed again in 1860 to 1863, and although he would not succeed in selling his paintings with any regularity for another decade, his course as an artist of truly original character was now fixed.

Le dessinateur (*The Draughtsman*) was subsequently shown at Daumier's retrospective exhibition at Durand-Ruel's gallery in 1878, an exhibition organized by a committee of friends and backed by republican political supporters, which opened a few months before the artist's death. It was a failure in financial terms (at least for Durand-Ruel), and the public remained indifferent to these aspects of Daumier newly revealed. The myth of his *separate* activity as an artist, however, was born at that point.[2] The documents concerning the exhibition also reveal that an address list of sixty-eight private owners of his oils and/ or watercolours and drawings was drawn up. The person who owned the painting under discussion, Monsieur Guyotin, lent it together with an equally small panel painting of two advocates, and two drawings or watercolours of court scenes. In 1896 a Monsieur D. Guyotin was noted in the address book of the American dealer George A. Lucas, as a very discerning collector of Diaz, Jongkind, and other naturalist painters.[3] If this was the same person, he would have been more than thirty years younger when he bought *Le Dessinateur*, as a neophyte *amateur* with perhaps a short purse but a good eye. All of which raises the question of what type of collectors Daumier's fine art patrons were.

In April 1860, finding himself in suspension, as it were, from being a caricaturist (and of course he could have had no idea how long the suspension would last) Daumier must have felt he was at a crossroads. A projection of his dilemma, much discussed in recent years, is the pen-and-wash drawing fig. 64, *L'Artiste en face de son œuvre* (*The Artist Regarding His Work*). The available evidence suggests that before 1860 Daumier was only able to sell a few watercolours and independent drawings on themes best known to his patrons from his lithographs, such as the *Robert Macaires*, the butchers, lawyers and court scenes, or scenes from domestic life. We also know that he began a lot of oil paintings in the 1850s, even if he did not finish them. What kind of artist did he hope to become? There is abundant evidence that politically he was a man of his time interested, like

64. Daumier:
*L'artiste en face de
son œuvre (The
Artist Regarding
His Work).*
1860–63. Pen,
bistre ink and
grey wash,
38 x 29. Private
collection. MD
367.

Baudelaire, in 'the heroism of modern life', whatever that might mean in pictorial terms. So what type of painting is this artist contemplating on his easel in front of him? It is framed, so it may have been just brought to completion. French commentators have generally followed Fuchs's identification of the artist as Daubigny, on the grounds of a rather superficial likeness, but although there is no resemblance to Daumier himself it seems much more likely to be a self-projection. Klaus Herding has interpreted it as symbolizing the crisis of the 'modern' artist. 'It shows us', he writes, 'a painter who sits pensive, inactive, between two easels – a variation upon the theme of the melancholy artist. In this silhouette we may be able to recognize a philosopher; neither apparel nor equipment reveal his calling as painter'.[4] Herding sees this drawing, therefore, as an intellectual abstraction.[5] The problem facing this artist is whether to pursue traditional themes of 'history paintings' that would make a name for him in the Salon, or to exhibit contemporary genre themes that were also popular with the public but of minor importance as high art. The pose is perhaps reminiscent of Delacroix's romantic painting of *Michelangelo in His Studio*,[6] but Daumier's artist looks tense and bewildered by his predicament, rather than indulgently melancholic. The crux of the problem is that the modern artist – that is to say, Daumier – is left to his own devices as to how to function creatively. It is significant that the larger canvas shown in the drawing, behind the artist's back, is nearly blank: there is just a shadowy suggestion of a 'Charity' group, which calls to mind Daumier's competition painting *La République* (fig. 24). Is the artist thinking what to do next, or critically analysing what he has done already?

Further compounding the problem of interpretation is the existence of an oil *ébauche* (beginning) on canvas, three times the dimensions of the watercolour drawing, which repeats the design exactly.[7] The canvas has been squared up to effect the transfer, but the drawing on paper clearly has not been. (That could have been effected by a tracing, however.) What is puzzling is that the oil version, which is basically just another drawing done with a brush, adds absolutely nothing to the first version.[8] Did his interest in it suddenly dry up? There is another group of paintings of an artist standing at work before his easel, datable to 1870 or later, which shows him as confident and active. It seems possible that a psychological shift may have taken place in the interim.

Another factor of which Daumier was undoubtedly conscious was the mentality of the potential buyer. The term *amateur* was used in France with a fairly wide range of connotations. Basically the *amateur* was an art collector, usually but not always male, and his roots went back to the great collectors of curios and antiques during the Renaissance. In mid-nineteenth century France, however, he was more likely to be bourgeois than aristocratic, and not necessarily possessed of any great means. In the auction rooms of the rue Drouot he could be found as a bargain hunter for artifacts of every kind including paintings, and easily ridiculed for his guileless susceptibility to the idea of getting something good, cheap. At the same time the *amateurs'* ranks did contain some bourgeois of considerable wealth and taste, who could vie in knowledge with the appointed *experts* (dealers) who made reserve-price evaluations for the auctioneers before sales. Such persons were more appropriately called *connoisseurs*. By the 1860s their interests were beginning to extend, with the encouragement of dealers, beyond speculating in the art of the past to collecting *l'art moderne*.[9] If a rich *connoisseur* took up a near monopoly of the production of one contemporary artist he was called, with some slight irony, a *Maecenas*, and every struggling artist no doubt hoped to find one. An exceptionally renowned relationship was that of the collector Alfred Bruyas with Gustave Courbet, one which was, at least in Courbet's eyes, more like a collaboration in art theory than a mere case of patron supporting artist. More characteristic of the time was a collector like Emile Gavet, who commissioned and bought up all J.-F. Millet's pastels between about 1865 and 1868, until he was displaced by the industrialist Frédéric Hartmann towards the end of Millet's career. Such patrons might operate independently, or they might have agents

Fichtre !... Epatant !... Sapristi !... Superbe!... ça parle!...

65. Daumier: from the series *A travers les ateliers* (*Around the Studios*). Lithograph published in *Le Boulevard*, 20 April 1862. Los Angeles, Armand Hammer Daumier and Contemporaries Collection. UCLA at the Armand Hammer Museum of Art and Cultural Centre. LD 3246.

acting for them (as George A. Lucas was appointed to act for the American industrialist and collector William Walters), or they could be put in touch with their artists by dealers such as Durand-Ruel. Although Durand-Ruel claimed that he had dealt in Daumier's watercolours since about 1865,[10] Daumier's surviving account books do not reveal extensive transactions through him, and it would appear that clients for his watercolours – George Lucas among them – tended to go to his studio direct. More significantly, to assess Daumier's position in the contemporary art league table, so to speak, we must observe that he never had a *Maecenas*.[11] Representations of *amateurs*, *connoisseurs* and patrons in Daumier's *œuvre*, we shall find, have an element of good-humoured mockery about them, which straddles rather neatly the line between his role as artist and his role as public entertainer. The relations between artists and collectors, and between collectors and their collections, came under his critical scrutiny.

Daumier drew the designs for two wood engravings about *amateurs* at picture sales for *Le Monde illustré* early in 1862, which gives us a firm indication of his special interest in these people, and for another engraving published in April, entitled *Peintres et Bourgeois*, he drew blundering visitors peering over the shoulder of an artist at work in his studio.[12] Five more wood engravings showing scenes at the Hôtel Drouot were published in *Le Monde illustré* in 1863, to illustrate a series of articles by Champfleury on 'L'Hôtel des Commissaires-priseurs'.[13] The articles are full of mocking stories about collectors. Visitors to an artist's studio were also dealt with in a lithograph published in *Le Boulevard* on 20 April 1862 (fig. 65). A group of enthusiastic visitors (all *connoisseurs*, all artists, or some of each?) stand behind the artist as he sits beside a completed picture on his easel. They give extravagant gestures of approval. Daumier's librettist added the legend *Fichtre!..Épatant!..Sapristi!..Superbe!..ça parle!..*(all expressions of praise).[14] The dramatic arrangement of this lithograph was further developed in two large and elaborately finished watercolours (figs 66 and 67), done possibly in the second half of the 1860s, both known as *Visiteurs dans l'atelier d'un peintre* (*Visitors to an Artist's Studio*). The element of farce is now removed, but the expressions of enthusiasm remain, and the relationship between artist and patrons is staged, as it were, in alternative scenarios in these two works. In the first, the version now in the Walters Art Gallery, Baltimore (fig. 66), the artist assumes a commanding position in the centre of the room, although the principal *connoisseur* is in the seat of honour before the picture on the easel (which we cannot see), expressing astonished approval. The tall figure holding a maulstick appears to be the archetype of an academic classical artist.[15] His affluent bourgeois friends lack his severity, however, and their expressions (admiring or amused?) allow for the possibility that the picture we do not see could be of a rather erotic nature. Consider the framed pictures which Daumier has invented to hang on the wall behind them. An equestrian figure is the subject in the centre, above the artist's head; possibly a castle on fire on the left; two Barbizon-type landscapes and an oval portrait below; and at the upper right an Entombment – or is it a satyr unveiling a naked woman? The element of ambiguity which Daumier has left seems at first to be at the expense of the artist, but it could also be a critique of the business of selling contemporary art to *amateurs* in the 1860s – a burgeoning new trade. The first owner of this watercolour, Monsieur P. Aubry, seems to have been an *amateur* who preferred to keep his name restricted to his initials only when it appeared in publications such as the 1878 exhibition catalogue and Alexandre's 1888 monograph on Daumier.[16] Aubry's name will come up again, but first we should look at the second scenario for the artist and his patrons which Daumier put forward.

In the second version (fig. 67) the tall, commanding figure who stands centre stage is now no longer the artist but a *connoisseur*. With his elegant blue gloves, his neat cravat over low collar, and thrown-back frock coat he looks like an affluent dandy of the 1860s.[17] His stance, in relation to the large painting on the easel – which Daumier has painted vaguely, as some kind of Deposition – seems to be that of an aristocrat, or at least

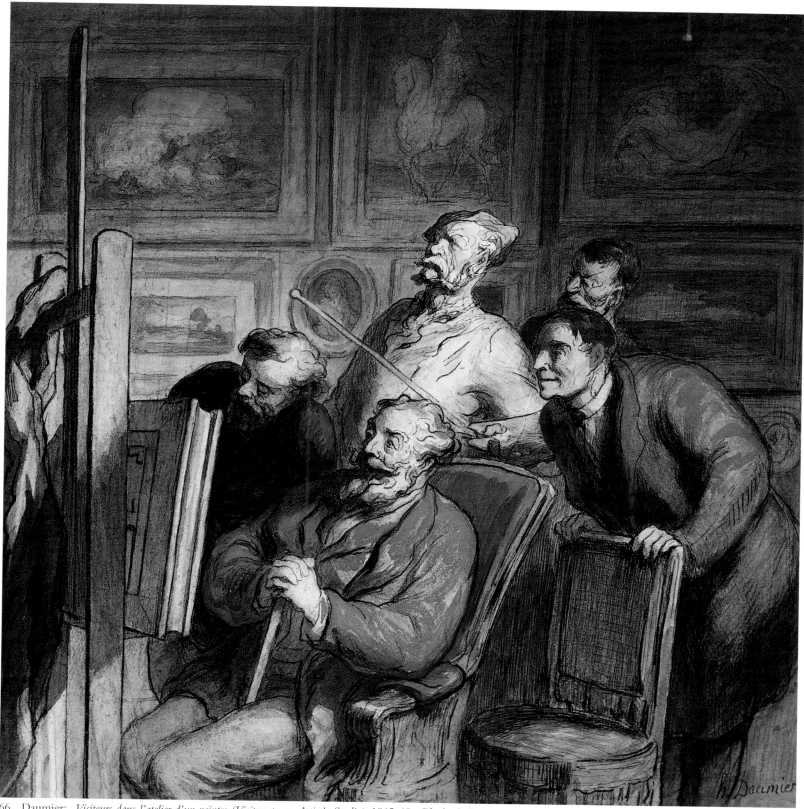

66. Daumier: *Visiteurs dans l'atelier d'un peintre (Visitors to an Artist's Studio).* 1865-68. Black chalk, pen, watercolour and gouache, 32.4 x 31. Baltimore, Walters Art Gallery. MD 385.

a prince of commerce (admittedly not quite the same thing). Below him sits, in the chair of honour, an older guest who might be first cousin to the seated figure in the Walters version: he simply registers approval. The dark coated figure behind him might be an expert, if he were not holding his *connoisseur*'s magnifying glass at such an absurd distance from the canvas. The artist himself, palette in hand, is relegated to the background shadows as he talks to a friend who seems to be in conspiracy with him about something. Everything is eminently respectable and bourgeois, with the exception of some of the art works on view: a satyr about to embrace a heavy nymph in terracotta on the table in the foreground; a *fête-champêtre* including at least one naked lady hanging framed in the centre background (fig. 68), and on the extreme right on the wall is part of either a female bather drying herself or a Bathsheba episode without the watchers (fig. 69). This brilliantly illuminated drama about the *presentation* of art is surely not meant to be at the expense of the artist. Is it made at the expense of the *connoisseurs*? Technically, this work

67. Daumier: *Visiteurs dans l'atelier d'un peintre (The Critics: Visitors to an Artist's Studio)*. 1866-68. Black chalk, pen, watercolour and gouache, 36 x 45. Montreal, Museum of Fine Arts. Bequest of Mrs William R. Miller in memory of her husband. MD 384.

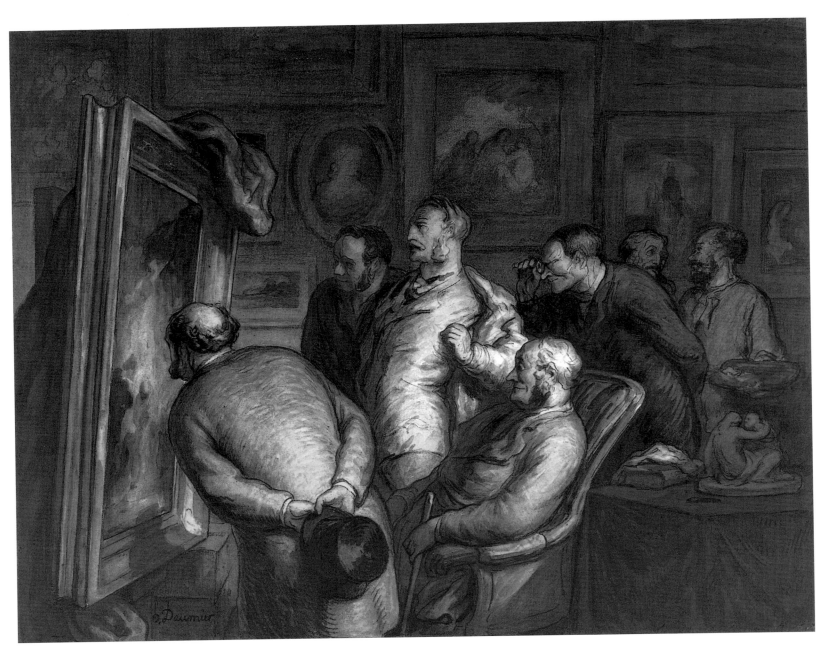

68 and 69. Daumier: *Visiteurs dans l'atelier d'un peintre (The Critics: Visitors to an Artist's Studio)*. Details of fig. 67.

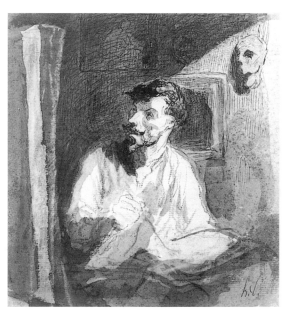

70. Daumier: *Un peintre à son chevalet (An Artist at his Easel)*. 1865-70. Black chalk, greyish-blue wash, and gouache, 19.5 x 18.5. Westbrook College, Portland, Payson Gallery. MD 363.

is one of the most complex of Daumier's watercolours, and more highly finished than the Walters version. There are signs of an underdrawing in black chalk or charcoal,[18] followed by tonal foundations in grey and grey-ochre washes; these washes are separated into loose, discrete brush strokes of grey on the clothes of the nearest three figures where their clothes catch the light. Colour notes were then added: yellow and brown ochre on the near picture-frame, applied transparently over a reserved white ground; pink and reddish brown on faces and hands; light blue on clothes, and so on; and ultramarine mixed with gouache and black for the darkest coat. A prominent patch of earth red catches the light on the table top; it is echoed in a spot of red on the artist's palette. After all this elaboration Daumier re-drew all the facial expressions and postures of the figures, in heavy black chalk and pen, and reinforced his highlights with white gouache. If Degas's famous response to those who thought him to be a spontaneous impressionist, 'no art is less spontaneous than mine', were applied here it would carry the same irony of meaning.

There seems to be a strong case for identifying this watercolour with one that Daumier exhibited at the Paris Salon of 1869, nr.2659, *Amateurs dans un atelier*, which was one of two *aquarelles* under that numeration lent by M. le Dr Court. It appears that it was also at a loan exhibition in Montreal in 1868, but since the Montreal Art Association exhibitions were large, prestigious affairs it is not inconceivable that it could have been lent from Paris and returned there.[19] One more question remains: is this really an artist's atelier, or are we in a private picture gallery? The variety of works shown, not to mention the clientele, suggests the latter.[20] The artist himself, although relegated to the background, may play a rather subtle role in this pompous gathering of experts: he seems to be smiling at something quite different. He also has a certain facial resemblance to the subject of a drawing from the Payson collection, *Un peintre à son chevalet (An Artist at His Easel)*[21] whose visage is more reminiscent of portraits of artists in the romantic era (fig. 70). This solitary figure might even signify a self-portrait, projected, as it were, by Daumier into another personage. In other words, any of these portrayals of artists could be read as projections of different aspects of 'the Artist' as conceived by himself and by society at this era. The Payson drawing is no more than a rough beginning, although

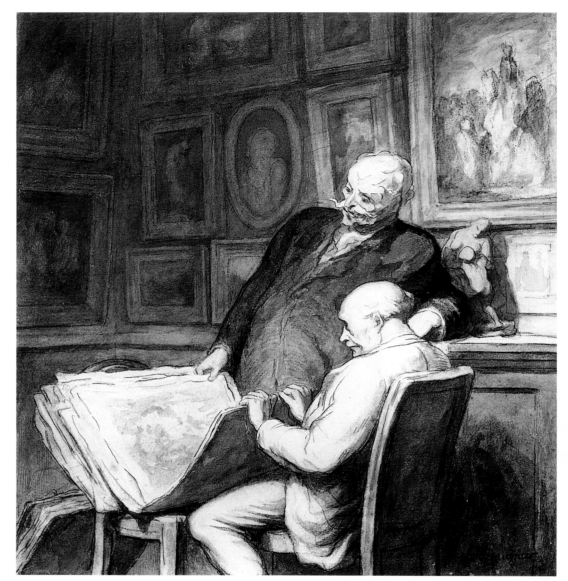

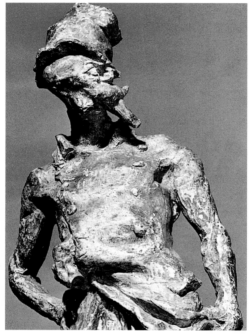

72. Daumier: Statuette of *Ratapoil*. Detail of fig.188.

71. Daumier: *Deux connoisseurs avec une folio (Two Print Collectors with a Folio).* 1865-70. Charcoal, pen and watercolour, 35 x 32. London, Victoria and Albert Museum. MD 379.

several drawing media are used. The broad distribution of light and shade in grey washes of diluted ink, and the edge of the picture-frame redefined in white gouache, suggest that it was an idea for an oil painting never executed.

In a number of Daumier's interiors with *connoisseurs* the collections themselves bear a family resemblance to one another – not surprisingly since he invented them all himself. They may be intended as critiques of contemporary establishment taste. If we compare the backgrounds of the *Visiteurs dans l'atelier d'un peintre* (figs 68 and 69) with *Deux Connoisseurs avec un folio* in the Victoria and Albert Museum (fig. 71), for example, we find an equestrian picture to be *de rigueur*; an oval portrait of a lady, likewise; several natural landscapes with sky effects; and in two of the collections at least a terracotta *bozzetto* of baroque type. In *Deux Connoisseurs . . .* the open folio is the focal point of the design, although the print they are looking at is scarcely adumbrated. Perforce, we transfer our attention to the expressions on their faces, which are actually slightly sinister. The gentleman with the waxed moustache could almost be an elderly Ratapoil smart-ened up for the occasion, while his companion's helmet-like head and bony profile conjures up an image of death (the very antithesis to the *Caritas* statuette of a nursing

mother on the shelf behind them). Ratapoil (fig. 72) was Daumier's political personification of bonapartism, invented at the time approaching Louis-Napoléon's *coup d'état*, representing not exactly the President himself, but the kind of *agent provocateur*, or demonic scoundrel, that he employed to increase his 'popular vote'. This seventeen inch high statuette had served as a three-dimensional source for a number of Daumier's political cartoons, until state censorship was reimposed. So one may well ask, why should such an association be made with this elderly *connoisseur*? The reader must judge whether there is any physical similarity. If the generally accepted stylistic dating for the watercolour of *c*.1865 to 1870 is right, we are also nearing the end of a reign which Daumier considered odious, although he could not openly say so.

In *Les Amateurs . . . (Amateurs Looking at a Print by Raffet)* another figure of Charity

73. Daumier: *Les amateurs regardant une épreuve de Raffet (Amateurs Looking at a Print by Raffet)*. 1863-65. Black and red chalks, pen, and watercolour, 26 x 31. Paris, Louvre (RF 4036). MD 387.

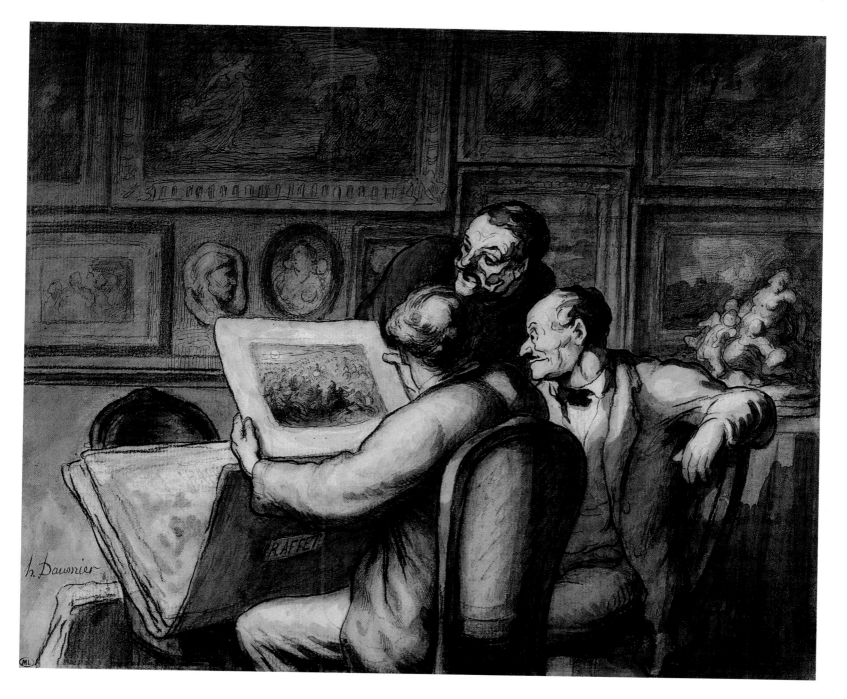

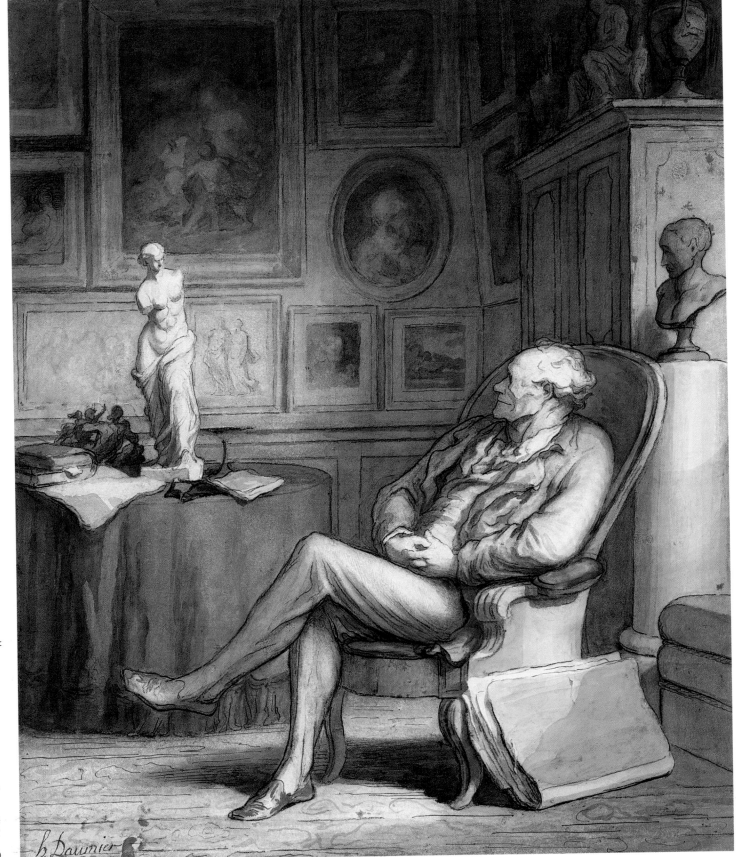

74. Daumier:
*Le connoisseur
(An Amateur
with His
Collection).*
1863–66.
Black chalk,
pen and
wash,
watercolour
and gouache,
44 x 35.
New York,
Metropolitan
Museum of
Art. MD 370.

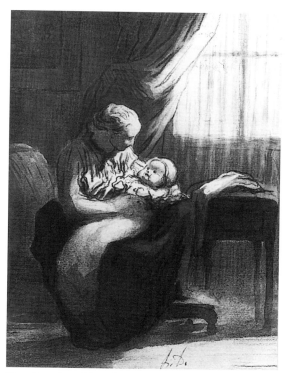

75. Daumier: *Une mère (A Mother)*. 1860-63. Black chalk, pen and wash, and watercolour, 22 x 16. Private collection. MD 689.

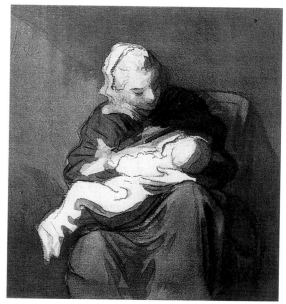

76. Daumier: *Maternité (Woman Nursing a Child)*. 1860-63. Black chalk and wash, 16.5 x 14.5. Private collection. MD 222.

appears in the background, as a muscular female now with three babies at her feet (fig. 73). She is closely related to the allegory of the Second Republic that Daumier had painted in 1848 and stands in contrast to the print by Raffet, *La Revue Nocturne* which, made in 1836, celebrated the Napoleonic legend as it was approaching its height.[22] In 1863 a *Raffet Œuvre Catalogue* was published by Giacomelli, who was also the first owner of this watercolour. 1863 may then be a reasonable date to assign to its execution. The *connoisseurs* in this case seem to be united in their enthusiasm for one of Raffet's most famous prints, but their backs are turned to the Charity figure. In the 1860s, Napoleon III's military aspirations were aping those of his more illustrious uncle, and Daumier's introduction of his *Republic* behind them may be subtly indicating a desire to distance himself from the military legend, if not actually offering a criticism of militarism.

Most interesting of all of Daumier's 'invented collections' is the one that forms the environment of *The Connoisseur*, the watercolour now in the Metropolitan Museum, New York (fig. 74). Again we have the books, the folder of prints, the paintings, the framed drawings in various styles, the little baroque *bozzetto* on the table and, at the centre of the surrounding space, the object of the collector's gaze, a reduced-size cast of the Greco-Roman Venus de Milo.[23] The collector himself, relaxed, pensive, solitary, has an inscrutable expression; his profile is very like that of the seated figure in fig. 71, and equally skull-like. Klaus Herding has suggested a degree of dislocation here between the rich collector and his art, even detecting eye contact between the Venus statue and the bust on the table behind this *amateur* as if, Pygmalion-like, they had been brought to life by the artist and commune without their owner's knowledge[24] – the owner being also Daumier's invention of course. Among the framed pictures are two drawings, one in sanguine for decorative effect, and one of classical figures matching the form of the Venus de Milo, and above them the roughly indicated form of a nude woman accosted by two putti, not unlike the *Caritas* sculpture group in *Les Amateurs*. . . . All Daumier's inventions seem to have family affiliations. This watercolour, richly detailed yet restrained in execution, is possibly the finest of this entire group of *Amateurs*, which should be dated between about 1863 and 1870.[25] Taken together with the scenes of visitors to artists' studios, they must surely reflect Daumier's own view of the problematic interdependence between art collectors and art makers. His release from *Charivari* in 1860 immediately brought him face to face with the problem of finding new financial support. This could account for the finely ironic and somewhat ambivalent picture of the artist's relation to his patrons shown in these works. However, this was not the artist's last word on the subject – we will find him treating it again in the 1870s.

A different class of fairly affluent patrons seem to be recorded by Daumier not so much with a critical eye as an affectionate one. A watercolour said to represent Mme Pierre Bureau with her baby son, entitled *Une mère (A Mother)* was first owned by the Bureau family (fig. 75). This broadly handled drawing was begun as usual with grey washes over black chalk, and colour added to Mme Bureau's blonde hair and blue skirt, with a white gouache highlight on the cloth on the table. Its treatment is left informal in terms of conventional finish, and the cursory initials *h.D.* suggest that this might have been asked for as a gift rather than commissioned. It is unlikely to have been executed much before 1855, and in fact seems confident enough to belong to the 1860 to 1863 period. The baby, Paul Bureau, later became the owner of a large and important collection of Daumiers, but it should be noted that it was Mme Bureau who lent many works to the 1878 retrospective, and although Paul may have added to the collection later on, before its dispersal in 1927, his parents must have established it. A study of a woman nursing a child (fig. 76), with the tones worked out entirely in graded monochrome washes, is very similar to Mme Bureau in features, but given the customs of the time this figure could have been her wet-nurse. On the other hand the nursing mother in the watercolour in

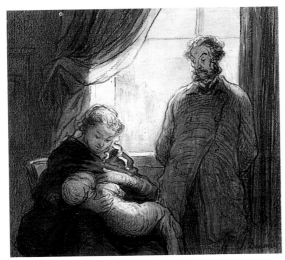

77. Daumier: *Monsieur, Madame et Bébé (The Family).* 1860-63. Black chalk, pen and wash, watercolour and gouache, 17.4 x 19.2. Washington D.C., Phillips Collection. MD 699.

78. Daumier: *Les spectateurs au théâtre (Study of Spectators at a Theatre).* 1860-65. Charcoal, pen and grey wash, watercolour, 31.5 x 30. Los Angeles, Armand Hammer Daumier and Contemporaries Collection. UCLA at the Armand Hammer Museum of Art and Cultural Centre. MD 403.

the Phillips collection, *Monsieur, Madame et Bébé (The Family)*, does resemble Mme Bureau, and the entrance of Monsieur Bureau to admire his offspring completes this surprisingly conventional family group (fig. 77).[26] Again 1860 to 1863 seems a probable date for this very fine, almost impressionist work which would have pleased Degas, that artist so fond of *contre-jour* lighting.

Spectators at the theatre was another subject which Daumier had treated often enough in lithographs, and which might have struck him as good for private sales of water-colours. An inveterate spectator himself, Daumier also liked to draw people watching each other. His many studies of theatre audiences include roughly drawn compositional groupings, often done in charcoal; impressions (memories) in light watercolour brush drawings; every kind of quick notation of heads smiling or with their mouths open; and some fully finished multimedia drawings like those found in the *Connoisseurs* group. The study of spectators at the theatre (fig. 78), in the Hammer collection, is an example of Daumier's lightness of touch when bringing up a scene from instant recall. He draws expressive body movements: spectators leaning forward with curiosity, chins thrust out or heads cocked to one side as they try to see the stage from a side aisle. The distribution of light is indicated with grey washes, modified by atmospheric blue and rose, contrasting with the deep black of a man's evening coat. The finished watercolour which was developed out of this study, alas, is more forced and the figures have become stiffened.[27] *L'entr'acte (The Interval)* is another elaborate work which has better survived the finishing process (fig. 79). It is one of three variants, all picturing well-to-do bourgeois in the stalls of the Comédie Française. Basically they are all studies of facial expressions, as members of the audience – entirely male in the orchestra stalls – chat among themselves, look up at the circle boxes with opera glasses (we know that is where the women are), fall asleep, or wake up to look and laugh at the stage. Daumier had been drawing cartoons of theatre audiences for *Charivari* during most of his career, but this subject is not found in his oil paintings and watercolours before about 1860. To some extent these expressive faces reflect his cartoon style,[28] but they are less exaggerated and without any anecdote necessitating a legend to accompany them. Audiences in his oil paintings, which include women, tend to be rather staid and serious.[29] In these watercolours the characterization of individuals seems to be somewhere between the two extremes; it is well above the popular comic level, but sardonic nevertheless. There is enough information given for the viewer to imagine the types of conversation and the thoughts of these people. The question remains, however, as to what date they were made. Technically, as watercolours, they seem to have that cumulative richness of surface which is typical of the period 1865 to 1870. Daumier's frequent changes of medium as the drawing develops, and his habit of emphasizing the final accents with heavy lines in black chalk or pen, actually parallels the 'hidden' technique of his lithographs, where all changes of mind and *pentimenti* in dry chalks on the stone were eliminated by the final drawing executed in greasy lithographic crayon.[30] This too suggests that these elaborate water-colours were being produced while Daumier was still thinking in his lithographic mode, as it were. If their date is indeed 1865 to 1870, then the epoch in question would be that of the dying days of Napoleon III's Second Empire – not that very many Frenchmen saw it as dying until near the end.[31] An alternative possibility is that some of them were actually produced in the 1870s, since his last account book indicates sales made to dealers and *amateurs* right up to 1877.[32] We will return to his account books shortly; for the moment it may simply be observed that these well-fed theatre audiences could equally have been found in post-war France, during the opening years of the Third Republic, when once again the notion of the city of Paris as one great *spectacle* was in everybody's mind. One watercolour giving a particularly affluent image of the audience, *Les fauteuils d'orchestre*, had an excellent wood engraving made after it by A. Lepère, which was

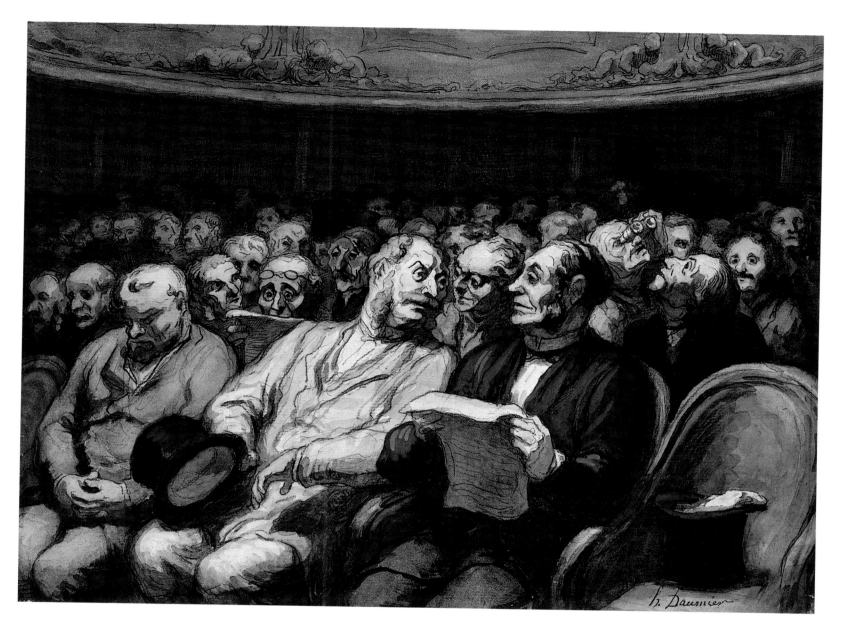

79. Daumier: *L'entr'acte (The Interval at the Théâtre Français)*. 1860-65. Black chalk, pen, watercolour and gouache, 24.5 x 33. Winterthur, Oskar Reinhart Collection. MD 500.

published in *Le Monde illustré* on 4 May 1878, just after the opening of Durand–Ruel's exhibition featuring Daumier as *artiste-peintre*.[33]

We began this chapter with a drawing of an artist in his studio, apparently questioning which path he should take. Now that it can be demonstrated that Daumier continued to have business relations with amateur collectors well into the 1870s (and I shall argue that he continued to produce watercolours for them during that era) it might be possible to reach some conclusions about the path that the artist *did* take. *Trois connoisseurs dans une salle des ventes* (*Three Connoisseurs in a Saleroom*) is drawn on paper with a Whatman watermark dated 1869, which gives it a *terminus post quem* (fig. 80). The poses of the three gentlemen in question are elegant and relaxed, stylish almost to the point of mannerism. The object of their gaze is an undisclosed painting hung high across the saleroom, while they manage to ignore a hastily sketched–in female walking towards them at ground level. The whole drawing gives the impression that it might have been drawn on the spot, although that would hardly have been practical considering that Daumier was

80. Daumier: *Trois connoisseurs dans une salle des ventes (Three Connoisseurs in a Saleroom).* 1870-75. Pen, grey and brown washes, traces of charcoal, 49.3 x 39.2. The Art Institute of Chicago, gift of Mrs Helen Regenstein. MD 390a.

81. Daumier: *Un peintre et deux connoisseurs dans un atelier (An Artist and Two Connoisseurs in a Studio).* 1873-77. Stumped charcoal, pen and wash, 31.2 x 46. New York, Joseph Mugrabi Collection. MD 386.

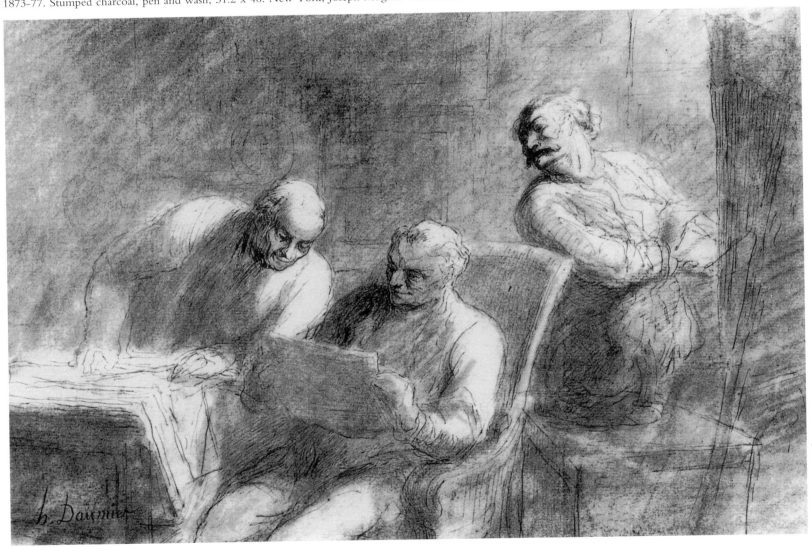

using, consecutively, charcoal, black chalk, grey and brown washes, and pen-and-ink to achieve his result. In fact this drawing is a reworking of the composition of a more finished oil painting executed perhaps about 1858 to 1862, in which there were strongly contrasted light effects and an almost sculptural solidity to the forms.[34] Here, by contrast, the atmosphere is transitory, beautifully perceived but less certain of the concrete facts of existence. The calculated *mise-en-page* of the figures, and the placing of the final accents with the point of a mapping pen, suggest a tranquil recollection of the art world, from which Daumier had now withdrawn to live in his retirement cottage in Valmondois in the country a few miles north of Paris. This is his late drawing style. *Un peintre et deux connoisseurs dans un atelier* (*An Artist and Two Connoisseurs in a Studio*) must belong to this same late stage (fig. 81), perhaps as late as 1873 to 1876. Its first owner was P. Aubry, who is recorded as the purchaser of at least a dozen works by the artist in Daumier's last account book of 1876 to 1877 (one wonders if he was not also a dealer). The entry for this drawing, made on 20 April 1877, runs as follows:

> . . . *vendu à M. Aubry / 1 dessin* [*pas fini* crossed out] *Esquisse amateurs dans un atelier . . . 200* [francs].

It is interesting that Daumier regarded this late work as only a study, though he decided against describing it as unfinished. Was he planning to add touches of colour over the grey wash, or to start the whole thing again on another sheet? In any event, his conception is clear concerning the relation between the artist and the *amateurs* here — they are the best of friends and understand one another.[35] The interior arrangement of the studio (or library) is indeterminately rendered, as once again a fine pen line wanders over the surface of forms that have first been expressed as light and shade put in with charcoal and grey wash. The artist leans gracefully backwards as he looks over the shoulders of the two *connoisseurs*. All their features are firmly yet gently drawn, as though the now partially blind artist was peering closely at each one in turn.

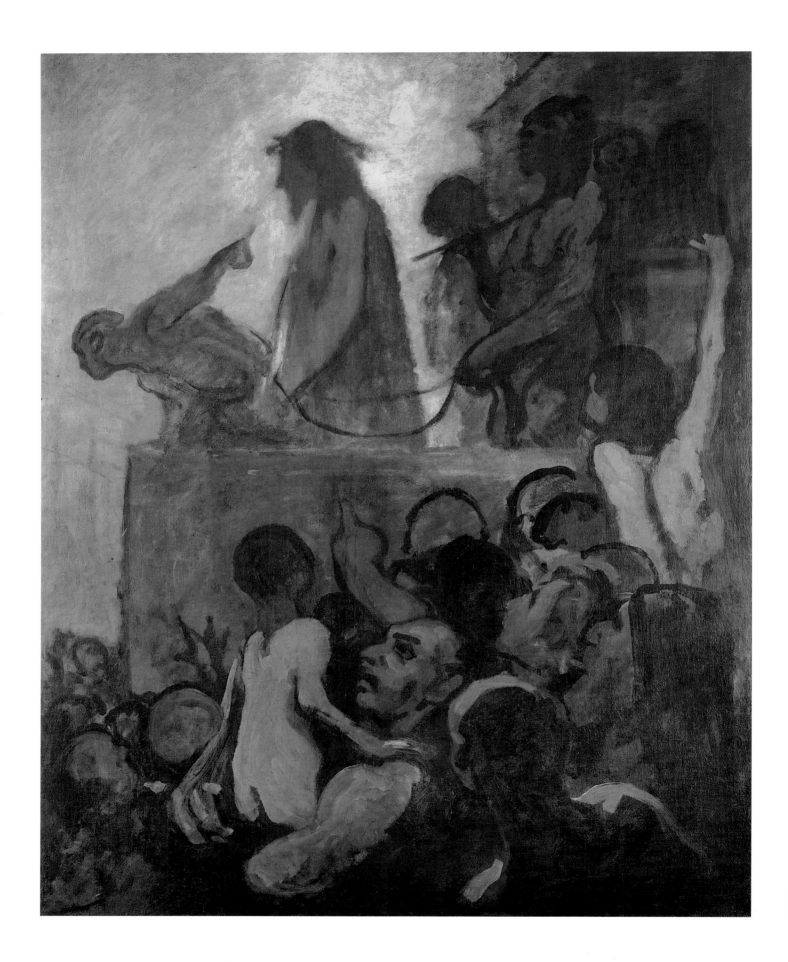

Chapter 5

DAUMIER'S OIL PAINTING TECHNIQUES, *c*.1850—1863

*'Daumier peintre naît et grandit à côté de Daumier caricaturiste et dessinateur de
mœurs'[1]*

When Daumier found private clients for his work during the decade of the 1860s, it
seems that most of them were purchasers of his watercolours rather than oil paintings.
This surmise is confirmed by the records of sales listed in his *Carnet IV*,[2] by the fact that
he sent four watercolours (but no oils) to the Salon of 1869, and also by the sheer
quantity of finished watercolours by him that exist today. Some we have noticed already,
and more will be discussed in specific iconographic contexts in later chapters. It is
opportune at this point, however, to observe that as a painter in oils Daumier had neither
the same facility nor the same success with patrons, at least not after 1852 when he
virtually retired from exhibiting in public. In *Carnet IV*, during the period June 1864 to
December 1867, he recorded selling thirty-six drawings at prices between 100 and 200
francs each and a total of only nine paintings in much the same price range (which
suggests that they were small-scale sketches). By July 1867, however, his prices had risen:
the dealer Hector Brame paid him 800 francs for one smallish canvas of *Don Quixote and
Sancho Panza*,[3] and he sold 'Un dessin pour l'Amerique' in December for the same
respectable sum. But a finished canvas by Daumier was the exception rather than the
rule: large numbers of very unfinished oil paintings exist (some of them unfortunately
'finished' by other hands), and it becomes evident that his painting language was
something quite other than the accepted conventions of his day and age. This phenom-
enon now needs to be examined.

After the delivery of the *Martyrdom of Saint Sebastian* (see chapter 2), the next major
picture of a religious subject (and probably the last) that Daumier undertook was *Ecce
Homo!*, now in the Museum Folkswang, Essen (fig. 82). Both Adhémar and Maison
dated this quite early, under the impression that it was related to one of his religious
picture commissions from the state, but now that these have been satisfactorily identified
and located elsewhere the probability is that this was not a commission at all. It is more
likely a canvas that Daumier began with the Salon in mind, during the mid-1850s, after
the seizure of political power by Louis-Napoléon. When Baudelaire and the writer
Poulet-Malassis visited his studio in January 1852, four months before the next Salon was
due to open, the only subjects that Poulet-Malassis specifically recalled seeing were an
ébauche of a martyrdom (namely, St Sebastian) on the easel, a wax relief on the wall (mis-
identification of the *Emigrants* relief), an *ébauche* of St Mary Magdalene (the other
religious commission, never completed), and another *ébauche* of a washerwoman drag-
ging her child along the quayside (which moved him deeply). He saw a number of other
canvases turned face to the wall. Now, while it is true that *Ecce Homo!* could have been
among the latter, it would be strange if Daumier's biggest known canvas after that of St
Sebastian would have been kept a secret from his visitors had it been begun at that time.
Moreover, this painting shows, even in its unfinished state, stylistic characteristics very
different from the baroque exuberance of his Salon exhibits hitherto. When asked if he
would send anything to the Salon that year, he replied that 'he hadn't got anything'.
Most likely then, he had not yet begun *Ecce Homo!* In order to argue a date of between
1853 and 1859 for this important picture, we should examine it from two further
standpoints: its technique and its iconography.

82. Daumier: *Ecce Homo! c.*1853-59. Oil on canvas,
160 x 127. Essen Museum-Folkwang. MI 31.

On first encounter, the canvas appears unexpectedly large, and is evidently painted with big brushes. The colour is not quite monochromatic because the figures, which emerge from an overall dark-brown layer of paint covering the priming, are drawn in transparent tones of a mixture made with black, blue and white, scumbled over this ground layer in different thicknesses. A yellow-grey penumbra of light shines around the head and shoulders of Christ, who is being presented to the people. Its yellowish look is made by simply thickening the white paint over the brown ground layer, which is therefore probably composed of raw umber. The crowd, drawn with heavy black outlines, some heads with expressions and others left blank, is reminiscent of the rioting mass in the big mixed-media gouache called *L'émeute* (*The Riot*) of *c.*1848 to 1850 (fig. 45), heaving and struggling at they know not what. Although many previous commentators (including the present writer) have labelled this piece 'We want Barabbas!', its iconography is clearly *Ecce Homo!* according to the account in John 19, 5:

> Then came Jesus forth, wearing the crown of thorns, and the purple robe. And Pilate said unto them, Behold the man!

This incident took place *after* the crowd had chosen Barabbas, and Jesus had been taken away and scourged. Daumier gives Jesus an austere whitish-grey robe, but he shows the crown of thorns, and the guard holding his prisoner with a rope and carrying a stick, while Pilate leans forward over the crowd and points back to Christ.[4] Various compositional precedents have been suggested for Daumier's picture, including one of his lithographs in the series *Les divorceuses* in which a feminist divorcee harangues a crowd of her fellow women. Rembrandt's etching of *Christ Presented to the People* is the great precedent for Daumier's representation, however, not so much for its figural arrangement as for its manner of visualization. In Rembrandt's print, in its earlier states, the heads of the crowd break across a wall below the figure of Christ; in later states the artist increased Christ's isolation from the crowd (and the viewer) by effacing the spectators across the front and replacing them with a blank wall (fig. 83). What is outstanding about Rembrandt's visualization in this case is its naturalness: the resigned calmness of Christ's stance (echoed in the Daumier) and details like the man holding up his child to see what is going on. An earlier Rembrandt etching called *Ecce Homo* (*Christ before Pilate*), in his more baroque style, shows Christ with a more agonized, dramatic expression, but it also includes a man holding out his arm across the crowd below, which Daumier may have remembered.[5] Both prints could have been familiar to him by at least 1853, the year in which Charles Blanc published an edition of photographs after Rembrandt's etched work which included them.[6] T.J. Clark has very reasonably suggested that in 1849 (the date he ascribed to this picture) the saints and the Passion were 'the commonplace of everyone's speech', and that metaphorically 'Christ *was* the republic, the Great Proletarian, the prophet betrayed by his people'.[7] In Daumier's picture the thin silhouette of Christ stands etherial against the light, a pilloried figure, in contrast to the vigorous musculature of the bodies surrounding him. Is this how he saw his dream of the Republic after the reality had vanished? The scale and the unruliness of his technique adds to the viewer's unease.

It would be convenient for a socialist art history if the remarkable canvas of *L'Emeute*, known as *The Uprising* (fig. 84) could be brought in at this juncture to match and compare with the style and intention of *Ecce Homo!* Unfortunately, however, so little of the top paint layer seems to be by Daumier's own hand that it is impossible to date the work by style with any degree of certainty . It could be supposed that the subject, a street scene in which a crowd is heading towards the barricades (or so it seems), might relate to the revolution of 1848, but the specific scene is less than clear. Every viewer is bowled over by the first impact of its composition: the young worker in shirt sleeves, leading a surging crowd, seems to be trying to break out of the picture plane towards us. Only on

83. Rembrandt: *Le Christ présenté au peuple (Christ Presented to the People)*. 1655. Drypoint etching, 35.7 x 45.5. New York, Pierpont Morgan Library. B.76, VIII.

84. Daumier: *L'émeute (The Uprising)*. 1848/49 and 1850s. Oil on canvas, 62.2 x 113. Washington D.C., Phillips Collection. MII 19.

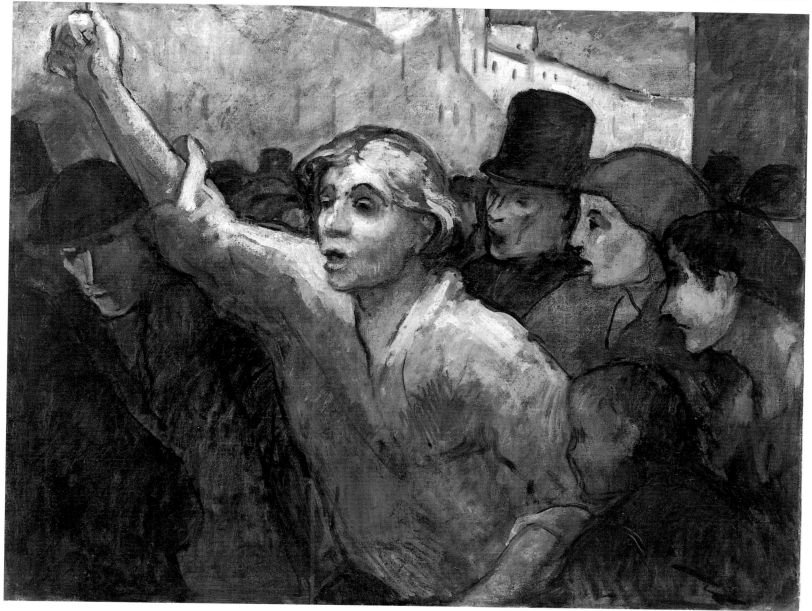

a second look (and not necessarily even then) does K.E. Maison's criticism, that no serious student of Daumier's paintings could consider any one of these 'expressive heads' in the foreground to be authentic originals, become tenable.[8] Jean Adhémar, in an early article on Daumier's 'revolutionary studies', wrote that this painting surpassed all the others in the group, and suggested that it could be more justly entitled *La Marseillaise*. He added, however, that it was a pity that Daumier did not push his *esquisse* further and, significantly, he did not reproduce it in his seminal monograph of 1954.[9] Albert Boime reproduces *The Uprising* in his monograph on *Thomas Couture*, and claims that its composition derives essentially from Couture's *Enrolment of the Volunteers of 1792* (1848 *et seq.*), therefore putting Daumier's picture to a later date. He thinks that the central figure is taken from Couture's enthusiastic worker on the right with his shirt-sleeved arm upraised.[10] However, a charging figure with raised arm is so common in martial iconography (think of Delacroix's *Liberty at the Barricades*, for example) that this part of his argument is not very convincing. What is more significant in Boime's discussion is his equation of Daumier's painting *technique* with that of Thomas Couture.

Boime believes that Daumier's technique reveals the combination of scumbled layers of reddish-brown underpainting, the strong tonal contrasts of the *ébauche*,[11] and the heavy outlines developed by Thomas Couture and disseminated through his teaching.[12] The question remains open, however, whether it was Couture who actually taught Daumier this, or whether Daumier developed his own methods of dealing with an *ébauche* from seeing the work of other artists such as Delacroix and Millet.[13] Couture was noted for spreading a red-brown or salmon pink colour over his canvas after putting down his outlines, and developing his design in successive warm and cold layers over that.[14] However, not all Daumier's ground layers are reddish-brown.[15] While it is not always possible to determine the ground tone of a finished painting without a laboratory examination, a sufficient number of Daumier's paintings are left unfinished to enable the ground tone to be perceived with the naked eye. Among some seventy paintings which I have looked at with this factor in mind, about half appear to have a reddish-brown or dark-brown ground layer of pigment spread over the priming, some made with bitumen in the mixture (with deleterious later effects). No distinction was made between its use for canvas or wood panels. Over such a ground the main lines and tonal gradations of the composition are laid down in black and grey with various degrees of transparency, which produces vibrations between warm and cool. A smaller number, which includes the *Ecce Homo!* discussed above, suggest that a cooler brown ground was used, more like a raw umber, spread thinly over the white priming. Another group show a much lighter ground, ranging from a pale yellow ochre to a sepia tone, again spread thinly over the white priming. This group includes some paintings on paper (mounted later on canvas or board), possibly of a tan colour which was itself used as a ground tone. Whereas the reddish-brown or dark-brown grounds are found in all periods of Daumier's painting from the beginning, these lighter coloured grounds begin to appear from about the mid-1850s. Finally, certain canvases, of which *Don Quichotte et la mule morte* (fig. 182) is an outstanding example, received Daumier's brush drawing straight away on the white ground. These begin to appear in the 1860s, and there is probably a fine distinction to be drawn between a ground colour and a light tonal scumbling over certain parts of the canvas only, leaving more of the original white priming layer to shine through in areas such as the sky. An important point to bear in mind is that, if Daumier did not really expect to exhibit or even sell much of his work in oils once he had retreated from the competitive Salon world, for whatever reason, he was more likely to have experimented with different techniques that suited his purpose alone.

It may be useful to take a look now at some particular cases which use these various techniques, noting their approximate dates. We can begin by considering the other paintings in Adhémar's group of 'revolutionary studies', which may have been conceived

85. Daumier: *Tête d'homme (Head of a Man). c.1855/ 56.* Oil on canvas, 26 x 34. Cardiff, National Museum of Wales. MI 81.

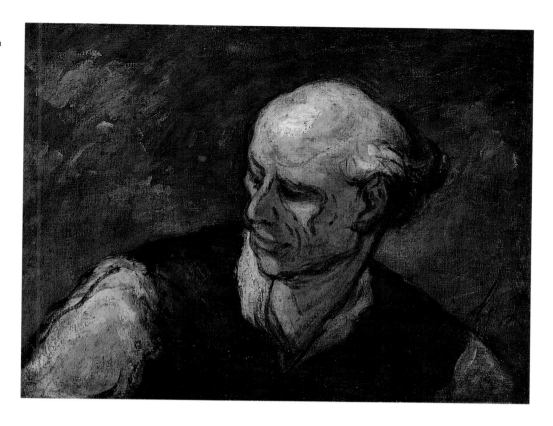

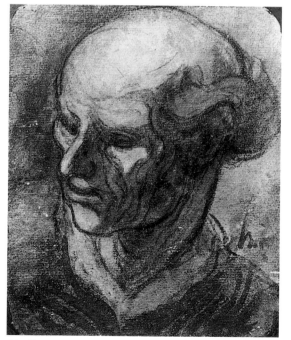

86. Daumier: *Tête d'homme (Head of a Man). c.1849-1855/56.* Black chalk, charcoal, brush and wash, on paper laid on board and varnished, 23 x 18. Private collection. MD 31.

in 1848 or 'on the morrow of the revolution' but which, put quickly out of date by current events, remained in Daumier's studio for the rest of his life. He may well have continued to work on some of these for several years, even though they represent a part of his ideology that was necessarily suppressed, at least in public, after 1852. Such a one is *Scène de la Révolution (Revolutionary Scene)*, on view in the Pushkin Museum, Moscow (see note 9). The viewer is projected into the centre of a crowd during a populist uprising. It is very like the Phillips *Uprising* in conception, but more startling in its initial effect.[16] The leading figure is a robust young woman in a white shirt – a 'Marianne' – with a long oval face and yellow hair. It is very thickly and coarsely painted on what appears to be a dark toned ground, with strong contrasts of light and shade comparable to the *Martyrdom of Saint Sebastian* of 1852. Here, however, there is a greater range of colour: patches of yellow, red (in a woman's cap) and Antwerp blue call to each other across expanses of blue-grey and blue-black. A distant crowd disappears into the blackness of the night, with no faces distinct. Gustave Kahn[17] remembered the painting as the 'ornament of the Centenary' at the Paris Exposition Universelle in 1900, where it was catalogued as *Mouvement populaire dans la rue* – perhaps a 'politically correct' nonreference to the 1848 revolution at that time, in that place.

Another painting in this group, *La famille sur la barricade (Family on the Barricades)* in the Narodni Galerie, Prague, is unfortunately overpainted in many places. It is about the same size as *Scène de la Révolution*, and in effect replaced it at Daumier's exhibition at the École des Beaux-Arts in 1901 where, under more privileged circumstances, it was given the full title of *Révolution de 1848. Un famille sur les barricades.* A painting related to this one gives us a better idea of Daumier's technique in such works. A small canvas known simply as *Tête d'homme (Head of a Man)* is an independent study of the central figure, the worker who heads his family as they move to an inexplicit destination (fig. 85). There is also a black chalk drawing of the same head (fig. 86), and since both works are superior in execution to the head in the original composition, they could well post-

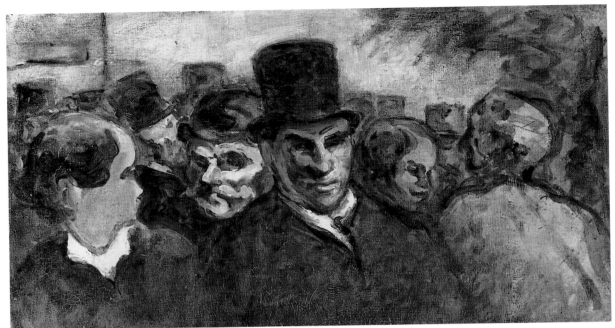

87. Daumier: *Passants (Crowd in the Street).* *c.*1855–60. Oil on paper laid on canvas, 19 x 34.2. Private collection. Maison, *Some Additions.*

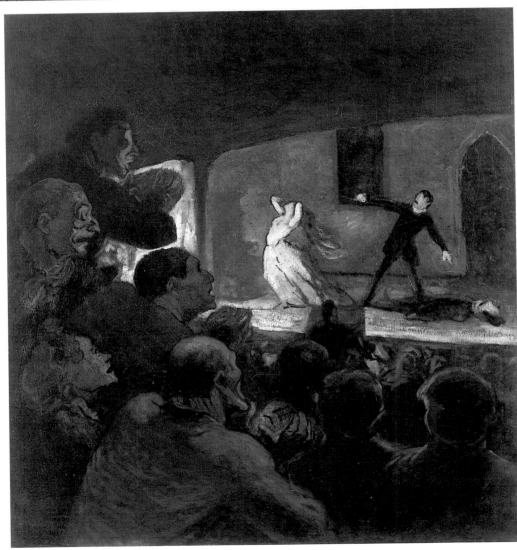

88. Daumier: *Le drame (The Melodrama).* *c.*1856–63. Oil on canvas, 98 x 90. Munich, Neue Pinakothek. MI 142.

date it. In the oil version a reddish-brown ground layer of pigment is clearly visible. On this, the man's head and shoulders have been drawn in black with a sable brush, his waistcoat toned in with black and grey, and impasted lights in white and Naples yellow put on his shirtsleeves, collar and balding head. The background is scumbled in with a rich blue which allows the reddish ground to show through it. The vigorous and energetic lines of the man's bony profile were then finally corrected again in black, leaving the glowing red-brown ground clearly visible in the shadowed areas of his face. These are just the colours that Couture recommended.[18] Although this procedure is apparently very simple technically, the effective character of the piece is actually achieved with great subtlety, in several layers of paint. The man's expression, patriarchal and forceful, has achieved the same intensity and spontaneity as the monochrome drawing which, one assumes, preceded it (fig. 86).

Another of the subjects which Adhémar linked with the 1848 revolution was fig. 87, *Passants* (*Crowd in the Street*). Why this should be seen to have a socialist connection is not immediately clear, except that the milling crowd in these paintings (there are three versions) could perhaps be related to *The Uprising* (fig. 84). In this composition, however, the top-hatted bourgeois has taken centre stage, although he is surrounded by a crowd which seems to be predominately proletarian. The biggest version of this subject is a canvas in Lyon Museum, comparable in size to *The Uprising*. It is equally unfinished (no more than an *ébauche* in fact), but it has not been tampered with and there is some white priming still visible on the canvas. The small study on paper has the function of an *esquisse* for the composition (fig. 87). This is essentially a brush drawing, with shadow tones lightly stippled, over a ground layer of yellow ochre. The features of two of the central figures were then modelled with thicker, impasto strokes (yellow ochre and pink) around the eye sockets, noses, and mouth forms. White was added on some shirt collars and in the sky. All the essential features of the big painting are already here, and although the format was lengthened horizontally in the large version to admit two more figures and a tree, the characterization of figures was not developed any further. In the *esquisse* the relation of the three people on the right is a study in contrasts: the top-hatted bourgeois with a rather menacing expression, the man in the bowler hat behind him with a fierce *mustachio*, and the *gamin* or street urchin who stares insolently across at him. (This boy appeared in the same pose in *La famille sur la barricade*.) An oil sketch of this kind seems unlikely to have been prepared for a private patron: it looks more like Daumier's own agenda. It is also less conventional in technique than anything we have seen so far – it could be called impressionist.

Other subjects found among the oil paintings that should be assigned to the period between 1853 and 1863, a period of variety and experimentation, include scenes of working-class life around the Ile Saint-Louis, washerwomen, men watering horses, bathers, shop window-gazers, and one very unusual scene in a popular theatre or music hall, (fig. 88), *Le Drame* (*The Melodrama*). In addition, scenes from Cervantes' *Don Quixote*, a subject which Daumier had already sent to the Salon of 1851, continued to appear in his *œuvre* for the rest of his life. (The significance of that fact will be discussed in a later chapter.) *Le Drame*, which more properly deserves the title *Le Mélodrame*, may be tentatively dated *c.*1856 to 1863, which implies that he could have continued working on it during the period after he was sacked from *Charivari*.[19] The theatre and theatre audiences often figured as subjects for Daumier's lithographs, at all levels from the Paris Opera down to vaudeville, and the locale of this scene must be at the proletarian end of the scale. It is interesting, therefore, that Daumier should choose this particular kind of ham-acting melodrama for treatment in a major painting. Apart from the strong lighting contrast between stage and audience, which accentuates the crude action on the stage, he has taken particular trouble with the expressions on the faces in shadow: even those with their backs toward us are characterized by their rapt attention. (Conversely the faces of

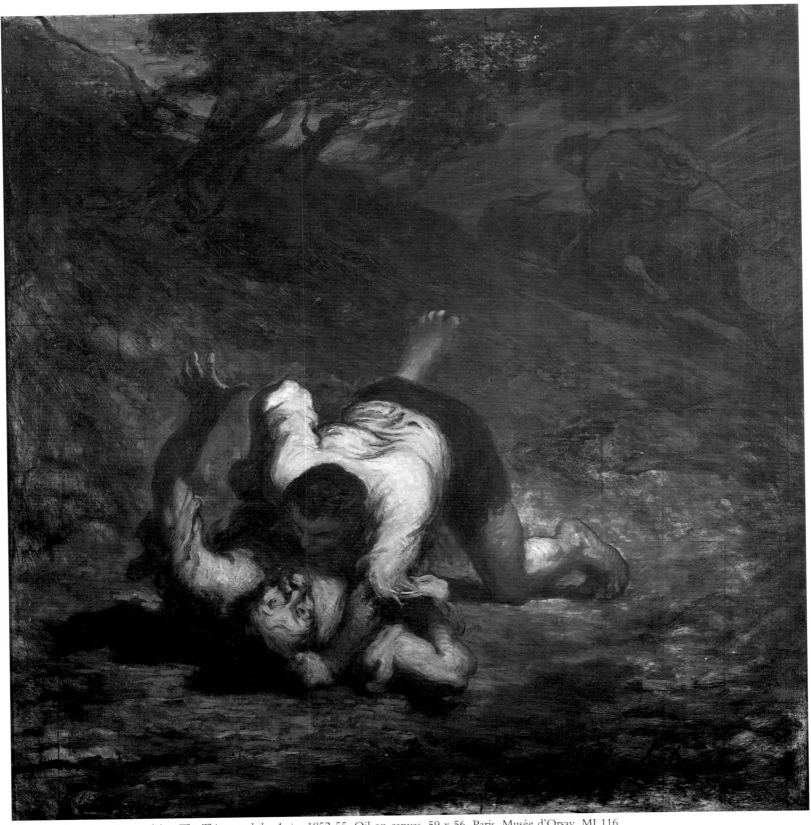

89. Daumier: *Les voleurs et l'âne (The Thieves and the Ass). c.*1852-55. Oil on canvas, 59 x 56. Paris, Musée d'Orsay. MI 116.

the actors are all blank: they perform by gesture). This canvas is not quite on the scale of the *Ecce Homo!*, but it is as ambitious in its way, and slightly less monochromatic. It is thickly painted, especially on the light area of the stage which has been gone over many times. There appears to be a dark red-brown ground tone, into which the audience's faces have been drawn in black, using the brush as if it were an outsize pencil. As we have already noticed in the case of the watercolours made for private sale, the probability is that because Daumier was so famous as a caricaturist, to sell a painting the subject had to be something that his clientele expected of him. In other words the caricaturist and the artist were *not* separated in most people's minds (as they tend to be today). Moving from one to the other was apparently quite simple. When, after Daumier's return to *Charivari* in 1864, he produced a lithograph closely modelled on this painting for yet another series of *Croquis dramatiques*, his script-writer found it easy to provide appropriate lines for it as a cartoon, inventing an interaction between the words bellowed by the actor on stage and a cheeky interjection by a *titi* (urchin) in the audience.[20] But the depth and subtlety of the painting are of course lost in the cartoon: such are the problems of assessing Daumier's art. The subject of the painting is, moreover, not quite as intellectually low-brow as it might seem at first sight: change the personnel on the stage slightly, emphasize the vaguely Elizabethan period setting, move the audience up a bit socially, and we might be watching a scene from *Hamlet*. (Was Daumier sending up Delacroix's romantic view of Shakespeare?)

Another case of an oil painting which served as the source for a later lithograph is Daumier's rendering of La Fontaine's fable, *Les voleurs et l'âne* (*The Thieves and the Ass*). The two preliminary drawings of this subject in charcoal can be dated as early as *c*.1849 to 1850, linking La Fontaine's original political intention in his fable to a more contemporary one for Daumier, namely the Austro-Hungarian War of 1849, when the Hungarian patriots were defeated after the arrival of Russian forces in support of the Austrians.[21] The painting, however, which may be later in date than the drawings, seems relatively less agitated and more of a considered illustration to the tale in question, concerning two men fighting on the ground, each searching for 'the better hold' (fig. 89). Although the painting in the Musée d'Orsay shows squaring-up lines which indicate that its design was transferred from a drawing, there also exists a preliminary *esquisse* in oil which is not a transfer but composed directly on a coarse-weave canvas with a white priming. The oil sketch was drawn first possibly in black ink,[22] and the main tones then applied in a dark bistre (made of raw or burnt umber), followed by colours: Indian red with an admixture of white, and grey-blue in the background, with further applications of white and black on the man's shirt and shorts. This is the technique of a completely academic *esquisse*: it goes back as far as Géricault.[23] The Musée d'Orsay painting, on the other hand, is more like an incomplete *ébauche* for the final work. It is thinly painted over the squaring on a canvas probably primed with white, on which a ground has been scumbled in a brown-ochre mixture for warm tones and a blue-and-ochre mixture for cool tones. This technique, then, is different from the traditional red-brown grounds noticed above. Although the painting lacks conventional finish it is interesting that Daumier signed it, probably for the benefit of Geoffroy-Dechaume who became its first owner. (As was the case with some of the watercolours, a fellow artist would not be so troubled by lack of 'finish'.) K.E. Maison was the first to point out that a lithograph which repeats this design fairly exactly (except for some adjustment to the landscape), and which was published in 1862 in Berthaud's *Souvenirs d'artistes*, bears the imprint *H. Daumier pinx. et lith.* so the painting must precede it. How Daumier managed to draw so exact a reproduction of his design *backwards* onto the lithographic stone (which still exists, conserved in Boston Museum of Fine Arts), so that it would print in the original sense, must remain his professional secret.

Another group of paintings, variously entitled *Le fardeau* (The Burden) and *La*

blanchisseuse (The Washerwoman) was produced over a period of time which encompasses several changes of technique.[24] This woman with her child in hand became a Daumier *leitmotif*: she has already been noticed here in a monochrome wash drawing of about 1855 (fig. 40), and she appeared in little oil panels earlier than that. The earliest recorded reference to the subject occurs in Poulet-Malassis's account of his visit to Daumier's studio in 1852 (see p. 65). He describes 'a washerwoman dragging a little girl along the quayside, blown by a great wind – an *ébauche* so sad in feeling that one might say the huge bundle of linen stuck under her arm was *en route* for the pawn-shop'. It is most likely that the *ébauche* which caught his eye was the large canvas now in the Hermitage Museum, St Petersburg, in an earlier state (fig. 90). There are four versions of this particular composition, in which the parapet at the side of the street (which

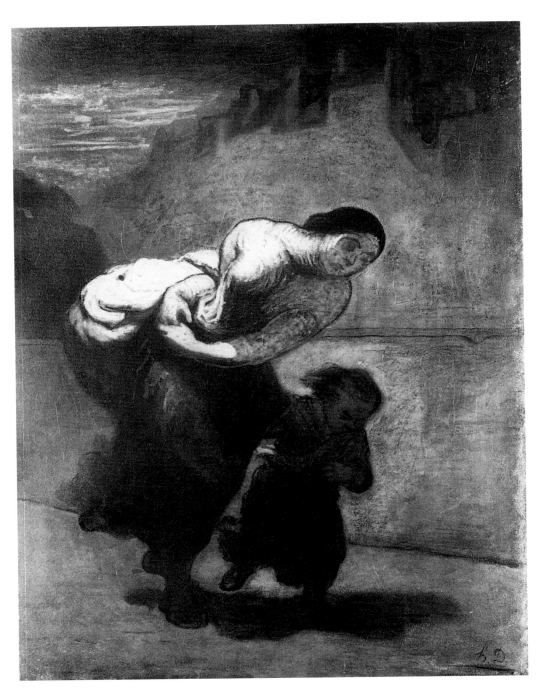

90. Daumier: *Le fardeau ou La Blanchisseuse (The Burden or The Washerwoman).* *c.*1857–63. Oil on canvas, 130 x 98. Hermitage Museum, St Petersburg. Ex Gerstenberg-Scharf Collection.

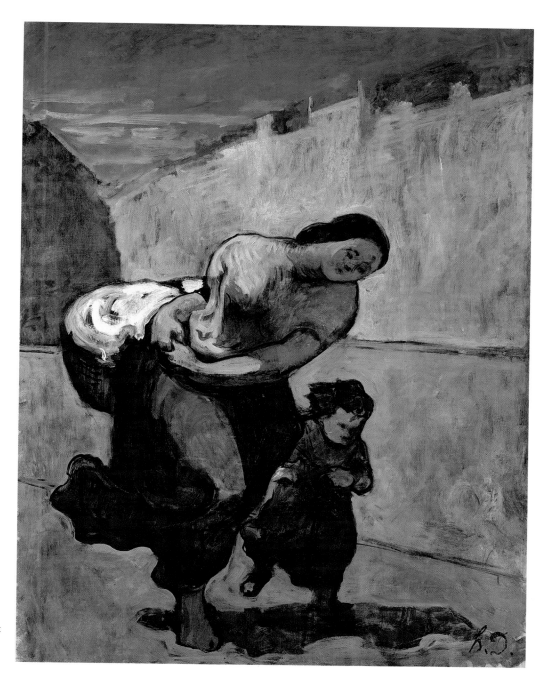

91. Daumier: *Le fardeau ou La Blanchisseuse (The Burden or The Washerwoman).* *c.*1865-70. Oil on canvas, 116.3 x 89.2. Private collection, on loan to the National Gallery, London.

overlooks the quays of the Seine) is nearly level with the picture plane.[25] The washerwoman is of heavy build, yet is bent over by the weight of her bundle and the force of the wind. The little child in the shadow, who both clings to her and seems to pull her along like a tugboat, reveals upon close inspection a face like a little old man's. The washerwoman's face is expressionless, with a small mouth and turned-up nose absorbed by the much larger, sculptural forms of her body. What began as a tonal *ébauche* on a dark-brown ground has been repainted several times, so that the background sinks into the darkness and her figure appears spot-lit by a shaft of cold light coming out of a stormy sky, in which a few dying sunset rays appear over the buildings silhouetted on the horizon. The contours of her upper body were finally redrawn with a brush in black and red, while below, the solid blue-black mass of her skirt obstructs the passage of light. The

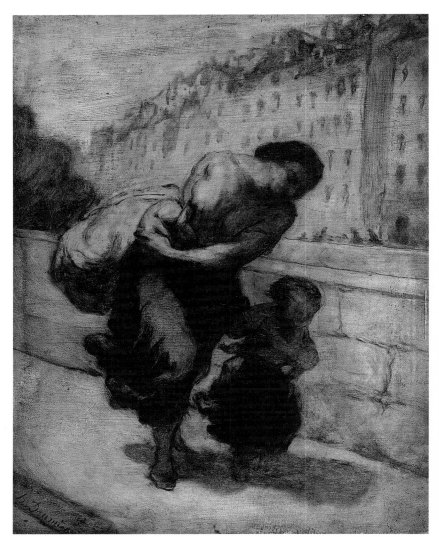

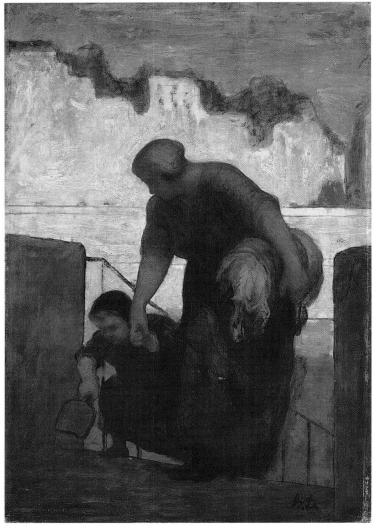

92. Daumier: *Le fardeau (The Burden)*. 1855/56. Oil on panel, 40 x 30. Glasgow City Museums, Burrell Collection. MI 85.

93. Daumier: *La blanchisseuse (The Washerwoman)*. 1863/64. Oil on panel, 49 x 33.5. Paris, Musée d'Orsay. MI 160.

final thick strokes of repainting on her laundry bag, shoulders, breast and arms are applied in parallel strokes of broken colour, in a similar manner to the later retouching of the *Two Nymphs Pursued by Satyrs* (fig. 36), which I suggested could have been as late as 1863. But this painting is no baroque revival romp: it presents us with an amalgam of hope and despair in the bleakest of modern landscapes.

Daumier may have found that painting this canvas over so long a period (say, 1852 to 1863) made it impossible to reach a consistent stylistic conclusion. This is further evidenced by a second version, almost as large, with virtually the same design but with more vivid colours (fig. 91). This version is a *reprise* of the St Petersburg composition, not squared up but painted more or less from memory, if not in a single session, at least painted 'all together' in a short space of time. The canvas was given a light ochre ground, and then scumbled over again in most places with a dark reddish-brown tone to obscure another painting underneath, which was recently discovered through an X-radiograph.[26] It is basically treated here as a decoration, without the intense characterization of the first version. Strong black contours in balancing rhythms are an integral feature of the design, and the white linen in the basket is also painted in linear fashion with a big brush, the curls echoing the fluttering draperies below. The coloured planes between the lines are applied flatly, without any indication of spatial recession by tones. The terrace across the river is illuminated by a brilliant golden light, and the sky is a bright blue streaked with

pink. This combination of techniques is characteristic of a painting style which begins in the later 1860s, and I would now date this painting *c.*1865–70, making it the latest of the whole group. Both versions were owned, according to Maison, by Arsène Alexandre at different times, having acquired them from Daumier's widow. He lent the first version to the Paris Exposition Universelle in 1900, and again to Daumier's retrospective exhibition held at the École des Beaux-Arts in 1901. When it appeared at Alexandre's sale in 1903, the cataloguer described it thus:

> A woman of the people passes along the quays of the Seine, carrying a heavy load of laundry which swells out her chest with the effort and gives her an anguished expression . . . The unfinished state of certain parts of this tragic painting render it still more interesting, because one sees, for example, how the master sought the form of her breast, sculpted it so to speak in the nude, before clothing it. In view of its size and its subject, this picture . . . must be considered one of the exceptional items in Daumier's œuvre.[27]

This view of Daumier as a 'painter of the people' ushers in a twentieth-century reading of his work, taken up with particular enthusiasm by the German art historian, Eduard Fuchs, for example.

A less harrowing variant of *Le fardeau* exists in two almost identical, small-scale oil sketches, datable to the mid-1850s, in which the parapet behind the woman recedes at a sharp angle.[28] A certain sophisticated, balletic rhythm may be perceived in the painting from the Burrell Collection, Glasgow, illustrated here (fig. 92). The woman is heavily built and heavily laden, yet she walks with grace as she leans into the wind. This smoothly flowing image is created in a rather unusual way: essentially it is a drawing in black oil paint over a light ochre scumbled ground, almost Naples yellow in colour.[29] One or two contour lines are painted in with red, as in the St Petersburg painting. This oil sketch has a similar visual effect to a monotype – a medium which Daumier never used. Some slight craquelure on the black and grey toned areas reveals a white priming, so Daumier must have put on the yellow-toned ground himself, and gone on with the painting when it was not quite dry.

A different aspect of the washerwoman and her child presents them at the top of a staircase that leads down to the river (fig. 93). In 1861 Daumier sent a small panel called *Une blanchisseuse* to the Salon, where it was hung high up on the wall. Yet Thoré-Bürger noticed it in his Salon review, in which he wrote, 'Here is Daumier, another poet of the people . . .', followed by flattery about his long career as a humorist, touching on every aspect of life, and concluding 'The sole small picture that we see at the Salon represents *A Washerwoman*, who with her child is climbing back up the steps of a Paris quay . . . vigorous colour and grand effect'.[30] This painting, which had already been exhibited at the Galerie Martinet earlier the same year (along with artists of the Barbizon School and other realists), was noticed by other critics as well. Poulet-Malassis remarked in his brochure on the Salon that one could hardly see the tiny panel 'grand comme les deux mains ouvertes' because it was so badly placed above a cornice, and Hector de Callas noticed it in his review in *L'Artiste* as having 'brushwork with plenty of spirit and a great skill in contrasts'.[31] This was encouraging, perhaps, though hardly likely to have been noticed by many of the general public. Nevertheless Daumier repeated this design in two more paintings of larger scale, signing and dating one in 1863 and perhaps completing the final version in 1864.[32] This last is highly finished in a careful and traditional technique, notwithstanding the rough surface of some of the paint which seems to go along with the harsh vision of labour with which we are presented here (fig. 93). The horizontal lines of the parapet seen across the river have been ruled, the contours around the woman's head and shoulders have been gone over several times, and the woman's whole silhouette is a dark reddish brown overlaid with some cool grey

glazes. The child's cloak is of an Antwerp blue colour. It is impossible to tell from the surface what kind of ground preparation was employed, but I suspect it to be a dark red–brown, overlaid with thick white impasto in the light areas. This is Daumier making a formal public statement, eschewing technical experiment. Frequently exhibited and reproduced, this composition has been the source of numerous forged imitations, Maison observes.[33]

There are a number of other paintings datable to the 1860s which still use the Couture-type reddish brown ground for their *ébauche*, including the well-known *Chess Players* in the Petit Palais and another version of *Don Quixote and the Dead Mule* in the Metropolitan Museum. Some of this group have bitumen in the grounds which has led to considerable darkening and, in some cases, deterioration. During this same decade, however, Daumier was also beginning to try different grounds and to use a more variegated range of colours.

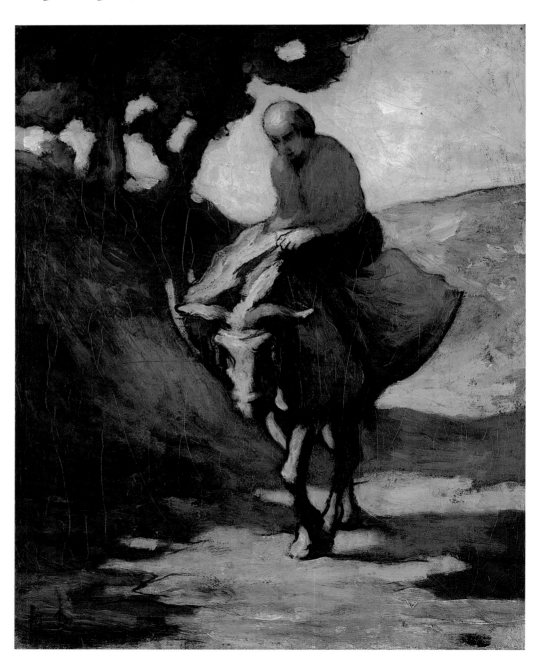

94. Daumier: *Le retour du marché (Return from the Market)*. *c*.1858-63. Oil on paper on canvas, 35 x 28. Winterthur, Oskar Reinhart Collection. MI 89.

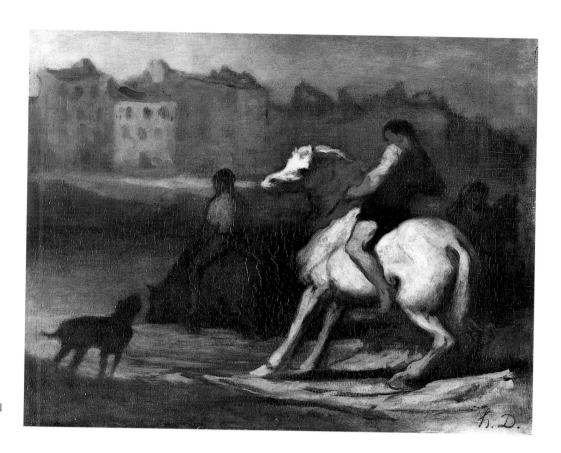

95. Daumier: *L'abreuvoir (Men Watering their Horses).*
*c.*1855-60. Oil on panel, 44.5 x 54.6. Cardiff, National
Museum of Wales. MI 74.

The Return from Market is painted on paper mounted on canvas (fig. 94). The paper has
a warmish tint which in places is used by Daumier as if it were a toned ground. On top
of this is scumbled a brownish ochre tone covering the area from the foreground to the
middle distance; it does not, however, extend as far as the sky, which is of an opaque pale
blue painted directly onto the paper. The thickly impasted light colours on the sunlit
hillside, on the donkey and on the road are in strong tonal contrast with the cool darks
of the tree, grassy bank and shadows. These are painted in thinner, grey-green mixtures,
dragged over the brownish ground to give a cool effect. These contrasts of light and dark
are parallel to the contrast of colours between the man's vermilion shirt and the bright
blue cloth over his saddlebag. Although one could hardly call this technique 'impres-
sionist', it does seem that at this juncture Daumier was consciously trying for a more *plein
air* effect of light, anticipating thus the general trend of French landscape painting in the
1860s.

Horsemen by the river Seine is the theme of a group of drawings and paintings of a
subject which must have been close to Daumier's heart. They all deal with work-horses.
This is a realist subject, yet they are often invested with more romantic overtones about
the relationship of man and beast, sometimes strongly reminiscent of Géricault as in the
painting in Cardiff (fig. 95). The men watering their horses are generally shown on the
banks of the Seine upstream, on the outskirts of the old city of Paris, at the end (or
beginning) of the day's work. They are muscular young men, presumably apprentices to
the horses' owners, and usually wear only shorts, though at least on one occasion they
are rendered nude. The Cardiff panel is painted in very dark greys, like an evening scene,
but it is fully resolved in both atmosphere and contours. Another such group in Boston
Museum of Fine Arts (fig. 96) has a more sculptural look, partly as a result of Daumier's
technique and partly because of the likeness of the prancing white horse to Guillaume
Coustou's horses of Marly, which by Daumier's time had been set up at the edge of the

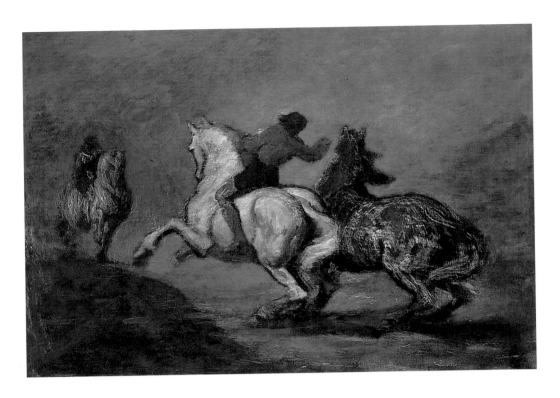

96. Daumier: *Les cavaliers (Horsemen). c.*1858-63. Oil on panel, 60.6 x 85. Tompkins Collection, Boston Museum of Fine Arts. MI 76.

Place de la Concorde and which he certainly knew. It is true that Coustou's horses are riderless, with their handlers beside them, but as Michael Levey has pointed out, what had been most original about that sculptor's conception was that the horses were both 'romantic and natural'; indeed they were originally sited at ground level by a pond which at one end was open and shallow to allow 'ordinary, real horses to enter the water'.[34] The sculptural or relief appearance of Daumier's panel is also caused by the fact that he has for some reason scraped down the colours of the dark horses, revealing the original white priming of the support, which gives them a plastery look. This white priming layer lies beneath a light brown or ochre ground tone, on which he applied the cool grey half-tones and dark tones of the horses and riders (greys made up of colours like cobalt, burnt sienna, and perhaps some madder lake). A thin, transparent white is scumbled over the darker background plane, creating an atmospheric, misty effect somewhat Spanish in character, like certain Goya paintings.[35]

The oil paintings discussed in this chapter all belong to the period 1850 to 1863, but within that period they should probably not be separated too neatly, as if some kind of 'annual stylistic development' could be discerned. Although some paintings with brownish-red toned grounds might belong to the 1850s rather than to the 1860s, we have seen that Daumier was not consistent in the techniques that he used. It is, however, obvious that after his financial disaster of 1860 and subsequent move from the Ile Saint-Louis to Montmartre, the lesser demands made on his time by commissions for illustrations left him free to paint much more during the next three years, whether he finished his pictures or not.

The range of subject matter in the oils discussed so far has largely been confined to people of the poorer *faubourgs* of Paris — as if this was Daumier's natural milieu. (The exception is the paintings of lawyers, which will be dealt with in the next chapter.) Another of his favourite subjects at this time was the bourgeois of the middle or lower middle class seen as print collectors, at all levels, including merely curious passers-by gazing at displays of prints for sale in covered stalls open to the street.[36] One of the finest of these paintings is *Devant un marchant d'estampes (The Printseller's Shop Front).*[37] Here the

intense curiosity of the passers-by is expressed by their body language, and also by the specific emphasis given to their noses (fig. 97). Eduard Fuchs once put forward an extraordinary argument, based on the theories of the psychologist Wilhem Stegel:

> Daumier has always painted the same noses, and his noses are extraordinarily characteristic. Whenever the person caricatured, or the situation which he wanted to characterise, permitted it the noses are always energetically protruding. Daumier put great weight on the nose of a person, or a situation personified, to emphasise energy directed towards activity. The nose of a person caricatured by Daumier absolutely expresses the special character of that person, or at least his momentary feelings and intentions.[38]

While this statement obviously applies more to Daumier's cartoons than to his paintings, it might be considered in relation to this particular picture. Do these window-gazers signify, in some subliminal way, Daumier's own desired public? If so, which one? Those who felt his absence as cartoonist (assuming a date of 1860 to 1863 for the painting), or those to whom he would have liked to sell his work as artist? (The 'prints' shown hanging on the back wall look lively and even colourful, more like original drawings.)

97. Daumier: *Devant un marchand d'estampes (The Printseller's Shop Front).* *c.*1860-63. Oil on panel, 33.5 x 25. Present location unknown (ex Leigh Block Collection, Chicago). MI 145.

98. Daumier: *L'amateur d'estampes (The Print Collector).* *c.*1860-63. Oil on canvas, 35.5 x 25.4. Glasgow City Museums, Burrell Collection. MI 151.

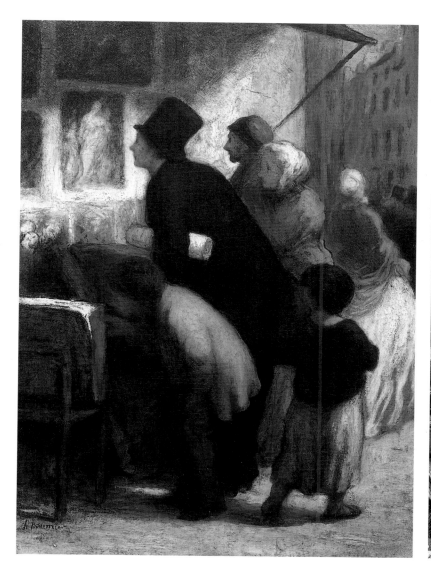

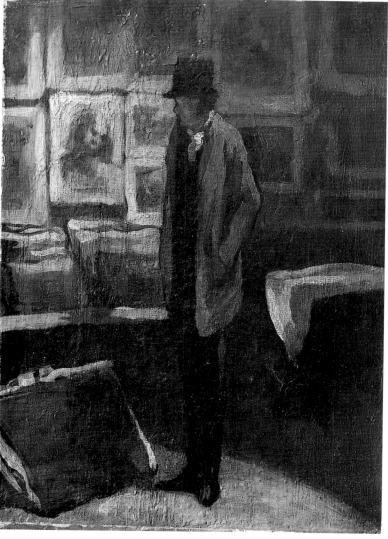

The lightly toned ground of this panel indicates a more advanced stage in his oil painting technique, while the beautiful pink shawl of the retreating lady indicates his new (or renewed) feeling for colour.

A closely related subject found in both paintings and watercolours is that of the print collector. One *mise-en-scène*, found in several oil versions, features a solitary figure inside the dealer's gallery, sometimes rifling through sheets in a folder, sometimes looking at prints on the wall, with the folder at his feet. This person is projected as the embodiment of absorbed concentration in his private world. The version in the Burrell collection, Glasgow (fig. 98), is fairly thickly painted, over a sepia half-tone ground which has been transparently washed over a solid white priming layer (as in *Le fardeau*, fig. 92). Basically it is painted with only three colours, distributed among tones of grey and black: yellow ochre on the man's coat, Antwerp blue on the folder covers, and light red on the drawing of a girl's head upon which the print collector fixes his gaze. Firmly and competently painted, this small canvas sets a new standard which must itself must have been aimed at a collector's market: the *modest* collector's market. The early history of this particular version is not known,[39] but a closely similar version, now in the Chicago Art Institute, was first owned by Corot, whose artist's studio interior scenes it resembles both in technique and its spirit of solitary contemplation.

This chapter began with the object of elucidating Daumier's oil painting techniques as they developed alongside, but evidently quite separately from, his techniques with watercolour drawings. While this discussion is neither complete nor particularly scientific I think enough evidence has been produced to suggest that when Daumier began to find his own way of handling the relatively intractable medium of oil paint – at least 'intractable' to a natural draughtsman such as he – his use of it tended to be for more personal ends than the finished watercolours of his 'other' public persona. How these two media relate to each other in Daumier's later development, and how both for a while continue to interrelate with his lithographs, will be examined in the course of the ensuing chapters.

Chapter 6

DAUMIER AND DRAMATIC EXPRESSION: ACTORS AND LAWYERS

Daumier was not alone in being both a painter and a caricaturist. What was unusual was his talent at both and the fact that he became a painter so late. Earlier in the nineteenth century there had been artists such as Louis Boilly (1761–1845), Carle Vernet (1758–1835) and his son Horace (1789–1863), all of whom were trained as painters and became well known as such, but who took up lithography when it became the vogue in the 1820s and produced series of prints which were really popular genre scenes rather than cartoons, although many were of a humorous nature. (Boilly specialized in the grimace.) Closer to Daumier's generation, Edme Pigal (1798–1873) and Henry Monnier (1799–1877) had both been in the atelier of Baron Gros, and both turned to lithography to supplement their incomes, specializing in the comedy of manners which could be found, broadly speaking, in the city streets or inside middle-class homes. Monnier had a very versatile career.[1] He was best known for his creation, in 1831, of the character of Monsieur Prudhomme, a scheming and self-satisfied bureaucrat, which he both acted on stage and drew and painted. He was still writing about Prudhomme and drawing self-portraits in this role as late as 1860. Fig. 99, where Prudhomme is seen importantly holding his watch with an expression which seems to say 'You're late!' was drawn by Monnier as a presentation watercolour, and again in the same pose but full-length, wearing slippers with bows, as a lithograph in the same year.[2] Daumier, who had known Monnier since he was a young man, drew a cartoon of him in 1852 as Prudhomme on the stage in this costume.[3] The cartoon made the character much more comic than does Monnier's drawing of himself, but a later drawing by Daumier in black chalk and pen, traditionally said to represent the actor, seems to be quite serious (fig. 100).[4] On the stage Monnier must have played many parts, and in so far as two vignette sketches on this same sheet are related to Daumier's watercolour of *Death and Two Doctors* (see figs 103–105), it could be Monnier in a dramatization of La Fontaine's fable. The actor is certainly wearing a long robe like a stage doctor, but his expression borders on the tragic. The relationship between acting and facial expression is, manifestly, something which Daumier was continually observing: nearly all human expressions can be the result of 'studied behaviour', as he frequently shows us. Many of the surviving sheets of paper from his studio are covered with little heads of different kinds, of which it is impossible to say whether they were directly observed, half remembered and recalled, or completely invented. Fig. 101 is one of these sheets, interesting also because it shows Daumier using several different drawing mediums, initiating ideas with any tool that comes to hand. In the centre is a male torso drawn in black chalk; below, a seated old clown scribbled in pen, and given shadows with a sable brush. Above him, the same brush creates the heads of two or three men watching something: it then moves across the page to model the head of a pretty young woman (no cartoon here) before she is decked out in colour. Finally darker, inkier washes cut brutally over the study of the torso and proceed to block in a sinister, balding head with beetling brows in the lower right corner. At any point Daumier is ready with his pen to adjust a facial expression, from the first free flow of ideas up to the most tightly finished 'watercolour paintings' made for the *connoisseur* client. On the verso of this process-revealing sheet (fig. 102) are more studies in the same vein, except that there the artist was thinking more in terms of groups; figures in a railway carriage or a waiting room, and a group of *connoisseurs* in a saleroom.[5]

A sequence of drawings for a finished watercolour, *Les deux médecins et la mort* (*Death and the Two Doctors*), demonstrates the stages of Daumier's thought when faced with a literary theme (figs 103–105). He conceives it as a kind of drama performed on stage. He begins by drawing a crazy little dance of the three figures, and then pushes Death to the background, leaning on her scythe to watch while the doctors begin their own *pas de*

99. Monnier: *Monnier en Joseph Prudhomme (Monnier as Joseph Prudhomme).* 1860. Pencil, pen and watercolour, 25 x 14.8. Paris, Louvre (RF 4630).

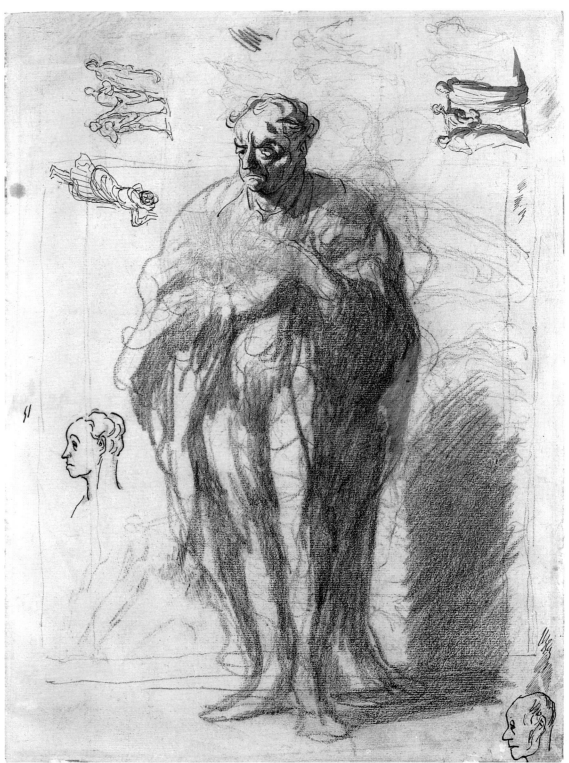

100. Daumier: *Un acteur - Henry Monnier? (An Actor - Henry Monnier?) and Other Studies.* c.1855-65. Black chalk, pen and wash, 42 x 30.3. Rotterdam, Boymans-Van Beuningen Museum. MD 448.

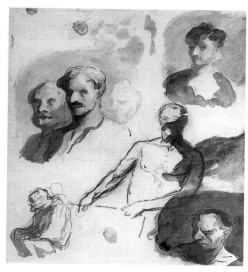

101. Daumier: *Études des têtes et des torses* (Studies of Heads and Torsos). 1860–65. Black chalk, pen and wash and watercolour, 26 x 40.5. Private collection. MD 777a.

102. Daumier: *Études des figures et des groupes* (Studies of Figures and Groups – verso of fig. 101). 1860–65. Charcoal, black chalk and wash, 26 x 40.5. Private collection. MD 777.

103. Daumier: Études pour *Les deux médecins et la mort* (Studies for *Death and the Two Doctors*). 1857–58. Black chalk and grey wash, 38 x 24. MD 399.

104. Daumier: Étude pour *Les deux médecins et la mort* (Study for *Death and the Two Doctors*). 1857–58. Black, red and white chalk, 26 x 21. Ex Maison.

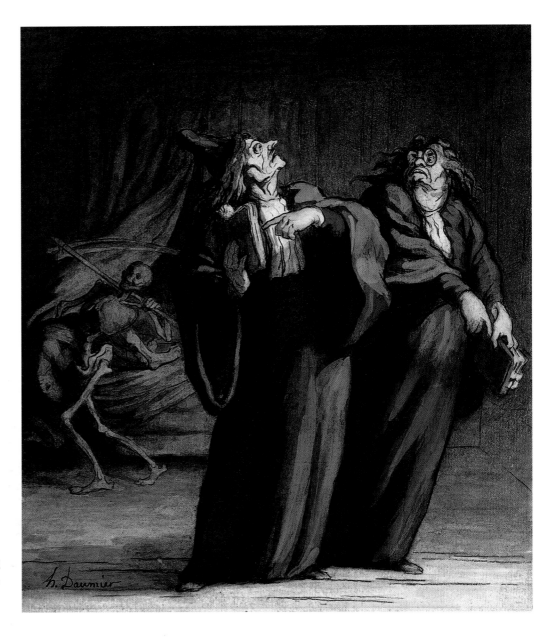

105. Daumier: *Les deux médecins et la mort* (Death and the Two Doctors). 1857-58. Black chalk, pen and ink, watercolour and gouache, 32.5 x 28. Oskar Reinhart Collection, Winterthur. MD 400

deux. These figures are conceived sculpturally, their shadows put in with a brush. A second study is plainly intended to fix the structure of the final watercolour.[6] A canopied bed is indicated in the background, and Death carries off the cadaver of the expired patient while the two doctors remain in dialogue. This study is drawn coarsely and vigorously in charcoal with numerous *pentimenti*, and red and white chalks have been applied to the central figure just before Daumier broke off: his scheme now clear to him, he would begin again on a new sheet.[7] The final watercolour betrays none of the hesitations and changes of mind that had taken place. The gruesome figure of Death with her burden in the background, executed in near-monochrome, could belong to a high baroque funerary monument. In the foreground, however, the two doctors are alive and in full colour as they make the following exchange:

> 'Dead,' said one, 'as he was warned.' The other replied,
> 'He'd be living now if he'd listened to me.'[8]

Daumier had this work exhibited at the Salon of 1869, whence it was lent by M. le Baron

86

de Boisseau – evidently an important client. Considered together with the two water-colours lent to the same Salon by Dr Court, one of which we have already identified (fig. 67), a major change in Daumier's fortunes is now apparent. The last time he had tried for Salon recognition in 1861, he had sent in a small realist oil painting of a washer-woman and child.[9] Now we find him presenting to the public meticulously finished watercolours of *amateurs* in a painter's atelier, judges at the assize court, and a scene from La Fontaine's *Fables*. The inference is that he had decided to capitalize on his fame as a draughtsman and to break into the fine art market at a different point. We will find that to some extent he succeeded, although the relation between the cartoonist-draughtsman and the artist-draughtsman remained problematic, even in the eyes of his admirers.

Baudelaire claimed that Daumier had several affinities with Molière as a moralist: 'like him, he goes straight to the point . . . you only have to look to understand'.[10] Daumier also drew and painted several subjects from Molière's plays. Dr Diafoirus, the pretentious physician in *Le Malade Imaginaire* (*The Imaginary Invalid*), is taking the pulse of a toad-like

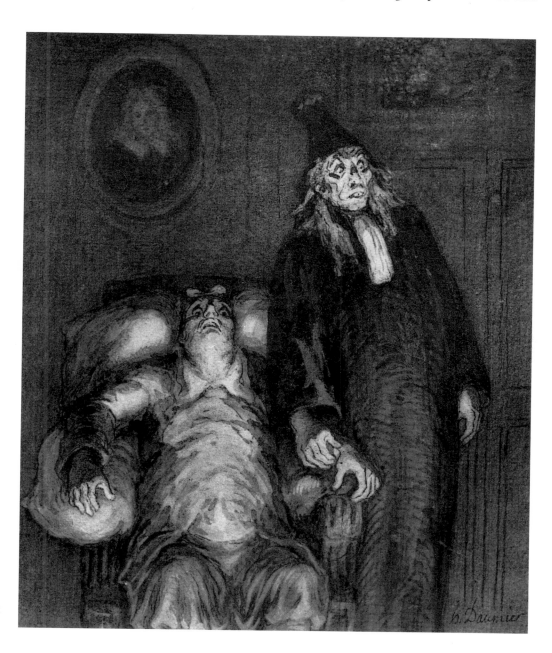

106. Daumier: *Le Malade Imaginaire (The Imaginary Invalid)*. 1868–75. Charcoal, black chalk and wash, 28 x 24.2. Present location unknown. MD 476.

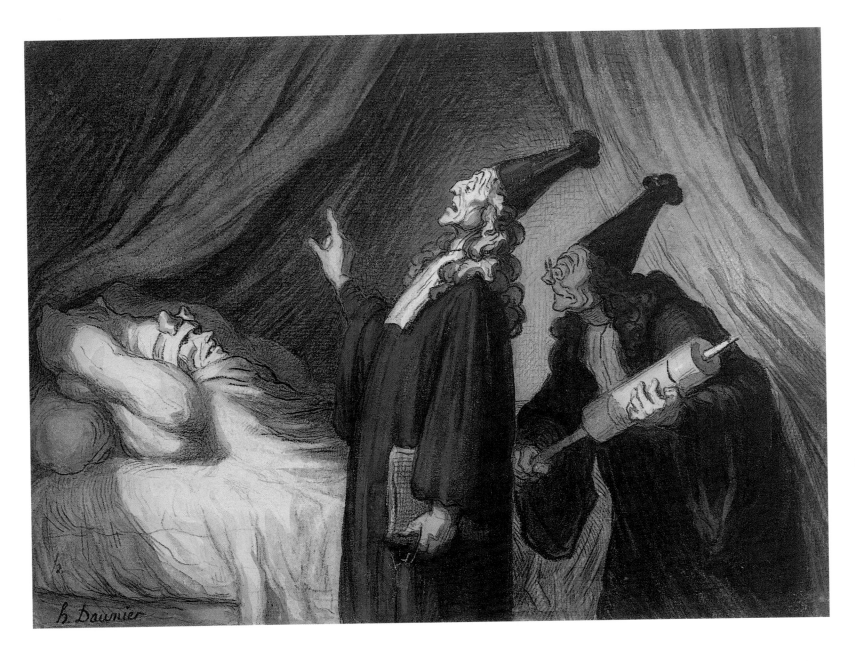

107. Daumier: *Le Malade Imaginaire (The Imaginary Invalid)*. 1858–63. Charcoal, black chalk and watercolour, 19.5 x 26.5. London, Courtauld Institute of Art. MD 486.

M. Argot under what looks very like theatrical lighting, the light source coming from below (fig. 106). Daumier undoubtedly saw many productions live, with variations of stage business, and this seems to be a generic recollection of the scene rather than an exact illustration to the text.[11] The simultaneous expressions of alarm and stupidity are so vivid that, as Baudelaire said, 'you only have to look to understand'. The date of this rich piece of characterization is most likely the late 1860s, but it could be even later.[12] Another scene from Molière is the watercolour in the Courtauld Institute (fig. 107), of an earlier date, which concentrates more on the action than the psychology. It appears to be the scene in which Dr Purgon (again in *Le Malade Imaginaire*) gives Argan a terrific telling-off for not using the huge clyster he has provided for giving enemas. According to the script there should only be Purgon, Argan and his maid present, rather than both doctors as here, so again the treatment is generalized. The baroque arrangement of bedding and curtains (reminiscent of fig. 105) and the burlesque poses are used to recreate, in Daumier's terms, the whole intertwining rigmarole of medicine, trickery, and human

mortality. The joke about the clyster is pure ham, of course, and was part of the stock in trade of all cartoonists – Daumier had used it in satirical lithographs since the 1830s. He used it once more in a caricature of Aesculapius, published in *Charivari* in 1859, in which that doyen of the medical profession defends himself with a clyster-gun *contre tous les novateurs blonds ou noirs qui viennent pour l'attaquer* (against all innovating ways, white or black, which threaten to attack him).[13] In other words the clyster becomes a symbol of resistance to change (nowadays we would say, of anal retention). A date of *c.*1858 to 1863 might be about right for this watercolour, in which the facial expressions recall Daumier's caricatural style of earlier years.

An opaque, inky dark blue or blue-black is the constant colour of the clothes of Daumier's doctors and lawyers, in both oil paintings and watercolours. Both professions become, in his hands, personifications of high bourgeois power, profit and fraud (although doubtless he had some patrons among them!). He would have been familiar with doctors, and particularly with alienists, since his father died in the insane asylum of Charenton and as a young man he himself had been diagnosed as mad for political reasons. As for the law, in his youth he had run errands for a bailiff, and throughout his life the impressive neo-classical edifice of the Palais de Justice (not far from his home on the Ile Saint-Louis) provided a kind of stage setting for his legal subjects, whether in its halls and corridors or on the steep steps of its main entrance. The principal actors in these legal dramas were of course the advocates, with their capacities for histrionic display, but every variety of human interaction between lawyers and clients, and between the lawyers themselves, came under Daumier's scrutiny.

Judges and lawyers had appeared in his lithographs as early as 1832, but the series that brought him most fame was called *Les gens de justice* (*Men of Law*), which appeared in *Charivari* between 1845 and 1848 (fig. 108). These precede his oils and watercolours of similar subjects, and they provide a basis from which he was to develop a more profound, humanistic satire of the legal profession. The first example given here is characteristic of

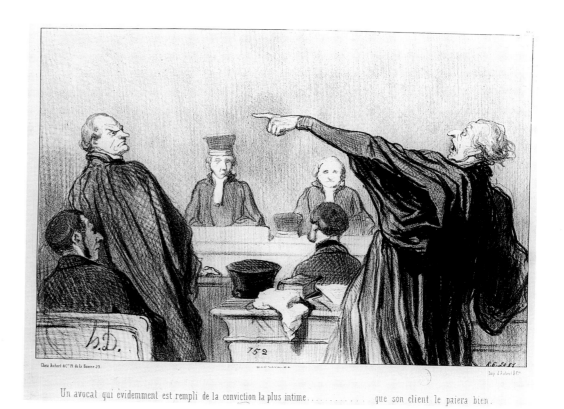

108. Daumier: *Un avocat qui évidement est rempli de la conviction la plus intime...que son client le payera bien (An advocate who is evidently fully convinced with inside knowledge...that his client will pay him well).* Lithograph, published 24 April 1845. Paris, Musée Carnavalet. LD 1342.

Un avocat qui évidemment est rempli de la conviction la plus intime............... que son client le paiera bien.

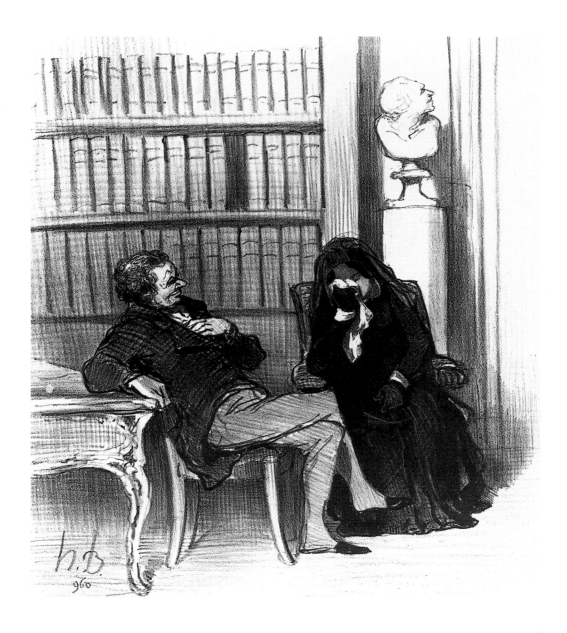

109. Daumier: *La Veuve (The Widow)*. Unpublished lithograph 1846. Paris, Bibliothèque Nationale. LD 1375bis.

the basic plot, so to speak. The dramatized conflict between the two advocates in court is made instantly clear to the viewer – the accusatory finger, the studied expression of rebuttal – and if the figure in the bottom left corner is the client he ranks a low place in the action, apart from his money. This plot is spelled out again by Daumier's scriptwriter, but the written text is not really necessary. Forty-seven of these subjects were drawn during this period, although only thirty-seven were published as *Les gens de justice*. Six were unused or not published in *Charivari*, and four were published later in 1851.[14] Possibly the number was kept down because his editor feared a repetition of themes, or perhaps that some scenes might offend public taste. For example, a plate numbered 39 in the series, which shows a robed lawyer embracing a young female client, with the caption 'You are very pretty . . . we shall easily prove that it was all your husband's fault . . .', was probably never printed, since it only exists in a few proofs. Another (fig. 109), of which only two proofs are known, was never given a caption and wiped off the stone after only two prints were pulled: it acquired the title *La Veuve (The Widow)*. This brilliant and cruel drawing was doubtless thought to be too scandalous or distasteful, in its revelation of a lawyer leering at his female client while a bust which resembles him

110. Daumier: *Un plaideur peu satisfait (An Unsatisfied Litigant)*. Lithograph, published by Aubert 1846. Paris, Musée Carnavalet. LD 1362.

exactly is placed on a high pedestal above them. The rich black of the woman's dress, contrasting with her white handkerchief so delicately held, somehow suggests that she is pretty without the viewer being able to see more than half her face. This lithograph was replaced on the same stone (numbered 960) by a scene which was not published in *Charivari* either: fig. 110, *Un plaideur peu satisfait (An Unsatisfied Litigant)*. This client wears an artisan's smock, and as a member of the working class was perhaps judged to be too threatening towards the smug lawyer for the taste of *Charivari*'s readers.

When Daumier translated these subjects into oil paintings and watercolours he tended to concentrate on the physiognomies of the judges, lawyers and their clients, rather than specific narrative situations as in the prints. An exception to this may be one of his earliest forays into watercolour painting, fig. 111, the crowd scene outside the court entitled *Au Palais de Justice (At the Palais de Justice)*. On the left, a successful notary departs with papers under his arm, and in the background an impersonal crowd is coming and going. On the right, a grieving woman and her child who have lost their case are straight from one of *Les gens de justice* lithographs, while the two colluding advocates on centre stage, leaving the trial, are another stock theme. I would date this work at about 1848 to 1853, that is, to an early stage of Daumier's decision to translate some of his lithographic material into separate artworks. Drawn on a small scale but highly finished, the technique of this watercolour establishes Daumier's mode. On cream-coloured laid paper the forms are drawn first in black chalk and fine pen, after which grey washes establish the main areas of light and dark: then the colours are added, an inky blue plus gouache on the lawyers robes, a yellowish light on the walls and pavement, a touch of red on a woman's hat, and the final highlights in Chinese white. There would be little variation on these methods in watercolours for ten years: only the level of skill would rise.

111. Daumier: *Au Palais de Justice (At the Palais de Justice)*. 1848–53. Black chalk, pen and wash, watercolour and gouache, 14 x 23. Paris, Musée des Beaux-Arts de la Ville de Paris, Petit Palais. MD 620.

Both Adhémar and Maison speculated that Daumier began to make oil paintings of his lawyer subjects as early as 1846, while *Les gens de justice* were in progress. However, there is no evidence other than arbitrary stylistic sequencing to support this view. 'Early' paintings of lawyers are all small scale, usually only half-length or busts, and stiffly executed.[15] They were presumably made in the hope of attracting clients who already knew this particular series of lithographs. However, where the subject matter of lawyers is concerned, Daumier was more successful in conveying his satirical intentions through the medium of pen and watercolour. This may be demonstrated by a direct comparison of two very similar compositions, one executed in oil on canvas and one in watercolour, of three lawyers conversing (figs 112 and 113). Maison dated the oil *c.*1855 to 1857, which may well be correct, but his assumption that the watercolour must be a later *reprise* of the design is difficult to sustain.[16] The facial features of the three lawyers are more specific in the watercolour but, since the painting is of only slightly larger dimensions,

112. Daumier: *Trois avocats conversant (Three Lawyers Conversing).* 1855/57. Oil on canvas, 40.6 x 33. Washington D.C., Phillips Collection. MI 91.

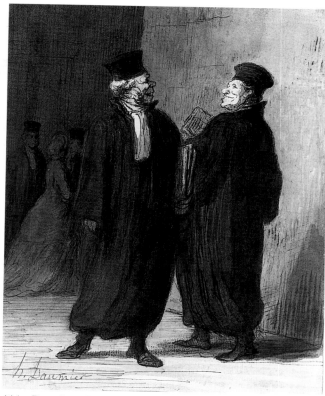

114. Daumier: *Deux collègues (Two Colleagues)*. 1855–60. Pen and black ink, black chalk, coloured washes and gouache, 23.5 x 18.6. Williamstown, Sterling and Francine Clark Art Institute. MD 593.

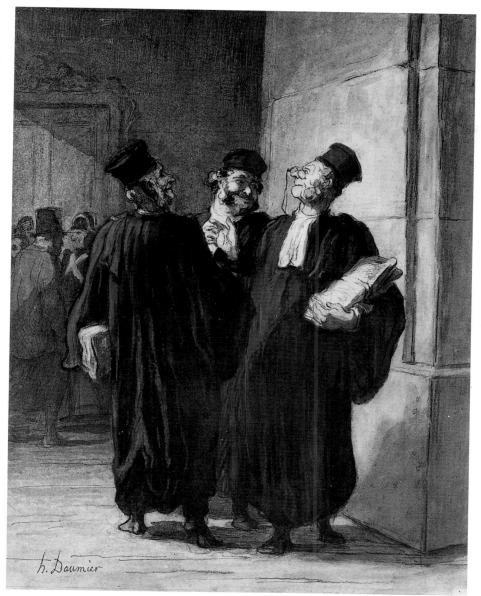

113. Daumier: *Trois avocats conversant (Three Lawyers Conversing)*. 1855–60. Pen and black ink, black chalk, coloured washes and gouache, 32.9 x 24.8. Williamstown, Sterling amd Francine Clark Art Institute. MD 604.

one may surmise that Daumier could not easily draw such details with oil paint brushes – indeed, he has put in some lines on the canvas with a sharp crayon or pen. The painting, however, has more depth and solidity to it than the watercolour. In the former, deep in shadow behind the lawyers, a figure of a grieving woman can be seen: she takes the place of the bustling group of figures in the background of the watercolour. The oil version suggests a stage-like setting for some ironic drama, while the watercolour retains a greater element of caricature in the expressions.[17] This I believe to be the fundamental difference between Daumier's use of the two mediums in the 1850s. Judging by the numbers of watercolours of lawyers which have survived, however, it would seem that Daumier found this to be the better medium for sales.[18]

It is possible to trace some evolving changes of style in Daumier's watercolours, by noticing how they develop *away* from simply recasting faces and situations found among the cartoons, and instead acquire a special form and meaning of their own. (Daumier's style and his meaning are usually inter-dependent.) His depiction of two lawyers in a corridor of the Palais de Justice (fig. 114) echoes the baroque swing found among the

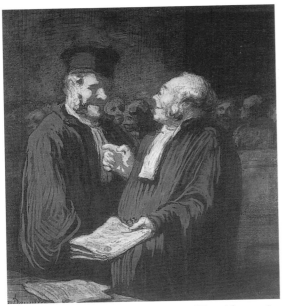

115. Daumier: *Deux avocats à la cour (Two Advocates in Court)*. 1855-60. Black chalk, pen and wash, watercolour and gouache, 25.5 x 22.4. Joseph Mugrabi Collection, New York. MD 591.

strutting lawyers in the lithographs of his *Les gens de justice* series, but now Daumier has developed the monkey-like grimace with which he will frequently endow his advocates. What is also new in such watercolours, compared to the lithographs, is the employment of shadowed spaces defined in the background: spaces which often contain secondary, anonymous figures, in psychological opposition to the action in the foreground. This feature is particularly evident in fig. 115, where we can perceive, behind the spot-lit, grinning lawyers so lovingly drawn with fine pen lines, a row of dark heads like ghostly animated skulls, seeming to convey incomprehension and bewilderment. What we might call the 'intimidated audience' occurs in a number of these works.

If the three examples discussed so far seem close to cartoons in their facial expressions, the element of dramatic expression that Daumier has introduced in *Le défenseur (Counsel for the Defence)* is treated with such penetrating realism as to be beyond a cartoon (figs 116 and 117). Since this heavy-set, balding advocate appears to be the same personage (of Daumier's invention) as in fig. 115, these two images may not be far apart in time. There are two watercolour versions of *Le défenseur*, and the first (fig. 116) evidently gave him a lot of trouble in its execution. The courtroom setting and the dramatis personae have been carefully drawn in minute detail with a mapping pen, before the colours were built up in layers of watercolour and gouache. Two kinds of blue are used, a greenish one and a slightly lilac one, and a sort of 'caput mortuum' grey which, placed on top of a dark transparent shadow of blue-black wash, creates the famous colour of his lawyers' robes.

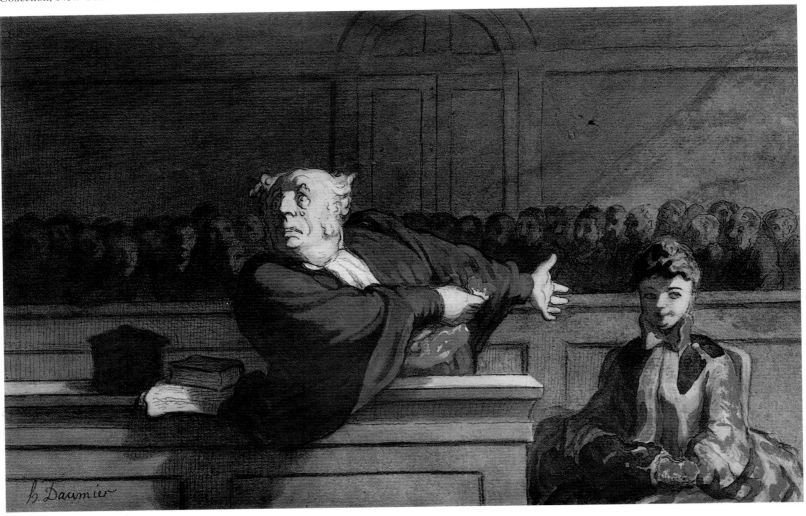

94

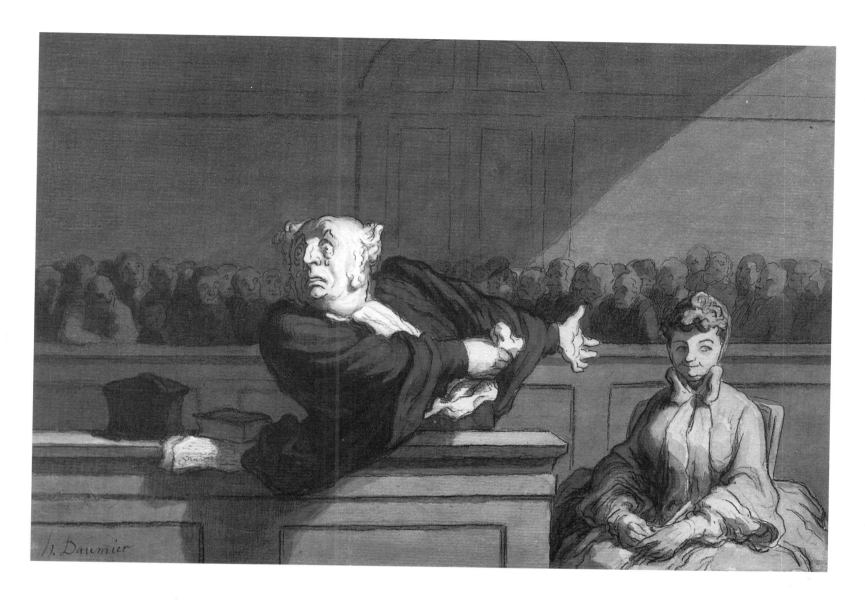

117. Daumier: *Le défenseur (Counsel for the Defence)*. 1860-63. Corcoran Gallery of Art, Washington D.C. MD 660.

116, opposite. Daumier: *Le défenseur (Counsel for the Defence)*. 1858-60, Black chalk, pen, watercolour and gouache, 19 x 29.4. Paris, Louvre (RF 36,581). MD 658.

The tonal contrasts on the defendant's dress are exaggerated to make it look silky in texture. Daumier has changed his mind about the lighting at the back of the courtroom, painting out a shaft of light where another anonymous crowd of spectators, all male, sits in the shadows. The lawyer's pinky-yellow face now appears to be spot-lit, illuminating his crocodile tears as he makes a sweeping gesture towards the young lady of demure demeanour but presumably dubious character. This highly pictorial treatment, which leaves the observer somewhat detached from the scene, is moving away from caricature to serious illustration with sinister, perhaps even cynical, overtones. The viewpoint here, under French courtroom practice, would have to be from the jury seats. Given Daumier's mood in about 1858–1860 (which might be signalled by his watercolours of butchers, his dwindling personal finances, and an unstable political scene) I would place this watercolour in that period. The second version (fig. 117), which is also signed in full, was made from a tracing of the first, and it employs the same techniques.[19] Daumier has returned to his original idea of a strong source of natural light coming from the right, and the spectators are now more clearly seen. Now his drawing is more cursive and free, with no *pentimenti*, as he repeats his design for a new client.

Comparable in technique but more freely handled is *Les avocats* (*Judge and Advocates Waiting to Enter Court*). This work (fig. 118), together with a number of others showing

groups of advocates looking important, secretive and conspiratorial as they stand about prior to entering the court sessions, could equally well be titled *Dans la salle des Pas-Perdus au Palais de Justice* – which is in fact the given title of an oil painting of another group in this location (fig. 130). A feature that recurs in several of Daumier's renditions of this vast hall is Corinthian pilasters springing from the bases of huge stone piers, the height of the bases varying somewhat through artistic license.[20] Architecturally, the *Salle des Pas-Perdus* provides a dramatic setting for the advocates and an intimidating one for the litigants. In the present watercolour, at least nine of the twelve figures have sufficient facial characterization to tempt the viewer to invent thoughts for them, and even to imagine how their voices might sound in court. (What is the man on the left whispering?)[21] The fact that the bases of the pilasters spring from above the level of their heads has a dwarfing effect on these legal gnomes. A number of variants exist of this waiting group, not all of them of acceptable attributions unfortunately, but the most finished ones are all signed in full and testify to the popularity of this theme with Daumier's clients.

When other court officials or litigants are not present, Daumier's lawyers meeting in

118. Daumier: *Les avocats (Judge and Advocates Waiting to Enter Court)*. 1860-63. Pen and wash, watercolour and gouache, 21 x 22. Private collection. MD 610.

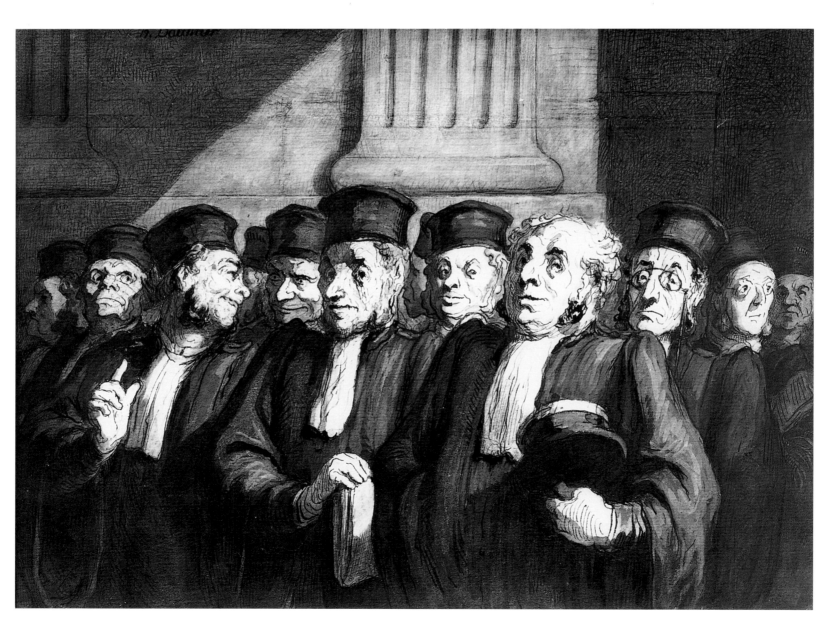

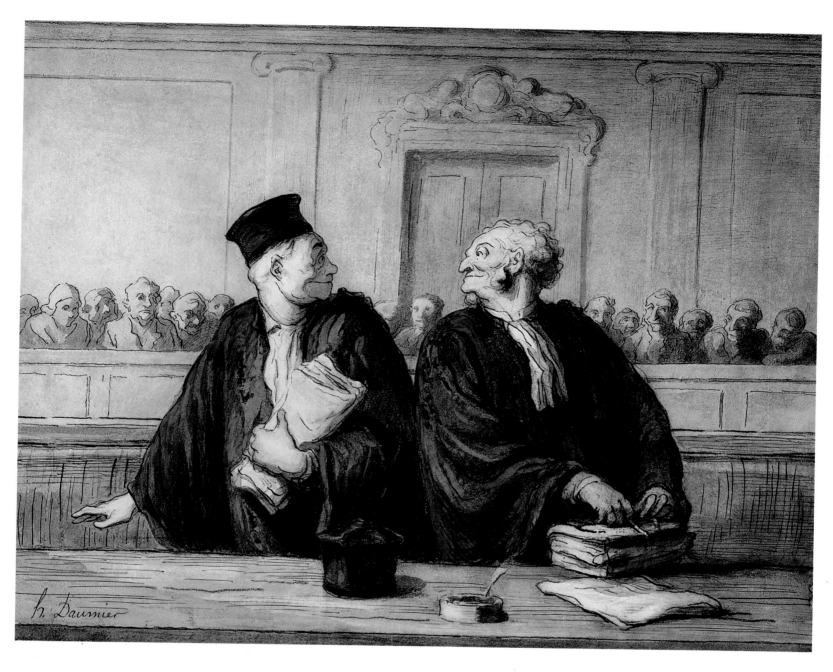

119. Daumier: *Après l'audience (After the Hearing).*
1858–60. Charcoal, pen, grey and beige washes,
watercolour, 29 x 35.8. MD 638.

the corridors of the Palais de Justice are quite at ease with each other, and on sociable
terms. A similar affability is observable in the courtroom itself after the trial is over, as
in *Après l'audience (After the Hearing)*, although in this drawing their display of self-
satisfaction is given a more caricatural look (fig. 119), and for that reason I wonder
whether it might not still belong to a transitional stage, perhaps just before 1860. This
balanced, frontal composition, with the barristers taking centre stage and a line of
spectators in the background, alert as if watching a football match, was repeated in a later
watercolour (fig. 120) known as *Une cause célèbre (A Celebrated Case).* (If taken as a pair,
however, the dramatic irony is increased if 'the case in progress' is viewed before 'after
the hearing'.) In *Une cause célèbre* the manner of drawing is more fluid and sophisticated,
while the dramatic expression remains extremely vivid. The idea of a verbal fight, with
one side working itself up into a deliberate frenzy while the opponent watches with a
sardonic expression and awaits his turn, is one that seems to have preoccupied Daumier

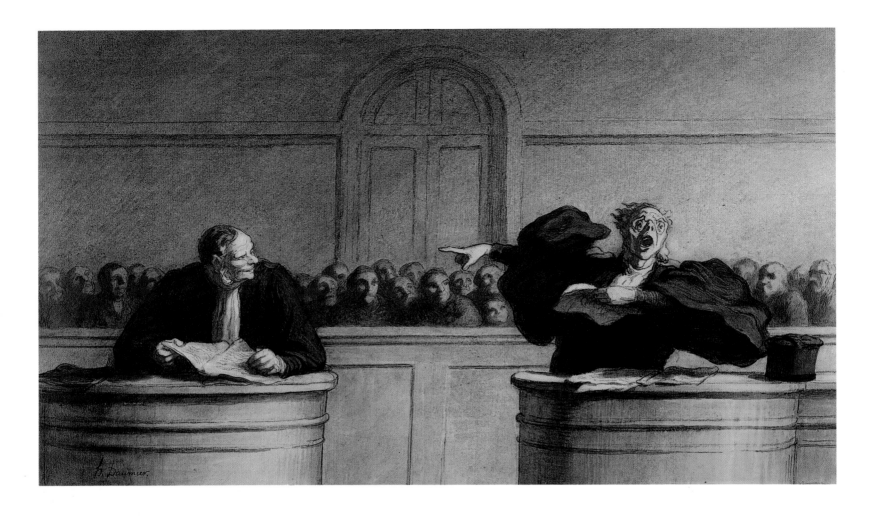

120. Daumier: *Une cause célèbre (A Famous Case)*.
1865-70. Black chalk, pen and wash, watercolour, 26 x
43. Private collection. MD 680.

121, opposite. Daumier: Étude d'expression pour *Une
cause célèbre* (Study of expression for *Une cause célèbre*).
1865-70. Charcoal, pen and ink, 27 x 17.5. Private
collection. MD 678.

122, opposite. Daumier: Étude d'expression pour *Une
cause célèbre* (Study of expression for *Une cause célèbre*).
1865-70. Charcoal, pen and ink, 27 x 21. Private
collection. MD 679.

over a period of time. Whereas in *Après l'audience* the row of spectators sit stiffly like
marionettes, in *Une cause célèbre* they swing round from both sides to focus on the speaker.
At this juncture Daumier has evidently got into his own rhetorical stride, perhaps as a
result of having begun to find more clients for his work. The theme of two advocates at
the bar was also the subject of a wood engraving, published in *Le Monde illustré* on 20
April 1867, which might or might not have preceded this watercolour.[22] Two prepara-
tory studies for it are known, in both of which the positions of the active and passive
protagonist are reversed.[23] Two separate sketches, one for each of the advocates, may
actually post-date the finished watercolour (figs 121 and 122). The right-hand figure is
very close to the watercolour but appears even more frenetic when he is rendered solely
in line with a pen. The left-hand figure, who has put on his hat and turned his head like
lightning, is an achievement of pure kinaesthesia in line.

The grand staircase of the Palais de Justice was exploited by Daumier as a setting for
his advocates in a lithograph of 1848, and in two oil paintings and two watercolours.[24]
The oil paintings are earlier in date than the watercolours. The idea of portraying two
lawyers passing each other on the stairs, not exactly as ships in the night but rather one
going up (to court) and one coming down (victorious), is the kind of nice ironic
opposition that Daumier liked. In the case of *Le grand escalier du Palais de Justice* (*The
Grand Staircase at the Palais du Justice*), however, we have approaching us a figure of such
monumental pride – preceded by his stomach, it would appear – as to suggest the dignity
of a cardinal (fig. 123). Perhaps this metaphor was not so far from Daumier's mind,
although there are no drawings satirizing the clergy and few lithographs that risk doing

so, due no doubt to the censorship laws. This watercolour was acquired by the American dealer George A. Lucas for his own collection, probably in about 1864, when he was also acquiring Daumiers for the Baltimore industrialist William Walters. This image became extremely well known in the twentieth century, after Lucas lent it to be copied and engraved in a colour woodcut by Alfred Prunaire in 1902.[25] In technique it is closely comparable to *Après l'audience* (fig. 119) in its dependence upon precise pen drawing and grey wash for its compositional structure, and in both cases the highlights on the lawyers' faces, white cravats and papers are achieved by reserving the ground of the white paper.[26] The dense blue-black robes, however, are modelled by adding white gouache to the lights, a particularly Daumier-esque combination of methods. We might note that the

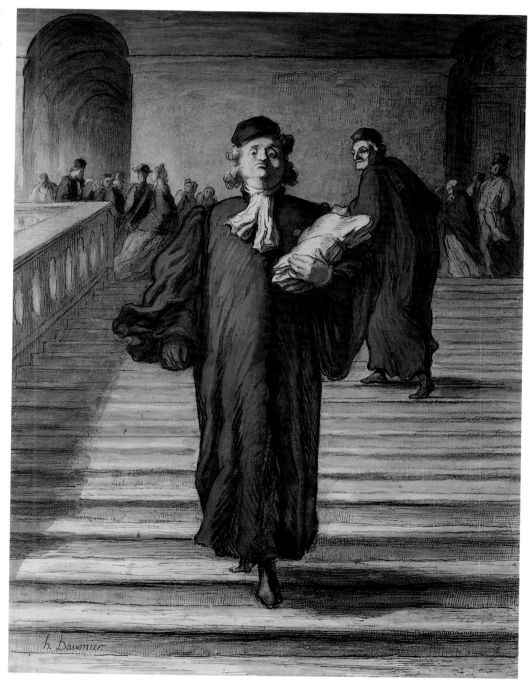

123. Daumier: *Le grand escalier du Palais de Justice (The Grand Staircase at the Palais du Justice)*. 1860-64. Charcoal, black chalk, pen and wash, watercolour and gouache, 35.8 x 25.6. Baltimore, George A. Lucas Collection of the Maryland Institute College of Art, on indefinite loan to Baltimore Museum of Art. MD 601.

99

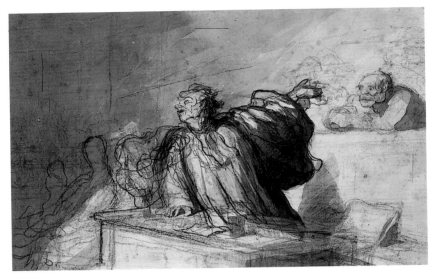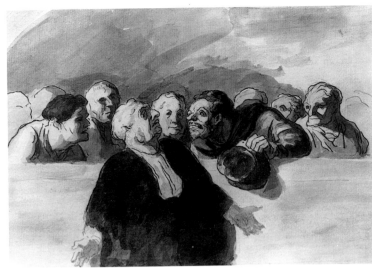

124. Daumier: *Le défenseur (For the Defence)*. 1865-70. Charcoal, pen and grey wash, black chalk, white chalk, 23.5 x 35.6. Washington D. C., the Phillips Collection. MD 664.

125. Daumier: *Le défenseur (Before the Hearing)*. 1867-70. Pencil, pen and watercolour, 20.5 x 27.9. Private collection. MD 653.

126. Daumier: *Une cause criminelle (A Criminal Case)*. 1867-70. Black chalk, pen and grey wash, watercolour and gouache, 38.5 x 32.8. Malibu, J. Paul Getty Museum. MD 673.

crowd in the distance contains many lay personages, as in his earliest watercolour of the Palais de Justice (fig. 111). The resulting people-mix is socially somewhere between a church and a railway station.

The relationship between lawyer and client in court is a motif that Daumier explored frequently, again beginning with his *Les gens de justice* series of prints. It has been suggested that he was sceptical of the integrity of lawyers and that in his drawings he often represents them in collusion with their clients in a manner expressing his 'aggressive distaste' for the proceedings.[27] Such examinations of human character undoubtedly belong to the 1860s, and there are a number of examples which could be used to illustrate this. Often the client is made to look pretty scruffy, and, in the case of the drawing *Le défenseur (For the Defence)* in the Phillips Collection (fig. 124), amazed at his defender's eloquence. This is a sketch for a courtroom scene related to at least three other versions including a tracing, although no finished watercolour of precisely this design is known.[28] It was probably drawn quite late in the 1860s. The extravagance of the advocate's gesture is not unusual in Daumier, but in this case two opposing stylistic factors hold this working drawing in precarious balance: the independent eloquence of the swirling lines of the lawyer's robes and, suspended above them, the two very detailed visages of counsel and defendant. Beneath these dominant lines in soft black chalk and pen is a substructure of searching beginnings in paler chalk, almost erased by brushed-in grey washes that establish the dramatic lighting. The single defendant in the Phillips drawing, probably a criminal, is replaced by a whole gang of ruffians in another rendering of *Le défenseur* in a French private collection (fig. 125). Here one of the accused, evidently the ringleader, leans over to speak to the defending counsel as if threatening him, while counsel holds out his hands in despair. This lively piece of characterization is so spontaneous in execution, and yet complete in its expression, that one could speculate the first owner might have bought it outright before it was finished. The earliest provenance found by Maison is A. Boulard, and this could be the watercolour lent by Boulard to the *La Caricature* exhibition held at the École des Beaux-Arts in 1888, as Nr. 389, 'En Cour d'assises'.[29] If *In the Court of Assizes* is its correct description, then an even earlier first owner could have been Daumier's patron M. Béguin, who owned several of his works and lent that title to the 'Dessins' section of Daumier's retrospective exhibition in 1878.[30] Not all of Daumier's customers insisted upon a high degree of finish.

Daumier's drawings on the theme of lawyers and defendants in court culminate in the finished watercolour *Une cause criminelle (A Criminal Case)*. The collusion between lawyer

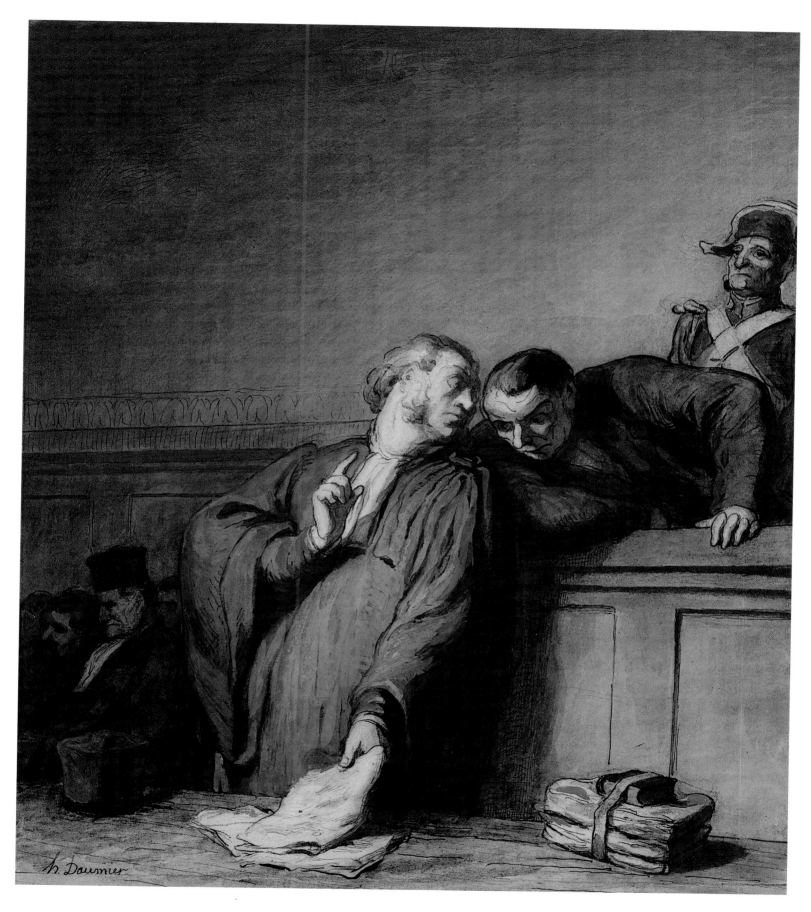

h. Daumier

and client shows itself as a sinister balance of power (fig. 126), expressed here by body language and the complex interlocking design formed by the two figures. Stuffmann has pointed out their 'restrained but incriminating gestures'.[31] The effect of this composition is both immediate and persistent. Visual tension is created by the placing of the two central heads on either side of a diagonal axis, very close yet just apart, as if attracted and repelled at the same time. The concentration of the moment persists in the accumulation of details: the 'still life' of legal documents on the table, the apparently inattentive legal council sleeping in the shadows on the left, the gendarme standing stiffly to attention above and behind the defendant, and even the complex decorative border or architrave in the background which signifies the severe decor of the Court of Assizes in the Palais.[32] This same border pattern appears again above a ledge at the back of the Court of Assizes in another highly finished watercolour now in Melbourne, *Les pièces à conviction*. Three judges are shown in full-frontal view, considering a bloody pile of evidence before them, while above their heads hangs a large painting of the Crucifixion.[33] A full-sized tonal study for this work, with touches of colour on the judges' robes and faces and their blue chair backs, is in the Chicago Art Institute (fig. 127) . Known as *The Three Judges*, this watercolour seems more obscure in meaning than its finished counterpart, as the *pièces à conviction* (here, a sheet and knife) are scarcely indicated on the table in the foreground, and the picture-frame above the judges' heads is empty. Its effect, however, is curiously telling today because of the complete absence of any specific situation: these three faces staring into space might have been condemned to this limbo of a courtroom for ever, like characters in a play by Samuel Beckett. Such are the dangers of modernist *post factum* reading! But if Daumier had got so far in these very practical preparations for a completed watercolour – there are no obvious mistakes or changes of mind between this and the Melbourne version – why did he abandon it? It is, of course, rather roughly done, with the edges of the design left ragged. Perhaps, even in a tonal study, the artist could not resist tinkering with the facial expressions as if they grew upon him.

Both the sheer quantity and the range of Daumier's drawings and watercolours concerning the legal profession are considerable. His lawyers are by no means uniformly flamboyant, sinister, or even self-important. Two final examples will show that at times

127. Daumier: *Les trois juges (The Three Judges)*. 1865-70. Black chalk, grey wash and watercolour, 30 x 46.5. The Art Institute of Chicago, gift of Mrs Helen Regenstein. MD 641.

128. Daumier: *Avant l'audience (Advocate Reading a Brief)*. 1870-75. Charcoal, pen and wash, watercolour and white chalk, 38 x 28.5. Sotheby's London, 3 Dec. 1991 (3). Ex Esnault-Pelterie Collection. MD 577.

the artist may even have admired their single-minded absorption in the business of their profession. A watercolour study of a solitary lawyer reading a brief outside the court-room, *Avant l'audience (Advocate Reading a Brief)*, has an almost romantic, brooding quality about it which reminds one of Delacroix (fig. 128). This is not Hamlet studying a soliloquy however, in the shadows of some Gothic hall, but a rehearsal of an altogether different performance on another stage; drier, perhaps, but no less concerned with human frailty. This is another instance of a watercolour matching an oil painting of the same subject.[34] Both works are quite freely handled in a late style, and it is not at all easy to guess which might be a *reprise* of the other. The first owner of the watercolour was Monsieur P. Aubry, who bought several of the artist's works in 1876 to 1877 and lent

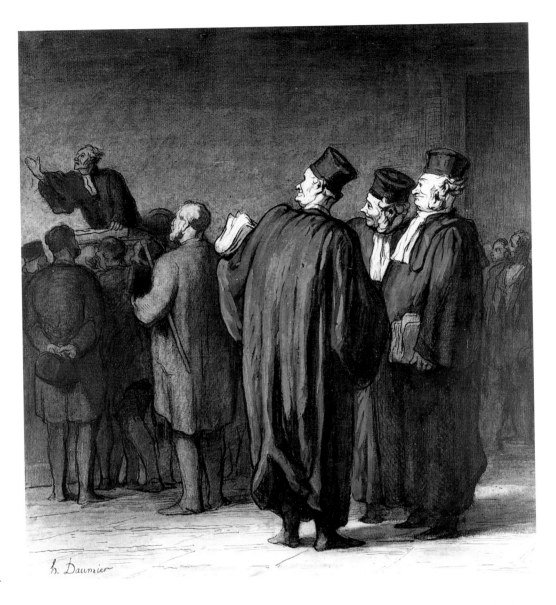

129. Daumier: *Les avocats (The Lawyers)*. 1870–75. Black chalk, pen and wash, watercolour and gouache, 34.9 x 30.5. Baltimore, Walters Art Gallery. MD 682.

this one to the Durand-Ruel exhibition in 1878: thus it could be fairly late in date, although the trembling initials may have been added later than the execution of the work itself.[35]

A similar situation of the lawyer being caught unawares by the viewer is found in a very mature and finished watercolour (fig. 129) simply known as *Les Avocats* (*The Lawyers*).[36] Again this work finds echoes in two oil paintings of the subject, but in this case the paintings are mere fragments of the composition and very summarily executed.[37] In this watercolour, a group of three advocates listens to another making an address to some tribunal from a high rostrum. A deep space is indicated and we, the viewers, stand outside the crowd, unnoticed by the three lawyers with their backs to us. Their facial expressions convey detached amusement as they watch their colleague at work. The other members of the audience may be lawyers, dressed as well-to-do bourgeois, who listen attentively. The whole tenor of this scene is cooly ironic rather than caricatural. One could reasonably speculate that this drawing might have been made for a client who was a lawyer himself. Which could put us in mind of the story told of the famous advocate and parliamentary deputy Léon Gambetta (1838–1882), who visited Daumier's 1878 retrospective exhibition with great enthusiasm and declared that he could recognize

all the advocates personally. His claim was unjustified as it turned out: Daumier's sculptor friend Geoffroy-Dechaume, who was guiding him through the exhibition, explained that

> none of these personages that you have named are who you say, for the good reason that Daumier does not know them at all and has not set foot inside the Palais [de Justice] for ten years. But I assure you that he does know advocates, and above all *the advocate*, better than they know themselves. That is the resemblance that surprises you.[38]

To this day some of the outstanding collections of Daumier's lithographs have been made by lawyers.

Many of Daumier's scenes showing advocates pleading can be placed in the old *Cour d'assises*, the central criminal court of Paris, the staircase to which was quite near the enormous *Salle des Pas-Perdus*. (He is less likely to have known the 'new' *Cour d'assises* above the *Vestibule de Harlay* at the west end, which was only just in service in 1870, after which the whole Palais de Justice was gutted by fire during the fall of the Paris Commune). He must have been quite familiar with the arrangements of the old court, even if he had not seen it for ten years before his death. The three judges, required in the French legal process, sat at one end, and the *procureur impérial* was seated to the right of them, a person of equal importance although he was required to stand when he addressed the court. The jury – seldom, if ever, rendered by Daumier – sat on the same side along the wall: the prisoners' bench was opposite, each prisoner having a gendarme by his side; the counsel for the defence addressed the court from in front of this bench. A contemporary guide reads: 'Persons desirous of witnessing a trial should go early to find seats'.[39] The roles played by the various participants were (and are) not quite the same as those of their counterparts in British and American law courts, however. This has some bearing on the way that Daumier actually saw his advocates. The judges, and the *procureur impérial* (the equivalent to a British crown prosecutor in Daumier's day), were appointed by the Ministry of Justice to these posts. Career judiciary are supposed to be beyond any possibility of political or personal pressure. The imperial prosecutor, known as the *avocat général*, had the rank of a magistrate and wore the same judicial gown as those of the president of the court and his two assessing judges. (It is not surprising, therefore, that Daumier made little visual distinction between these types, except for their expressions). In France, the more heinous crimes are tried before a *Cour d'assises*, but before a person can appear in this court his or her case has already undergone extensive pre-trial enquiries: a stage of indictment recommended by a *juge d'instruction* who has assessed the police evidence, and a review of this recommendation by a panel of three more judges who decide whether the case will go before a lower court of magistrates only (a *Cour correctionelle*) or be committed to the *Cour d'assises* where it will be heard by a panel of three judges and a jury of twelve men. Although all the evidence is gone over again in this higher court, commentators more partial to the Anglo-American legal system have sometimes seen this elaborate build-up as determining the accused to be 'almost certainly guilty' before he appears before the jury.[40] However, the presiding judge decides only upon points of law and, if a verdict of guilty has been reached, on the degree of punishment. The methods of presentation of evidence have differed between Anglo-American and French criminal law ever since the latter was established under the Codes enacted during the Napoleonic period. There is no public examination-in-chief of witnesses by counsel, for example: it is the presiding judge who questions the accused at length, using the dossier provided by the *juge d'instruction*.[41] The presiding judge is supposed to be neutral, and although inquisitorial he confines the proceedings to a strict examination of the evidence upon which the jury alone must deliver a verdict of guilty or not guilty, which is final. The real oratory is reserved for a verbal battle between the

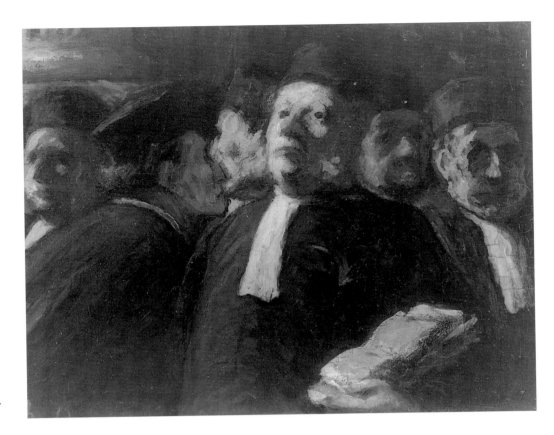

130. Daumier: *La salle des Pas-Perdus au Palais de Justice (Hall of the Pas-Perdus at the Palais de Justice).* *c.*1868–70. Oil on panel, 22.2 x 28. Private collection. MI 140.

prosecuting advocate and the advocate for the defence: the latter may argue for inno-cence, or for consideration of mitigating circumstances. After the jury's verdict is read out in court, the advocate for the defence can again make a speech asking for mercy in the sentencing. Thus the court drama which fascinated Daumier so much was principally that of the two adversarial counsel, and the expression of the accused's faces in the dock as they observed their trial proceed. The look of 'assumed neutrality' on the judges' faces as they listened to the advocates' speeches was translated by Daumier as boredom and indifference to the emotional drama being enacted before them. His subject was the strange triangular relationship between the accused, the prosecutor and the defence. He never appears to show the jury in a criminal case, though he often includes spectators in anonymous rows. When the accused do appear (as in figs 124–126) they are either rendered with every appearance of guilt and even hopelessness, or in collusion with the defence counsel about their plea, which suggests that Daumier did see the French system of criminal justice as based upon assumed guilt until proven innocent. He placed his dramas sometimes in the courtroom, and sometimes in the numerous corridors of the Palais de Justice where the defending advocates meet the attorneys and their clients. The great Corinthian pilasters that appear in various parts of the Palais, its arched corridors and grand staircases, provided him with a splendid theatrical setting for such encounters. He consistently satirized the different types of role-playing advocates, but satire is less often applied to their clientele, who vary between bewildered-looking working women and male members of the criminal classes. Whereas in *Les gens de justice* of the 1840s the defendants included some members of the middle-class bourgeoisie, in his later water-colours he takes off into a more symbolic realm in which advocates seem to perform rituals of their own making, while the substrata of the *classes dangereuses* are dragged in and out of the proceedings registering incomprehension. No wonder that the Goncourt brothers, *connoisseurs* of fine drawings, noted about a Daumier watercolour they had seen in 1865: 'The heads are frightful, with grimaces, laughs that cause fear. These men in

black have I know not what ugliness from horrible antique masks grafted into their make-up. These smiling lawyers have a Corybantic air. There is something faun-like in these macabre advocates'.[42] Perhaps this was an unduly harsh reading of Daumier's watercolours of advocates, but in the context of his time it seems to have been a possible one.

Few of Daumier's oil paintings attain the incisive and individual characterization found in his watercolours of advocates. What the best of the oils do have is a more generalized characterization of 'the lawyer', as in the case of *La salle des Pas-Perdus au Palais de Justice* (*Hall of the Pas-Perdus at the Palais de Justice*), which I believe must date quite late in the 1860s (fig. 130). There are several watercolours in which a group of waiting advocates is shown half-length (*cf.* fig. 118), all of which are probably earlier than this painting, and one thumbnail sketch in black chalk which Maison proposed as Daumier's first thought for the composition of his oil version.[43] Although there is some damage due to the artist's use of bitumen, enough clear paint survives to show that Daumier had finally succeeded, perhaps after two decades of struggling with this medium, in using his small hog's hair brush freely as a drawing tool, one with which he could both vary the opacity or transparency of the paint layers, and draw expressive lines on the wet surface. These means are used to present the viewer with some strangely remote, enigmatic masks, which seem to exclude the viewer from the thoughts of their wearers, although their intentions may be threatening. Such impassive faces are a long way from caricature. In twentieth-century terms of 'expressionism' they might prefigure the judges conjured up by Rouault, not to mention the lawyers of Kafka's imagining. But for Daumier such a painting may have been one of his last memory-impressions of this subject, before he turned to more unworldly images than these.[44]

131. Daumier: *Madeleine-Bastille (The Omnibus)*. Lithograph, published in *Le Boulevard*, 16 March 1862. Los Angeles, Armand Hammer Daumier and Contemporaries Collection. UCLA at the Armand Hammer Museum of Art and Cultural Centre. LD 3243.

MADELEINE - BASTILLE

Un zeste, un rien... et l'omnibus se trouve complet.

132. Daumier: *L'intérieur d'un omnibus (Omnibus Interior)*. 1864. Black chalk, pen and watercolour, 21.2 x 30.2. Baltimore, Walters Art Gallery. MD 294.

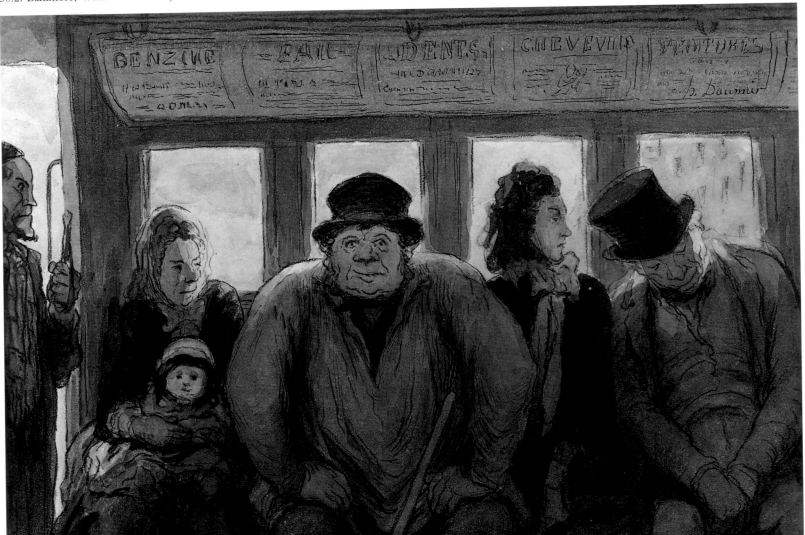

Chapter 7

THE PEOPLE TRANSPORTED, IN TOWN AND COUNTRY;
AND SOME OUTDOOR WATERCOLOURS

Public transportation, whether by horse-drawn omnibus in the cities or the railways across the country, was a popular subject for French cartoonists. Daumier made his earliest lithograph of an omnibus in 1839, and his first series of *Chemins de fer* (*The Railways*) began in 1843. The physical discomforts of these modes of transport were the main butt of *Charivari*'s jokes, in terms of overcrowding, exposure to the elements, and the railways' bizarre mechanical perils. They were, however, signs of modernity, and they made possible an intermingling of the population which may have contributed to a sense of what has been called 'the collective soul' of the Parisian bourgeoisie.[1] Daumier was still drawing these subjects in the 1860s, and observing the behavioural patterns of different class levels. A lithograph of an interior of an omnibus, published in *Le Boulevard* on 16 March 1862 (fig. 131), provided the basic setting for a watercolour later commissioned by George A. Lucas, acting on behalf of his American patron William Walters. The forms in this lithograph are as full and flowing as the fat lady herself, and the expression of astonished incredulity on the top-hatted gentleman's face behind her adds to their effect. The framework of this omnibus interior was used again by the artist for a woodblock design, engraved by C. Maurand and published in *Le Monde illustré* in 1864 (fig. 134). The four windows and the advertisements above were retained, as well as the man standing at the door, but the joke was now divided between a seated fat man on the left and a male passenger dozing off against the shoulder of an indignant woman on the right. This was evidently seen and admired by either Lucas or Walters himself, possibly both as Walters was in Paris at the time, and gave rise to the order to Daumier to repeat his design as a watercolour. The exact entries in Lucas's diary for 1864 are as follows:

[March] 18 Friday . . . at Daumier['s] & ordered drawing of omnibus for 100 fs.
[March] 19 Saturday . . . Carried drawing to H Daumier – drawing to be finished in a week.
[March] 26 Saturday . . . at Daumiers, drawing not finished.
[April] 13 Wednesday . . . Met Daumier who said the drawing of omnibus was finished.
[April] 16 Saturday . . . At Daumier['s] & took Omnibus drawing & pd 100 fs for same.[2]

100 francs seems to have been a fairly standard price for Lucas to pay for 'drawings' in 1864 – his prices noted range from about 50 to 200 francs for such items. The facial expressions in the watercolour (fig. 132) are very close to those in the wood engraving, and he must have used a print from it to guide him (perhaps that is what 'carried drawing to Daumier' means), rather than any preliminary drawing of his own. It does show greater subtlety, however: the fat man staring rudely at the viewer is a nice touch, and the woman looking coldly at the old man nodding towards her no longer has the exaggeratedly raised eyebrows of her counterpart in the engraved print. One more small but significant difference in the watercolour is in the row of advertisements above the passengers' heads: the end panel on the right reads 'PEINTURES' and is signed *h.Daumier*.

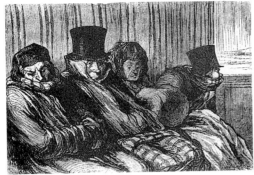

133. Daumier: *Train de plaisir: 10 degrés d'ennui et de mauvaise humeur (A Cold Day for the Excursion).* Wood engraving, 15.2 x 22.7, by C. Maurand after Daumier. Published in *Le Boulevard*, 18 January 1862. Bouvy 921.

William Walters was a civil engineer who had built up a variety of profitable business enterprises in Baltimore before the outbreak of the Civil War, which was the initial cause of his removal to Europe with his family. His interests included a steamship line and railway companies, which helps to explain his renewed commission to Daumier for the now famous railway carriage series of watercolours. One of these scenes, however, had already appeared as a print, the wood block again being engraved by C. Maurand, as far

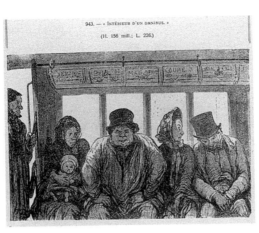

134. Daumier: *L'intérieur d'un omnibus (Interior of an Omnibus).* Wood engraving. 15.6 x 22.6, by C. Maurand after Daumier. Published in *Le Monde illustré*, 30 January 1864. Bouvy 943.

135. Daumier: *Le wagon de deuxième classe (The Second Class Railway Carriage).* 1864. Black chalk, grey wash, watercolour and gouache, 20.5 x 30.1. Baltimore, Walters Art Gallery. MD 297.

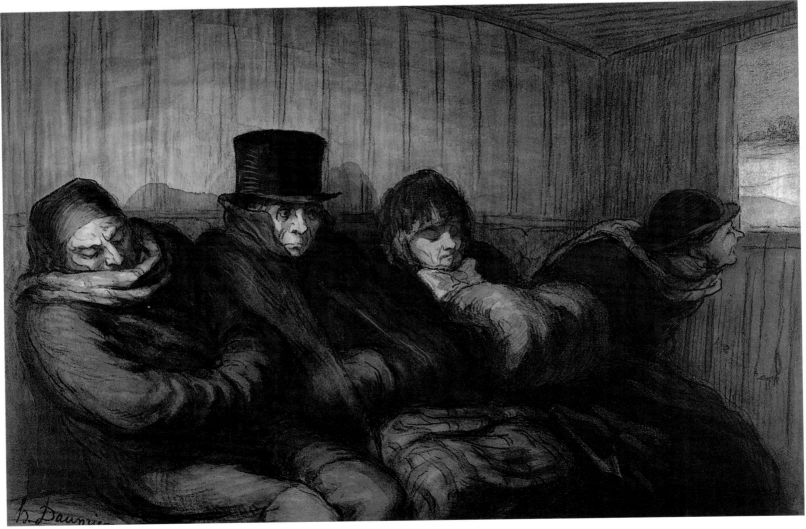

back as 18 January 1862 (fig. 133). Appropriately for the time of year, it represented four travellers muffled up against the cold. It carried the inscription *Train de plaisir, 10 degrés d'ennui et de mauvaise humeur*.[3] There is no mention of the class of passenger represented, but it certainly was not first class. Presumably Walters had seen this print too, and, as with the omnibus, ordered a watercolour copy of it. Whose idea it was to make a series of the three classes is not known. The relevant entries in Lucas's diary for 1864 continue as follows:

[April] 29 Friday . . . At Daumiers & ordered 1st & 2nd Class . . .
[June] 6 Monday . . . Note from Daumier . . . at Daumiers took & paid for (200 fs) for 2 drawings 1st & 2nd Class R Road[4]

No one seems to know at what point Lucas acquired the *Third Class Railway Carriage* (fig. 138), but as Daumier notes payment for *four* drawings at 100 francs each (first one drawing and then three together) in his accounts for 1864, either Lucas or Walters must have collected it soon after the first two.[5]

The facial characterizations are again very little changed between the wood engraving and the watercolour of the *Second Class Railway Carriage* (fig. 135).[6] The spatial depth in the latter, however, is greatly increased by successive grey washes, leaving the light effects on three of the passengers' faces as reserved areas of white paper. The effect of snowy

136. Daumier: *Le wagon de première classe (The First Class Railway Carriage)*. 1864. Black chalk, grey wash and watercolour, 20.5 x 30. Baltimore, Walters Art Gallery. MD 296.

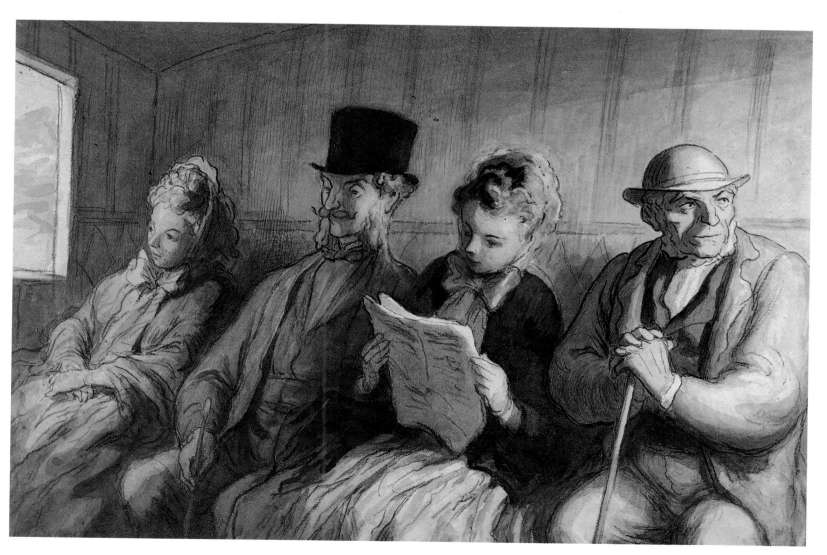

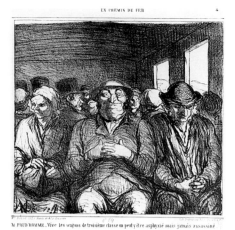

M. PRUD'HOMME...Vive les wagons de troisième classe on peut y être asphyxié mais jamais assassiné

138, below. Daumier: *Le wagon de troisième classe (The Third Class Railway Carriage)*. 1864. Black chalk, grey wash, watercolour and gouache, 20.5 x 29.5. Baltimore, Walters Art Gallery. MD 298.

fields against grey trees and sky, in the landscape seen outside, is achieved by scraping or rubbing off the grey wash and exposing thick white paper fibres. The same technique has been used on the face of the man looking out of the window: an orange-red pigment has been scraped off in slanted scratches to reveal white paper fibres, the resulting optical mixture being pink.[7] Curiously enough, although these passengers are so heavily wrapped up and suffering from the cold as to suggest an unglazed window, the carriage panelling seems exactly like that in *The First Class Railway Carriage* (fig. 136). There is some indication of upholstery here, however, and the weather is appropriately better. The passengers, who studiously ignore each other, make an interesting group. Two bourgeois young ladies, dressed fashionably for travelling, sit on either side of a top-hatted *flaneur* holding his thin cane between his knees and keeping his gaze straight ahead. On the right is a rather different character, a tough looking middle-aged man, plainly but comfortably dressed, wearing a bowler hat and resting his hands on a large walking stick, looking away from his neighbours. Is he perhaps a manufacturer, owner of a factory, one of the *nouveau riche* entrepreneurs? Parisian viewers, had they seen this, would probably have recognized the social distinctions, as wittily expressed here as in paintings by Manet, Degas or Tissot only a few years later. As to the precise relationships between the four, several readings are possible. Perhaps the reason the top-hatted

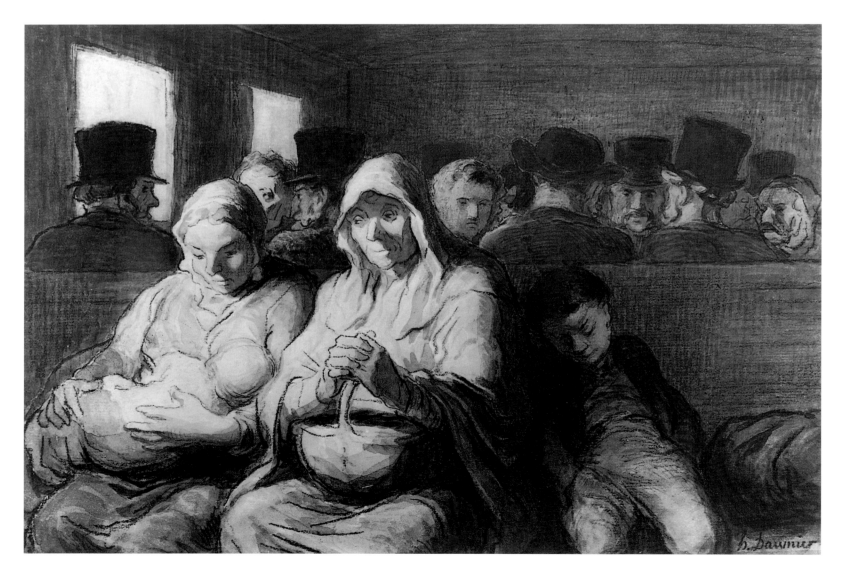

gentleman is ignoring the pretty lady to his left is that the pretty lady to his right is his wife, whom he guards with a proprietorial air. On the other hand the young lady reading her journal, who seems to be more independent than the other, could be his daughter, if she is not in the company of the bowler-hatted man. Her very bright blue blouse, bow and ribbons suggest an aggressive femininity, which could signify a new arrival on the social scene. In any event the man on the right is not at all concerned about the others: he is going somewhere with a purpose. One could even speculate that he stands in, as it were, for the businessman who commissioned the drawing. And then again it might be that none of them are related. All the passengers wear gloves, a fact which supports both their consciousness of class and their studied minimum of physical contact. Indeed, the dangers of contact with strangers during railway travel, especially for rich people who might be robbed or even murdered, were very much in the news at this epoch, and the subject of ridicule in a series of six caricatures, *En chemin de fer*, that were drawn by Daumier for *Charivari* in June 1864 – that is, at the very time of his completion of the watercolours for Lucas.[9] One of these cartoons features Daumier's version of Monsieur Prud'homme (*sic*) (fig. 137), who has adopted the strategy of travelling in a *third class* carriage where he is so safely squeezed into the working-class crowd that, as we read in the caption, 'one can be asphyxiated but never assassinated'. His clothing is noticeably close to that of the mercantile gentleman in the serious watercolour, *The First Class Railway Carriage* (fig. 136). One wonders, however, just how serious the watercolour itself was meant to be. Whereas the humour in Daumier's published prints was usually broad and obvious, in his private drawings the entertainment factor is often still there but much more subtle, inviting speculative readings such as we have just tried.

The Third Class Railway Carriage (fig. 138) operates on a different level from the other two watercolours, and the subject occupied Daumier's sustained attention through several versions over some years.[10] It has sometimes been assumed that this watercolour came first in the series, perhaps owned already by Walters because Lucas makes no mention of it, but now we know from Daumier's account book that it was bought at the same time as the others. A good deal of speculation has taken place about Daumier's meaning in this image. The most usual reading, taking the two largest and later oil paintings of the subject as the iconographical norm, is to take this scene as symbolizing the heroic dignity of the working class, something comparable to Millet's paintings of peasants. The resigned expression on the old woman's face and the woman breast-feeding her child would be the most potent signifiers of this interpretation. The nursing mother is perhaps reminiscent of *La Soupe* (fig. 48), but the treatment here is gentler, more *biblique*, as was once said of a painting by Millet. To some extent the family group in the foreground are detached, isolated from the miscellaneous crowd of men and women bunched into the adjacent compartment. The lighting arrangement emphasizes this, especially in the watercolour version where there is a large expanse of reserved white paper making the highlights on the two women. A distinctly proletarian feature is the absence of closed compartments in the third class, the seating areas being only divided by bench-backs, thus exposing the whole crowd to each other. The composition focuses on the lined features and reflective expression on the face of the old woman, which evidently fascinated the artist. Her hands are clasped as if in prayer, although they actually rest on the handle of her basket.

This watercolour was evidently traced before it was taken away by Lucas, and the tracing, since lost, squared up for transfer to a canvas on a larger scale. In fact it may have been used to start two canvases. The oil painting in the National Gallery of Canada (fig. 141) has revealed under X-radiography that at an earlier stage the sleeping boy was positioned as he is in the watercolour, with a rolled bundle at his side, and that the rectangular box with his hat on it is a later revision.[11] The Ottawa canvas, however, was worked on over a considerable period, and before it was finished a second version was

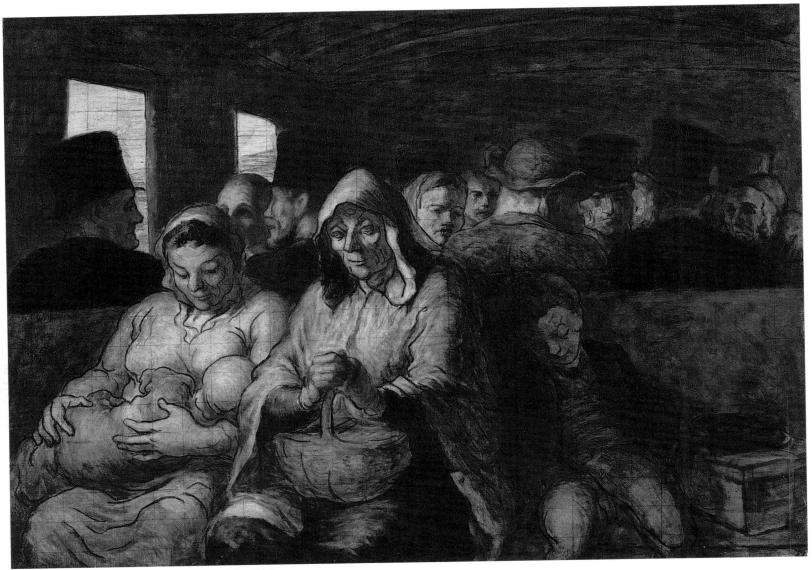

139. Daumier: *Le wagon de troisième classe (The Third Class Railway Carriage)*. 1864–65. Oil on canvas, 65.4 x 90.2. New York, Metropolitan Museum of Art. MI 165.

140. Daumier: Tracing, in reverse, from fig. 139. *c*.1865. Pencil on tracing paper, 68 x 92. Paris, Bibliothèque Nationale. MD 300.

begun, on the surface of which the remains of transfer squaring are clearly visible. This is now in the Metropolitan Museum, New York (fig. 139). The New York canvas is still close to the watercolour in composition, especially for the foreground figures, although Daumier has reworked the characterizations of the background figures, emphasizing the features of a second young working-class woman and the bull neck of a huge man seated with his back to us. A kind of square hatbox or shoebox replaces the bundle beside the sleeping boy. For some reason this canvas was left in an unfinished state and, after the intervention of another tracing made from it, and a second, inverse tracing made from that (fig. 140) with alterations and the addition of the arched carriage roof – from which, amazingly, another drawing was made the right way round on a full-size sheet of glass (that is, on the same scale as the canvases) – Daumier finally returned to the Ottawa picture.[12] During the stages of tracing the pose of the sleeping boy was completely altered so that his head slumped further forward. The head of the top-hatted man on the extreme left was moved to give him a more clearly modelled profile against a dark background; the back of the big man near the centre has grown monstrous (fig. 142); and the basic features of all the other heads behind the front row were repainted, so that as we see them now they all have new characters. Only the faces of the old woman and her

114

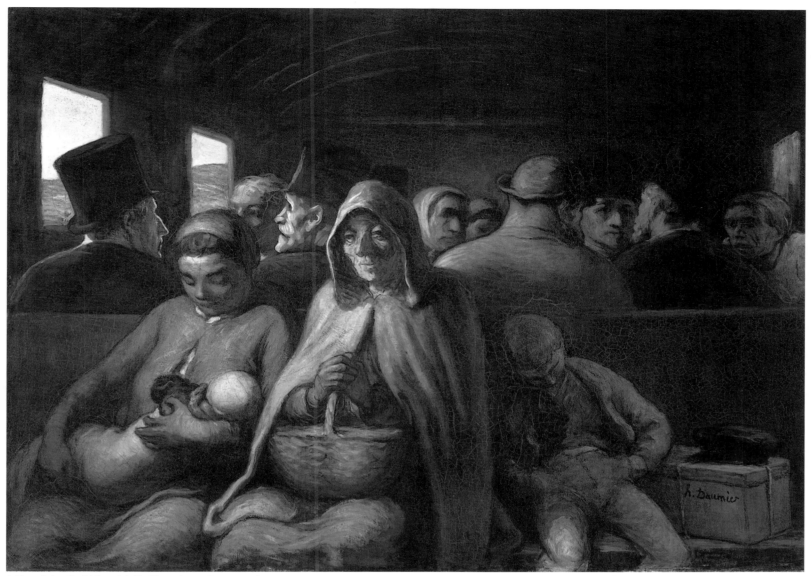

141 and details 142 and 143 Daumier: *Le wagon de troisième classe (The Third Class Railway Carriage)*. 1864–1870. Oil on canvas, 67 x 93. Ottawa, National Gallery of Canada. MI 166.

144. Infra-red photograph of fig. 141.

daughter remain unchanged, although they have gained a more sculptural plasticity in the final version. The ultimate link between Daumier's drawing and his painting is discernible by looking closely at the features of the old woman (fig. 143). The planes of her nose, eyelids, cheek bones, and so on are carefully modelled with short strokes using a loaded brush, but the rhythms of these features, the shape of the cowl-like hood which frames them, and the fastening of her cloak round the neck, are entirely linear in conception. The importance of these lines, drawn with a thin sable brush, is seen even more clearly when we look just below the surface using an infra-red photograph (fig. 144).[13] The old woman's head is the part of the Ottawa painting which has remained in closest *rapport* with the Metropolitan version. She seems to be detached from all the other people round her, whose various preoccupations all devolve away from this still centre.

Daumier's original idea for the Walters *Third Class Railway Carriage* (fig. 138) thus turned out to be one of the most fruitful of his entire career. Its scheme of motherhood and matriarchal old age has been described as 'memorable and a bit sentimental',[14] but be that as it may the theme obviously struck a chord with Daumier which went deep into his personal experience. It is neither an allegory nor an entertainment, but a profoundly expressed observation of working-class patience and fortitude. Since we know that this motif was invented in 1864, the unfinished Metropolitan painting should date to about 1865 to 1866, and the Ottawa painting, begun about 1864, might well have been completed after the Franco-Prussian War. The finished version was first seen in public at Daumier's retrospective exhibition in 1878.

There are two other watercolours on the third class carriage theme which, being very similar to the Walters version in technique, are probably close enough to it in date. One, lent for exhibition both to Daumier's 1878 retrospective and to the 1888 exhibition of *La Caricature* by the collector A. Boulard, is more caricatural than *biblique*; it contrasts rustic passengers with city proletariat out for the day.[15] The other, now in the Oskar Reinhart Collection, Winterthur, was lent to the Paris Exposition Universelle in 1900 by Monsieur Boy (fig. 145). The hard bench of the third class seat is more prominent here,

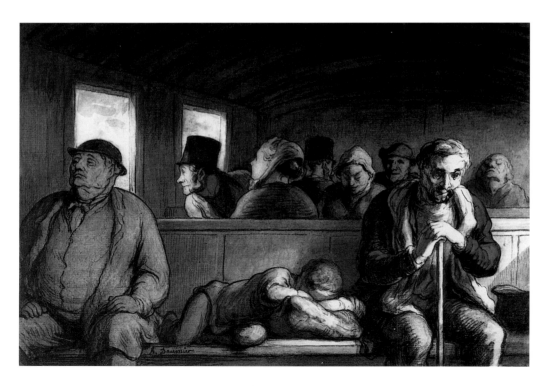

145. Daumier: *Le wagon de troisième classe (The Third Class Railway Carriage)*. 1866-68. Black chalk, pen and wash, watercolour, 23 x 33. Winterthur, Oskar Reinhart Collection. MD 303.

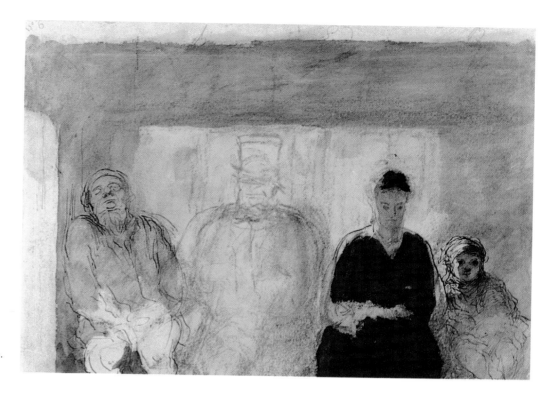

146. Daumier: *L'omnibus (The Omnibus)*. 1866-68.
Charcoal, pen, grey wash and watercolour, 24.8 x 33.4.
Private collection. MD 290.

with the figure of a boy (the one we have already seen?) stretched out sleeping on it, while in deliberate contrast at either end we find, on the left, a comfortable and aloof bourgeois looking rather like M. Prudhomme, and on the right, a miserable-looking creature leaning on his stick with an expression of hungry-eyed poverty. The mixed crowd in the background are carefully individualized, and one gets the impression that there is more specific social comment intended in this version than the others, something along the lines of, 'all classes can be found in the third class, from the rich and mean to the virtually indigent'. This drawing, with its very forceful linear contours in pen, could have been the artist's final word on that specific subject, leaving his more generalized musings on women and motherhood to his oil paintings.

Less easy to pin down in their intentions are the half-completed sketches of ideas for watercolours which were apparently not followed up. A sketch in black chalk, grey wash and pen, for example, is related in composition to the Reinhart watercolour but differs significantly in the characterization of the figures; it could have been done before or after the finished watercolour.[16] Another curious example is a second drawing of the omnibus theme (fig. 146) which is less mocking than the first version.[17] The spreading fat man in the centre remains a ghost, while a new character appears propped up against the door on the left. This figure has been rightly compared to napping train travellers found in Daumier's lithographs from 1866 and 1868. The drawing was begun in charcoal, then the lighting arrangement was blocked out in grey wash before developing two of the heads in pen: the sleeping man and the child in the opposite corner. The artist then turned to 'painting' the seemingly attractive woman in watercolour with pink and black, before abruptly leaving off his study as though the subjects in it had just got up and gone. If we did not know Daumier's methods better, it might have been thought that this was done *plein air* in the omnibus itself. It is quite wrong to read this watercolour as 'Impressionist', no doubt, but someone persuaded Daumier to put it into his retrospective exhibition in 1878[18] – which was held at none other than Durand-Ruel's gallery, the dealer who at that time had already begun to support the Impressionist painters as a group.

147. Daumier: *Le départ du train (The Departure of the Train)*. 1865–69. Black chalk, pen and grey wash, watercolour and gouache, 15 x 25. Private collection. MD 310.

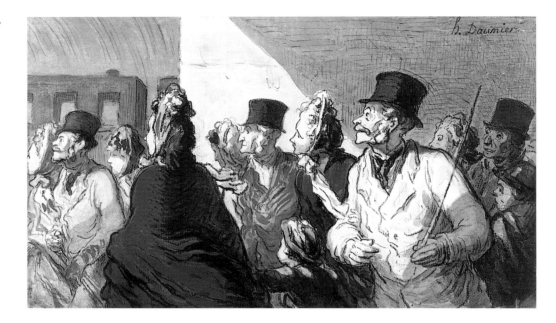

148. Daumier: *Le Gare Saint-Lazare (Saint-Lazare Station)*. 1863–68. Black chalk, pen and wash, watercolour, 38 x 55. Ex Gerstenberg-Scharf Collection. MD 311.

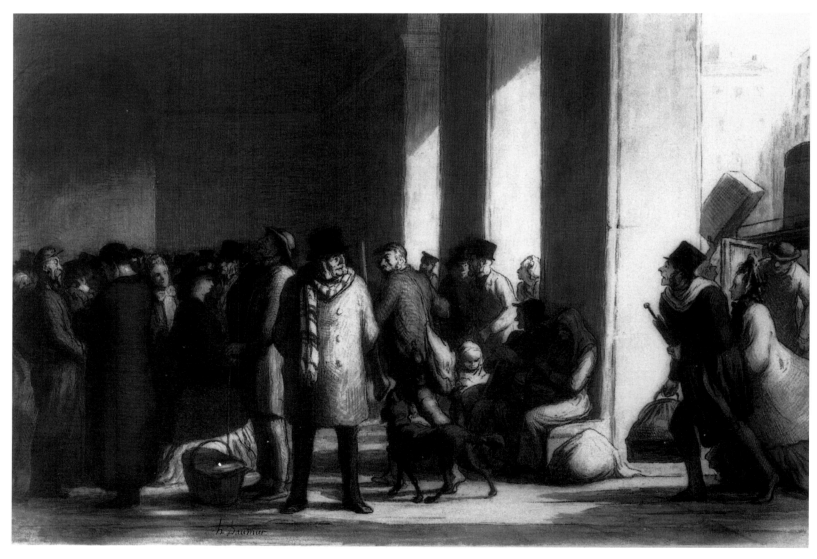

Moving from train interiors to the points of arrival and departure, Daumier again reflected the spirit of his time in his lithographs about the bourgeois Parisian's unrequited love affair with a countryside he could not understand. In 1864 we find Daumier making fun of excursion trains, a line, so to speak, which was popular enough for him to try making saleable watercolours in the same vein. As before, his characterization in watercolours is wittier and more subtle because it is made for private clients. The finished watercolour *The Departure of the Train* (fig. 147) belongs to this class of work. A crowd of passengers scrambling to get onto an excursion train was the subject of a wood engraving published in *Le Monde illustré* in 1862 labelled *Les voyageurs de dimanche*, and of a lithograph published in *Charivari* in 1864 with the caption *Grand train de plaisir . . .*,[19] but these prints do not necessarily date the watercolour: a client who knew them could have asked later for a new version. In this case Daumier has made a brilliantly clear image, using his traditional watercolour techniques. These involved an initial drawing in fine pen lines, grey wash for distribution of tones, with reserved white areas for space and light, and colour tints for decoration on faces, clothes and hair colouring. Additional spots of red on a woman's bonnet and gouache mixed in for deep blue-blacks on her shawl indicate the artist pulling out all the stops at the height of his powers (*c*.1865 to 1869). This should be contemporary with his best watercolours of lawyers and amateurs at that period. It is on a relatively small scale – only $5\frac{7}{8} \times 10$ ins – but clearly intended as a collectors' piece. Appropriately, it was first recorded in the collection of Henri Rouart, an early purchaser of works by the Impressionists and friend of Degas. Rouart did not lend any Daumier watercolours to the 1878 exhibition, but he did send two small oils, so he must have at least begun forming his large collection of Daumier's work in the 1870s.

The social status of the holidaying crowds seen on Daumier's railway platforms is that of the more modest bourgeoisie, dressed up in their Sunday best. The pursuit of leisure was a dominant preoccupation among Parisians from the last decade of the Second Empire onwards.[20] In *The Departure of the Train* Daumier has exactly caught this eagerness to get out of the city into the countryside on a sunny day. In a much larger watercolour (twice the size) he represents the imposing entrance hall of the Gare Saint-Lazare, the railway terminus for the Channel coast, with its cathedral-like proportions dwarfing a crowd of passengers (fig. 148). Unfortunately this work has disappeared, but a photograph gives us some impression of its quality. On one level it is anecdotal in the manner of British genre painters such as W.P. Frith, or the social realist painters like Luke Fildes and Hubert Herkomer (who also contributed illustrations to the London *Graphic*, first published in 1869), yet it contains some characters who could only belong to Daumier's world. The dominating figure standing in the centre of the concourse, dressed like an English 'm'lord', awaiting the tardy arrival of his daughter and son-in-law who have just tumbled out of a cab, seems to invite some anecdote which the viewer may feel free to invent. Other characters include the weekend huntsman with his dog, shotgun and game-bag, the very tall man watching the departure board; another in a long clerical coat looking at his watch and, inevitably, the mother and child and old woman seated waiting patiently in the shadows, an anonymous bundle of belongings beside them. The compositional arrangement is not unlike Courbet's huge painting *The Painter's Studio* which, it will be remembered, is represented as another kind of concourse with the world coming to Courbet. Daumier's railway station, however, simply represents the thrusting, material and entrepreneurial world of the 1860s; it is not a grand personal allegory like Courbet's picture of 1855. Daumier as cartoonist was frequently compared by his contemporaries to his rival Gavarni, and a critical view which persisted for some time was to contrast Gavarni's 'grace' with Daumier's 'robustness'.[21] In watercolour the robustness in execution comes from the cartoonist's hand – Daumier's talents can never be absolutely separated by medium.

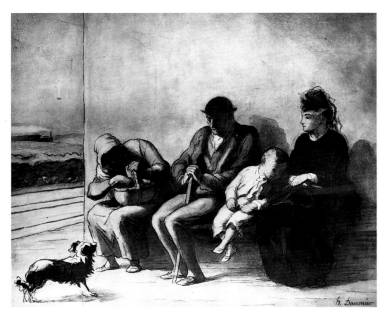

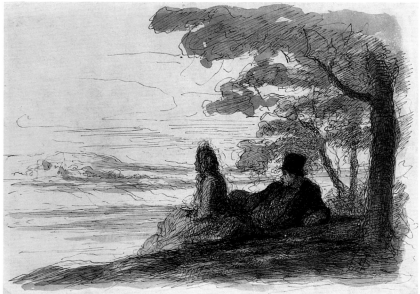

149. Daumier: *L'attente à la gare (Waiting at the Station)*. 1860-63. Black chalk, grey wash and watercolour, 28 x 34. London, Victoria and Albert Museum. MD 309.

150. Daumier: *En contemplation (Contemplation)*. 1860-63. Pen and grey wash, 20.9 x 28.4. Private collection. MD 718.

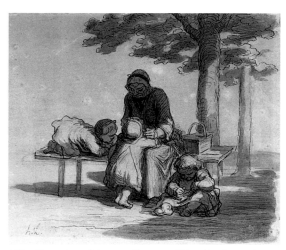

151. Daumier: *Une grand'maman (Grandmother and Children)*. 1855-60. MD 727.

Several of Daumier's drawings and watercolours are concerned with people in waiting rooms – it is not always clear whether they are waiting for omnibuses or trains. In *Waiting at the Station* (fig. 149), an approaching train is seen in the distance, and the effect of sunlight on the open platform reminds us that he could render landscape whenever he wished. This is a wayside station in the country. The tones are distributed in soft greys, with a green hedge and touches of pink and blue on the women's clothes. The lady in black has smart blue gloves and white cuffs, and her son is dressed in white: they are plainly 'townies' out for the day. Although they are quietly seated next to the locals on the same bench, there is no real contact between them, except for the curiosity expressed by the dog. Daumier had devoted a number of his cartoons to representing the Parisian bourgeoisie in the countryside, with a deliberately satirical treatment of their bewilderment in an alien environment, their boredom with it, and at the same time their use of the countryside to escape the pressures of the big city with its threats to the bourgeois class from the *classes dangereuses*.[22] One should not assume, however, that the lithographs sum up the whole of Daumier's attitudes to the countryside, considering him to be a 'townie' himself, for most of his painter friends were landscapists and he is known to have visited Millet and Rousseau at Barbizon in the forest of Fontainebleau quite frequently. In a drawing like *En contemplation (Contemplation)*, in which a bourgeois couple are at rest under trees overlooking a valley on a sunny afternoon (fig. 150), there is no element of satire at all. Drawings of 'pure landscape' without figures are quite rare in Daumier's *œuvre*, but scenes like this with effects of sunlight out of doors are not. In this case the tonal gradations are in grey wash only, and although the landscape looks authentic it is probably made from memory. *Une grand'maman (Grandmother and Children)* might be situated in the country or in a city park (fig. 151): this genre scene is enhanced by the pattern of light filtering through the leaves of the tree. Executed again in pen and grey wash, it belongs to a transitional stage of Daumier's move toward watercolours with colour. Along one edge of the paper can be seen trial marks to test both the pen and the tonality of the brush strokes.

One objective of the Parisian escaping the city would be to have a few glasses of beer or a bottle of wine in a country tavern. Beer became increasingly popular both with the labouring classes and the bourgeoisie during the Second Empire and later, as is evidenced by a number of Manet's paintings of *brasseries* in the 1870s. Daumier's full-fledged

watercolour *Les bons amis* (*The Good Friends*) celebrates this taste in the 1860s (fig. 152). The two drinkers look like shopkeepers or small businessmen off for a day in the country, although they could conceivably be in an outdoor beer garden such as the Moulin de la Galette in Montmartre, then still in the outskirts of Paris. The trees and foliage around them produce a rippling pattern of dappled light. Local colours are applied over tonalities of grey, and the final drawing is reinforced in black chalk. The impressionistic effect of this work may invite some comparison with the outdoor café scenes of Manet and Renoir, for example, in the next decade, but the choice of a bluff dialogue between two males as subject is characteristically Daumier's. Whatever they are discussing, their eyes meet directly, and the foxy sharpness of the man in the hat contrasts with the more benign expression of his companion.[23] An impressionist effect of light is also found in two watercolours of a man reading beneath the trees in an orchard, in spite of some possible fading of certain colours over time. The best known version, *Le Liseur*, traditionally called *Corot Reading* with no particular justification except its Corot-like

152. Daumier: *Les bons amis (The Good Friends)*. 1863–65. Charcoal, black chalk, pen and wash, watercolour, 23.3 x 30.3. Baltimore, George A. Lucas Collection of the Maryland Institute College of Art, on indefinite loan to Baltimore Museum of Art. MD 319.

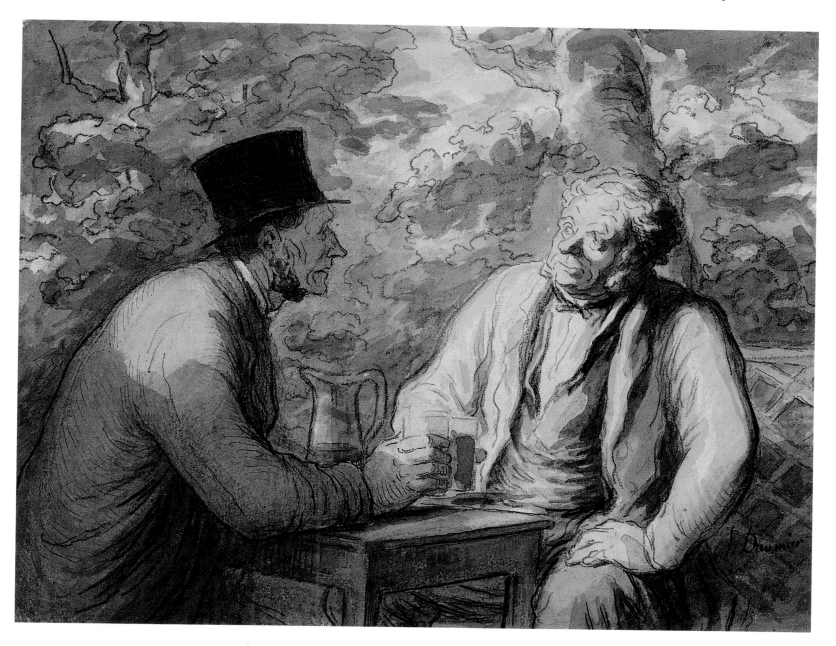

quietism, is in the Metropolitan Museum, New York.[24] A smaller version is reproduced here (fig. 153), the consummate handling of which suggests a date of *c*.1865 to 1870. In spite of the insistent reports that Daumier drew exclusively from memory, it is very hard in this case not to believe that he was recording his impressions directly on the motif, *en plein air*. The technique of applying transparent colour patches over a light under-drawing anticipates the watercolour techniques used by Pissarro and Cézanne in the 1870s, except that Daumier has reinforced his final image with strokes of a pen, and again gone over it with heavier lines in black chalk. The local colours are tints of yellow ochre, grey mixed with pink, and touches of malachite green.[25] No doubt Daumier shared with other Parisian city-dwellers the very yearning for the countryside which he mocked in his cartoons, and in 1874 he did eventually succeed in acquiring, apparently with Corot's help, the cottage which he had rented since 1865 in the village of Valmondois in the valley of the Oise, to which he retired after the Franco-Prussian war. The chances are that all his later landscape watercolours were executed at Valmondois.

An equivalent to the loose linear structure and impressionistic feeling of the last two watercolours discussed is found in an oil painting, *Déjeuner dans la campagne* (*Lunch in the Country*), which may be used to introduce Daumier's late style in this medium (fig. 154). The ground tone is of the light variety, possibly a light brown or raw sienna colour. The sky is brushed over thinly with Antwerp blue mixed with some white; the half-tones are put in with a brown ochre, and there is some bright emerald green in the foliage of the tree in the middle. All these are thin paint, over which the whites and flesh tones are densely impasted. In the shadow of the tablecloth an ochre and cobalt blue mixture have been transparently washed over the white, giving the effect of reflected colour in the

153. Daumier: *Le liseur ('Corot Reading')*. 1865–70. Black chalk, pen and watercolour, 17.2 x 19.3. Present collection unknown (ex Maurice Loncle Collection). MD 360.

watercolour *Les bons amis* (*The Good Friends*) celebrates this taste in the 1860s (fig. 152). The two drinkers look like shopkeepers or small businessmen off for a day in the country, although they could conceivably be in an outdoor beer garden such as the Moulin de la Galette in Montmartre, then still in the outskirts of Paris. The trees and foliage around them produce a rippling pattern of dappled light. Local colours are applied over tonalities of grey, and the final drawing is reinforced in black chalk. The impressionistic effect of this work may invite some comparison with the outdoor café scenes of Manet and Renoir, for example, in the next decade, but the choice of a bluff dialogue between two males as subject is characteristically Daumier's. Whatever they are discussing, their eyes meet directly, and the foxy sharpness of the man in the hat contrasts with the more benign expression of his companion.[23] An impressionist effect of light is also found in two watercolours of a man reading beneath the trees in an orchard, in spite of some possible fading of certain colours over time. The best known version, *Le Liseur*, traditionally called *Corot Reading* with no particular justification except its Corot-like

152. Daumier: *Les bons amis (The Good Friends)*. 1863–65. Charcoal, black chalk, pen and wash, watercolour, 23.3 x 30.3. Baltimore, George A. Lucas Collection of the Maryland Institute College of Art, on indefinite loan to Baltimore Museum of Art. MD 319.

quietism, is in the Metropolitan Museum, New York.[24] A smaller version is reproduced here (fig. 153), the consummate handling of which suggests a date of *c*.1865 to 1870. In spite of the insistent reports that Daumier drew exclusively from memory, it is very hard in this case not to believe that he was recording his impressions directly on the motif, *en plein air*. The technique of applying transparent colour patches over a light under-drawing anticipates the watercolour techniques used by Pissarro and Cézanne in the 1870s, except that Daumier has reinforced his final image with strokes of a pen, and again gone over it with heavier lines in black chalk. The local colours are tints of yellow ochre, grey mixed with pink, and touches of malachite green.[25] No doubt Daumier shared with other Parisian city-dwellers the very yearning for the countryside which he mocked in his cartoons, and in 1874 he did eventually succeed in acquiring, apparently with Corot's help, the cottage which he had rented since 1865 in the village of Valmondois in the valley of the Oise, to which he retired after the Franco-Prussian war. The chances are that all his later landscape watercolours were executed at Valmondois.

An equivalent to the loose linear structure and impressionistic feeling of the last two watercolours discussed is found in an oil painting, *Déjeuner dans la campagne* (*Lunch in the Country*), which may be used to introduce Daumier's late style in this medium (fig. 154). The ground tone is of the light variety, possibly a light brown or raw sienna colour. The sky is brushed over thinly with Antwerp blue mixed with some white; the half-tones are put in with a brown ochre, and there is some bright emerald green in the foliage of the tree in the middle. All these are thin paint, over which the whites and flesh tones are densely impasted. In the shadow of the tablecloth an ochre and cobalt blue mixture have been transparently washed over the white, giving the effect of reflected colour in the

153. Daumier: *Le liseur ('Corot Reading')*. 1865–70. Black chalk, pen and watercolour, 17.2 x 19.3. Present collection unknown (ex Maurice Loncle Collection). MD 360.

154. Daumier: *Déjeuner dans la campagne (Lunch in the Country)*. 1865-70. Oil on canvas, 25.4 x 33. Cardiff, National Museum of Wales.

impressionist manner. What remains most characteristic of Daumier, however, is the cursive linear contours throughout, describing such details as the man feeding his dog a biscuit, the movement of the man raising a coffee cup to his mouth, and the arabesques in the background giving the sensation of movement in the leaves. As we have often seen before, Daumier is at his happiest when drawing with the point of a loaded brush, and this he will now develop specifically in the medium of oil paint.

His equivalent *plein air* watercolour style is found in fig. 155, *Dans la campagne (In the Country)*, which is closely related in technique to *Le Liseur*, but with patches of colour that are brighter and more variegated than before. The two figures proceeding slowly along the path in opposite directions are reminiscent of a painting he had done some years previously of two Parisian washerwomen going up and down a flight of steps and, although this is a country scene, the woman carrying her bundle in the background could also be a washerwoman.[26] Malachite green, a rather metallic colour something like viridian, seems to have appealed to Daumier when placed in juxtaposition with second-ary colours like yellow ochre and earth red. In this watercolour there are further colour

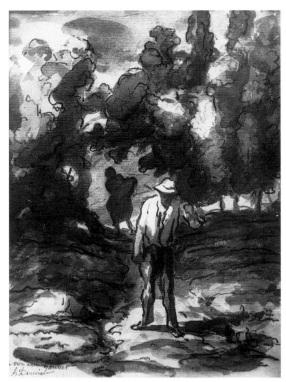

155. Daumier: *Dans la campagne (In the Country).*
1871-75. Black chalk and watercolour, 18.6 x 13.4.
Private collection. MD 711.

156, opposite. Daumier: *Les baigneurs (Two Male
Bathers).* 1865-70. Charcoal, black chalk, grey and
brown washes, watercolour, 21.2 x 18.5. Baltimore,
George A. Lucas Collection of the Maryland Institute
College of Art, on indefinite loan to Baltimore
Museum of Art. MD 719.

mixtures employing madder lakes, violet, blue and grey, to make a variety of rich dark tones. Unfortunately there is no record of Daumier actually meeting Pissarro or Cézanne at this time – we should suppose it to be the early 1870s – although from 1872 to 1874 they each lived and worked, respectively, at Pontoise and Auvers-sur-Oise, the latter being a village only a few miles down the road from Valmondois, and incidentally the home of Daumier's old friend the landscapist Daubigny. The effects of some of their earlier watercolours are strikingly similar to this, except that where the impressionists put in linear accents with a brush, Daumier preferred his stub of black chalk. This quite small drawing is dedicated to a younger painter friend of Daumier's, Amand Gautier (1825–1894), in a firm and clear hand on both sides of the sheet.

Another late watercolour, similar in style to the last three discussed but unusual in its relationship to Daumier's earlier lithographs, is *Les Baigneurs* (fig. 156). Two male bathers are seated at the edge of a public swimming bath in Paris. In the 1840s Daumier's cartoons of bathers had been admired by both Delacroix and Ingres, and he took this theme up again in a rather inferior series of ten lithographs published in *Le Petit Journal pour rire* in the summer of 1864, one of which is similar to this drawing in its arrangement.[27] The firm drawing of the figures in the watercolour, however, is more like the earlier series produced for *Charivari* between 1839 and 1842 (male bathers) and again in 1847 (female bathers). In those lithographs the line was springy and the designs clear and cohesive, and in the present instance Daumier has recovered those qualities in a straightforward drawing. The bather's bright red shorts and his companion's white bath towel – the luminosity of which is achieved by leaving the white paper reserved untouched – focus the design. Every other area on the paper besides these figures is covered by at least one layer of transparent grey wash. The washes serve to obliterate traces of a first drawing in charcoal of the seated figure to the right, which was originally placed to the left of the present position of both figures. Successive layers of grey and brown washes form a huge expanse of shadowed background, and within this area have been drawn the swimming pool and other bathers. A shaft of light from a skylight above appears to be the only source of illumination. It seems unlikely that this watercolour was created expressly to fulfil a commission by a client, since on the verso there are several trial drawings of heads, studies of a dog, and a great blob of black ink. It is more probable that, concurrently with his renewed interest in natural light in landscape, Daumier was seeing what he could make of one of his earliest and most favourite themes, in this new medium. The drawing has no known provenance prior to its acquisition by George A. Lucas at an unknown date, perhaps quite late in the nineteenth century, and it was one which he kept for himself.[28]

If landscape was for Daumier a kind of mental recreation, its increasing occurrence among the subjects of his later watercolours would point to some easing of the stress of his busiest years as a cartoonist. It is also worth noting the number of his lithographs in which the river Seine is prominent as an indicator of leisure, so that one might almost conclude that it was another route for the Parisian to reach the countryside – by boat. His drawings and paintings of men watering their horses in the Seine are another reminder of the tremendous importance of horse-drawn transport in his time, and the place of the river in the rhythm of daily life. Bathers, too, are associated with the river landscape. In one cartoon Daumier connected both elements: out in the country, two near-naked *baigneurs* facetiously hail a passing diligence with lady passengers and ask if there is room for two passengers on the running board.[29] A number of his smaller, late studies in watercolour impart the *idea* of landscape even though they are ostensibly dealing with figures. The little man in a bowler hat lying face down in the grass (fig. 157), for example, in a drawing known as *Le repos dans la campagne (A Rest in the Countryside)*, or the two men sprawling on a hillside (fig. 158) with a suggestion of trees brushed in with watercolour, *Deux personnes dans un paysage (Two Figures in a Landscape)*, are

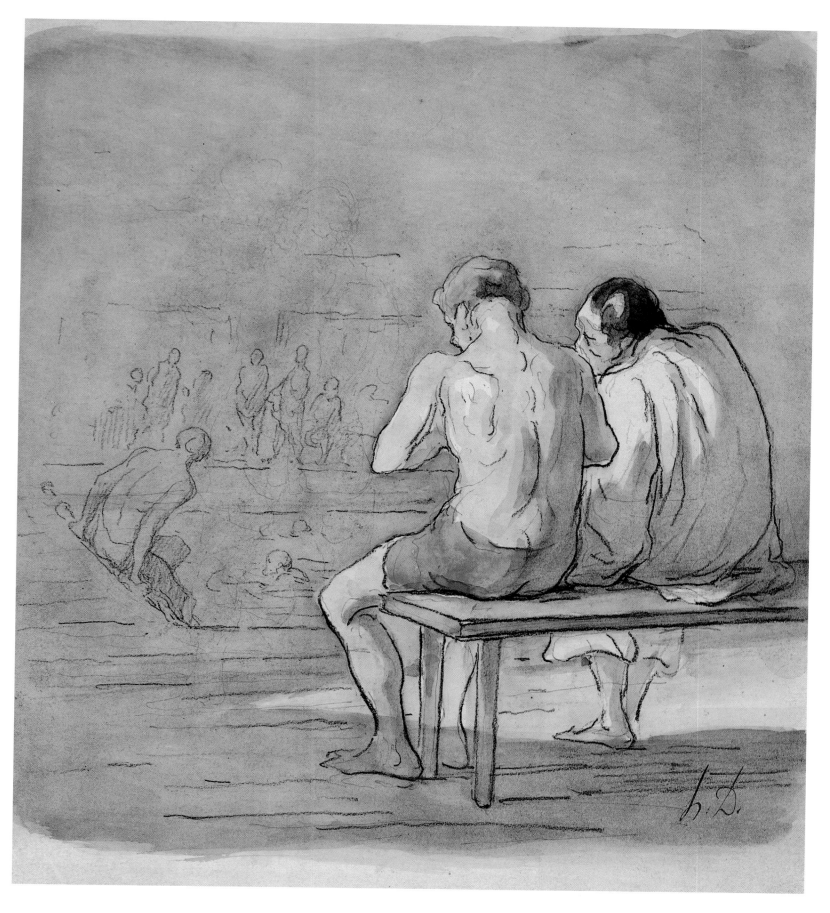

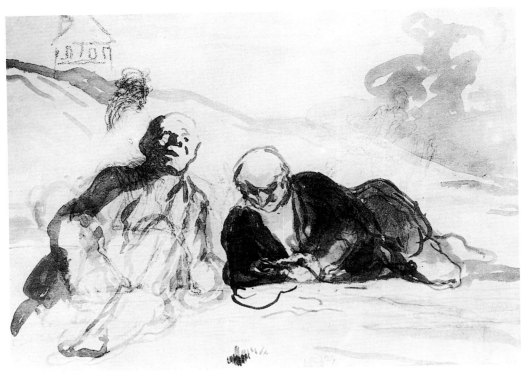

157. Daumier: *Le repos dans la campagne (A Rest in the Countryside)*. 1865-70. Black chalk and watercolour, 8 x 14. Washington D.C., National Gallery, Rosenwald Collection. MD 715.

158. Daumier: *Deux personnes dans un paysage (Two Figures in a Landscape)*. 1865-70. Pen, brush, black and brown wash, 23 x 32. Present location unknown. MD 717.

essentially images of recreation. They are also, in these two cases, connected with images of the imagination. Closer examination of the first reveals the faint silhouette of Don Quixote on his horse on the horizon: the little stout man who looks so contemporary is also Sancho Panza. The grass is green and there is a blue mountain in the distance. The landscape with two figures is more complex, including as it does some drastic pentimenti. Since it is on the verso of a drawing of a judge with studies of heads of lawyers,[30] it is not often seen. A partially erased figure of Don Quixote on horseback is visible to the right of the two reclining men, and between them there faintly appear the ears of a donkey – Sancho's, whose disembodied head then becomes recognizable near the house on the left. Thus this drawing originally began as Sancho Pansa watching his master charging away, but that conception became supplanted by a watercolour landscape in which the man reading might be intended as Don Quixote, though he does not look very like him. His companion appears to be either day-dreaming or declaiming to the sky. Either way Daumier has produced, purely for his own amusement, a rather poetic image of the outdoors from which the element of narrative illustration has been removed. We will return to Daumier's Don Quixote in the final chapter. In conclusion, after looking at this selection of Daumier's work concerned with travel and the countryside, when it was not made for the purpose of social satire, one might suggest that he had a much more personal rapport with landscape than has generally been realized, *even though he worked from memory*. For him the countryside signified leisure, rest and peace of mind.

Chapter 8

DAUMIER'S LIFE AND PATRONS (1864–1870),
AND HIS *SALTIMBANQUES*

Daumier's life, about which the literary evidence is scanty, is laid open to us through the evidence of his accounts. In 1864, the year in which George A. Lucas bought the omnibus and railway carriage watercolours, Daumier began to keep a new account book (*Carnet IV*) which recorded his sales of drawings and paintings as well as his receipts for lithographs and designs for wood engravings.[1] (He described the last items simply as 'bois'.) It becomes evident that after his return to work for *Charivari* at the end of 1863 he began to earn a dual income from his work for that journal and from private sales. Philippe Burty recorded seeing Daumier drawings for sale at 50 francs each in Geoffroy-Dechaume's studio in 1862, that is, during a period when he had nowhere else to show them,[2] but according to this account book he was now selling drawings for prices between 100 and 200 francs. During the period 1864 to 1867 he sold thirty-five drawings and ten paintings.[3] Another section of *Carnet IV* notes payments to suppliers, from October 1864 to May 1872.[4] The most important section, however, is the one that gives us access to precise details, for two years at least, of the relationship between Daumier's two sources of income. The recorded fee for each lithographic stone remained at 40 francs – unchanged since 1839 except for the short period of 1841 to 1843 when Dutacq was editor of *Charivari*. The income from lithographs in 1864 can also be calculated from the number of stones he finished – because *Charivari* paid on delivery, more or less – and in 1865 the total of his receipts in *Carnet IV* actually tallies with the number of stones listed in *Carnet III*.[5] Thus, in 1864 Daumier made a total of 1,530 francs from the sale of drawings and paintings, 4,560 francs from 114 lithographs, and one recorded wood engraving at 100 francs. This totals 6,190 francs, averaging 516 francs per month. In 1865 he made a total of 2,425 francs from the sale of drawings and paintings, 3,560 francs from 89 lithographs, and 100 francs for a page of studies to illustrate an article on him in *l'Autographe*. This totals 6,085 francs, averaging 507 francs a month, but this time the proportion of prints made has gone down in comparison to the number of drawings and paintings sold. This surely signifies the critical point of Daumier's career change from cartoonist to *artiste-peintre*.

Unfortunately, his monthly entries for the years 1866 and 1867 appear not to have been completely kept up; there are spaces marked out for each calendar month but regular entries stop at May 1866. There is, however, an extremely interesting entry on a loose page, which lists sales of drawings and paintings totalling 1,600 francs for an unspecified period, plus 550 francs worth of *bois* or designs for wood engravings – a total of 2,150 francs – and, at the bottom of the page this note: '1866 to 1867, from October to April, *per month* 581, 7 months'.[6] This sounds a quite plausible calculation. It is also not very different from what he had been earning in the 1840s. A newly published inquiry by the Chamber of Commerce into Paris Industries in 1860 revealed that the level of wages in the printing and engraving trades (and indeed for all workers) had not changed very much since the last one in 1848, although the number in the total workforce had grown slightly.[7] The upper echelons of artisan printers and engravers earned between 130 and 520 francs a month.[8] It does seem clear, therefore, that Daumier remained a *petit bourgeois* in income status, and it is probable that this would have been a contributing factor in his relationships with his potential clients.

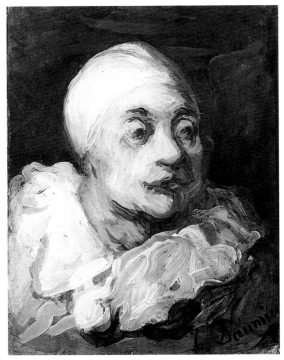

159. Daumier: *Tête de paillasse (Head of a Clown)*. 1866-67. Oil on panel, 22 x 16.5. Present collection unknown. MI 224.

In the receipts section of *Carnet IV* the names of three private clients occur: Pierre Bureau, whom we have already noticed, who buys two drawings and a *croquis*; George A. Lucas, of the railway carriages; and Auguste Boulard, a painter and engraver who had been a neighbour of Daumier's on the Quai d'Anjou.[9] Other purchasers named – Beugniet, Brame, Cadart, Mouraux and probably Delisle – were dealers. Adolphe Beugniet was the most frequent buyer during 1865 to 1867, and it is interesting that he was then paying higher prices for drawings than Walters paid in 1864. We will return shortly to Hector Brame, a major dealer, who paid 800 francs for quite a small painting of Don Quixote and Sancho Panza in 1867. The subjects of drawings are unfortunately not named, but paintings usually are. On the loose sheet for 1866 to 1867 we find that Beugniet bought a picture of musicians (200 frs.), a head of Scapin (380 frs.), a picture of two advocates (300 frs.), and a *pierrot tête* (150 frs.). The last entry brings us to one of Daumier's favourite subjects in his late work: the travelling entertainers, or *saltimbanques*.

The most likely identification for Beugniet's *pierrot tête*, given that the price suggests it was very small, is the panel painting now called *Tête de Paillasse* (*Head of a Clown*), which measures about $6^{1}/_{2} \times 8^{1}/_{2}$ inches (fig. 159).[10] This marvellously sensitive little head seems to reflect the internal feeling of the sad clown. The free flowing touch of the brush in this painting, wielded like a draughtsman's tool, is echoed closely in the pen and wash drawing (fig. 160) which must belong to the same period. This clown seated on his upturned drum, in his ridiculous frilly costume, hangs his head down as though miming total despair. He presents to the viewer the round white top of his head like a large vegetable. Perhaps he is not miming at all. Daumier would undoubtedly have known Baudelaire's prose piece 'Le vieux saltimbanque', first published in 1861 and then put into *Le Spleen de Paris* (1869). The sheer horror of Baudelaire's vivid word-picture of an old clown at the miserable end of his career is not, however, quite reached by Daumier in this particular image. His sadness is of a different kind. With such a painting we have reached a more private and final stage of Daumier's artistic production, modest indeed in terms of financial rewards, but at least contributing to his living expenses. The nature of Daumier's own role as an entertainer has taken a new aspect.

Saltimbanques, mountebanks and travelling street entertainers have a long history in popular folklore. Some of their performances originated in the Italian *Commedia dell'Arte*, the most celebrated of the European theatrical troupes of the later seventeenth century.

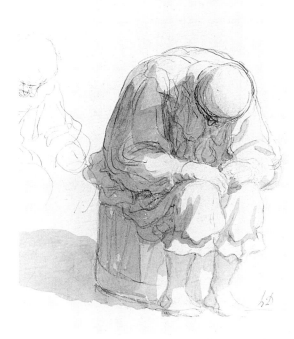

160. Daumier: *Pierrot assis au repos (Clown Resting)*. 1866-67. Black chalk, pen and ink wash, 42.2 x 36.8. Santa Barbara Museum of Art, gift of Mrs Hugh Kirkland. MD 518.

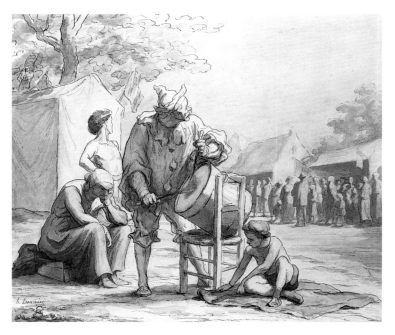

161. Daumier: *Saltimbanques à la foire (Saltimbanques at a Fair)*. 1865-69. Pen and grey wash, watercolour, 33.5 x 39.2. London, Victoria and Albert Museum. MD 542.

This troupe was very successful in France until banished by Louis XIV for an injudicious reference to his morganatic marriage to Madame de Maintenon, but they returned to Paris in 1716, when they were preferred to the *Comédie Française* and immortalized in the paintings of Antoine Watteau.[11] Pierrot and Harlequin come from the stock repertoire of characters used in the broad, populist social satire of the *Commedia dell'Arte*. The style of their performances was imitated by numerous small French touring companies, and the tradition lasted right through the eighteenth century into the early nineteenth, by which time, however, they had lost their aristocratic audiences and become increasingly plebeian, performing to audiences in tents in country fairgrounds, in theatres in the rougher areas of Paris, and on temporary stands set up in city streets. They merged into the category of circus performers, with 'strong men' and acrobats as well as clown-actors. However, there was one great clown who became famous for his mimed performances as Pierrot (or 'Gilles' as the French alternatively called this character), becoming a kind of hero of the poorer classes. This was Jean Gaspard Deburau, who had a book written about him in 1832 which made him a celebrity overnight. He performed in the Théâtre des Funambules in the boulevard du Temple, of which one stretch (now disappeared since the creation of the Place de la République) was known as the 'boulevard du Crime' because of the melodramatic nature of the entertainments to be found there. He died in 1846, and thereafter the character of Pierrot began to be developed into a new mythology by writers like Théophile Gautier and Jules Champfleury, who virtually invented 'the sad clown', an impractical dreamer with heart who saw the world as a human tragedy.[12] These writers were of Daumier's generation and in fact quite close to him, so he was undoubtedly aware of the current state of the myth in his time. It was further developed on stage by Deburau's son Charles, whose portrait Daumier painted from memory and dedicated to him some time in the 1860s.[13] However, the artist was also aware of the true state of the surviving troupes of travelling players in the countryside and outskirts of the city, people who had now descended to a displaced status comparable to gypsies. They incurred the hostility of the government, and a new law passed in 1853, requiring *saltimbanques* to have licenses (which few could afford) led to their being continually being moved on by the police.[14] They became one of society's marginalized, fringe groups – as indeed are those of their successors who remain today. Paula Hayes Harper opines that since Daumier's own career as a caricaturist had placed him in the category of an *amuseur*, there is a good possibility that he made a connection in his mind between his activities and the clown's.[15] He had used a Pierrot figure as a metaphor for Louis Philippe bringing down the curtain on the Chamber of deputies in 1834,[16] and we have already noticed the group of caricaturists, working for *Charivari* in 1839, represented as a *Parade* on an outdoor stage (chapter 1, fig. 12). In the late 1860s the journal *Charivari* itself was symbolized by a figure of a clown, cynically watching the world deteriorate.[17]

Daumier based his drawings and paintings of *saltimbanques* on the lowest and poorest class of clowns, and stylistically they all seem to belong quite late in his career. A case in point is a watercolour of about 1865 to 1869 (fig. 161), of a family of *saltimbanques* encamped on the edge of a country fair. The head of the family bangs on his big drum as for a *parade*, but none of the peasants at the booths across the field take any notice. His two sons, dressed as acrobats, wait listlessly, while the mother rests her head in her hand with an expression of melancholy. The meaning could not be clearer, notwithstanding that all this is set in a cheerful, sunlit landscape reminiscent of *Les bons amis* (fig. 152). Other, more heart-rending drawings show a family very similar to this carrying their miserable belongings through a city street, on the move again.

Daumier drew very few acrobats or circus performers in the ring.[18] An exception is the painting in Copenhagen of wrestlers performing in a circus (fig. 162), which has been compared to Courbet's large and politically complex painting of *Wrestlers* exhibited at the

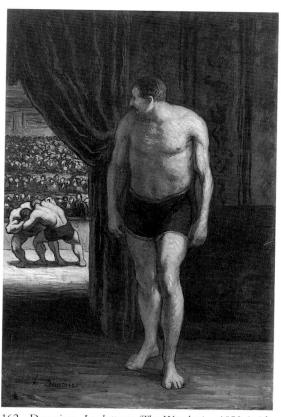

162. Daumier: *Les lutteurs (The Wrestlers)*. *c*.1853 (with later additions?). Oil on panel, 42 x 27.5. Copenhagen, Ordrupgaardsamlingen. MI 45.

Salon of 1853.[19] Since, in Daumier's version, we see the action being watched by another wrestler closer to us, standing behind a curtain, the artist–viewer is at one remove from it, observing the observer. (This is a distancing device which Daumier used more than once.) Daumier's painting has presented some difficulties in dating due to its rather

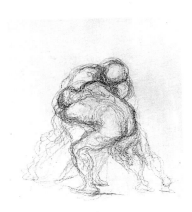

163. Daumier: *Deux lutteurs (Two Wrestlers).* c.1852/53. Black chalk, 26 x 20.5. Lyon, Musée des Beaux-Arts. Ex Maison.

164. Daumier: *Feuille d'études avec quatre paires de lutteurs (Sheet of studies with four pairs of wrestlers.)* c.1853. Black chalk, 20.5 x 17.8. Present location unknown. MD 526.

165. Daumier: *Le saltimbanque (Hercules at the Fair).* c.1860–65. Charcoal and black chalk, 31 x 30.8. Present location unknown. MD 511.

166. Daumier: *L'athlète (Hercules at the Fair).* 1868–73. Fine black chalk, 24.5 x 18.7. Vienna, Graphische Sammlung Albertina. MD 515.

167. Daumier: *L'Hercule de foire (Hercules at the Fair,* or *Pierrot and Columbine).* 1865–70. Brown chalk, pen and ink, 42 x 29.7. Rotterdam, Museum Boymans-Van Beuningen. MD 532.

awkward and hesitant technique, but it was quite likely to have been initially inspired by Courbet's unusual picture, which can be read as a kind of evocation of the people, that is, the immigrant working classes in Paris. It is possible that Daumier's painting was conceived soon after Courbet's was exhibited, but some hatched brush strokes with separated colours on the flesh tones of the foreground figure are reminiscent of his later additions to *Two Nymphs Pursued by Satyrs* (fig. 36) which, it has been suggested above, may have been influenced by the handling of Delacroix's Saint-Sulpice frescoes, unveiled in 1863.[20] A drawing in the Albertina, Vienna, is a preliminary study for the whole composition.[21] The action of the wrestling figures in the distant ring became the subject of no fewer than seven further studies.[22] Five are illustrated here, one with a characteristic, searching tangle of lines, and continual modifications of contours and changes of position for the wrestlers' legs (fig. 163), and four more on one sheet, with different wrestling positions (fig. 164). In this sheet the pairs of wrestling figures are arranged in a counterbalancing sequence of movements, almost as if Daumier had been drawing while the actual match was going on, in a sequence of time. Each group is boldly drawn with a kinaesthetic rhythm of lines, and although the pair at the bottom left are perhaps the closest to the wrestlers in the painting, in fact none of these groups are exactly in the pose adopted in the final work, which is much less dynamic. This is one of those cases where Daumier's imaginative invention in drawing proved greater than his achievement in painting – perhaps a good reason for dating this painting quite early in his technical development.

'Strong Men' occur quite often in Daumier's *saltimbanque* imagery, both in the *parades* outside the tent before the show, and as characters behind the scenes. Some are slightly reminiscent of Baudelaire's description of the genus in *Le vieux saltimbanque*, first published in 1861: 'The Hercules, proud of the enormity of their limbs, without foreheads or brains, like orang-outangs, strutted majestically wearing tights washed the day before for the event'.[23] Daumier drew these muscular creatures in studies for parades, seen both frontally on the barkers' platforms (fig. 165), and from behind as they addressed the crowd (fig. 166), as if the artist himself had been moving round them, unobserved, with a sketchbook. But these figures are drawn nude, anatomically, squeezed out of the artist's imagination, and no doubt stimulated by memories of the fair as vivid as Baudelaire's own. The man facing us has an enormously developed stomach like a wrestler's, and his gesture is a piece of huge physical rhetoric. His muscles are slotted into one another over an invisible but palpable frame, their tension indicated by a succession of curved lines, some arched and some flattened by the strain of extension. His counterpart (fig. 166), seen from behind, is rendered in a later drawing style, in which memory probably plays a greater part than recent experience. Here the thin, fine lines in black chalk (so sharp pointed that it looks like pencil) course over the paper in a more groping fashion, finding the image through a kind of aerial space. The ragged athlete, thus summoned up, seems to be haranguing a crowd of spectators, their faces just faintly visible. He makes a rabble-rousing gesture with his right arm – would his invisible hand be with palm open or fist clenched? – the people calling to the people.[24] Daumier's vision may now be ironic, and in any case the cartoonist is wholly absent.

Other 'Strong Men' in Daumier's repertoire are seen in less aggressive situations. The sad *saltimbanque* resting, noticed above (fig. 160), is found again, as a kind of ghost, in an unfinished watercolour showing the inside of a circus tent, seated on an upturned drum in the same disconsolate pose, with an equally tired and despondent-looking 'Hercule' standing beside him.[25] Another 'Hercule' appears in a curiously poetic, stage-like situation, dressed perhaps as Pierrot, looking pensively down over his great stomach while an attractive Columbine whispers into his ear (fig. 167). But she too is a performer at the fair – one of the dancing girls that Baudelaire saw there and described as: 'pretty as fairies or princesses, jump[ing] and somersault[ing] under the light of lanterns which illumi-

nated their sparkling skirts'.[26] The propinquity of Daumier's pair is given an added *frisson* by their virtual nudity – as he usually first conceived his figures – which further emphasizes their contrasting physiques. The introspective effect of this drawing is particularly striking. If it is true that there is an element of self-projection in Daumier's *saltimbanques* (the suggestion is not new), then the Daumier persona in this case would be that of the strong-man–clown – exactly the kind of role he was generally assigned as a public cartoonist, a role of which he was no doubt accutely aware.

The subject which occupied Daumier most often when drawing *saltimbanques* was the *parade* – the preliminary show intended literally to drum up a crowd. He tried out numbers of different compositions for this theme, lifting particular figures from one variant to another, reversing and tracing designs for reuse, and even shifting locations of the same recognizable troupe from countryside to urban setting. There exist at least four variant compositions of the most famous watercolour version of *La parade*, which is now in the Louvre (fig. 168). Its distinguished first owner was Alexandre Dumas *fils*, who lent it to Daumier's exhibition in 1878.[27] Unfortunately there is no record of the sale to him, and it is curious that the work is not signed, considering that it has been developed to quite an advanced state. A variety of watercolour tints is used, including emerald green

168. Daumier: *La parade (Parade of saltimbanques).* 1867-70. Black chalk, sanguine and watercolour, 26.6 x 36.7. Paris, Louvre (RF 4164). MD 556.

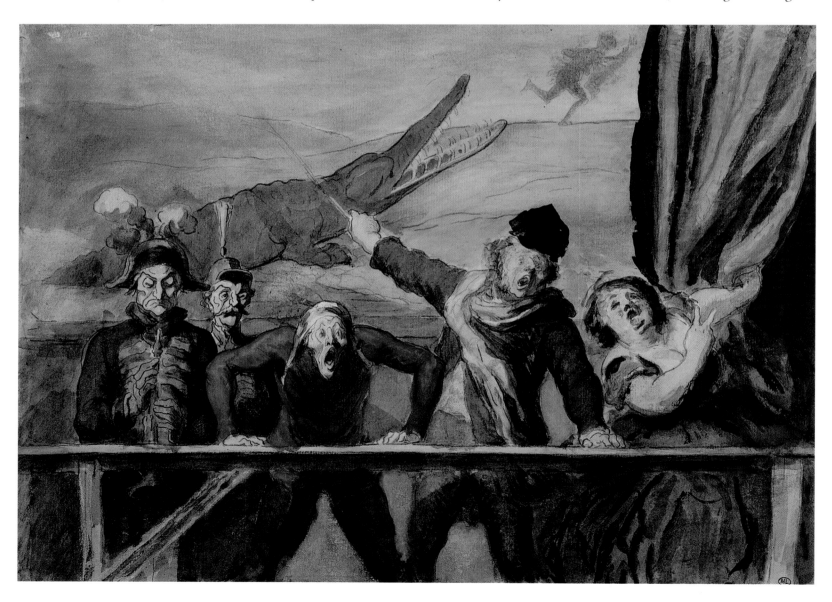

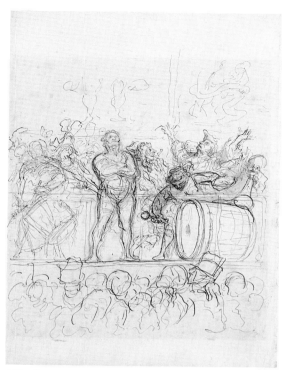

169. Daumier: *La parade (Parade of Saltimbanques)*.
1865-70. Charcoal, black chalk, pen and grey wash,
50.8 x 36.8. The Art Institute of Chicago. MD 553

on the crocodile in the backcloth, Indian red and blue in the uniform of the clown-soldier on the left, and bright red on the tunic of the man behind him. A second, more earthy green is used on the skirt of the fat woman. More drawing than usual is done with a brush, one loaded with black and dark brown paint. This has rather run away with him at the right, where the fat lady holds back the curtain to reveal the dark void of the interior. Her features are rendered with the brush rather than drawn with black chalk. There is some smudging in the landscape on the left, and it is just possible that the artist was not satisfied with the final result – Dumas might even have persuaded him to give it to him. Be that as it may, this is plainly an ambitious watercolour of an unusual subject for high art: a group of buskers on a raised platform outside their tent, loudly advertizing a sensational spectacle within. They presumably make their appeal to a rough crowd of passers-by on a fairground. Daumier, and perhaps Dumas too, might have enjoyed this translation of a vernacular form of entertainment into the delicate language of watercolour. The other versions of this subject all have in common the noisy agitation of the *saltimbanques*.[28] Only three of the eight variant sketches show a crowd of watchers in front of the platform, however. One of these is a charcoal, pen and chalk drawing, now in the Chicago Art Institute, in which a strong man stands, arms akimbo, as the still centre of a crowd of performers who seem to have gone into a complete frenzy (fig. 169). The style of drawing must certainly belong to Daumier's later years (compare his gesticulating lawyers, figs 121 and 122). This drawing has been interpreted as an allegorical condemnation of Louis-Napoleon's propaganda methods; noise, strength, frenzy and even the unexpected appearance of a man in a lawyer's powdered wig on the platform.[29] The figure of the 'Hercule' may symbolize the power of the emperor and his political system. However, Hercules had also been used in French imagery as a symbol of 'the people' as a whole,[30] and since in this drawing the 'Hercule' seems to set himself apart from all the demonstrations, standing silently before the crowd of watchers below, it may be that he does symbolize 'the people' here. The gesticulating range of characters around him, with their faintly eighteenth-century costumes, would then symbolize the corruption of the old regime. Such a subversive peace of imagery, likely drawn *c.*1865 to 1870 during the last wave of Napoleon III's imperial aspirations would not, perhaps, have had much appeal to the type of client likely to purchase finished watercolours. Certainly, no more complete realization of this rapid but ambitious sketch is known to exist, although there are other studies of the strong man as a single figure.

An entirely different conception, in which the theme of the *parade* is expressed by a single, dominant clown drummer, began to obsess Daumier in the late 1860s (figs 170 and 172). Once more there are several studies of the final composition, and it is also repeated in variants arrived at by the use of tracings. The earliest version of this design is, in my view, a drawing now in the Burrell Collection, Glasgow.[31] The media employed are characteristic when Daumier was inventing a new theme: underdrawing in charcoal and pencil; tonal distribution in grey wash; final reinforcement in black chalk. Pierrot is drumming up a crowd at a country fair, in front of a poster showing a fat lady; beside him a thin clown, his sidekick, stands precariously to attention on a chair. A crowd is indicated in a narrow strip of background visible behind the poster. From this version three traced drawings were made, one in pen, one in pencil, and one in black chalk.[32] A combination of these last two drawings led to the first highly finished watercolour (fig. 170). This remarkable work is rendered in full colour over bluish-grey half-tones. Red, white and blue – the colours of the *tricolore* – are prominent on the foreground figures and elsewhere. In the background, passing strollers glance at a noisy free show taking place on a platform very like that in the Chicago drawing (fig. 169). This Pierrot in the foreground, however, appears to have no audience other than the artist-viewer. The expression on his face might be read as questioning, threatening,

171. Daumier: *Prusse Colosse (Colossal Prussia)*. Unpublished lithograph, drawn in September 1866. LD 3607.

170, opposite. Daumier: *La parade (Mountebank Playing a Drum)*. 1865-68. Charcoal, black chalk, pen and grey wash, watercolour, 44 x 33.4. Ex Esnault-Pelterie Collection. MD 534.

scornful – an expression, in fact, faintly reminiscent again of Baudelaire's 'Vieux saltimbanque' in *Le Spleen de Paris*:

> He did not laugh, the miserable soul! He did not dance, he did not gesticulate, he did not cry out; he sang no song, neither gay nor lamentable, he did not ask for anything . . . but with what a profound gaze, unforgettable, he looked over the crowd and the lights, of which the moving tide ceased a few yards from his repulsive misery![33]

Baudelaire spins a different tale of 'spleen' to Daumier's picture, but what their clowns have in common is a sense of alienation.

Two other figures in the *parade* groups relate to Daumier's political cartoons of 1867 to 1868, a period when the belligerent expansionist policies of Prussia were causing increasing alarm and counter-belligerency in France.[34] One is found in a cartoon drawn late in 1866 (fig. 171) but suppressed by the censors, which shows the Kaiser in drag as a fat woman wearing a dress labelled *Prusse*; its caption was to have been 'Trop grosse'.[35] It has been argued that the fat woman on the poster outside the tent ('a staple of nineteenth-century sideshows') resembles the figure in this cartoon. The other is the 'timid jumping jack' on the chair who resembles 'Carmagnole', the popular name for French soldiers under Napoleon I, whose resurrection during Napoleon III's reign Daumier satirized as 'Mars'.[36] That pathetic figure stood for French military force in 1868. The conclusion is that the watercolour is another of Daumier's attempts to warn his countrymen of the impending danger of war with Germany. But while this clearly had been his intention in a number of lithographs, especially after censorship eased in 1868, it is difficult to see this connection as the *sole* point of the watercolour, which was only going to be seen by the client who bought it. It was, admittedly, reproduced to illustrate an article by Eugène Montrosier on political caricature in 1878 (he was the first owner), but that was long after the relevant events. It seems more likely that Daumier was exteriorizing, in some more general way, a deep basic conflict between the clown as a needs-be entertainer and the clown as communicator of primary truths. If that is what this Pierrot's grim expression means, it would help to explain why the work imparts a sense of unease today, even though the original circumstances of its creation may no longer be known to the viewer. One further point about the execution of this watercolour is worth mentioning. When the proportions of the Pierrot are measured, it becomes apparent that whereas the upper part of his body corresponds exactly to the preparatory tracings, in the finished watercolour his legs have been lengthened by about half an inch on the paper, down to a new base line for his feet. The whole figure is over seven heads high, proportionately. This has the effect of giving him a more statuesque appearance, with a corresponding increase in authority.

Similar proportions are maintained in the magnificent watercolour of *La Parade*, known as *Mountebank Playing a Drum* in the British Museum (fig. 172), which, in my view, was executed later. This Pierrot has been moved from the country into the city. Standing in a shaft of full sunlight between tall buildings in a Paris street, he seems isolated from the passing crowd. Behind him is a table on which are the props of one of the 'turns' which are to follow. Note the three coloured balls and inverted cups: these are the stock in trade of an *escamoteur* (conjuror, trickster) found among the types of the 'Cris de Paris' from the period of the First Empire.[37] In the shadows behind are contained significant details, including a street urchin who watches the *saltimbanque* drummer intently, and a top-hatted bourgeois who studiously ignores him. In the far background is a mixed crowd including more bourgeois, a street porter carrying a load, and what looks like a horse-drawn bus carrying passengers on its top deck. The street urchin has been compared to the boy watching the barrel organist in *L'orgue de Barbarie* (fig. 62), leading to an assumption of a similar date of about 1860. However, the Paris *gamin* had been a stock image of Daumier's for many years before that, and could be summoned up,

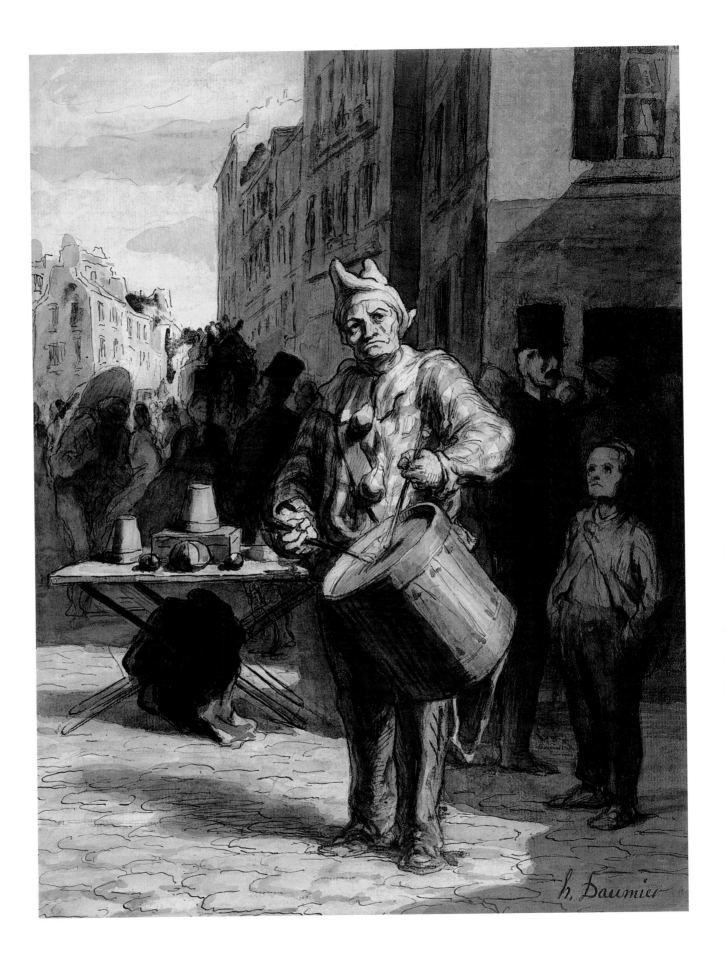

Daumier: *L'orgue de Barbarie (The Barrel Organ)*. Detail of fig. 62.

173. Daumier: *Le baiser de départ (The Parting Kiss)*. Lithograph published 20 September 1870 (subtitled *La République nous appelle!*). LD 3810.

172, opposite. Daumier: *La parade (Mountebank Playing a Drum)*. 1869–70. Black chalk, pen and grey wash, watercolour and gouache, 35.7 × 25.7. London, British Museum. MD 539.

as it were, any time later. I believe that this grim city Pierrot carries an even clearer reference to the Franco-Prussian war than his country twin, and that the British Museum watercolour is the last of this series, datable *c*.1869 to 1870. Technically it is also the most elaborate, carrying a greater variety of colours laid over a base of grey washes. At the same time its linear expressiveness is still recognizable as related to the lithographic style of the great cartoonist. Compare the linear force in one of Daumier's late lithographs, drawn in September 1870, to which he gave the title *Le baiser de départ (The Parting Kiss)* before a scriptwriter applied the more patriotic caption *La République nous appelle!* on the day the siege of Paris began (fig. 173).[38] The almost cursory haste with which this seems to have been drawn should not allow us to overlook the strength of the soldier's hands, comparable to those of the mountebank in fig. 172 or the near-abstract rhythms where a sea of faces merges into a sea of bayonets. And note that the ragged boy who watched the mountebank drumming appears to have joined the march. There seems every reason to believe that the conception of the British Museum watercolour is closely linked to the events that led to the fall of Napoleon III and the seige of Paris. It is not, however, a propaganda piece: its imagery is more obliquely personal to the artist.

Chapter 9

LAST YEARS (1870–1878), AND DON QUIXOTE

Daumier ceased keeping regular accounts of receipts from his publishers and private clients in *Carnet IV* after May 1866.[1] That is, with the exception of two isolated entries in 1867: a drawing sold 'for America' in October for 800 francs; and a painting sold in July to the dealer Hector Brame, of *Don Quixote and Sancho Seated at the Foot of a Tree*, for the same fair sum.[2] This quite small canvas is relatively highly finished, by Daumier's standards at least. His planned layout of *Carnet IV*, with equal spaces left for each month but mostly unused, suggests that he could have simply stopped entering his income in detail, after it became reasonably well assured. He certainly had more private clients than are entered here, and he went on drawing lithographs for *Charivari* until June 1872. In 1869 he was emboldened to send three watercolours to the Salon – and they were all lent by private owners. Neither Dr Court, who lent *Amateurs dans un atelier* (*Visitors to an Artist's Studio*, fig. 67) with another called *Juges de cour d'assises*, nor the Baron de Boisseau, who lent *La Mort et Les médecins* (*Death and the Two Doctors*, fig. 105) are listed in *Carnet IV*, although the probability is that he sold these elaborate watercolours to them not long before the Salon. At this point the artist was living at 36, boulevard de Clichy in a good studio apartment on the border of Montmartre in the 18th arrondissement, his last Paris address before he retired to Valmondois permanently in 1872.[3] A substantial *œuvre* in watercolour must have existed by then which he was using for sales, although he probably did not cease working until quite close to his death, and there is an identifiable body of later work in both oils and watercolours. We will find, moreover, a visible change in his attitude towards his subject matter after the disasters of the Franco-Prussian war.

Daumier remained in Paris throughout the months of the German siege, and also during the period of the Commune, when the city was besieged in turn by the Versailles government forces from 28 March to the end of May 1871, until the final week of bloodshed, incendiarism and executions which terminated the rebellion.[4] In his cartoons for *Charivari*, drawn with a new vivacity due to his obvious personal involvement in political events, he followed closely that tortuous period of French history, commenting on, for example, the crucial dispute about whether or not Paris rents which had remained unpaid during the siege should be made immediately payable. He selected this subject for two lithographs published in *Charivari* as a double page spread: one celebrating a decree of the Paris Commune granting a general remission of rents from October 1870 to April 1871, which showed a body (presumably a landlord) buried beneath a shower of *quittances de loyers*, the other showing Dufaure, the minister of justice at Versailles, presenting to an incredulous-looking group of lawyers his proposal for 'amiable arbitration'.[5] These were almost the last cartoons by Daumier published by *Charivari* before it shut down between 21 April and 12 June, evidently badly shaken by the turn of events. Daumier himself was drawn into the Federation of Artists of Paris, a body which had been chaired by Gustave Courbet since the declaration of a Republic on 4 September 1870, and he was elected to the Committee of Artists on 17 April. There is no evidence, however, to show that he was directly involved in the destruction of the Vendôme Column (the monument in the Place Vendôme topped by a statue of Napoleon I), much as he is known to have hated Bonapartists. We do know, however, that he was horrified by the effects and aftermath of the civil war – this can be gleaned from the evidence of

his last lithographs, which begin to read like a personal testament of despair. His decision to stay in Paris during the Commune – which might have been expected from one with such Republican sympathies – must have affected him more deeply than those artists who simply got out.[6]

Daumier drew his last lithographic stone in June 1872. It shows a group of three right-wing deputies (he called them 'réac[tionnaires] pied de nez' in his list) with long noses, asleep in parliament.[7] This final crack at his lifelong enemies, however, is overshadowed in our memories today by a more general image of death in an unpublished lithograph, *Les témoins* (*The Witnesses*), drawn the previous month (fig. 174). This has been thought by some to have been his last, but its order in *Carnet III* shows that it was not. His own title for it is very specific: *Morts témoins Bazaine* (meaning the Dead can testify against Bazaine). Marshal Bazaine, whose army had been immobilized at Metz while Napoleon III and MacMahon's forces were being destroyed at Sedan, was finally brought to trial before the War Council at Versailles in October 1873. (Edouard Manet was present at the trial and made some drawings in court.) In effect, he was held responsible for the great number of lives lost during the French defeat. By drawing an angry family of skeletons approaching the War Council as witnesses, therefore, Daumier actually antici-pated this trial by some fifteen months. Evidently he had been closely following events and made his own accusation in this form – which naturally would have been censored at that date. What is most interesting of all, however, is the wild symbolist style of drawing and the extreme nature of the imagery (one of the skeletons is decapitated even). A similar linear agitation is found in some of the late watercolours: the *paillasse* (clown)

174. Daumier. *Morts témoins Bazaine (Bazaine's Witnesses from the Dead)*. 1872. Lithograph published posthumously by Alexandre 1888 as *Les témoins*, wrongly dated 1873. LD 3936.

175. Daumier: *Paillasse (Clown on Parade)*. 1872-73. Black chalk and watercolour, 36.5 x 25.5. New York, Metropolitan Museum of Art. MD 547.

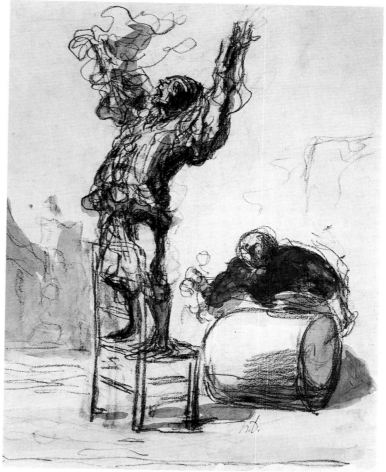

176. Daumier: *Paillasse (Clown)*. 1872-75. Pen and watercolour, 11 x 7. Paris, Louvre (RF 36,000). MD 507.

177. Daumier: *Deux saltimbanques au repos (Two Saltimbanques at Rest)*. 1873-76. Pen and grey wash, 24 x 15.7. Frankfurt, Stadelsches Kunstinstitut. Ex Maison.

178. Daumier: *Violoniste chantant (The Singing Fiddler)*. 1869-73. Charcoal, pen and grey-brown ink, grey wash, 29 x 23. Private collection. MD 333.

standing on a chair in an empty street, for example (fig. 175). He appears to be signalling madly to some lost audience, raising his voice in a deserted city landscape that looks remarkably like one of Daumier's own lithographs about the devastation of war.[8] The gnome-like drummer in a blood-coloured shirt who crouches behind him, hands flailing with drumsticks in multiple positions, looks as though he might be announcing the imminent fall of a guillotine. This watercolour was surely executed after the Franco-Prussian war, even though an idea for this pair of clowns may have existed in Daumier's mind in the 1860s.[9] On the verso of this sheet is a contour drawing in pencil of the British Museum's *Mountebank Playing a Drum* (fig. 172), which is probably a tracing used in its making. If the recto was subsequently used for *Paillasse*, a likely date would be *c*.1872 to 1873. It may seem unfinished compared to some of the watercolours, but the idea expressed could not be more complete, and it bears the artist's initials. Its first owner, Mme Bureau, lent it to Daumier's retrospective exhibition in 1878, so she evidently held it in some esteem.

The clowns that appear in Daumier's late drawings are not all sad and resigned, nor all frenetically active. However, they do show some signs of introspection and a certain nostalgia for the past.[10] A small watercolour sketch of an elderly *paillasse* is surprisingly cheerful in his expression, looking as though he could have stepped out of the Commedia dell'Arte in the eighteenth century (fig. 176). The relationship of Daumier's late oil paintings to the style of Fragonard has often been noticed, but in this drawing the rapid, spontaneous movements of pen and brush make one think of an even earlier precedent, namely the dancing figures of Jacques Callot.[11] Daumier added decorative touches of pink and blue to this wash drawing. In another study of two old clowns, drawn with trembling pen lines and washed lightly with grey, we find a reflective calm, suggesting a detachment not found previously in Daumier's work (fig. 177).[12] If one of these old fellows is telling the other a joke, it is for their own enjoyment, not for an audience. Such a work as this was likely made near the end of the artist's life, in private reverie.

Another class of entertainers closely allied to the *saltimbanques*, living on the edge of society and almost off into a world of their own, were the singers and musicians to be found on the streets of Paris at various descending levels of poverty. *Violoniste chantant* (*The Singing Fiddler*) is one of these (fig. 178). This theme is found in *Les Chanteurs de rue*, a wood engraving that Daumier designed for *Le Monde illustré*, published on 20 December 1862 at a time when the artist himself was somewhat down on his luck.[13] In the engraving the scene is set very explicitly: there are two men at a street corner, under a window-sill holding a flower pot, one playing a harp (an out-of-work orchestral player?) and one playing a kind of old-fashioned treble viol held low. In the drawing there is no locality indicated and the instrument is different: we see only the upper half of a dishevelled violinist sketched in charcoal, redrawn in ink and touched with grey wash. Everything is concentrated upon his character: open mouth, cavernous and exposing a single tooth; the exact relation of right hand and bow to the body of the violin (or viola?) and, more unexpectedly, the peg box and scroll of the instrument out in space, the left hand entirely absent. Clearly this is a drawing from imagination, a projected 'essence' of an old street musician, and I believe a late work.[14]

In Don Quixote and Sancho Panza, Daumier plainly found his two alter egos. The masterly if rambling tale could serve as a metaphor for Daumier's life: if the public still saw him as a streetwise clown, in private he was becoming a philosopher-dreamer. *Don Quixote* had always been extremely popular in France, frequently translated and published in illustrated editions from the seventeenth century onwards. In the eighteenth century it had appealed more as a kind of comedy of manners, and was illustrated as such in a series of twenty-eight sumptuous Gobelins tapestries commissioned from Nicolas Coypel (executed 1714 to 1757), and another colourful series of ten Beauvais tapestries designed by Charles Natoire (*c.*1734 to 1743). It was also the source of some thirty brilliantly lighthearted drawings by Fragonard – an artist Daumier is known to have

179. Daumier: *Don Quichotte et Sancho Panza en promenade aux chevaux (Don Quixote and Sancho Panza Riding)*. 1865-70. Black chalk, pen and grey wash, water-colour, 14.7 x 28. Providence, Museum of Art, Rhode Island School of Design. MD 440.

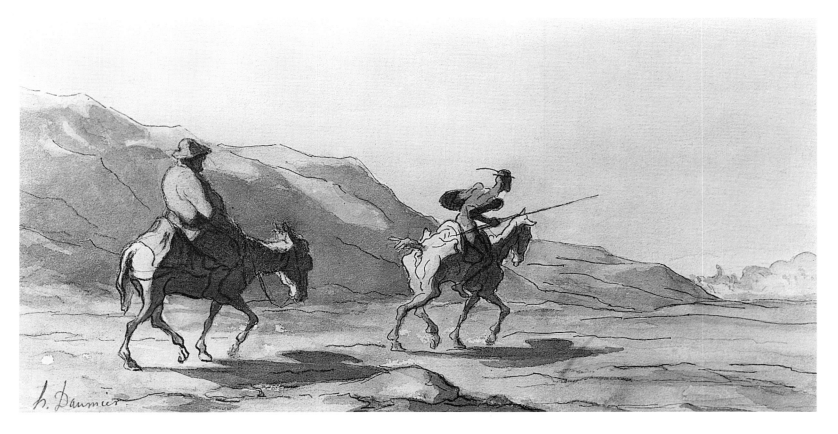

admired. In the Romantic era, however, Don Quixote and Sancho came to be viewed somewhat differently, as representing the dual nature of every creative personality, corresponding to the spirit and the flesh. One of Daumier's first paintings shown, at the Salon 1850/51, was catalogued as *Don Quichotte et Sancho se rendant aux noces de Gamanches* (it has never been certainly identified)[15] and in fact he treated this subject more often in oil paintings than in watercolours. Don Quixote and/or Sancho Panza appear in nearly thirty paintings with many variants of similar scenes, which suggests that the subject had some deeply personal meaning for Daumier. A number of drawings of these figures also survive, some related to paintings and some as independent conceptions. Finished watercolours of Don Quixote are rare however, which suggests that this subject had more limited appeal to Daumier's paying clients than it did to him. An exception is *Don Quixote and Sancho Panza Riding* (fig. 179), which exists in three versions in watercolour and a fourth in grey wash.[16] In the version illustrated, Don Quixote is preparing for battle with 'the enemy' in the distance, actually a group of travelling merchants, while Sancho hangs back. The construction of this watercolour is spare and concise: an underdrawing in black chalk is brushed over with coloured washes, mainly beige and grey, then all contours were redrawn in pen and touches of colour added to Sancho's shirt and saddle. This arid desert landscape perfectly suits Daumier's rather theatrical conception, which emphasizes the difference between the two characters by their silhouettes and body movements. The watercolour was lent by its first owner, M. Béguin, to Daumier's retrospective exhibition in 1878, and a nearly identical version lent by M. Van der Hoewen to the same exhibition![17] There are several other drawings and oil sketches of the pair in this line-ahead arrangement, showing them trotting towards whatever disaster. At other times Sancho Panza gets left behind, when nature calls or he falls asleep. The finest renditions of Don Quixote and Sancho together were executed during Daumier's last years, generally in the medium of oil paint. One of these was *Don Quichotte courant sur les moutons* (*Don Quixote Charging a Flock of Sheep*) which he sold to Mme Bureau in 1876 (fig. 181), as he recorded in his last account book. Before looking more closely at these late oils it is worth examining the evidence provided by *Carnet V*, in the light of reports of his supposed blindness in old age.

On the outside cover of this last surviving record are written the dates 1875–6: it belongs entirely to the period of Daumier's retirement at Valmondois. Only two pages contain entries, but these are written in a firm clear hand and run from November 1875 to April 1877 (see Appendix, *Carnet V*, pp. 173–4).[18] During this period of twenty months he sold eleven paintings and approximately fourteen drawings[19] for a total of 10,450 francs. Taken together with his small state pension which was then 1,200 francs a year, this would have given the artist an average monthly income of 622.50 francs. His widow had some financial problems after his death, but evidently they should have been managing all right when he was alive. The problem which now presents itself, is were these sales all from a heap of old works brought from Paris, or was he actually working, after his retirement in 1872, in the studio at the end of the garden which his landlord had constructed for him when he first began to rent the cottage? I would like to suggest that the latter may have been true. There is the romantic notion that Daumier's labour over his lithographic stones got too much for him and he retired 'blind', but this is not the same thing as weakening eyesight. His biographer, Arsène Alexandre, is quite specific with his information about Daumier's last years. After making a great fuss about his 1878 exhibition at Durand-Ruel's being organized by friends because of Daumier's sickness and poverty (which was not altogether true, as some political interests were involved as well) Alexandre writes that at this point, namely early in 1878, his sight had been getting feebler for some time already ('sa vue allait en s'affaiblissant, depuis quelque temps déjà').[20] This was not absolute blindness, but a dimness of sight ('un trouble'), a fatigue, a sort of intermittent veil which, at each new health crisis, grew darker. He could still

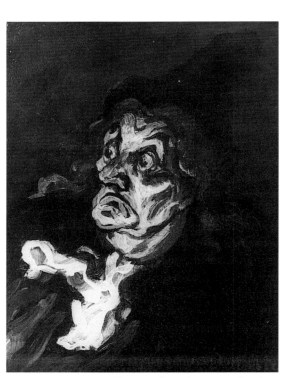

180. Daumier: *Le médecin Diafoirus (Doctor Diafoirus)*. *c*.1873-76. Oil on panel, 23 x 17.5. Private collection. MI 223.

distinguish objects vaguely, but only just enough to be able to regret his infirmity all the more. And then, he could draw no more, being explicitly prescribed from it by the doctors. That sad state was reached a year before his death in 1879. One wonders what his visitors found him doing before then.

The purchasers listed in the 1875 to 1877 account book differ from the buyers in the 1860s, with the exception of Mme Bureau. Monsieur P. Aubry, who lent seven works to the exhibition in 1878, bought the largest number of paintings and *croquis* (small drawings), perhaps as many as sixteen items. They include a 'D.Q^tte' [Don Quixote] *toile de 6* bought in November 1875 for 1,000 francs, possibly the late oil now in the Armand Hammer Collection,[21] and a picture of an advocate for the same sum on 28 April 1876 which, if it was the same size, could be the late painting of an advocate reading in a private collection in Winterthur.[22] It is possible that the description *avocat* applies equally to the painting and to the *croquis* sold to Aubry on 12 May for 150 francs, here identified with the watercolour later in the Esnault-Pelterie collection (fig. 128).[23] It is odd that Daumier should have described that fine watercolour as a *croquis*, but again its loose handling may not have met conventional standards of finish. Aubry also bought a '*panneau de 1*' described as 'Esquisse médecin de Molière' in April 1877, identifiable as *Le médecin Diafoirus* (*Doctor Diafoirus*), executed in a style figuring a peculiar weaving motion of the brush (fig. 180), leaving trails of paint which nowadays we would call expressionist, but in fact simply echoes his touch with graphic tools near the end of his career (compare fig. 177). Was Daumier beginning to find that with failing eyesight he could manage better with a large brush than with chalks or sable? There are about a dozen paintings only in this very late style: otherwise it seems possible that he could have been painting with a fairly firm hand up to within a year or two of his final loss of effective sight.

It is worth questioning what Daumier thought he meant by the word *esquisse* when recording his sales. He used this term for the wash drawing *Amateurs dans un atelier* (identifiable as *An Artist and Two Connoisseurs in a Studio*, fig. 81) that he sold to Aubry on 20 April 1877, although normally he only applied it to oil paintings. The word is also used in his description of the highest priced item in *Carnet V*. On 1 October 1876 he wrote: *Esquisse Don Quichotte (courant sur les moutons) à Mme Bureau / 1,500* [francs]. This is the large canvas now in a private collection in New York (fig. 181). It seems incredible that he could have regarded this magnificent painting in full colour, which is a *chef d'œuvre* among his representations of Don Quixote,[24] as a *study*. At 56 × 84 cms it is a 'marine' *toile de 25*, an unusual size for Daumier. Perhaps he had meant to go on with it, before Mme Bureau got it away from him. Another possiblity is that the deeply personal meaning of Don Quixote for Daumier (as mentioned above) meant that he never intended such works for sale: as Werner Hofmann put it, 'Don Quixote represents the artist who refuses to bend towards the exigencies of the market and proclaims the right to dispose himself freely'.[25]

It is possible to read *Don Quichotte courant sur les moutons* (*Don Quixote charging a flock of sheep*) as in some way being a projection of Daumier's inner self. Don Quixote – the refined, ultra-sensitive artist broken out of his atelier, as it were – is shown charging down a hillside at a long white cloud of dust which he sees as a prodigious army of men, but which Sancho Panza knows perfectly well is churned up by a large flock of sheep. Daumier has understood Cervantes' text perfectly: by not painting in the sheep, he makes it clear that what the white cloud stands for depends upon who is looking at it. Don Quixote's alter ego, Sancho, the down-to-earth one, is now prominently in the foreground on his mule, wringing his hands and turning towards the viewer with an agonized expression as his warning goes unheeded: 'Turn back! Oh I wish I had never been born!'.[26] The dramatic spaciousness of Daumier's conception, with the dark, richly coloured figure of Sancho rooted to the spot in the foreground while an equally

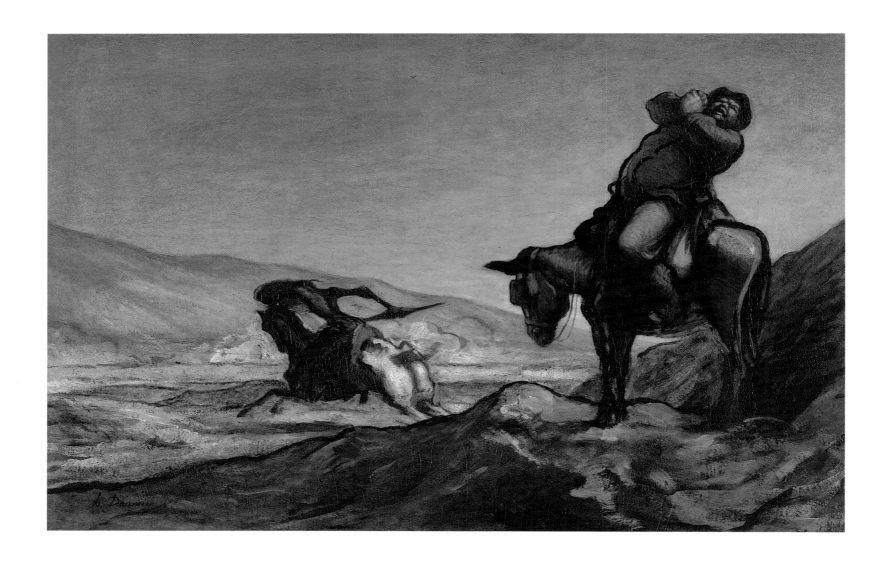

181. Daumier: *Don Quichotte courant sur les moutons (Don Quixote Charging a Flock of Sheep).* c.1867-75. Oil on canvas, 56 x 84. Private collection. MI 184.

sharp silhouette of Don Quixote leaps across the stage, as it were, into an ethereal and chalky background, is like the climax of an opera. The writhing, heavy lines with which Sancho and his mule are enclosed are reinforced, once more, *on top* of the colour that models their forms. A similarly powerful use of paint-drawn contours is found in a more sketchy composition, *Don Quichotte et la mule morte* (*Don Quixote and the Dead Mule*) which is datable to 1867 (fig. 182). On the assumption that Daumier had gained full control of the oil medium by that date, it is a possible starting point for *Don Quichotte courant sur les moutons*, though as this painting appears to have been worked on over a period of time it is highly likely that he took it to Valmondois with him and continued to paint it there.

Don Quichotte et la mule morte, on the other hand, could hardly have been taken with him because it was painted as a mural decoration on the wall of Charles-François Daubigny's studio in Auvers-sur-Oise in 1867.[27] The canvas which was used as its support has a white absorbent ground which makes it look very like a mural. The paint was thus put on very dry, without a single drip from either the wet, brush-drawn contours or the scumbled tones and colours. The principal subject, the dead mule, who appears in this position in two other paintings[28] is rendered purely in line, with a brush that shows absolutely no hesitation. A characteristic Daumier touch is the interested expression of Sancho's living mule, compared to the aloof indifference of his master's

144

horse, Rosinante. Don Quixote himself is seen from below, an ethereal figure like the white horseman of the Apocalypse. An evening sky of pink, blue and grey was added behind the steep enclosing mountain walls, and Daumier's 'decoration' was left laconically complete. Camille Corot painted a pendant for it soon afterwards, more elaborately finished, which also included Don Quixote and Sancho Panza. (Both paintings were commissioned by Daubigny in the same year.) Corot's composition is in some senses the

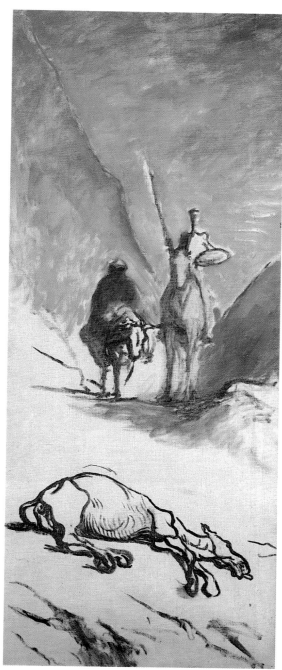

182. Daumier: *Don Quichotte et la mule morte (Don Quixote and the Dead Mule)*. 1867. Oil on canvas, 137 x 59. Paris, Musée d'Orsay. MI 209.

183. Daumier: *Don Quichotte à cheval (Don Quixote on Horseback)*. *c*.1870-73. Oil on canvas, 51 x 33. Munich, Bayerische Staatsgemäldesammlungen. Neue Pinakothek.

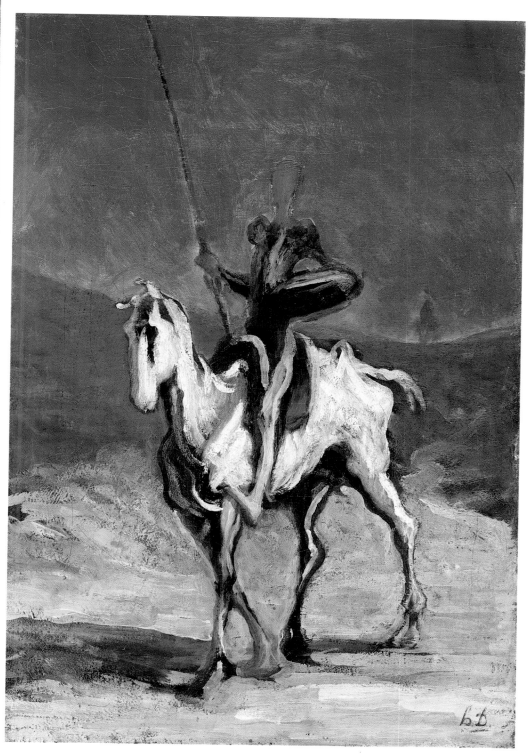

reverse of Daumier's: Don Quixote and Sancho are relegated to small silhouettes in the background of a landscape, while the foreground is filled with dark trees and a rock against which a man (Cardénio, the owner of the dead mule) prostrates himself in despair.

Even more laconic in narrative content are Daumier's later paintings of Don Quixote, in which he appears riding with Sancho through barren landscapes or mountainous defiles with no story line at all. They are more like disembodied presences (even Sancho), sometimes spaced apart as in the arid setting of the Munich painting *Don Quixote on Horseback* (fig. 183) in which Sancho is almost out of sight under the torrid blue sky, and sometimes close together, as if for comfort in the falling dusk, as in *Don Quixote and Sancho Panza Riding* (fig. 184). Both paintings are very abstract in conception, both in the formal and the literary senses of the term, but because the Munich painting is so 'modernist' – its colouring makes contemporary viewers think of Matisse – it has become the better known of the two. I had dated it *c*.1868 to 1870,[29] but in view of more recent researches I would now conjecture that it could be later still: even a kind of silent celebration of Daumier's retirement in 1873. The silhouette of Don Quixote's figure on horseback, and the angle of his projection, are identical in both versions, but the scale of the Courtauld Institute painting is twice that of the other. In both cases the knight's features are left virtually blank, the points of his shoulders are raised like the bones of a skeleton, and he holds his shield flatly like an artist holding a palette. The horse Rosinante, on whom he sits with a high-pommelled Spanish or Mexican-type saddle, is equally bony with skeletal prominences, but master and horse manage to maintain a kind of crazy, aristocratic aloofness from the reality of things. All this is expressed by body-posture alone, which Daumier was a master at portraying. Unique to the Courtauld version is the close proximity of Don Quixote and the usually trailing and whining Sancho; here for once he seems as resigned to his fate as his master, hands folded in front of him like a priest, and the mule with meekly lowered head as though in imitation of the donkey bearing Christ. The deep irony of this representation goes well beyond any specific incident in the written narrative, though not necessarily outside the deeper significance of Cervantes's intention concerning his whole discourse. The two figures are ridiculous in their disparity, pathetic in their raggedness and utterly noble in their bearing. The image thus conveyed mentally is in fact passed to the viewer very precisely by means of its style of painting. The paint is dribbled and scumbled, lines drawn in liquid paint meander and criss-cross all over the place, and the final image emerges through a mysterious series of overlaid glazes, until at last the full visual effect on the viewer sinks in. (It takes a little while to do this.) There are three or four horizontal black chalk lines drawn on the canvas in the bottom left corner, as though Daumier was mentally marking out his stage, so to speak, and signs of chalk underdrawing elsewhere on the figures. From then on all lines are drawn in wet, with a brush, in burnt umber or burnt sienna, with white and grey touches laid over them which begin to model (but not to solidify) the forms. The ground colour of this wood panel is a roughly brushed, scraped-down white, which has then been toned in certain areas with a thin reddish-brown imprimatura. The subsequent drawing and modelling in liquid brown paint and trans-parent whites and greys gives enough warm and cool vibrations to dispense with further colouring. This calls for some definitive analysis of the final stage of Daumier's art: his late style in oil painting.

A relatively unproblematic late painting, *Le Troubadour* (fig. 185) serves as an exemplary case study of Daumier's technical mode of composition, to employ a musical metaphor. It has been suggested that the subject may relate to a play performed in January 1869 entitled *Le Passant*, about a high-minded fifteenth-century Italian troubadour, from which Daumier might have been asked to do an illustration for a private client.[30] Be that as it may, what is most interesting here is the evidence of Daumier's

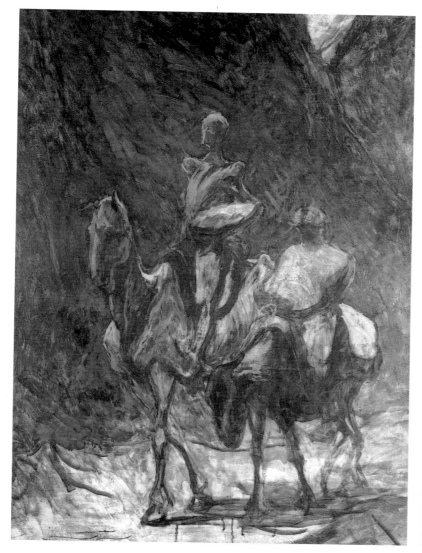

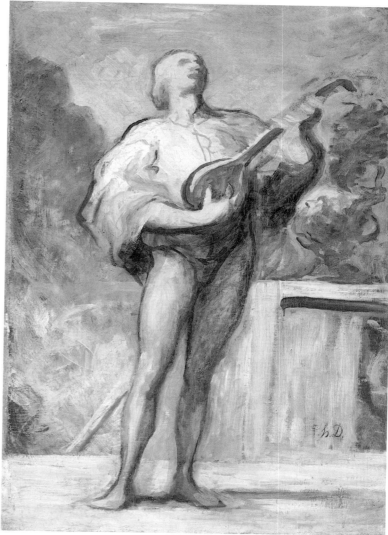

184. Daumier: *Don Quichotte et Sancho Panza en promenade aux chevaux (Don Quixote and Sancho Riding)* c.1870-75. Oil on panel, 100 x 81. London, Courtauld Institute Galleries. MI 227.

185. Daumier: *Le Troubadour.* c.1868-73. Oil on canvas, 83.6 x 56.8. Cleveland Museum of Art, Leonard C. Hannah Collection. MI 186.

preparation of his ground tones. Research has revealed that he applied a white ground layer (the bottom tacking margin is bare canvas for the most part) and then a thin transparent brown imprimatura, covering most of the front surface. This brown imprimatura has a boundary, running down roughly from where the background foliage meets the sky, through the shadowed part of the lute-player's torso and up the other side. Where the scumbled blue and white sky colour meets this boundary, a grey line is formed by the overlap. Kenneth Blé writes:

> Darker brown layers of paint were thinly applied in broad areas, as well as thicker brush-textured applications of white paint. Subsequent applications of white are translucent brush-marked layers with some wet-in-wet mixing of adjacent and under-lying layers of other colours. The white paint [strokes] on the proper right shoulder of the lute player were applied with a flat tool like a palette knife. Dark brown fluid strokes of paint form the outlines of the composition.[31]

This most useful analysis indicates that Daumier applied several layers of toned ground while working out the definition of his figure, and also that there are several 'translucent brush-marked layers' of white paint here which act upon and modify the colours beneath them. In total, this painting seems to be a deliberate experiment in glazing techniques

147

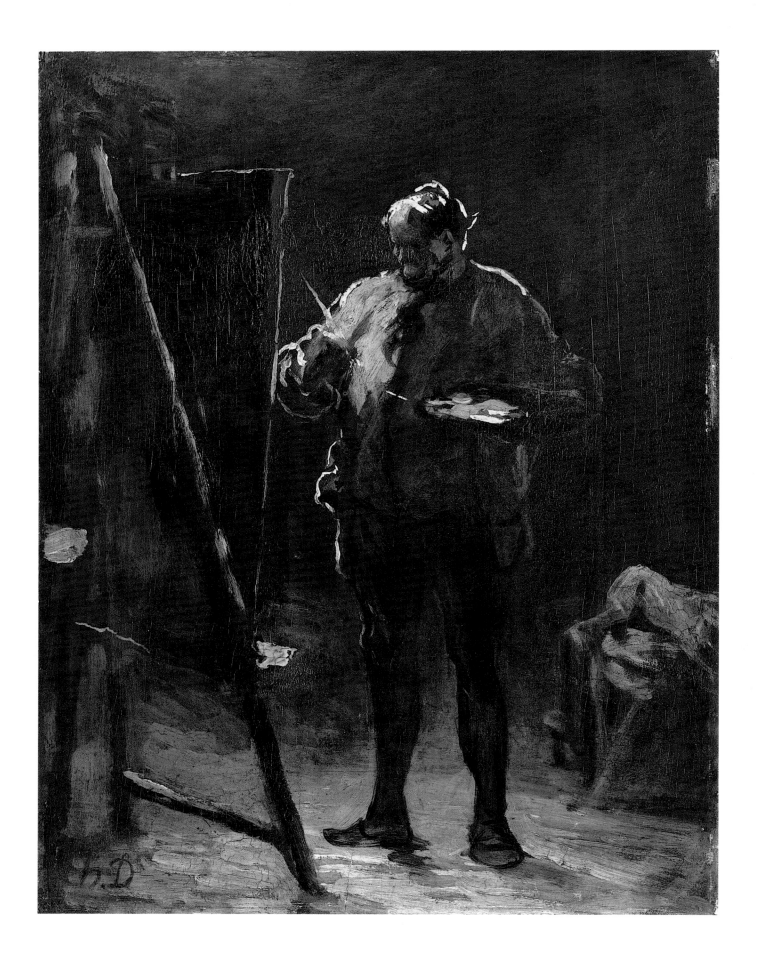

with oil paint, combined with expressive use of the brush as a drawing tool, which defines and will dictate Daumier's practice in his late painting style. In this style the whole process of the painting is revealed, and remains revealed as it progresses, so that the image when completed (or abandoned, it does not much matter which) is like a continuous transparent skein of paint. In such a context it becomes quite misleading to describe Daumier's late paintings in terms of either traditional finish or impressionist homogenous spontaneity. What he appears to have been seeking at the end of his career was a single image of 'creative performance' that could be read all at once, through all its stages of physical creation. That, to my mind, is the only possible explanation for the existence of two or even three replicas of the same image in several cases among Daumier's late paintings: he was trying to perfect the performance.[32]

The three versions of *Le peintre devant son tableau* (*The Painter at His Easel*) are about the most extraordinary case in point. All the versions are oil on panel, but whereas two of them are the same size, the third is what Maison calls 'a miniature version' of the others — whether done before or after them is impossible to say. The Phillips painting (fig. 186) is identical with its twin in Williamstown, form for form but not stroke for stroke. In each case the ground tone is a very dark red-brown. Upon this the first drawing is done in black with a brush; the final contours and modelling are indicated in thick white paint using the point of the brush. A hidden source of light illuminates the artist from behind, so that he is framed by a kind of halo. There are other colours in the shadows, bluish-green and grey, and brighter colours in the highlights: light red on the palette, pinkish-ochre on the artist's head and shoulders. Touches of vermilion are found on his cheek, on the shadow side, and on his palette. The key to this performance is in the lines of the silhouette. These are just drawn once, with a sable brush, with slightly different rhythms in each version. It is like watching a virtuoso practice: and in this case the virtuoso is himself represented in the persona of 'the artist' (who is not necessarily Daumier himself). So who is this artist? He stands, slightly astride, on muscular, springy legs like those of the men in Daumier's most powerful lithographs (compare the legs of the belligerent 1830s printer in fig. 10). The canvas the artist works on is relatively large, and so active is his stance, brush in hand, that we can hardly assume that it is empty. Psychologically, this picture is the very antithesis of the mental state conveyed by the earlier watercolour of the artist seated before his easel, clasping his knees (fig. 64). Small-scale though this painting is, it surely represents an artist of independence, no longer encumbered by the material obligations of earning a living. Yet if we are hoping to catch a glimpse of 'the true Daumier' here, it must be admitted that this is a very reticent image, one which ignores the presence of the viewer. The artist's attention is given to another picture we cannot see: the result is a closed, internalized meditation, not that far from the ambience of Don Quixote.

In the opening chapter I mentioned Daumier's capacities as a sculptor. Two things need to be born in mind: one, that in spite of the magnificent achievement of the *Ratapoil* maquette of 1850 (fig. 188)[33] and a very few other pieces, in all cases his sculpture was quite ancillary to his drawings and paintings. Clay modelling was a medium he used occasionally to explore something else: a visual three-dimensionality that would be conveyed time and again in his most imaginative works on paper and on canvas. Secondly, many of his friends were sculptors, starting with Geoffroy-Dechaume, the loyal and lifelong friend who helped him in times of trouble and was the centre of a solid craftsman's business working on the restoration of public monuments. (It was Geoffroy-Dechaume who made the best plaster casts of Daumier's clay models.) Other friends were the heroic, unassimilable romantic sculptor Auguste Préault, who died (poor) in the same year as Daumier, and the solitary, but prodigiously talented, animal sculptor Antoine Barye, who also belonged to the Romantic generation and died in 1875, the same year as Corot. Sculpture was notorious in the nineteenth century for being the

186, opposite. Daumier: *Le peintre devant son tableau (The Painter at his Easel). c.*1873-75. Oil on panel, 33.3 x 25.7. Phillips Collection, Washington D.C., Gift of Marjorie Phillips. MI 222.

worst possible medium through which to achieve public success and acclaim; the materials were hideously expensive and the working conditions arduous, and costly also in terms of renting studio space. So if Daumier as a painter was a solitary fellow, many of his sculptor friends were probably still more isolated from success. All this is somehow implied in fig. 187, his very late painting known as *L'atelier du sculpteur* (*The Sculptor's Studio*). The bearded figure on the left has sometimes been thought to resemble another sculptor who was both romantic and republican, J.-B. Clésinger, though not on any firm grounds. This head is rendered with very loose strokes, as though the paint itself were modelling clay or plaster rapidly applied: it could be arbitrarily compared to a portrait head by J.-B. Carpeaux of *Dr Achille Flaubert*, modelled in 1874 as a private commission and therefore open to a more expressive texture than would be expected of a more public work.[34] (Carpeaux's own loosely executed paintings bear a superficial similarity to Daumier's.) However, the two figures in his painting might just as well be *connoisseurs* visiting the studio. The maquette they are looking at, which we see from the back, resembles the sensual little groups which can be found amongst the bric-a-brac in

187. Daumier: *L'atelier du sculpteur (The Sculptor's Studio)* c.1875-77. Oil on panel, 26.6 x 35.5. Phillips Collection, Washington, D.C. MI 233.

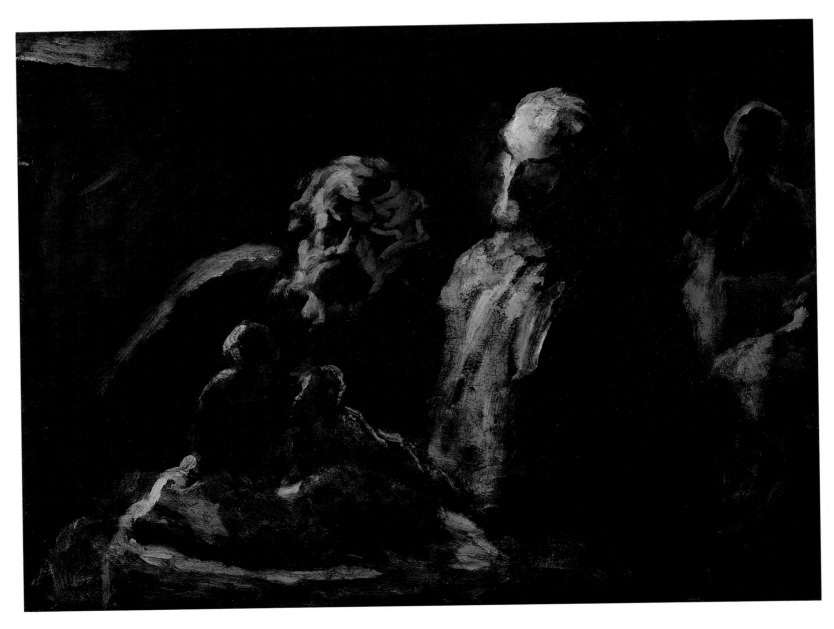

150

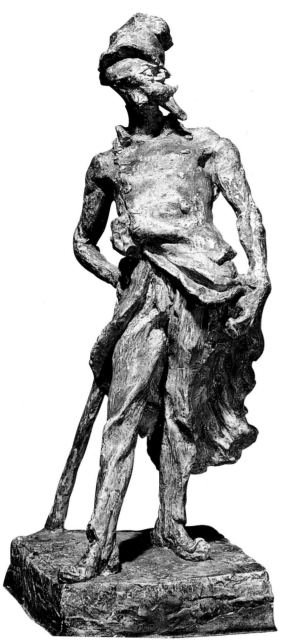

188. Daumier: *Ratapoil*. Plaster statuette from clay of 1850, 43.18 high. Buffalo, New York, Albright Knox Art Gallery, Elizabeth H. Gates Fund.

Daumier's watercolours of *amateurs* with their collections. But now the whole effect depends upon the gestural brush strokes which evoke this scene: the 'graphic' scumbling of white, pink and blue-black over a dark reddish ground, lit up by a touch of vermilion in the background, the whole kept transparent and fluid. The head of the man standing up straight lacks the definition of an eye, as though the socket had just been gouged out by a sculptor's scalpel. In his very latest works Daumier seems to have been preoccupied only with the process of being an artist, with or without any relation to a patron, and certainly without any relation to the requirements of the state or the Salon. These were the conditions under which he had been working at the end when, after he finally became unable to use his eyes any more, a group of friends organized a retrospective exhibition.

The exhibition was held in Durand-Ruel's galleries at 11, rue Peletier from 15 April to 15 June 1878. It was organized by a large committee of friends and supporters, mainly artists and writers with republican connections. The motives behind the timing of that event were fairly complex: it amounted to the first historical attempt to place Daumier before a wider public as *artiste-peintre*, above the level of his general renown as cartoonist. The moving spirit was Daumier's sculptor friend Geoffroy-Dechaume. Victor Hugo accepted the title of *Président d'honneur*, and he was joined by three vice-presidents, the republican senators Corbon, Henri Martin and Peyrat. Two large galleries contained ninety-four paintings, 139 drawings and watercolours, two plaster reliefs of *Fugitives* and some of the terracotta busts of parliamentary deputies that Daumier had made in his youth; one drawing on a wood block, five separately framed lithographs,[35] together with twenty-five frames of other lithographs the selection of which was changed twice a week. This selection of Daumier's lifelong *œuvre* thus gave a quite different slant to his achievement than that which had previously been taken for granted. He himself provided sixteen paintings and thirteen drawings and watercolours, but the bulk of the exhibits were lent by private owners, including several fellow artists. Unfortunately the publicity was badly organized and few people came on a rather disastrous opening day. While the exhibition was on, however, a number of press articles appeared praising Daumier as a great artist, although they all encountered difficulty in explaining how a genius of a *cartoonist* should now be regarded as an artist on an altogether higher plane of production: his work as a painter was presented as a surprise discovery.[36] Baudelaire, Champfleury, and even Hippolyte Taine had previously published articles arguing for the recognition of Daumier as an artist 'in a domain considered non-artistic',[37] but the presentation here stressed the 'artistic' works. All aspects of Daumier's subject matter were represented amongst the oils and watercolours, though in the case of the latter by far the largest number exhibited were of lawyers and court scenes – an area in which he had previously made his name as a cartoonist. The oils were more evenly distributed, including fair representations of *saltimbanques*, Don Quixote, theatre scenes, amateurs, bathers in the Seine and children playing. There were two washerwomen. It also emerges, from the titles printed in the catalogue, that Daumier's revolutionary sympathies were played down, or at least safely relegated to the past. The picture of *La République* was subtitled *Concours de 1848*; the *Scène de la Révolution* in which a young woman leads a populist uprising was exhibited simply with the title *Une foule*;[38] and four representations of fugitives were catalogued as *Le coup de vente, Course au bord de la mer, Émigration* and *Une fuite* respectively.

The debate about which aspect of Daumier should be valued most has gone on ever since depending, apparently, upon what interested groups or individual polemicists want to use his work to prove. I have tried to show that the 'great cartoonist' is the same artist with the same mind, whether working as a maker of prints, providing watercolour drawings for sale at modest sums for modest clients – dwellers in the same social world to which he belonged – or painting in greater solitude his unfinished pictures in the

traditional 'high art' medium of oils. Few great artists have been as unassuming as he, in pursuing their enquiries into the condition of men and women.

Daumier died at Valmondois on 10 February 1879, after several periods of illness. As mentioned above, he had been virtually blind for the last year of his life. A number of obsequies appeared in the national press and journals. He was first buried in the local Valmondois cemetary, but a group of friends raised a public subscription for a monument in Père Lachaise cemetary, on a plot which was provided by the Municipality of Paris. He was reinterred there on 16 April 1880, and Madame Daumier was buried beside him when she died in 1895. Neighbouring tombs are those of Corot and Daubigny.[39]

Daumier's 1878 exhibition at Durand-Ruel's had not brought him any great increase in fame, but it did bring the full range of his work to the attention of an enlightened group of collectors, and prices for his work, especially his watercolours, increased considerably after his death. Ten years later his work made a prominent contribution to an exhibition held at the École des Beaux-Arts, entitled *Exposition des Peintures, Aquarelles, Dessins et Lithographies par les maîtres français de LA CARICATURE, et de la Peinture de Mœurs au XIXᵉ siècle.* This was drawn up by a committee of thirty members chaired by Antonin Proust, and it cast a wide net for its exhibitors. Among 517 catalogue entries, there were engravings after Carle Vernet, lithographs, drawings and paintings by Delacroix, Isabey and Decamps, as well as all the major nineteenth-century cartoonists and portrayers of manners, from Raffet to Gill. What was distinctive about it was that all the exhibitors were represented by original drawings (and often paintings as well) in addition to their prints. The catalogue contained an historical essay by Paul Mantz on 'La Caricature Moderne', in which Gavarni and Daumier come out as the two dominant figures: 'the grace of Gavarni' is contrasted with 'the robustness of Daumier'.[40] Daumier himself was represented by twenty-one oils, forty-six drawings and watercolours, twenty-one major lithographs and eight more frames of prints containing about eight items each: the emphasis was therefore more on his achievement as a cartoonist than as a painter, in spite of his august company. As in 1878, a large proportion of his watercolours exhibited were of lawyers and court scenes.

This situation was finally reversed when Daumier was represented by important groups of both oils and watercolours in the Paris Exposition Universelle in 1900. His reputation as an *artiste-peintre* was further cemented by the very large *Exposition Daumier* held at the École des Beaux-Arts in 1901, devoted entirely to his paintings and drawings (306 items). The brief preface by Gustave Geoffroy stressed the universality of his art. Thereafter, when major paintings by Daumier began to be acquired by public museums in Germany in the early years of the twentieth century, and the foundations were laid for *catalogues raisonnées* of his *œuvre* in all media and various languages, he finally became recognized as a major figure in the history of Western culture. We may be sure, however, that he would have resisted canonization.

Daumier's Account Books[1]

Five notebooks or *carnets* inscribed in Daumier's hand were acquired, at different times, by the late M. Jean Cherpin, and they are now in the archives of the Municipal Library of Marseilles. They were all made by the artist himself from sheets of Canson-type drawing paper cut and folded small, sewn together at one seam to make books of different shapes and sizes. Each *carnet* is of divergent date and purpose. The entries are made sometimes in pen but more often using a blunt conté-crayon, too thick for the size of the handwriting aimed at, and put down probably at the end of the day's or week's work. Two of the *carnets* (numbers I and IV) record his cash receipts for lithographs and woodblocks sent to publishers, the later entries overlapping with receipts for paintings and drawings sold to private clients from 1864 on. Records of payments out, and promissory notes to pay, occupy all of *Carnet II* and part of *Carnet IV*; *Carnet III* is devoted exclusively to numbering and dating his lithographic stones, and also records his own short titles of the subjects. In *Carnet V*, two pages only record sales of paintings and drawings in 1875–77. Although the years covered by these surviving account books give a far from complete picture of Daumier's affairs, there is enough variety in these idiosyncratic records to allow insights into specific aspects of his productive life. We may perceive Daumier's priorities.

Cherpin listed the *carnets* in chronological order from the dates of commencement of each.[2] The pages are not numbered in the originals, but for convenience of reference I have assigned them numbers in the transcriptions which follow, giving odd numbers to recto and even numbers to verso folios.

Carnet I

(Bibliothèque Municipale, Marseille. Accession No. MSD4).
Laid paper folded and sewn together to form 16 folios 16 × 12 cms, including covers.

Records all Daumier's orders for lithographs and wood engravings (referred to as *bois*) delivered from November 1837 to September 1840. The lithograph references generally refer to titles of series. I have tried to reproduce the written forms that Daumier used: he abbreviated as much as he could, and was not particular about putting in accents. All entries are in black chalk (the crayon sometimes blunt) unless otherwise indicated. Commentary is confined to endnotes.

Outside front cover: numerical calculations.

Inside front cover and page 1:

Monsieur Dagnot est venu pour vous parle	*Novembre 1837*	
	1r – 1 robert M[acaire][1]	40
	4 – id	40
	7 – id	40
	13 – id id	40
	22 – 1 histoire N[aturelle][2]	35
	29 – 5 histoire N	150
		—
		345
		—
	Decembre id	
	1r – 1 robert M[acaire]	40
	8 – petite affiche	40
	12 – pte affiche	40
	18 – 1 Robert M	40
	21 – R.----M.	40
	23 – petite affiche	40
	27 – Robert M	40
	31 – R----M	40
		—
		Total 320

Pages 2 & 3:

Janvier 1838		Mars	
le 8 1 robert M.	40	6 – 1 croquis expressions	40
le 11 id 2. M.	40	7 – 1 histoire N[aturelle]	35
16 revue physionomique[3] . .	40	11 1 croquis d'exp.	40
25 id	40	13 – Bourdes caricature[5]	60
29 robert M.	40	23 – Croquis d'exp.	40
	—	26 – Croquis id	40
	200	Bourdes	45
	—	31 – 2 Croquis d'exp	80
			—
fevrier		[Total should be 380]	400
le 4 1 revue physionomique	40	avril	
8 1 id – id	40	le 4 1 Robert Macaire	40
10 1 robert M.	40	le 9 Robert M.	40
14 2 croquis d'expressions[4]	80	14 1 id	40
16 1 id – id	40	27 Piat	40
20 1 id – id	40	+ robert M.	40
23 1 histoire N. gorge toreau			—
[sic] [not priced]			200
26 2 Croquis d'Exp.	80		
28 1 robert M.	40		
	—		
[Total should be 440 or 435] 400			

Pages 4 & 5:

Mai		Juin Total	
			—
le 2 Croquis d'Exp.	40		320
6 2 id – id	80		—
10 1 id – id	40	Juillet	
15 1 id – id	40	12 1 Croquis d'Exp.	40
21 1 id – id	40	[inserted] sur les 350 fr avancé/1	
25 1 robert M.	40	retenue de 10 f[8]	
id 1 Croquis d'	40	14 1 double faces[9]	
28 1 id – id	40	40
31 1 id – id	40	16 1 id – id	40
	—	19 1 id – id	40
	400	22 1 id – id	40
Juin		25 1 id – id	40
le 5 1 Croquis d'exp.	40	31 1 id – id	40
6 1 robert Macaire	40		Tot —
9 1 robert id	40		280
13 1 pierre vente	20	Aout	
16 1 robert M.	40	3 1 robert Macaire p. Lyon	40
20 1 quiproquo[6]	20	id 1 Croquis d'Exp	40
26 1 croquis d'Exp.	40	6 1 id – id	40
29 père françois[7]	40	10 1 Croquis d'Exp	40
30 1 robert M.	40	14 1 id – id	40
		18 1 id – id	40
			—
		Tourner le fl 240	

Pages 6 & 7:

Aout		23 Septembre	370
du 3 au 18	240	25 Bois	20
le 20 1 robert Mac.	40	28 Bois	30
23 1 croquis d'Exp.	40	28 1 Croquis d'Exp	40
27 1 robert M	40	29 Bois	50
30 1 Croquis d'Exp	40		—
	—	Total 510	
T. 400			
Septembre		Octobre	
1 robert Mac.	40	2 1 Robert Mac pr Lyon	40
5 1 robert M. par Lyon	40	3 1 id	40
id id – id	40	6 Bois	20
8 1 Robert M.	40	7 Bois	65
11 1 Croquis d'Exp.	40	8 Bois	40
14 Bois pour M. Lesestre[10]	25	10 Bois	40
15 id – id – id	25	[inserted] du 10 au 31	
17 1 robert Macaire	40	1 titre gravé de la Caricature[11]	100
19 Bois – id	25	Bois	55
22 1 robert macaire	40		—
23 Bois	15	Total 400	
	—		
a reporter 370			

154

Pages 8 & 9:

Novembre		Decembre 335	
du 1r au 13 –		18 Bois	65
1 Mr. Gogo[12]	40	22 titre de la caricature[13]	40
1 Croquis d'Exp.	40	27 titre de la caricature tonture . . .	40
17 1 Gogo	40	29 prospectus a la plume	
22 1 Gogo	40	Charivari[14]	125
24 1 Gogo	40	30 Bois	30
26 1 Croquis d'Exp.	40		—
29 Bois p. Dutacq	40		T. 635
	—		
	T. – 280	Janvier 1839	
Decembre		4 Bois	60
1r 1 Croquis d'Exp	40	8 Bois	60
4 Bois	90	12 titre de la Caricature	40
8 Bois	60	15 3 titre de la Caricature Métier	120
12 2 Croquis don 1 p. Lyon . . .	80	id Bois	85
14 1 Bois	25	22 Bois	40
18 1 Croquis d'Exp	40	25 Croquis d'Exp	40
	—		—
a reporter 335		a reporter 445	

Pages 10 & 11

Janvier 1839		du 1r au 19 fevrier	195
du 1r au 25.	445	23 Bois	65
28 2 Croquis d'E [illeg.] p Lyon	80	25 Bois	55
31 1 Croquis d'Exp remené . . .	30		
31 4 Croquis id	160		
	—	Total	315
Total [95 crossed out] 715		Mars	
Fevrier		– 1r retour des 2000	
5 1 Croquis d'Exp	40	2 Expos. de l'industrie	40
9 1 id id	40	2 Bois	40
15 1 Boeuf gras p. Lyon[15]	40	9 Jury de Peinture[16]	40
17 1 Croquis d'Exp	40	Le 9 Mars touché 1000fr	
19 Bois	35	27 Bois	30
	—	29 Tête de la Caricature	40
a reporter 195			—
		Total	190

Pages 12 & 13

Avril 1839		Mai	
1 2 robert M. Bois	40	5 1 annonces[19]	40
7 1 Tête de la Caricature	40	10 2 celibetaires	80
id 1 Celibetaire[17]	40	13 1 Tête de la Caricature	40
11 2 Celibetaires	80	id 1 Moeurs Conjugales[20]	40
14 1 Tête de Caricature	40	1 robert M. Bois	20
15 2 robert M. Bois	40	17 1 id	20
17 Bois p. Dutacq	35	21 1 Tête de la Caricature	40
20 1 Saltimbanques[18]	40	23 No. 2 et 3 Moeurs Conj	80
id 1 Tête Caricature	40	27 1 Celibetaire	40
28 1 Saltimbanques	40	30 1 Natation[21]	40
id 1 Bois salon	40	id id Moeurs Conjugales	40
id 1 robert M. p Dutacq	80	31 1 Moeurs Conjugales	40
id 3 Rob. M. Bois	60	id 1 Scènes Grotesques[22]	40
id 1 retouche de R.M.	20	id 1 Tête de Caricature	40
	—		—
T. — 635		T. — 600	

Pages 14 & 15

Juin 39		[40 crossed out] Juillet 200	
3 1 figaro émotion	40	8 2 Grotesquerie	80
7 2 Celibetaires 1 annonce	120	1 Emotion de P[aris]	40
14 1 Baigneurs 2 Tête d'E.	120	12 1 Cinq Sens odorat[25]	40
18 Baigneurs i Moeurs C.	80	13 1 Moeurs Conjugales	40
+ 1 Tête de Car.[23]	40	id 1 Coquetterie	40
+ 1 Grotesquerie	40	17 1 Moeurs Conjugales	40
1 Moeurs Conjugales	40	id 1 Scène Grotesque	40
1 Coquetterie[24]	40	25 3 Célibetaires	120
1 Natation	40	id 1 19me Siècle	40
	—	30 1 Moeurs Conjugales	40
T. – 560		1 Coquetterie	40
	—	1 Emotions parisiennes	40
Juillet			—
3 Emotion de Paris	40	Total 800	
1 Scène Grotesques	40		
8 1 Coquetterie	40		
1 Conjugales	40		
1 Baigneurs	40		
	—		
a reporter 200			

Pages 16 & 17[26].

Aout 1839		Septembre 1839	
2 1 Cinq sens la vue 50		6 1 TYPE Parisien 40	
id 1 Baigneur 40		11 2 Actualités 80	
9 1 Cinq Sens le gue 50		16 1 Type P 40	
1 Caricature le Creancier[27] . . 50			
14 1 antichambre d'un mideian		2 Baigneurs 80	
Carica. 50		2 Emotions 80	
1 Le toucher 50		17 1 Baigneur refait[32] 20	
1 L'ouie 50		2 Types parisiens 80	
16 1 Baigneur 40		2 Bois 20	
id 1 Baigneur 40		21 1 Actualité Beterave[33] 40	
23 1 Emotion 40		25 1 Actualité Bourse[34] 40	
id 1 Emotion nr. 6[28] 40		31 2 Types parisiens 80	
29 1 Emotion nr. 7[29] 40		—	
id 1 Baigneur 40		T. 600	
id 1 id......nr 10[30] 40			
id 1 Type Parisien[31] 40			
id 1 Actualité 40			
id 2 Actualités 80			
—			
T 780			

Pages 18 & 19

[written in pencil, top right]: au 21 8br 1140 de retenir		9bre	
8bre		6 3 Bois 120	
		12 2 Nemesis 80	
3 2 Moeurs Conjugales 80		14 1 Bois p Dutacq 40	
8 3 Moeurs Conjugales 120		id 3 Emotions 120	
11 2 id id 80		17 2 Bois némésis 80	
14 1 pratique de paris 40		18 1 Emotion 40	
1 Emotion 40		25 2 Les parisiens[37] 80	
17 2 Emotions 80		26 2 Bois Dutacq 80	
21 1 Moeurs Conjugales 40		id 1 Emotion 40	
id id 40		30 1 parisiens 40	
id id 40		4 Emotions 160	
25 5 petits bois 100		—	
31 1 Emotion 40		T. 880	
id 1 bois 20			
id français[35] 75			
id 1 Tête de page 25			
id 2 Nemesis médicale[36] 80			
—			
T. 900			

Pages 20 & 21

10bre		Janvier 1840	
2 1 Nemésis 40		6 1 Nemésis 40	
12 2 id 80		7 Bois p. Curmer 150	
17 3 Coquetteries 120		10 1 Nemesis 35	
21 2 Nemesis 80		14 1 Emotion 40	
31 3 Emotions 120		1 Coquetterie 40	
id 1 Coquetterie 40		1 Actualité[38] 40	
id Bois pour Curmer 45		14 2 Nemésis 70	
—		20 Bois de Curmer 69	
T. 525		id. 1 français 125	
		28 2 Emotions 80	
		30 1 français 125	
		Bois P. Curmer 70	
		—	
		884	

Pages 22 & 23

fevrier		Avril 1840	
3 2 Nemesis 70		8 2 Emotions 1 Coquetterie . . 120	
6 Bois P. Curmer. 60		10 1 actualité 40	
22 2 Moeurs Conjugales. 80		1 attention 25	
28 2 id – id 80		1 Nemésis 35	
—		15 actualité 40	
T. 290		1 Moeur Conj. 40	
		1 Types parisiens 40	
Mars		17 1 id id 40	
3 Nemesis. 95		23 2 id id 80	
1 actualité. 40		1 Coquetterie 40	
20 Bois p. Curmer. 155		29 1 Baigneur 40	
22 1 Moeur Conjugale. 40		30 3 Baigneur 120	
25 2 Parisiens. 80		—	
27 1 Nemesis. 35		T. 660	
31 3 Charivari donc 1 de 25[39] 105			
—			
T. 550			

Mai			Juin		
	1 Type parisien	40		1 Type parisien	40
	1 id	40		1 proverbe	40
	1 id	40		1 parisien	40
15	2 Sentiments[40]	80		1 ventre affamé [proverb][42]	40
	1 baigneur	40		1 moeurs conj.	40
	1 Types p	40	16	1 a bon chat bon rat [proverb]	40
	1 Jour de famille	40		1 la patience est la vertu	
	1 parisiens	40		[des ânes: proverb]	40
	1 proverbes de f.[41]	40		1 Bien venu qui apporte	
	1 actualité	40		[proverb]	40
		—		1 Les petits présens	
	T	440		[entretiennent l'amitié:	
				proverb]	40
				1 pecheur à la ligne	40
				1 un homme sans abri[43] [est	
				comme un oiseau sans nid:	
				proverb]	40
				1 comme on fait son lit on se	
				couche [proverb][44]	40
				2 Types parisiens	80
				2 proverbes	80
				nemesis[45]	35
					—
				[Total 640 crossed out]	
				T	675

Juillet			aout		
1 Sentiments et P.	40		1 Moeurs Conjugales	40	
1 Emotions	40		1 Caractère[47]	40	
2 Proverbes	80		2 Caractères	80	
2 pecheurs[46]	80		Nemesis	100	
1 Emotions	40		Moeur Conjugale	40	
1 Pecheur	40		Caractère	40	
1 Baigneur	40		Croquis d'Expression[48]	40	
1 Emotion	40			—	
1 Moeur Conjugale	40		T.	380	
2 Pecheurs	80		Septembre		
1 Emotion	40		1 caractère	40	
	—		1 moeurs Conjugales	40	
	560		1 Coquetterie	40	
			1 Caractère	40	
			2 Caractères	80	
			2 Nemesis	80	
				—	
			T. a reporter	320	

[September 1840 continued]		
7bre	320	9ᵉ h le matin
2 moeurs Conjugales	80	
1 Coquetterie	40	Te casse votre
1 macaire	40	
1 Coquetterie	40	pipe en pas fait [?]
1 Caractère	40	
	—	votre attention [?]
T.	560	-----
		Mlle. Gruaux rue du
		chemin neuf 24
		Montmartre

Outside of back cover: rough sketch of gable section of a house and numerical calculations.

Carnet II

(Bibliothèque Municipale, Marseille. Accession number MSD3.)
Laid paper sewn together to form 14 folios 31 × 12 cms, including outside front and back covers both used as pages.

In boxes drawn freehand for each month of the year from September 1852 to November 1862, Daumier notes bills outstanding, in most cases cancelled with a cross to denote payment. Names of suppliers and dates are inscribed, and also certain deliveries of fuel, and wine by the cask. While some of these names recur fairly constantly, the sums listed are extremely irregular, ranging from zero to over 400 francs in one month. The probability is that they are notes of debts outstanding at the end of each month, rather than records of how his total budget was spent. It is possible to reconstruct his lifestyle, to some extent, during this period by identifying certain of his creditors. Notes on these will be found at the end. It can be deduced that by September 1860 Daumier was heavily in debt, for the second time in his life.[1]

Most of the entries are in pen and ink, with additions in black crayon some of which are so faint that they may have been deliberately erased.

Pages 2–3 (1853)

Janvier 1853		Mai	
fin Billet ville[part crossed out]	37f	fin Billet Touzard	100f
20 Billet Lyon [sic, for Lion]	50f	15 Billet Thibault	100f

fevrier		Juin	
fin Billet poietevin		fin Billet Touzard	40f
[sic, for Poitevin]	60f		
20 Billet Touzardy	100f	15 Billet Thibault	100f
25 billet Willems	25f	25 Billet Willems	25f 60

Mars		Juillet	
fin Billet Poitevin	50f	fin Billet Thibault	100f
20 Billet Touzard	100f	15 réglé M. Thibault le terme	
25 Billet Willems	25f	de Janvier 1853	
		15 réglé Mr Willems son compte	
		montant a 169 en Billets de 25f	

avril		Aout	
fin Billet Touzard	100f	fin Billet Thibault	100f
renouvellé		15 Billet Willems	25f
p. fin 7bre			

Outside cover (which serves as page 1):

7bre 1852		
		Payé
15 Billet Verolot .	.50f	payé
30 Billet Vauquelan25f	

8bre 1852		
		Payé
15 Billet Verolot .	.50f	
30 Billet Vauquelan25f	
fin Billet Willems .	.25f	
20 reçu 3 voies de Kok et une voie		
de bois		

9bre 1852	
20 Billet Dauphin	60f
fin Billet poietevin [sic, for Poitevin]64f 50c
fin Billet Willems .	.25f

10bre 1852	
fin Billet poietevin .	.60f
15 Billet Lion .	.40f

Pages 4–5 (1853–54)

Septembre		Janvier 1854	
fin Billet Touzard	100f	fin Billet Willems	25
15 Billet verrolet	125 payé	10 reglé a M. Lion la facture de 62f	
1er reçu une pièce de vin de 148f		15 Billet Thibault	100
18 réglé a Mr. Thibault le terme		20 Billet Touzet	20
d'avril 1853			

octobre		fevrier	
fin Billet Willems	25	15 Billet Willems	25
15 Billet Thibault	100f	20 Billet Touzet	20
29 reçu 3 voies de Koke une		fin Billet Camus	100
demi voie de bois		11 reglé a M. Thibault le Terme	
30 reçu une pièce de vin		d'octobre 1853	

novembre		Mars	
fin Billet Willems	25	15 Willems	19f
15 9bre Thibault	100	fin Mars Billet Camus	100
reglé le 15 a M. Camus la		15 Billet Thibault	100
somme de 280			
pour 2 pièces de vin reglé en			
3 Billets			

decembre		avril	
5 Dejorte Thés [note in crayon]		15 Billet Thibault	100
15 fin des BB. [note in crayon]		4 reglé a M. Willems la facture	
fin Billet Willems	25f	montant [a]	63f
15 Billet Thibault	100	4 reglé a M. Thousard la	
20 Billet Touzet	25	dernière facture montant a . .	310f
21 reglé a M. Thibault le Terme			
de Juillet 1853			

Mai	7ᵇʳᵉ
15 Billet *Camus* 80	15 Billet Touzard 90
17 reglé a M. Thilbaut le terme de Janvier 1854 en 2 billets de 100f pour fin d'aout et fin 7ᵇʳᵉ	fin Billet Thibault 100
25 Billet Desmarest 74	
fin Billet Thilbaut 100f	

Juin	8ᵇʳᵉ
15 Billet Lion 62f	15 Billet Verollot 100
29 Juin Billet Touzet 30	fin Billet Thibault 100
fin Billet Thilbaut 100f	10 h. 18 Octobre reçu une pièce de vin de 190f de Ceuille
29 [reçu] une pièce de vin de 170f Percot	

Juillet	9ᵇʳᵉ
15 Billet Desmerest50	15 Touzard 90f
27 reglé a M. Peraut [sic, for Percot] une Pièce de vin de 170f en deux Billets	25 Billet Verollot 46f 50
	fin Billet Thibault 100
	le 8 reçu une voie de Koke et une demi voie de charbon de terre

aout	10ᵇʳᵉ
15 Billet Touzard 50f	15 Willems 63
fin Billet Thibault 100	25 Billet Touzard 50
10 reglé a M. Thibault le terme d'Avril 1854 en deux Billets fin 8ᵇʳᵉ et fin 9ᵇʳᵉ	fin Billet Percot 100
	28 reçu une voie de Koke

Janvier 1855	Mai
15 Billet Touzard 90	20 Billet Vauquelin 25
25 Billet Percot 70	Billet Ceuille [very faint] 90
T. 20	fin Thibault 100
8 assurance 20	
le 9 reglé a M. Thibaut les termes de Juillet et octobre 1854 en 4 Billets fin mars avril, Mai et Juin	

fevrier	Juin
15 Billet Touzard 50	20 Billet Vauquelin 25
T. 80	fin Thibault 100
assurance 20	
fin Percot 70 [very faint] [same as bill above] 17 reçu une voie de charbon de terre 220	

Mars	Juillet
15 Billet Italens 56	T. 80
assurance 20	fin Billet Lion 37
25 Billet Laveur 100	
fin Mars Billet Thibault100	
28 reglé..	

avril	Aout
T. 80	20 Billet Vauquelin 25
25 Billet Laveur 90	15 Billet Desmarest 50f
assurance 20	fin traite Camus 95
T. 20	21 reglé a M. Thibault le terme de Janvier 1855 en deux Billets fin 7ᵇʳᵉ fin 8ᵇʳᵉ
fin Thibault 100	

Pages 10–11 (1855–56)

7^{bre}	Janvier 1856

7bre	Janvier 1856
20 7bre Billet Vauquilin 25	15 Billet Verollot 50
15 Billet Desmerest 66	20 Billet Touzard 50
fin Traite Laveur 95	T. 20
[Laveur carried down to next month]	fin Traite Laveur 95
15 7bre Thibault 100	[pencilled total] (215)

8bre [95]	fevrier
T. 20	15 Billet Verollot 98
15 Billet Thibault 100	fin Billet Touzard 50
	T. 60
	fin Traite Laveur 95
	[pencilled total] (303)
	fin Billet Thibault 100
	25 reçu une pièce de vin de 200f

9bre	Mars
fin Billet Bamier 75	20 billet Touzard 50
T. 60	15 Billet Desmarest 50
9 reçu 3 voies de Koke 1 voie de bois et une demie voie de charbon de terre 15 reçu une pièce de vin de 200f [in margin] 28 reglé a M. Thibault les termes d'avril et Juillet 1855 en quatre Billets de cent francs fin février mars avril et Mai	fin Billet Thibault 100

10bre	avril
fin Billet Bamier 80f	[20 crossed out] fin 50
15 Billet Verollot50	Billet Touzard
	15 Billet Desmarest 50
	fin Billet Thibault 100

Pages 12–13 (1856)

Mai	7bre
20 Billet Touzard 50	fin B. Desmarest 40f
15 Billet Desmarest 50	
fin Billet Thilbaut 100	fin D.C. payé 100
Laveur 100	

Juin	8bre
20 Billet Touzard 39	fin Billet Desmarest 40
15 Billet Desmarest 58	fin D.C. 100
23 reçu une pièce de vin de 220f	fin Laveur 100

Juillet	9bre
15 Billet Desmarest 60f	fin Billet Desmarest 40
	fin D.C. 100
fin D.C. payé 100	21 reçu 3 voies de Koke
[An entry in black chalk here was erased]	½ voie de charbon de terre

Aout	10bre
fin Billet Desmarest 60	fin Billet Desmarest 26.45
	fin Billet Destot 40
fin D.C. payé 100	

Pages 14–15

Janvier 1857	Mai
fin Billet Destot 34.55	fin billet Desmarest 25
le 4 reçu un tonneau de bière	15 B. Peullier 50

fevrier	Juin
fin Billet Desmarest 50f	fin Billet Desmarest 25f
fin Billet Peullier 50f	fin B. Tousard 40
	le 9 reçu un fût de bière

Mars	Juillet
fin Billet Peullier 50f	fin Billet Desmarest 25
16 reçu un tonneau de bière	fin B. Touzard 40
	le 30 reçu un fût de bière

avril	Aout
	fin Billet Desmarest 25
	fin B. Touzard 42

160

Pages 16–17 (1857–58)

7^{bre}	Janvier 1858
	fin Billet Desmarest 25
	fin Billet Thibault 100



Pages 16–17 (1857–58)

7^{bre}	Janvier 1858
	fin Billet Desmarest 25
	fin Billet Thibault 100
8^{bre}	**fevrier**
5 Billet B. 250	fin fevrier B. Desmareth 25
fin Billet Laveur 100	fin Billet Thibault 100f
9^{bre}	**Mars**
fin Billet Laveur 100	fin Billet Desmarest 25
	fin Billet Laveur 65
10^{bre}	**avril**
fin Billet Touzard 47	fin Billet Desmarest 25
	fin billet Laveur 65
	10 Billet B. [crossed out] 200
2 reçu une voie de Koke B.	
Billets R. fin Janvier	
[crossed out] 200	

Pages 20–21 (1859)

Janvier 1859	Mai
fin B. Verrollot 50f	fin Desmarest 50
15 Thibault 100	15 Billet Touzard 92
	25 B. R. 200f
fevrier	**Juin**
fin B. Verrolot 50	[blank]
Desmarest fin 50	[June and July must have been the
25 B. R. 200	period of Daumier's nearly fatal
	illness, recorded by Baudelaire]
Mars	**Juillet**
fin Billet Verollot 72	[blank]
fin Desmarest 50	
avril	**Aout**
fin Desmarest 50	fin Billet Debove Balny 50f
	fin B. Desmarest 25

Pages 18–19 (1858) (several entries on these pages are in black chalk instead of ink)

Mai	7^{bre}
fin B. Desmarest 50f	fin B. Verrollot 50f
fin B. Thibault 100	Touzard 50
	fin Desmarest 25
	15 B. Thibault 100
Juin	**8^{bre}**
fin B. Desmarest 50f	fin B. Verrollot 50
fin B. Thibault 100	Touzard 50
	fin Desmarest 25
	Thibault 100
Juillet	**9^{bre}**
fin B. Desmarest 45f 80c	fin B. Verrollot 50f
fin Touzard 50	Touzard 42
fin Mareux 70	fin Desmarest 50
fin B. Thibault 100	20 B.R. 200
	[sideways in box] Traite Homéo
aout	**10^{bre}**
fin B. Verollot 50	fin B. Verollot 50f
[in faint pencil] Touzard 50	fin Desmarest 40–20c
[in pencil crossed out] 20 B.R. 200	fin B. Brémont 35–75
	15 Thibault 100

Pages 22–23 (1859–60)

7^{bre}	Janvier 1860
fin Debove Balny 50	fin B. Lefevre 50
fin B. Desmarest 25	fin B. Thibault 100
fin B. Lefevre 50	
8^{bre}	**fevrier**
fin Billet Desmarest 25	fin Billet Lefevre 50
fin B. Lefevre 50	fin Desmarest 39f
	fin B. Thibault 100
9^{bre}	**Mars**
fin Billet Desmarest 50f	B. Lefevre 70
fin B. Lefevre 50	fin Desmarest 25
	fin B. Brémont 35
10^{bre}	**avril**
[blank]	fin Billet Rellay 50

Pages 24–25 (1860)

Mai		7^{bre}



Pages 24–25 (1860)

Mai	7^{bre}
fin B. Rellay 50f	[top of page blank]
fin Desmarest 25	
fin B. Thibault100f	
	fin . 500

Juin	8^{bre}
fin Billet Rellay 70f	fin Billet Verollot 82
fin B. Lefevre 72	fin Rellay 52
fin Desmarest 25	
fin B. Thibault 100	

Juillet	9^{bre}
fin Billet Rellay 50f	[blank]
fin B. Desmarest 25	
fin B. Thibault100f	

Aout	10^{bre}
fin B. Desmarest 25	[blank]
15 B. Thibaut [sic] 100	[Daumier's new financial difficulties have evidently begun]

Pages 26–27 (1861) In the last two pages of this carnet Daumier crammed in two years' entries by drawing smaller compartments. His format is reproduced here for clarity.

1861		[1862]	Juin
Janvier B. Debove Balny fin50	Juillet fin B. Lefevre 50	[page torn]	Juillet
fevrier fin B. Debove Balny50f	aout fin B. Lefevre 50 fin Mareux . . 50	Janvier 1862 fin Lefevre . .50f fin Debove . .50	aout
Mars fin B. Debove Balny 46	7^{bre} B. Lefevre fin 50 fin Mareux . . 71	fevrier fin Debove . . 56	7^{bre}
avril [blank]	8^{bre} fin B. Lefevre 37 Lefevre fin renouvellé . . .50	Mars [blank]	8^{bre} Billet Debove Balny fin 75f–75
Mai fin B. Lefevre 50 Mareux fin 100 renouvellé 50f	9^{bre} fin Lefevre . . 50 renouvellé	avril [blank]	9^{bre}
Juin fin Billet Lefevre 50 fin Mareux . . 71	10^{bre} fin Lefevre . . 50 fin Lefevre . . 50	[page torn]	[page torn]

Page 28, which forms the outside back cover, has no named records but under the sign *T.* is this list of figures:

150	Billet 110
100	18
100	20

which is repeated lower down and totalled as *698 [sic]* francs.

This total is added together with another of 168 (arrived at by multiplying 42 by 4) under the heading *T . . . 1861 to 1864*. This dubious calculation is the only tenuous link between this *Carnet II* and *Carnet IV*, in which bills are listed beginning December 1864.

Notes on some of Daumier's creditors, in the order in which their names first occur

Verolot or *Verrolot* received fifteen payments between 1852 and 1860, most often in the late autumn and winter months. His name does not appear in Didot-Bottin, which suggests that he was not a shopkeeper or a registered professional. These monthly payments are quite large, never less than 50 francs, as high as 125 francs, and they come in groups in certain years: therefore for a substantial commodity. It happens that the payments to Verrolot in 1852, 1853, 1854, and 1856 (winter) match Daumier's records of deliveries of coke ['Kok' or 'koke'], wood and coal in those years, and although the dates of delivery and payment do not exactly coincide it does suggest this was his supplier of winter fuel. In some years he seems to have paid in instalments, some before and some after delivery. After receipt of 'une voie de Koke' in December 1857 Daumier no longer notes the arrival of these items, although Verrolot is paid an unusual total of 322 francs during the winter of 1858/59, and a further 82 francs in October 1860 before his name disappears.

Vauquelan or *Vauquilin*, who was paid a total of 50 francs in 1852 and 75 francs in 1855, all in 25 franc bills, turns out to be *Vauquelan*, a *médecin-oculiste* who lived on the Ile Saint-Louis at 3, rue Arcole. We could speculate one pair of close-work glasses purchased in 1852, followed by a modified prescription three years later.

Willems is more puzzling: a series of payments of 25 francs each are probably all advance-dated bills. An account totalling 169 francs on 15 July 1853 was settled by eight such separate bills, the last one paid on 15 March 1854 for 19 francs to complete the total. Further evidence will show that this was about the price of a cask of wine, although Willems is not listed as a wine merchant in Didot-Bottin.

Dauphin, an unusual surname, is found among woodworkers and frame makers in the north of Paris. The single payment to Dauphin of 60 francs on 20 November 1852 could conceivably have been in settlement for a frame supplied for a painting submitted to the Salon of 1853, but as nothing of Daumier's was accepted that year it is impossible to verify this.

Poitevin (November 1852 to March 1853) can definitely be identified with a grocer of that name living in the rue Saint-Louis-en-l'Ile, in the centre of the Isle Saint-Louis. 50 or 60 francs a month for groceries might be taken as indicating a norm, therefore.

The fairly common name of *Lion*, which occurs in five separate entries from 1852 to 1855, is found in Didot-Bottin among shoemakers in the Marais. The account *reglé* for 62 francs on 10 January 1854 was apparently settled by means of a bill forwarded to 15 June for the same sum. Groceries would not be paid for so irregularly, and it was probably for ladies' shoes or mens' boots (Lions made both).

Thibault was Daumier's landlord at 9, quai d'Anjou (see chapter 3, pp. 34 and 42). The first mention of Monsieur Thibault, a veterinary surgeon, as an inhabitant of this house at the time when Daumier is said to have been living there is in the Didot-Bottin *Annuaire Générale de Commerce* for 1847. In the 1854 edition Thibault is described as 'le jeune Polonaise'. He is established as the proprietor of No. 9 in the *calepins cadestraux* (registers of assessments for property taxes) for the 9th arrondissement, which included the Ile Saint-Louis at that epoch. The description of Thibault's property in the *Révision cadestrale* of 1863 includes a covered entrance with a coach house at the back; four floors of apartments above the concierge on the ground floor, each with its own entrance hall, two rooms and a kitchen, assessed at rental levels from 750 francs to 640 francs (moving up the staircase) per quarter. On the top (fifth) floor, reached via a small room with a fireplace, was an atelier with four windows, valued at a 'prix réduit' of 300 francs per quarter. (Data from Archives de Paris, Département et Ville de Paris. *Les calepins de révision du cadastre* are found under the code DP⁴. These have been preserved back to 1840 for certain streets; otherwise those of the *Révision* of 1862 are more complete. I am indebted to Alison Garwood-Jones for pointing me towards these.) 300 francs is the price that Daumier records paying Thibault in this *carnet*, at 100 francs a month, either on the 15th or at the month's end. He keeps a running tally of *termes* (quarters) owed, which were *réglé* (settled up) anything from two to six months in arrears. He occasionally misses a payment or, more rarely, pays twice in one month in an effort to catch up (as in July and December 1853). On 28 November 1855 he is eight months behind, and undertakes to settle up the quarters which had been due the previous April and July in four forwarded bills of 100 francs each (his usual strategy). There is a hiatus in the entries for Thibault between May 1856 and January 1858, only partially filled by payments to an agent called 'D.C.'. When payments to Thibault recommence there are more gaps, with blank boxes for June and July 1859, when Daumier was so ill that he 'almost died' according to Baudelaire, who was keeping Mme. Daumier company then [*Correspondance Général*, VI, p. 26]. Payments to Thibault finally cease after August 1861.

The name of *Touzard* is found in Didot-Bottin only for tailors, but Daumier's 28 payments to this person from 1853 to 1859 are far too frequent for such a trade, and the nature of his business is difficult to determine. The 100 franc bills in the first months of 1853 look almost like a rent-collecting agency, but they overlap payments to Thibault (q.v.) so this cannot be so. The *dernière facture montant à 310f* settled on 4 April 1854 follows a period of six months without payment: could this be grocery bills averaging just over 50 francs per month? (If so, Touzard could be the replacement for grocer Poitevin.) The average monthly payments to Touzard slowly diminish through 1855–56 and then become irregular; after a final payment of 92 francs on 15 May 1859 his name disappears abruptly, which coincided with a notable change in Daumier's fortunes (see chapter 3, p. 42). It may have been the last bill of credit that he could obtain in this line of supply.

A certain amount has been written (inaccurately) about Daumier's regular consumption of wine. His suppliers can be readily identified in this *carnet*. Both deliveries from and payments to wine merchants *en gros* are noted. *Camus* is the first name to appear, delivering *une pièce de vin de 148frs* on 1 September 1853, another on 30 October, and his account is 'settled' on 15 November by three promissory bills dated February, March and May 1854. That was the Daumier's winter supply of wine. Camus is followed by wine suppliers *Percot*, *Ceuille*, and *Laveur*. The price of the casks varies, but a steady rise can be perceived from about 140 francs a cask in 1853 to as much as 220 francs on 23 June 1856. If Daumier's supplies lasted him to the end of the latter year, it could be calculated that over a period of $3\frac{1}{4}$ years he, together with his wife and visitors, consumed nine casks of wine. Given the capacity of the casks as averaging 220 litres each (another variable there), their average consumption would be 609 litres per year or 1.67 litres per day of good quality wine. However, purchase at these prices evidently could not be sustained, and in 1857 Daumier switches to drinking beer instead! *Laveur*'s name reappears, however, later in 1857 and in 1858, though with smaller bills: either for cheaper wine or smaller quantities. In 1859 no wine merchant entries can be identified, but the five modest payments to *Rellay* in 1860 can be associated with a wine merchant of that name who lived on the Ile Saint-Louis and is listed in Didot-Bottin. So Daumier enjoyed his wine.

Desmarest, whose name continues in Daumier's accounts through his change of address from the Ile Saint-Louis to Montmartre, is a very puzzling case. There are no fewer than 40 monthly payments running with fair regularity from May 1854 through July 1860 (1859 being an exception), mostly in 25fr. and 50fr. bills with some other specific small sums, and five more entries (in *Carnet IV*) ranging from 30 to 50 francs in 1864–65. Daumier was hardly likely to have kept the same grocer after he moved, and although Didot-Bottin does list Desmarest grocers,

none are in any of the vicinities where Daumier lived. It is a fairly common name. One surprising possibility could be a *Desmarest, impr. lithog.*, listed in Didot-Bottin for 1852 and 1856 as living in the rue Grenelle-St. Honoré in the old 4th arrondissement near the Palais Royal. But why should Daumier be paying a lithographic printer when all his printing arrangements were made (and presumably paid for) by *Charivari*? Did he have to replace his own stones when they wore out? The payments certainly suggest an essential running account. At present this mystery is unexplained.

Debove-Balny, who begins dealing with Daumier when he is still living in the Ile-Saint-Louis, is listed in Didot-Bottin for 1861 as being a supplier of wood fuel with a timber yard in the rue Chaussée-Clignancourt in the Butte-Montmartre district. This firm was paid regular sums in 1859, 1861 and 1862 — all years in which Daumier's finances were bad. (It is not even certain that he was still living at 9, Quai d'Anjou in 1862.) It is interesting that this merchant continued to supply Daumier after he reestablished himself in the boulevard de Clichy in 1864. His name reappears in *Carnet IV* as *Debove*, and transactions (always in the winter months) continue right up to 1872, the year in which Daumier left Paris for good. Since fuel was a major item in the family budget, it seems fitting that one of Daumier's last lithographs was in fact a commission for a large poster for a charcoal warehouse, the *Entrepot d'Ivry*, drawn for a friend and former neighbour of his on the Ile Saint-Louis, Charles Desouches. His illustration shows a porter arriving in a large kitchen with a huge sack of charcoal on his back, while a cook throws up her arms in delight.

Frustrating though some of these details may be, and cryptic though Daumier's notations may seem, I would suggest that a certain character emerges from them. We are not dealing directly here with Daumier's creative activities, but we are dealing with the circumstances of his production. These accounts are quite meticulous in many ways, although the manner of their keeping is idiosyncratic and the evidence of increasing debt as he fell upon bad times is sadly clear. There is not much evidence of panic or despair, however: in the final two years he even economized with the space in his notebook! And when his fortunes recovered in 1864 he started again with a new set of accounts.

Carnet III

(Bibliothèque Municipale, Marseille — Accession No.MSD1)

Laid paper folded and sewn together at one edge to form 20pp. 1 covers, 23.5 × 10.3 cm.

Devoted exclusively to lists of stone numbers for lithographs, with Daumier's own short titles of subjects. These often differ considerably, in their description of content, from the legends applied to the lithographs when printed. A limited selection of comments have been made by this editor, where significant indications about Daumier's original intentions seem to be revealed.

Daumier's entries run from March 1864 to June 1872 (presumably the date of his last executed lithograph). This notebook thus begins just a little earlier than *Carnet IV*, in which he was simultaneously recording the other side of his artistic life during part of this period, namely his paintings and drawings sold to private collectors. Although *Charivari* recommenced publishing his lithographs in December 1863, only a few appeared until the month of March 1864, when Daumier begins these lists at stone number 37, and indicates a regular ouptut of ten stones per month. That this represented a regular contract is confirmed in an unpublished letter from Alfred Sensier to Jean-François Millet, dated 21 November 1863. Sensier added this snippet of news from Paris in a postscript: 'Daumier rentre à Charivari à 400 francs par mois Il était tems [*sic*]'.

On the outside of the front cover are found:

Thumbnail sketch in frame, of three figures

Letters 'C h' (large), and sketch of a pelvis, upside down

'Janvier 9 / 2 février repris'

[much lower down]
'22 sur 27 / La Fontaine'[1] — and a few doodles.

(Inside cover)	Page 1 (first recto)		
Etex rue de la Michodière No.1	**1864**		
------------------------	Mars	Avril	Mai
Mr. Lucas 41 rue de l'arc de	37	47	57
triomphe	38	48	58
------------------------	39	49	59
Mme. Paris Cardente	40	50	60
169 rue Mercadet	41	51	61
------------------------	42	52	62
Mr. Delislle	43	53	63
47 rue Taitbout[2]	44	54	64
------------------------	45	55	65
Dacier Archiviste du Cantal	46	56	66
à Aurillac (Dept de Cantal)			
------------------------	Juin	Juillet	Aout
M. Adolphe Hugendubel			fin B. Comte
tailleur 14 rue Rambuteau			150fr.
		Charivari	Charivari
Steinheil 89 rue du cherche midi	67	77 Amusant	86 Amusant
------------------------	68	78 1	86 5
Felix Deligny Blanchisseur	69	79 2	87 6
à Clichy la Garreau [?]	70	80 3	88 7
rue des [illeg] No.11	71	81 4	89 8
------------------------	72	82	90
Latouche rue St. Augustin	73	83	91
25 ------------------------	74	84	92
Soury dentiste 16 R. de	75	85	3
Grenimont [?]	76		

	1864				
7bre	8bre	9bre	Mars	Avril	Mai
fin B.	[blank	15 B. Leclame	fin Desst		
Comte	column]	150f	50f		
140.50c.		fin Desmarest	Charivari	Charivari	Charivari
------		50f	9		17
Charivari		Amusant	10		18
/Amusant		9	11		19
[2 blank		10	12		20
columns]		11	13		21
		12	14		22
			15		23
			16		24
			Amusant	Amusant	Amusant
			21		25
			22		26
			23		27
			24		28 [4]

10bre	Janvier **1865**	Fevrier	Juin	Juillet	
fin Desst	fin Desst	fin Desst			
30f	30f	61f.40			
Charivari	Charivari	Charivari	Charivari	Amusant	Charivari / Amusant
93	[column	1			25
94	blank]	2			26
95	Amusant	3			27
96	13	4			28
97	14	5			29
	15	6			30
Amusant	16	7			31
[column		8			32 [6]
blank]					
		17			Amusant
		18			
		19			
		20 [5]			

Aout		9bre		Fevrier		Mai
Chari-	*Amusant*	*Chari-*	*Amusant*	*Chari-*	*Amusant*[8]	Charivari
vari	29	*vari*	37	*vari*		17 Empédocle
[blank]	30	49	38	1		18 Bascule
	31	50	39	2		Bourse
	32	51	40	3		19 Olivier et
		52		4		Girard[in][9]
		53		5 refusé		20 lanterne Mque
		54	[7]			21 Emballage
						22 relàche trône
						23 omelette[10]

Septembre		10bre		Mars		Juin
Chari-	*Amusant*	*Chari-*	*Amusant*	Charivari		Charivari
vari	33	*vari*		5		24 Théâtre de
33	34	55		6		Guerre
34	35	56		7		25 Berceau
35	36	57		8		26 Epic[ure]
36		58		9		Damoclès
37		59		10		27 Cendrillon
38		60				28 allemagne
39						29 Danaïdes
40						30 le vote
						31 fiacre

	8bre	Janvier **1866**		Avril		Juillet
		Chari-	*Amusant*	Charivari		Charivari
Chari-	*Amusant*	*vari*	41	11		32 John Bull
vari			42	12		borgne[12]
41			43	13		33 Le tombeau
42			44	14		de Mahomet[13]
43				15		34 chemin de fer
44				16		35 le Rhin
45				[17, 18: Numbers		36 prud'homme[14]
46				repeated above]		37 enterrement
47						
48[11]						

Aout	9bre	Fevrier **1867**	Mai
38 Mars	57 danse des oeufs	7 tribune	25 Mars Girardin
39 carte de Europe	58 irlandais	8 femme a barbe	26 Diplo^{tic} Locom^{ve}
40 La paix	59 Landwes [sic]	9 Galilée	27 Boursier chassepot
41 italie grande	60 Le temps	10 Galilée Josue	28 Canons
42 Rhin [illeg][15]	61 le monde	11 Colis Anglais	29 Congrés Medecine
43 les Canards duel	62 pipelet	12 Théâtre de l'Exposition	30 Exp. voitures.
44 les deux chasseurs			

Septembre	10bre	Mars	Juin
45 Quadripatère	63 dorby Stegmund [?]	13 fesseaux [sic]	31 telegraphe turc
46 italie Vénetienne	64 déraillement	14 Voltaire Galilée	32 ouvrier foule
47 prusse Colosse	65 1867	15 Mars Giboulé	33 Clichy
48 Balance	66 pipelet	16 l'Europe et le paix	34 temps chiffonier
49 pompiers	67 Le temps	17 Statue de Voltaire	35 prudh. voiture
50 1866 pluie	68 la france 15 koke[16]	18 Equilibre Européen	36 italie Banque

8bre	Janvier **1867**	Avril	Juillet
51 margravia	1 orient	19 Exposition	37 Ann[iversaire] Sadowa
52 italie palerme	2 rocambole	20 prussien pèche	38 Mars endormie
53 Europe et Turquie	3 Exposition	21 Colin Maillard	39 La paix
54 les morts	4 Candie	22 prussien sur le mur	40 Clichy démolissé[18]
55 vote	5 Europe suspens	23 Tartine Conféd*on*	41 prix de croissance prusse
56 venise	6 Mars Exposition (5 non numerété)	24 poudre aux yeux[17]	42 chemin mort[19]

Aout	9bre	Fevrier	Mai
43 Prisons [Irlande]	61 Canons	7 Budgets boulots	25 anglais Abyssinie
44 Mars Concert	62 Champs de Mort[21]	8 Souricière	26 Mars endormie
45 [Moulin de] sans souci	63 Cochon	9 vent du nord	27 Balon Captif
46 augure [de la Diplomatie]	64 q. ravine orient	10 ça ne mord plus	28 hannetons
47 chasse f. [fermée]	65 Europe étrennes	11 Turc magnétisé	29 Europe dort canon
48 prusse colosse[20]	66 Augures sérieux	12 Martyr Bazile[22]	30 Progrés manqué

7bre	10bre	Mars	Juin
49 Paix Expos[ition]	67 emplâtre . . .	13 charivari blanc	31 Mars Médard
50 Zouave G[uérisseur]	68 équilibre Europe	14 printemps Mars	32 Paix araignée
51 Le Temps Liberal	69 furieux lion	15 Laocoon	33 Canon compteur
52 Turgot & Condé	70 arbre noël	16 politic sabre	34 ramolis Wagner
53 roi perdu	71 Europe Orient	17 couveuse	35 Mars muselé
54 Loup Berger[23]	72 John Bull	18 Balancier de Budget	36 Deputés baigneurs

8bre	Janvier **1868**	Avril	Juillet
55 Europe Canarde	1 Mars débacle	19 Pyramide humaine	37 Penélope [moderne]
56 Allemagne stranglée	2 Noeud Gordine	20 Rhubarbe séné	38 théâtre été
57 piédestaux	3 Europe damocles	21 Statues de l'avenir	39 bains d'académie
58 brouillards	4 Dr Noël Chass*pt*	22 Aménités	40 Budjet Hercule
59 l'h. masqué [Death]	5 réassion B.	23 Printemps Mars	41 Theodorous
60 Ballon	6 Mme. Prudhomme vivandière	24 Bureau désarmement	42 Deputés en Wagon
		Véron lundi – mercredi samadi / de 4 à 5	Le matin mardi mercredi vendredi de 9 à 10

Aout	9bre	Fevrier	Mai
43 Paix futile	61 Civières	7 Mars à table	25 Bancel
44 M. à Cologne	62 rois cabaret	8 La volant Europe	26 Liberté et Candidats
45 chiens d'eloquence	63 suffrage Géant	9 tribunes Députés	27 Ballotage Elect.
46 Temps canon	64 Chadrue fin l'an	10 Olivier livre[24]	28 France Candidate
47 Cirque luthérien	65 inondation journ[aux]	11 Charybde et Scylla	29 Mars Equipmt
48 L'ours en marche	66 Le Boa [digere]	12 E. Olivier – blanc drapeau	30 Camp de Châlons

7bre	10bre	Mars	Juin
49 Paix vélocipède	67 3 Géants sur Esp.	13 Olivier ailes	31 jeu de Bagues
50 Mars Bouche	68 1868 Mort [31 dec.]	14 Oliv 2 selles	32 député et paysan
51 Sourire électorale	69 Noël soulière	15 Budget sanglé	33 Liberté chanteuse
52 Saute Mouton	70 Goussets vides	16 France toise	34 Liberté et Mars
53 Pensionners internat[le]	71 Q d'orient ressortirant	17 Suffrage sculpture	35 entrée à son débuts
54 Bouteille d'encre	72 épouvantailles	18 Sourirant Candidat	36 verification pouvoirs..[de sa voix]

8bre	1869 *Janvier*	Avril	Juillet
55 Toile d'araignée	1 Dép Couteaux papiers	19 Mitrailleuse Elec.	37 Député et Huissier
56 Temps Maison	2 Conférence	20 Urn [sign for sun at dawn] elect.	38 deux Cochers
57 Paix Miroir	3 Eau troublé	21 Candidats[26]	39 trône régence
58 Grenouilles roi	4 Badigeon	22 Danaïdes [Le nouveau tonneau]	40 Liberté feu d'artifice
59 urne electorale . . .	5 Sisyphe	23 Champs de B[ataille] électorale[27]	41 Balon Constitution
60 Les ours Esp[agne]	6 Député pour Paix[25]	24 Electeur écartelé	42 député Kioske

Aout	9bre	février	Mai
43 Mât de Cocagne[28]	61 Lanterne Magique	7 Thiers la perche	25 accombement [sic]/Médécin[29]
44 nez d'argent	62 Election Bulletin/ cartouche	8 Bazile Borgia	26 Bourgeois Café[30]
45 dynastes s'alignés	63 Liberté travaillée	9 l'aveugle guarantit	27 Sculpture opéra
46 Constitution diligence	64 Spectre rouge/ bourgeois	10 Nouage dissolution	28 vote de la tribune
47 Const[on] couturière	65 Glais Bizoin	11 Liberté en cage	29 Bank Marathon
48 Lib[té] magnétisé	66 Crémieux Arago	12 Dissolution serpent	30 R MACAIRE[31]

7bre	10bre	Mars	Juin
49 La badinerie Bazile	67 Thiers Silence	13 enterrement soupière electorale	31 Budget
50 paysan lit journal	68 Etrennes à 1870	14 hiboux lanterne	32 La Presse chargée
51 Escargots	69 1870 et le temps	15 tombeaux des 56	33 Les Arènes [Législatives]
52 Crime Pantin Prusse	70 dép Rochefort en cage	16 Sénateur Belvédere	34 Ministère nourrice[32]
53 Père Hyacinthe	71 Députés athlètes	17 le timbre forçats	35 où on voit [les batteries]
54 Prorogation port fermée	72 Balance	18 infaillebilité assomption	36 Chiffonier commissions [parlementaire]

8bre	Janvier **1870**	Avril	Juillet
55 Maçons C[orps] legislatif	1 Derailler	19 Vaccin 52–70	37 Prudhomme syphon
56 Art[icle] 75	2 Syllabus dictionaire latin	20 Plebiscite Maire	38 Concours Conservatoire
57 Concile	3 Bazile infaillible	21 Com[ission] parlementaire	39 Voltaire Bazile
58 rève validation	4 Thiers souffleur	22 électeur écriture[]	40 Astronomie prusse[33]
59 Bazile Concile	5 France sur la planche	23 Prud'homme Jokey [sic]	41 paysan Badois
60 Prud'homme Pyramide	6 Eau Arcadienne	24 députés sous l'orme	42 Trône d'Espagne cadavrai [sic]

Pages 14–15 **[1870–71]**

Aout	9bre	février 71	Mai
43 les Badois et prussiens 44 Le Rhin 45 Cauchemar Bismarck 46 Invalide pension 47 Mobile 48 Volontaires[34] 49 remplacements	62 les Chatiments 63 Prussien transi 64 France vote 65 plume vendue 66 Boulevard tombeaux 67 Prussien journaux 68 Canard et pigeon 69 Assemblée N[tle] 70 Paysage siège 71 Pare-Balle	11 femme sur table de dissection 12 prussienne pillage 13 Théâtre Bordeaux 14 Le ravitaillé 15 Thé de Bord. P. au F. 16 livre de Histoire 17 l'Eclipse 18 le paix mort 19 entrée de Bazile 20 les modérés [de Bordaux	
7bre 50 France entre 2 canons 51 Le baiser du départ 52 Le couronnement d'édifice 53 Concile falloyant [sic] 54 France balayeuse 55 Mobiles[35]	**10bre** 72 trône d'espagne 73 John Bull reine 74 Rouleau maçon 75 Dragée j[our] de l'an 76 Rois Laquais 77 Angleterre et Macaire 78 [Bismarck] et pigeon 79 1871 [héritage] 80 les Rois 81 Balthazar	**Mars** 21 Paris Député à croix 22 assemblé rurale 23 Termination paysan 24 Les Loyers 25 Les loyers[36] 26 les pendules	**Juin**
8bre 56 La Guerre[37] 57 Lion Brittanique 58 Vic. Em[le] pape 59 Musée du Souverain[38] 60 Sans ours 61 les marins	**Janvier 71** 1 Empire d'Allemagne 2 Atten.. de Const.. 3 obus Hôpital[39] 4 Marguerite[40] 5 arbre France[41] 6 France corbeaux 7 'oui' 1870 8 France Heritiers 9 Lazare[42] 10 [France] Prométhée	**Avril** 27 [détruisant] guillotine[43] 28 char d'état 29 Poste deraillement [On 22 April *Charivari* suspended publication]	**Juillet** 30 [illeg.] écrasé milliards 31 France Emprunt 32 aigle empaillé 33 Bazyle pour Rome 34 pouvoir Temporel/ morte 35 Louis XIV [illeg][44]

Pages 16–17 **[1871–72]**

Aout	10bre	Avril	Aout
36 Députés battant 37 Drapeau blanc 38 République Milo 39 Thiers Colosse de Rhodes 40 La Torque 41 Prusse et Austriche piège	60 Théâtre politique 61 chaud et froid 62 Louis XIV 63 souliers de Noël 64 enterrement 1871 65 1871 Balayeuse [des systèmes][45]	19 l'enquête retiré 20 printemps Polit[que] 21 Bataille de Maçons[46] 22 3 Bilboquets[47] 23 Thiers chef de gare[48] 24 Casque sonnette	
7bre 42 monarchie chaise 43 Entretien avec Charivari 44 voiture de prelat/valets 45 pompe d'orY[49] 46 l'aigle JournalY[50] 47 Pot de vin	**Janvier 1872** 1 Gateau des Rois Sédan 2 Député wagon drapeau rouge 3 Dép. chem. de fer [illeg] 4 St. Ignorance[51] 5 Basile et paysan 6 Rouher cors[52]	**Mai** 25 Linge Rouher 26 Bazile fusillant 27 Charivari Espagne 28 Monarchie en mariée 29 Écuries D'augias 30 Morts Témoins Bazaine[53]	**7bre**
8bre 48 Eole [sic][54] 49 Ratapoil Sedan 50 Ratapoil et paysan 51 Escamoteur–Ratapoil[55] 52 retiré [=returned] 53 statue République tirée	**Février** 7 Tir à la République 8 tricolore blanchi 9 la fusion bocale 10 Rabagas [a comedy] 11 Champ de Mars[56] 12 Locomotive Rép[57]	**Juin** 31 Monarchie Morte 32 Ratapoil et Bazile 33 réac. [tionnaires?] pied de nez[58]	**8bre**
9bre 54 suffrage et arbre 55 Solution de la femme 56 huitre plaideurs 57 Rentrée de chambre 58 Chambre face de voyage 59 Députés conscrits	**Mars** 13 Monarchieste tête 14 Hercule monarchie 15 Les éteignoirs 16 roi berné 17 L'épervier 18 Rouher	**juillet**	**9bre**

Pages 18–19 are blank.

Page 20 (verso of 19).

Four lines are crossed out and scribbled over to make them illegible.

Inside back cover.

Addresses as follows:

> Laneret agent d'affaires
> 8 rue du Fᵍ [Faubourg] poissonière
> -----------
> Boulevard St. antoine
> 9ᵇⁱˢ 11 et 13 près et par
> Versailles – Hurreux

Back Cover (5 outside page)

The number '228', in black chalk

The following address:
Mʳˢ Ivre et Barré[59]
rue Thévenot Nº 6 –
lithographe

Carnet IV

(Bibliothèque Municipale, Marseille. Accession Nº MSD2)[1].

20pp. + covers + one loose sheet, 23.5 × 10.3 cms, Canson paper.

I have represented the pages as numbered consecutively, taking page one as the first recto within the hand-made covers. There are two sets of entries, in different formats. The first set, found on page one and continuing from page eleven through to page twenty, and the inside back cover, contains entries relating to Daumier's income, from sales of paintings and drawings and receipts from *Charivari* and the *Journal Amusant*. These entries begin about June 1864 (from the date inscribed inside the front cover), and the last was made in December 1867. Daumier entered drawings and watercolours as either *dessins* or *croquis*. He entered paintings as *tableaux*, *esquisses*, *panneaux* or by title. The other set of entries, between pages two to nine inclusive, relates to payments to suppliers, in a 'monthly diary' format which continues that found in *Carnet II*. Daumier drew monthly blocks freehand, and his system has been reproduced in schematic form here. He used such accounting terms as *Traite* (draft or bill); *Billet* (account) and *Balance*, often in abbreviated form. The names of Desmarest (lithographic supplies?) and Debove (fuel merchant) have already occurred in *Carnet II*. Comte (frères), Sarazin, Levecher, Buret, and Balmont all appear in the pages of Didot-Bottin as wine merchants. Hugendubel has been noted as Daumier's tailor. The *only* Diaz to appear in Didot-Bottin between 1862 and 1866 is 'Diaz, artiste-peintre', still living at 8, place Pigalle – in other words the Barbizon School artist and Daumier's friend. Could this have been a personal loan? The other names are too difficult to pin down. Wolf (or Wolff Levy) is a fairly common name in either spelling, but the small payments to him (between forty-five and seventy-five francs a month) are so regular between December 1868 and December 1872, with a significant hiatus during the seige of Paris and the Commune, that one suspects he might have brought in groceries from the suburbs. The fact that Daumier's last payment is recorded in June 1872, the same month in which he sent off his last lithographic stone to *Charivari*, suggests that he retired permanently to Valmondois at this date.

Outside of Front cover: sketch of a window frame with a sill or lintel.

Inside front cover

24 juin 1864
[line obliterated]
1865 22 Mars

[over thumbnail sketch of 3 figs in frame]
156c. sur 2m.20c y compris 2c. par 25c.
le double justement
131 cm. de hauteur

Oudinot 64 bis rue Dulong
 Batignolles[2]
[sideways in page]:

Beaumont[3]

67 avenue Wagram
et 24 rue des dames
 aux Termes

Préault 350 rue St Jacques[4]

Page 1

1864	
Bureau un dessin[5]	100
Boulard id[6]	200
Lucas id[7]	100
Croquis	40
Moureau[x] dessin	90
id.esquisses panneaux	300
Lucas 3 dessins	300
Delisle[8] dessins 3	300
Moureaux 1 dessin	100
1865	
Janvier	
Moureaux esquisse	80
Delisle dessin [2 small marks]	250
Bureau dessin.	150
Delisle dessin	150
Lemaire dessin	150
	—
	T 780
	—
Fevrier	
Moureaux esquisse	100
Charivari	240
Charivari	320
	—
	T 660
	—
Mars	
15 Charivari	160
21 Charivari	120
28 Charivari	240
	—
	T 620

Pages 2–3 (Entries generally in ink: some cancelled in black chalk.

10bre **1864** fin B. Desmarest ---- 30	Avril Terme 300	Aout Billet– Hugendubel fin Aout 100 fin Billet Comte 100	10bre fin Gend 130	Avril	Aout
Janvier **1865** fin B. Desmerest ------- 30f Terme 275	Mai 31 Traite Levecher 112	7bre 15 traite de Bordeaux 150 Traite de 125 fin Buret 80	Janvier **1866** fin traite de Bordeaux 125	Mai	7bre
Fevrier fin Desmarest ---- 61f-40c fin Buret . .135	Juin M. Huygndubel fin 66 15 Billet Diaz ------- 240	8bre fin B. Debove 59	Fevrier	Juin	8bre fin Billet R = 500 payé
Mars fin Desmarest ------ 50ffin Buret 135	Juillet	9bre fin Mareux 79 fin Debove 100 Sarazin 189	Mars	Juillet	9bre fin B Debove 70 20 B.R 400 payé

Pages 4–5

10bre B. Debove 69.50	Avril	Aout 15 B.R. 300	10bre fin Debove 53f 15c Le 1er rendu à Lobot 40f	Avril 5 B Maraine 60	Aout
1867 Janvier	Mai 5 BB 500 payé	7bre 5 BR 400	**1868** Janvier fin B Balmon 195 18 R a Lobot 40f	Mai 5 B Maraine 60	7bre
fevrier	Juin	8bre fin Billet Hugendubel 58	fevrier	Juin	8bre
Mars	Juillet 5 rendu à Lobot 40f rendu à Lobot le 27 40f	9bre fin Debove 50 fin Hugendubel 50 fin B.R 420	Mars 5 Billet Maraine 60 4 Lobot payé 40	Juillet	9bre fin Debove 50

Pages 6–7

10bre fin Debove 48f 50c fin B. Wolf 50	Avril fin B. Hugendubel 73	Aout fin Wolf 75 fin Balmon 95	10bre fin Debove 50.50c 15 Gagougnolle 72	Avril fin Wolf 50 volff Levy / 20 rue du Cloitre / St Merry	Aout fin Gagougnolle -------- 80 fin Wolf 75
Janvier **1869** fin B wolf 62f	Mai fin Wolf 50 fin Balmont 95	7bre fin Wolf 50	**1870** Janvier fin Wolf 65	Mai 15 ---------- 72 Gagougnolle	7bre fin Wolf 50 renouvellé
fevrier fin B. hugendubel 50 fin Balmont 100 fin W [50?]	Juin fin Wolf 50 Balmont 95f	8bre fin Wolf 50	fevrier 15 Gagougnolle 72 renouvellé au 15 mai	Juin fin Gagougnolle --------- 80	8bre fin Wolf 50 renouvellé
Mars fin B. Hugendubel 50 fin Balmont 90 fin B Wolf 46	Juillet fin Wolf 50	9bre fin Wolf 50 fin Debove 50	Mars fin Wolf 50	Juillet	9bre

Note: There is a hiatus in Daumier's monthly accounts between November 1870 and September 1871 – the period covering the conclusion of the Franco-Prussian War, the Paris Commune and its aftermath. He must have been hard put to make ends meet, and the length of time elapsing before these pages were resumed may be some indication of the length of time that it took ordinary tradespeople to recover from those political and social disasters.

Pages 8–9

7bre **1871** ---------- fin B wolf 50	10bre fin B Debove 50	Avril fin Debove 80	Aout
8bre fin B Wolf 50	Janvier **1872** fin B Debove 50 10 Wolf ---- 45	Mai 10 Wolff 48.50 25 500f̂	7bre
9bre fin Gacougnolle de 80 à 100	fevrier fin Debove 80 10 B. Wolf -- 45 renouvellé au 10 Mai avec les interets [?] mis 48.50	Juin 10 500f[°]	8bre
	Mars	Juillet	9bre

pages 10–11

(Loose sheet inserted here on top of blank page 10)

Beugniet tableau Musiciens	200
Beugniet tableau	
Scapin tête id sujet	380
id.2 avocats tableau	300
id. 1 dessin avocat	250
– 1 dessin fable	200
1 bois	100
Bureau croquis	120
Monde illustré bois	450
Beugniet – pierrot tête[10]	150

1866 à 1867
de 8bre à fin avril sur mois 581
7 mois

page 11

Avril 1865[11]

Le 11 Beugnet [sic] 1 dessin		200
Le 28 Cadar (sic, for Cardart) 2 dessin		350
		—
	Total	550
		—

Mai

Le 8 Beugnet 1 dessin.		100
Charivari le 12 .		240
Charivari le 29 .		160
		—
	Total	500
		—

Juin

Le 6 croquis pour l'autographe[12]	100
Le 13 1 dessin Beugniet	150
Le 14 Charivari .	160
	—

Juillet

Le 17 Charivari .	260
	—

Aout

Le 10 Moureaux 1 croquis	30
Le 29 Charivari .	140

7bre

Le 14 Charivari (320 retenu 40)	280
26 Amusant[13] .	240
	—

8bre

22 Charivari 320 retenu 40	280

9bre

Page 12

9bre

7 Amusant (sans retenue)[14]		240
29 Charivari (6 pierres, retenu 40f)		240
30 Beugniet un dessin		200f
		—
	T	680
. .		

10bre

Le 8 Un dessin pour Beugniet	200f
Id Mouraux croquis .	40
Le 12 Beugniet 2 dessins	275
28 Charivari .	240
	—
	755

Janvier 1866

10 Amusant[15] .		240
30 Charivari .		360
		—
	T	600

Fevrier

12 Beugniet 1 petit dessin	100
27 Charivari .	240
	—

Mars

15 Croquis Mouraux	150f
Bgniet Cquis .	50
28 Charivari .	240
	—

Avril

fin Charivari .	240

Page 13

Mai

28 2 dessins Bgniet .	400f
fin Charivari .	240
	—

After this, the remaining months of June to September indicated on this page are left blank.

Pages 14–15 are blocked out in months like the pages above, but all of them are blank from October 1866 to May 1867.

Pages 16–17 are blocked out similarly, from June 1867 to January 1868, and contain two entries as follows:

Juillet [1867]

1 tableau Don Quichotte et Sancho au pied d'un arbre, rendu a Brame[16] .	800f

10bre [1867]

1 dessin pour l'Amerique	800

Pages 18–19 contain blank months from February to September 1868.

Page 20, and the inside of the back cover, contain the months marked out from October 1868 to May 1869. On this last page are two entries only, which refer to payments out:

10bre [1868] fin B. Wolf	50f
Janvier 1869 fin B. Wolf	62

On the outside of the back cover is the name and address of Daumier's actor friend:

M. Cléophas
7 bis rue de Tivoli.

Carnet V

(Bibliothèque Municipale de Marseille, Acq. No. MSD5).[1]
It consists of six pages of laid paper, 21 × 15.3 cms, only two of which have any inscriptions. On the outside cover is written **1875–76**. All the transactions listed are sales of drawings and oil paintings to private clients or dealers. The largest proportion of purchases are by Aubry and Jacquette. Aubry was probably a dealer because several works with his provenance appear in other private collections quite early. Jacquette left his collection to the Musée des Beaux-Arts de la Ville de Paris, Petit Palais in 1899.

A feature of this account book is Daumier's new habit of noting his standard canvas sizes by number, which assists towards identification of individual items. These numbers had been in common usage since pre-Napoleonic times, when measurements were in feet and inches (*pieds* and *pouces*). In a catalogue of ready-stretched canvases by Lefranc & Company, issued *c*.1863, dimensions were given in both centimetres and *pouces*. Since the more traditional system seems to have determined the number of the canvas at this period, the size in centimetres comes out to a fraction, so that there is some variation possible when trying to identify works listed in this *carnet* by matching their sizes to known works. In addition to the nineteen stock sizes listed by Lefranc, from '1' to '120' for 'Figure' canvases, there was a further range of dimensions for 'Landscape' and 'Marine' formats, with two variants for each size number, from sizes five to thirty. One might have assumed that Daumier's subjects would generally call for 'Figure' sizes, but this does not always turn out to be the case.[2]

Judging by the prices, drawings are described as either *dessin* or *croquis*. Paintings are clearly *tableau*, *toile* (T) or *panneau* (P[n]), but the word *esquisse* seems to have been very loosely applied to both classes of work.

The arrangement here is to print my transcriptions of the pages illustrated in the left column, with my comments in the right column opposite each item.[3]

189. *Carnet V*. Page 2 recto. Laid paper, 21 x 15.3.

folio 2 recto (fig. 189)		*Comments by B.L.*
9bre 75		
J.D. ----- avocats P.[re] [peinture]	500	If J.D. is Jules Dupré, this could be M I–140, which Dupré lent to the 1878 exhibition (26) with the title *Un avocat sortant du Palais* (panel, 22 × 28 cm) (see fig. 130).
Le[te] ---- Esquisse Janvier [**1876**]	300	Not readable as Le[mr], and therefore not Lemaire (as in Cherpin).
Aubry -------- D.Q.tte T. de 6. 18 Janvier [**1876**] --------	1000	Toile de 6 is 40.5 × 32.4. Possibly M I–206, Don Quixote and Sancho Panza descending into a valley (Armand Hammer Museum). Provenance F. Roybet in 1880.
Jacquette 13 F[er] un Tableau T. de 4 ------ 1000f ---------	1000	Toile de 4 is 32.4 × 24.3. Jacquette bequeathed M I–168, *Les joueurs d'échecs* (24.5 × 32.5) to the Musée du Petit Palais in1899. It is, however, on panel.
Avril – 76		
7 un Croquis à Aubry	100	P. Aubry lent 3 paintings and 4 drawings to Daumier's 1878 exhibition.
13 un croquis à Guyotin	100	Guyotin lent 2 paintings and 2 drawings to Daumier's 1878 exhibition.
15 deux croquis à Aubry	300	
28 un Tableau à M. Aubry avocat	1000	
Mai un Croquis à Aubry	150	The word 'avocat', sandwiched between two lines, could apply equally to the picture and the study. Was the painting a toile de 6 or a toile de 4? If the former it could be M I–213, *Avocat lisant*, which Maison lists as provenance 'Corot (?)' as if he was not sure. Aubry did lend an important watercolour study of the same subject to the 1878 exhibition (100) (see fig. 128).
Juin 8 [un] Esquisse à Paschal (*sic*) ---	300	Michel Pascal lent one small panel, 20 × 15, to the 1878 exhibition, identified by Maison as M I–53, *Course au bord de la mer* – apparently a reprise of an early subject of refugees.
Juillet 20 4 Croquis à Aubry	300	Aubry's total is now 8 *croquis* for 850 francs: average 106.25 frs. These were very probably watercolours.
23 un panneau de 5 public du Cirque à Paschal	1200	Toile de 5 is 36.9 × 28.8. This canvas has not been identified.

In faint pencil at the bottom of folio 2 recto is a total of sums received – 6,450 francs – and also the beginning of the entry for the next page, 8bre 1500, which was transferred in ink. At the top right, also in faint pencil, are Daumier's interim calculations of the totals on this page and about half way down the next.

folio 2 verso (fig. 190)		*Comments by B.L.*
8bre 76		
1 Esquisse Don Quichotte (courant sur les moutons) à Mme. Bureau	1500	This is M I-184 (private collection) with the title as Daumier gives it. The canvas size is 56 × 84 cms: a 'marine toile de 25'. Described by Alexandre (p.246) and identified by Cherpin (see fig. 181).
Fevrier 77		
Chanteur panneau de 3 à Jacquette reçu à comte 480f	800	M I-170, panel 21.6 × 27.5 cms. Provenance Jacquette; Musée des Beaux-Arts de la Ville de Paris, Petit Palais. The subject is actually two singers and a violinist. Identified by Cherpin.
Mars		
18 une lecture paneau de 5 rendu à Mr Tabourier reçu à comte 220f de Jaquette [sic]	1200	M I-100, panel 27 × 35 cms (a 'paysage de 5'). Provenance Tabourier; on deposit with the Stedelijk Museum, Amsterdam. A man reading aloud to another. Identification corrected by Maison.
Avril		
20 une Esquisse médecin de Molière Panneau de 1 vendu à M. Aubry	200	M I-223, panel 23 × 17.5cms. *Le médecin Diafoirus* (Bakwin Collection, New York). Provenance Aubry; identified by Cherpin. Late painting style (see fig. 180).
1 dessin [pas fini crossed out] Esquisse amateurs dans un atelier [sic]	200	MD 386, stumped charcoal, pen and ink, and wash, 31.1 × 46 cms (New York, José Mugrabi Collections, provenance Aubry) is argued for here (see fig. 81). Maison thought MD 385(Walters Art Gallery, Baltimore), but *pas fini* or *esquisse* could not apply to that highly finished watercolour.
Croquis divers -------	150	Three small drawings or sketches?
24 une tête Croquis ----- Aubry	50	
28 reçu de Jaquette [sic] 100f à valoir		i.e., on account concluded for the 'Chanteur' panel above.

190. *Carnet V.* Page 2 verso. Laid paper, 21 x 15.3.

ABBREVIATIONS

MD K.E. Maison, Daumier catalogue raisonné, vol. II, Drawings Watercolours, London 1968 (followed by catalogue number).

MI *idem*, vol. I, *Paintings* (followed by catalogue number).

LD Loys Delteil, *Le peintre graveur illustré: Daumier*, vols XX–XXIX, Paris 1925–30 (followed by catalogue number).

Bouvy E. Bouvy, *Daumier: l'Œvre gravé du maître*, 2 vols, Paris 1933 (followed by catalogue number).

Ex Maison Not catalogued by Maison.

NOTES

Dimensions for works of art illustrated in the text are given in centimetres.

Title references are abbreviated where they also appear in the Select Bibliography.

Introduction

1 The problem of studies and repetitions is currently bedeviled by a further one, namely, how many works on paper attributed to Daumier are actually by him? The problem here is different from that of the oil paintings being 'finished' by later hands, although there are a few examples of badly rubbed drawings having been touched up in this century. There are many imitation Daumier drawings concocted from the published lithographs and wood engravings. Conversely, a significant number of (bad) faked oil paintings have been made after known watercolours.

2 See B. Laughton, 'some Daumier Drawings for Lithographs', *Master Drawings*, 22, 1, 1984, pp.55–63 and plates 39–45.

3 Unlike the English watercolourist Philip Wilson Steer, for example, who painted in the twentieth century but trained in the nineteenth, and who could afford to keep 'a good stock of old paper' for his watercolours including Michallet. *Cf.* D.S. MacColl, *Philip Wilson Steer*, 1945, p.117.

4 The drawing of a *Street Violinist* in the Burrell Collection, Glasgow, is on old paper blind-stamped CANSON & MONTGOLFIER VIDALON, but in this case I am not happy about the attribution to Daumier.

Chapter 1 Daumier's Earlier Career, up to 1848

1 Roger Passeron, drawing on documents published by Grass-Mick, Cherpin and others, has written the fullest account to date of Daumier's family history. (Passeron, 1979, English edition, 1981, pp.11–29.) He ascribes the term 'worker poet' to Daumier critics of the late 1920s (a period when the artist was rediscovered by socialist-minded historians). However, this term could not be applied in the sense of 'overtly confronting the central issues of working class experience', as Nicholas Green put it when discussing another self-educated worker-poet, the carpenter Durand of Fontainebleau, in his book *The Spectacle of Nature* (Manchester, 1990, p.14). Green also points out that worker poets were a distinctive phenomenon in 1830s and 1840s France.

2 The sisters were Victorine-Marie, three years older than Honoré, and Marie-Louise, five years his junior. Marie-Louise later got married, but Victorine-Marie left home at some unspecified date and apparently developed a penchant for having illegitimate babies (see chapter 3, note 6). Daumier's father eventually went mad apparently, and was committed to the asylum at Charenton where he died in 1850. His mother lived near her son until her death in 1859.

3 See Edmond Duranty's two-part article 'Daumier' in the *Gazette des Beaux-Arts*, 1878, pp.429–43 and 528–44; and Alexandre, 1888, chapter II.

4 For a full account of the remarkable history of the Musée des Monuments Français, see Francis Haskell, *History and Its Images*, New Haven and London, 1993, chapter 9. That chapter concludes with a quotation from Jules Michelet, reminisc-ing on how visits to this museum had acted upon his historical imagination when a child. Part of the same passage, interestingly enough, is quoted in Alexandre's biography of Daumier (*op. cit.*, p.20, n.1), with the suggestion that an analogy might exist with Daumier's own discovery of the sculptural treasures of the Louvre. Michelet himself became an admirer of Daumier's powers of physiognomical expression when he saw his figure of *Ratapoil* in 1851 (fig. 72).

5 Edmond Duranty, 'Daumier', *Gazette des Beaux-Arts*, 1878, p.436.

6 At this time Charles Philipon was a principal shareholder in *La Silhouette*, which was probably how Daumier came to his attention. Ricourt left when the journal folded in 1831, and founded the journal *l'Artiste*.

7 Nicholas-Toussaint Charlet (1792–1845) was an accomplished draughtsman and watercolourist, as well as a lithographer. He had been apprenticed to Napoleon's painter Baron Gros, and after the restoration accompanied Géricault on a visit to London, where he helped the latter make a lithograph after his painting *The Raft of the Medusa* when it was on exhibition there. Charlet and his one time apprentice Auguste Raffet (1804–60) both enjoyed considerable reputations in the 1830s and 1840s, and were both admired by Daumier. Their capacities to combine independent careers as artists with profits from selling prints may have encouraged him. Charlet ended up by becoming drawing master at the École Polytechnique, from 1838 until his death.

8 The equation of the shape of Louis-Philippe's head with that of a pear was a figurative invention of Philipon's. In his famous trial for libel in 1831 he argued, through a series of metamorphosizing drawings, that at no point

could a clear distinction be drawn between the sign for Louis-Philippe (a recognizable portrait) and the sign for a pear (a recognizable pear). All his cartoonists used this subterfuge sign for ridiculing the Orléanist monarchy. When Daumier used it, his images varied between a kind of recognizable turnip-head and a looped-up testicle.

9 First exhibited in *Honoré Daumier Zeichnungen* (*Daumier Drawings*), Frankfurt and New York, 1992–3 (ex catalogue), and published by Colta Ives in her catalogue essay 'Drawing at Liberty; Daumier's Style', pp.10–11, fig. 11. The lithograph made from it is catalogued by Loys Delteil, *L'Œuvre lithographié*, Appendix No. 33 'Le peintre graveur illustré', XXIX, Daumier. It is one of a series of twelve subjects of diabolical actions, wild dreams, *idées fixes*, and chimeras of the imagination, 'painted' by Daumier and lithographed by Ramelet after him, which were announced by *Charivari* on 14 January 1833. We are told that their author had composed these works 'in prison', while serving his sentence *chez* Dr J.P. Casimir Pinel who directed a home for the mentally ill at Chaillot (79 Champs-Elysées). It is a nice piece of irony that an artist declared to be mad (politically) should oblige with appropriate illustrations of his (supposed) condition.

10 Cited in Jean Adhémar, *Honoré Daumier*, 1954, p.24.

11 In fact there are four lithographs of this type, all of which look like black-and-white pictures, in the Reserve Collection of the Cabinet des Estampes in the Bibliothèque Nationale. LD 254, *La Bonne Grand-Mère*, deposited on 14 March 1835, and LD 255, *Le Malade*, deposited on 4 June 1835, were both reproduced in *La Revue des peintres*. In similar style is LD 256, *La Lecture du journal aux famille*, very Greuze-like in sentiment – there are only two extant prints known of this. LD 257, *Cavalerie legère*, a child on a donkey, was reproduced by Aubert in 'livre d'images pour les grands et les petits enfants' in 1836 (cited in Provost, 1989, p.129).

12 Henry Monnier (1799–1877), actor, cartoonist, watercolourist and writer, is best known for his invention of the character of M. Joseph Prudhomme, an archetypal bourgeois whom he first used in his stage satires, from 1831 onwards. (M. Prudhomme was also adopted by Daumier in the 1860s, as we shall see.) Monnier published a series of lithographs about *Grisettes* from 1827 to 1829, and contributed a characteristically sinister set of drawings of *Prisoners* for *Les Français peints par eux-mêmes*. He lived a peripatetic life as an actor, during which he produced a large number of signed and dated monochrome wash drawings and brightly tinted watercolours, dependent for their structure on strong contours drawn with a pen or with the point of a sable brush.

13 The original clay models, which were coloured at some point for further effect, remained in the possession of Philipon and his family for many years, in a deteriorating condition, until they were sold to Maurice Le Garrec in 1927. After repairs, a limited edition of bronze casts were made from them by the Barbedienne foundry. Today 36 such busts are known. The clay busts were restored to their original colours while in the possession of M. Le Garrec's granddaughter in 1980, and subsequently sold to the Louvre Museum. They are now permanently exhibited at the Musée d'Orsay. For more details see Jeanne L. Wasserman, 1969, and Wasserman, de Caso and Adhémar, 'Hypotheses sur les sculptures de Daumier', *Gazette des Beaux-Arts*, series 6, vol. 101, February 1983, pp.57–73.

14 A small oil painting called *L'Aquafortiste*, which Adhémar thought was very early and Maison proposed as 1835–7, was sold at Sotheby's, London, on 1 December 1993, lot 114. Although Maison thought it of 'negligible artistic quality' compared to what came after, it is a lively composition cleanly painted with good colour. It is impossible to say, however, whether or not Daumier was painting like this much before the end of the 1840s.

15 Since in all probability Daumier composed this directly on the lithographic stone, the original design would have read from left to right, but is now reversed in the print; thus we should read it from right to left.

16 Cited in Provost, 1989, p.125.

17 There were many conflicting accounts of the incident, from which both political wings tried to make capital. A deposition from an eyewitness is quoted in the contemporary account published by the republican politician Ledru-Rollin, cited in Courthion, 1945, pp.41–2.

18 Philipon, who with his brother-in-law Gabriel Aubert effectively ran La Maison Aubert, had also edited *La Revue Moderne*, as well as several other subsidiary journals to which Daumier contributed. Daumier's choice of subject matter was not always in his own hands. For a detailed account of this immensely powerful publishing house see James Cuno, 'Charles Philipon, La Maison Aubert, and the Business of Caricature in Paris, 1829–41', *Art Journal*, winter 1983, pp.347–54.

19 See *Carnet I* in the Appendix.

20 He had drawn for wood engravings earlier in the 1830s, but the blocks had been relatively crudely cut.

21 *Parade du Charivari* (LD 554) was commissioned to bump up subscriptions, and appeared in a special number on 6 January 1839. Represented on the platform are, from left to right, Grandville (cartoonist), Philipon (who was then still editor), Aubert (publisher) and Traviès (cartoonist).

Daumier, on the steps, is the most youthful of this group.

22 Cited in Vincent, 1968, p.79.

23 To understand what this income meant in real terms, we could look at some comparative figures in the published Inquiry of the Bureau of Commerce into Paris Industries during 1847–48. This report, which gives very detailed lists of the wages of every class of industrial worker, spreads its categories upwards, as it were, to include certain specialized craftsmen and artisans who could also be classified as belonging to the 'Petite Bourgeoisie'. In the printing, engraving and paper trades, where 70% of the workers earned a daily wage of from 3 to 5 francs – that is, from 78 to 130 francs per month if they worked six days a week – more specialized groups earned more. *Éditeurs d'images et d'estampes* averaged 125 francs per month, with the highest paid earning 312 francs per month – near what Daumier's level had been in 1838. *Ecrivains et dessinateurs pour la lithographie* (a very small group) averaged only 125 francs per month, with the highest at 208 francs. A much larger group of nearly 2,000 lithographic *printers* averaged 116 francs per month, but in their case the maximum earned was 35 francs *per day* or 910 francs per month – these must have been master printers (perhaps specifically imaged in Daumier's belligerent cartoon 'Hands off the Press!', fig. 10). Many of these printers turned to working small independent businesses of their own.

24 Letter reproduced in facsimile in the catalogue of the exhibition *Daumier*, Paris, Bibliothèque Nationale 1958, p.LXX. It is also reproduced in Delteil, *op. cit.*, vol. 20, between pages for LD 25 and LD 26.

25 MD 75–77 and 444. They were lent by the collector Henri Rouart to the exhibition of 'French Masters of Caricature' held at the École des Beaux-Arts in 1888, and listed as in his collection by Daumier's biographer, Arsène Alexandre, also in 1888 (p.376 and one illustrated on p.137). At that date at least their authenticity was not doubted, although it has been questioned since.

26 Their authenticity has been strenuously denied, on grounds of style and quality, by Farrell Grehan in *Honoré Daumier: the Undiscovered Forgeries; Notes on K.E. Maison's Catalogue Raisonné . . .* , Chavannes-Ronans, Switzerland, 1975.

27 The 'blank' sets of prints were actually run off before being printed in the newspaper with text on the reverse side. See Passeron, 1981, p.95.

28 The element of caricature of the male figures in Daumier's *bas-bleus* scenes has been remarked upon more than once by the writer's female students.

29 In 1848 Daumier was to receive a state commission for an oil painting of the repentant

Magdalene, and the extant oil sketch which he produced (see the colour plate in Adhémar, 1954, pl. 51) is not unlike this pose.

30 1846 also happened to be the year when Daumier moved, with his young wife, to a studio at 9, Quai d'Anjou, on the Ile Saint-Louis. The well-known landscapist Charles Daubigny lived at no. 19. Corot lived a little further away, at 15, Quai Voltaire.

31 The fact that this word carries a masculine gender in French provided a fine irony for Daumier.

Chapter 2 Daumier as Artiste-peintre, Part I (1848–1852)

1 Michel Melot, 'Daumier and French Writers', at Colloquium, *Daumier Drawings in Context*, New York, Metropolitan Museum 1993. Baudelaire was the first writer to speak of Daumier as an artist, in his 'Salon' of 1845. Closely associated with Baudelaire's view was the younger poet Théodore de Banville.

2 Linda Nochlin has observed that the source of this maternal image is Andrea del Sarto's *Charity* group in the Louvre (New York Colloquium, cited above). Nochlin also pointed out the incongruities of scale, going so far as to suggest that *La République* is being 'brutally assaulted' by the two youths.

3 A similar technique is found in another early panel also in Cardiff, *Les noctambules* (M I-3). There, however, the tones are much darker, made to contrast with the white blob of the moon.

4 See Laughton, 1991, especially chapter 1 and pp.68–75.

5 Specifically, M I-15, 16 and 17, all of which include landscape settings of trees and river.

6 These were fairly standard prices at the time for government commissions – note that it could have taken Daumier three months of drawing lithographs to earn 1,500 francs. The documentation is in the Archives Nationales, Paris, AN F²¹ 23 (Daumier).

7 See Pierre Angrand, 'Un tableau de Daumier retrouvé', *Gazette de Beaux-Arts*, 6 (83), February 1979, pp.95–8. The large canvas was exhibited, before restoration, at the exhibition *Daumier et ses amis*, Marseilles, Musée Cantini 1979, cat. 42. Afterwards it was classified by the Monuments Historiques and transferred to the Municipal Museum of Soissons in 1980, being replaced in the church by a copy. It has been cleaned, relined and thoroughly restored.

8 Liance was at the same time a pharmacist and charity administrator resident in Paris.

9 The correspondence was found in dossier AN ²¹ 23. M. Liance requested the painting on 29 May

1852; the painting was despatched to Lesges about 24 June; and the balance of payment was made to Daumier on 30 June. I am obliged to the Documentation of the Musée d'Orsay for access to Jean Adhémar's notes on this subject and all other information relating to these paintings.

10 The oil sketch, which Mme Adhémar recognized without having knowledge of the researches of P. Angrand and J. Adhémar, was also exhibited at Marseilles in 1979 (cat. 43). It has since been donated by Mme Adhémar to the Musée d'Orsay in memory of her late husband.

11 Daumier may even have borrowed from his own idea for a lithographic cartoon of the conservative newspaper editor Dr Véron as *Le nouveau Saint Sébastien*, published in *Charivari* in December 1849 (LD 1917), although cherubs do not appear until his first charcoal drawing for the picture (Metropolitan Museum New York), which is probably of about the same date.

12 I am grateful to Jane Corbett for reminding me of this fact, and also for her observation that several of the pictures of martyrs in Louis-Philippe's *Galerie Espagnole* (which Daumier would certainly have known) depict the martyr holding a palm branch, but none are recorded showing an angel bringing a palm branch to the martyr.

13 M I-29 (Swiss private collection). Reproduced in colour in Adhémar, 1954, pl. 51. Alternative titles are *The Magdalene in Prayer* and *Repentant Magdalene*.

14 Ribera was well represented in the *Galerie Espagnole*, Louis-Philippe's personal collection of Spanish painting which had been on view to the public in the Louvre Palace between 1838 and 1848. Jane Corbett has pointed out to me that the extreme fervour of Daumier's portrayal of Mary Magdalene is interesting given that French critics of the religious paintings in the Spanish gallery often commented on their spiritual intensity, citing, for example, Zurbarán's *St Francis*.

15 A large *ébauche* for this picture, of equal size, in the Barnes Collection, Merion, contains the figures of the three girls only, with no reference to La Fontaine. At some point it acquired the title *Les ribaudes* (*The Ribald Girls*).

16 Stuffmann and Sonnabend, in the Frankfurt-New York catalogue of 1993, pp.94 and 108, convincingly suggest that Daumier took this subject from Delacroix's pendentive in the Bourbon Palace Library ceiling, which was unveiled in 1847. He could also have seen Delacroix's oil sketch of the subject, exhibited in Paris in 1852.

17 The schematic formulae for facial expressions of different types of human emotions were widely diffused through reproductions of the drawings by the academician Charles Lebrun (1619–90),

made for his famous illustrated lectures to students.

18 Certain figures in the relief are clearly related, as Stuffmann and Sonnabend have shown in the Frankfurt-New York catalogue of 1993, p.94, to Delacroix's refugees in the lower left corner of his hemicycle *Attila trampling Italy and the Arts* in the Library of the Palais Bourbon, which was unveiled in 1847.

19 This painting, in excellent condition, has probably been cleaned since it was in the Van Horne collection in Montreal in the 1960s, to judge by its colour reproduction in Adhémar, 1954, plate 45. It has not been cleaned or treated in any way, however, since it came on loan to the National Gallery, London, in 1980. The panel appears to have a warm brownish ground tone.

20 See exhibition catalogue *Goya, Truth and Fantasy: The Small Paintings*, Royal Academy, London, and Yale University Press, 1994, nos 40 and 41.

21 Rey, 1966, p.82; Laughton, 1991, p.72.

22 Cited by Robert Rey, *op. cit.*, p.84.

Chapter 3 Changing Directions: Daumier's Watercolours, c.1850–1860

1 The question of what exactly a watercolour is, in relation to 'drawing', is a vexed one. Since watercolour is normally applied on paper, for technical reasons watercolours are often stored and exhibited along with other drawings; indeed historically they have been called 'drawings'. The critic, museum curator and watercolourist D.S. MacColl used to argue for a return to the term 'watercolour *wash-drawing*', meaning the use of transparent washes of colour or tone on paper over an underdrawing to convey impressions, as opposed to what he called 'watercolour *painting* at the Royal Societies, a bastard form which aped, as far as it could, the elaboration of oil-painting, helped out by gilded mount and heavy frame'. (D.S. MacColl, *Philip Wilson Steer*, 1945, p.112). The traditional English eighteenth-century watercolour was most often executed in successive washes over a light pencil underdrawing, with linear accents added with the fine point of a brush. The nineteenth-century French version of this, as practised by Delacroix, Barye, Millet *et al.*, more often used watercolour washes in conjunction with contours in pen and brown ink. The addition of bodycolour in the form of gouache gives a denser texture and loses the transparency of the washes. Daumier eventually used all possible variants, as we shall see.

2 By Harold Joachim, in the catalogue *French Drawings and Sketchbooks of the Nineteenth Century*, Chicago Art Institute, 1978, vol I, p.44 (2D3).

3 Not in Maison's catalogue. Exhibited in *Daumier Drawings*, Frankfurt and New York, 1992–93 (cat. no. 38).

4 Hippolite-Guillaume-Sulpice Chevallier, known as Gavarni (1804–66). Elegant, sophisticated and ironic, his wide range of figure subjects included some acute observations of the working class and of vagabonds.

5 She was born on 22 February 1822, in the Marais quarter. Her father was a glass painter, and she became a dressmaker.

6 The parentage of this illegitimate child, named Honoré Daumier, is commonly misrepresented in the literature as being the artist himself and Didine. His birth certificate gives the mother as Marie Victorine Daumier and the father 'non dénommé'. Daumier's elder sister was then aged 40. The child was granted public assistance by the Département de la Seine on 10 June 1852. After that date there is no more trace of him, although his *Certificat d'origine* was verified, for some reason, by the Administration on 19 July 1872 (Archives de Paris).

7 de Banville, *Mes Souvenirs*, Paris 1882. Extract reprinted in *Daumier par lui-même*, Paris 1945, pp.145–62.

8 The fullest published account of this visit, made with Baudelaire, is in Laughton, *Daumier and Millet Drawings*, 1991, pp.96–7. For the French text see Adhémar, *Daumier*, Paris 1954, pp.44–5. See also this volume, chapter 5, p.65.

9 Chalks are obtainable, and were in Daumier's time, at various levels of dryness or greasiness, depending on the base material and the amount of binding medium in the form of wax or oil. 'Conté-crayon' is the term generally applied to fairly hard sticks of material prepared from chalk and wax, which draw like pencils but are softer and blacker. Drawing chalks can be obtained in degrees of softness or hardness, and can behave like pastels in application. They can be used to drag out broad, thick lines used in shading, for example. Lithographic chalks or crayons are prepared with a heavy admixture of oil, which makes a very deep black indeed when applied with pressure. Charcoal, made from wood carbon, is more brittle and friable than any chalk and rubs away easily. Daumier used every variety of chalk and crayon when drawing on paper, and for the purpose of keeping the terminology simple I have simply used the term 'black chalk' throughout when describing drawings that are not in charcoal, sanguine, red or brown chalk, or pen.

10 Maison, II, p.75 (MD 213).

11 Cat. *Vente Alexandre*, Paris 1903 (129); Maison, II, (MD 735). The Alexandre provenance is inscribed by Alexandre himself in the lower left corner of the drawing, where he says he bought it from Mme Daumier at Valmondois in February 1891. The cataloguers of the Frankfurt-New York exhibition of 1993 (cat. 27) speculate

that this work could be a study for a painting based on the artist's own experience of the 1848 revolution, instead of an historical illustration.

12 The Cordeliers was not as powerful as the Breton Club (known as the Jacobin Club after they established themselves in a Jacobin hall in Paris) which included J.-L. David among its members. Membership of such clubs was largely middle class, opposed to both the rich and those without property, and they came to think of themselves as ideologically élite (Alfred Cobban, *A History of Modern France*, vol. 1 3rd ed. 1963, I, pp.178–9). They were 'the very small number', as Camille Desmoulins put it in 1791, 'of those to whom only the witness of their conscience is necessary, the small number of men of character, incorruptible citizens'.

Desmoulins could evidently be critical of his revolutionary colleagues. Of Saint-Just he said 'His arrogance surpasses all bounds. He carries his head like the holy sacrament'. (Saint-Just was a prominent member of Robespierre's Committee of Public Safety in 1793.) In defence of the indiscriminate executions of 1793 Desmoulins is said to have cried 'Les dieux ont soif'. He seems to have been a follower of Danton, a prominent member of the first Committee of Public Safety who later supported a campaign for the relaxation of the Terror. 'With the approval of Robespierre, the Dantonist Camille Desmoulins, one of the most brilliant if one of the least reliable of revolutionary journalists, launched, in 'Le Vieux Cordelier', a devastating attack on the system of spies and informers which in the name of patriotism was turning France into a police state'. (Cobban, p.230).

13 Cobban, p.148. In 1789 orators there called the people to arms, and mobs formed daily. But during the counter-revolution in 1794 it became the headquarters of the 'Thermidoran reaction', from whence known Robespierrean Jacobins were chased off the streets by former Cordeliers (*Ibid.*, p.243).

14 For an account of a painting by Horace Vernet of the same subject, shown at the Salon of 1831, see Michael Marrinan, *Painting Politics for Louis-Philippe: Art and Ideology in Orléanist France, 1830–1848*, Yale University Press, 1986, p.109f. Daumier's portrayal of the incident is much more virile than Vernet's.

15 Rowlandson was suggested by the critic Duranty as early as 1878, in his article on Daumier in the *Gazette des Beaux-Arts*, June 1878, p.538.

16 A related study in charcoal (MD 705) has a similar central group of figures and dark corridor to the left, but a different staircase at the back of the stage right – one which resembles, in its configuration, the staircase in the *Salle des Pas-Perdus* at the Palais de Justice.

Until it was acquired by the Musée des Beaux-Arts, Marseilles, in 1990, it had not been

noticed that this drawing has a similar provenance to *l'Émeute* (see note 11). On an old mount behind the cardboard matt is inscribed 'Dessin d'Honoré Daumier provenant de son atelier de Valmondois / Arsène Alexandre'.

17 See Provost, *op. cit.*, p.152 (LD 2432).

18 See Laughton, 1991, pp.143–9.

19 Passeron, *op. cit.*, p.182, has pointed out that in the first state of the 1852 print (LD 2263) there was more space at the bottom, which has been cut out to make room for a long, gossipy and unnecessary caption. In a second lithograph published in 1857 (LD 2925) the same group has been redrawn, rather badly, to make a joke about the appearance of a comet. K.E. Maison, who recognizes that the watercolour (MD 697) is of finer draughtsmanship than the 1857 lithograph, also reproduces three fairly indifferent drawings which he thinks could be studies for either work; I find this proposition difficult to accept.

20 LD 638.

21 LD 982, 2639, 2817.

22 F. Braudel and E. Labrouste, *Histoire Économique et Sociale de France*, III, 1976, p.831.

23 Margret Stuffmann has pointed out that negative references to 'the bloody trade of the butcher' were common in French idioms of Daumier's time, and even had political references at the time of the suppression of the June Insurrection in 1848 ('Drawing from the Mind: Reflections on the Iconography of Daumier's Drawings', Frankfurt-New York exhibition catalogue, 1993, pp.25–6).

24 M I-110, oil on panel, 22.5 × 28cm. The cartoon, LD 3015, appeared in *Charivari* in November 1857.

25 *Butcher with a Carcass*, MD 264 (Fogg Museum, Yale University, Cambridge, Mass.), motif from LD 3012 (published 14 February 1858).

26 On the verso of this completed version is an unfinished watercolour of two lawyers outside a courtroom (MD 592). There are two other drawings directly related to this composition, which evidently had Daumier's attention for some time. MD 261 is a fragment of a preliminary study, cut in half. Another preliminary study in charcoal, black chalk and grey wash shows the same figure but with a different head: not in Maison, but in the Frankfurt-New York exhibition catalogue, 1992–93, cat. no. 56.

27 Baudelaire, *Correspondance générale*, III, 64; cited in Adhémar, p.50.

28 This explanation of Daumier's retirement as 'victim of police surveillance' was forcefully argued in S. Osiakovsky's 1957 thesis (see bibl.) p.200 ff., and has most recently been sustained by Michel Melot. For details of some of the metaphors that Daumier used to satirize Napoleon III in 1858–60, see Childs, 1989.

29 The first floor room was reached by a decent staircase, but the second floor was acces-

sible only by ladder. (Archives de Paris, Département et ville de Paris, *Calepins cadestraux*, 1863, D.IP⁴.)

30 In Didot-Bottin's *Almanach du Commerce* volumes for Paris, Daumier is listed at 9, Quai d'Anjou for the first time in 1854, as *peintre-artiste*, and for the last time in 1862, although it could have been out of date. His name appears at 48, boulevard Rochechouart in 1863, again as *peintre-artiste*.

31 The description of this 'appartement avec atelier artiste' in the 1862 *Cadestre* (official register of properties) sounds quite as good as the one the Daumiers had left on the Ile Saint-Louis. The rent was exactly the same: 1,200 francs a year, payable quarterly. (Archives de Paris, as in note 29, DP4, 1852.)

32 *Le Boulevard*, an 8-page weekly, ran for 76 issues from 5 January 1862 to 14 June 1863. I am grateful to Michel Melot for enabling me to peruse them all.

33 Daumier continued to publish wood engravings for *Le Monde illustré* until 1869: a total of 35. Various good engravers interpreted his designs, the most frequent being C. Maurand. Others who signed their names were Étienne, Peulot and Verdeuil. (Bouvy 921–55.)

34 Carjat published other *portraits-chargés* of contemporary writers, including one of *Maître Courbet* by Bénassit, seated on a bull, 'inaugurating his atelier of modern painters' accompanied by his 1855 text on Realism.

35 'The witty draughtsman who has written with the point of his crayon the finest and most amusing satire of these past thirty years' (*Le Boulevard*, 16 February 1862). When the journal ceased publication in June 1863 Daumier was again referred to in the closing editorial as 'le grand et inimitable dessinateur' (not 'caricaturiste').

36 See Laughton, 'Daumier's Expressive Heads', *RACAR*, XIV, 1–2, 1987, pp.135–42 and figs. 106 and 102–107. The sculptor Antoine Barye, a friend of Daumier's, was responsible for the 'restoration' (complete recarving) of 96 of these sixteenth-century corbel heads under the cornice of the famous bridge.

37 A second wood engraving after Daumier, entitled 'Membres d'une Société d'Horticulture' was published in *Le Temps* on 28 October 1860 (Bouvy 920). His humorous drawing (MD 720), in black chalk with stomped shading, is accurately reproduced by the engraver Dupeyron, and one wonders whether Daumier drew it first on the wood block in reverse and then copied the print, or whether the engraver copied his original drawing on paper. The block was used again to illustrate an article on horticulture in *Le Journal pour tous* in 1862.

38 K.E. Maison observes, apropos of the Esnault-Pelterie watercolour (MD 330) and of the

Williamstown version (MD 329) that forgeries based on these are unusually numerous. A photograph of a drawing of two heads closely based on MD 329 was given to me by the late Jean Adhémar, for example, which is quite a clever fake. Passeron, p.273, reproduces a charcoal drawing of two figures from the right foreground of MD 330, in a very cursive and 'nervous' style which he thinks is genuine but which Maison refused. The clue here is the even consistency of pressure, with no groping for forms such as Daumier would have made if this were a genuine exploratory study.

39 Catalogue published by the Armand Hammer Foundation, Los Angeles, 1980, pp.196–7. The actual block is reproduced as well as a print made from it. The engraver has not fully understood the original and has only been able to include seven heads.

40 Frankfurt/New York exhibition catalogue, 1992/93, p.151.

41 Technically, Daumier's contract to draw lithographs for *Charivari*, written or unwritten, was simply terminated; he was not an employee in the modern sense, so there would be no termination pay and the effects on his income would have been immediate and drastic.

42 MD 349, private collection, repr. Passeron in colour, p.214 pl. 152. This unfinished first trial clearly demonstrates Daumier's technique of drawing first in black chalk and pen, then laying down graded washes in grey for the main light effects, before putting in colour.

43 The first recorded owner of this watercolour, Jacquette, bought oil paintings from Daumier in 1876–77 (see *Carnet V*). Daumier's sales of watercolours are not recorded before 1864, but we could infer that Jacquette bought this work from him soon after it was finished – perhaps it was even made to order.

Chapter 4 Daumier as Artiste-peintre, Part II (after 1852)

1 Maison I, I-63 (as 1852/55). From the Florence J. Gould Collection, sold at Sotheby's, New York, 24 April 1985 (20), repr. in colour in cat. The painting has been cleaned and found to be in a very good state of preservation.

2 For a full analysis of the history and significance of the Durand-Ruel exhibition and the different Daumier discourses that devolved from it, see Michel Melot, 'Daumier and Art History: Aesthetic Judgement/Political Judgement', *The Oxford Art Journal*, 11:1, 1988, pp.3–24.

3 *The Diary of George A. Lucas*, transcribed and edited by Lilian M.C. Randall, Princeton 1979, I, p.99.

4 Klaus Herding, in 'Daumier critique des

temps modernes: Recherches sur "l'Histoire ancienne"', *Gazette des Beaux-Arts*, series 6, 113, January 1989, pp.29–44. See also Herding, 'The Artist and the Connoisseur', in Frankfurt-New York exhibition catalogue, 1992–93, pp.48–59.

5 'The ability to abstract is what most distinguishes Daumier's imagination' ('The Artist and the Connoisseur', cited above, p.51).

6 Delacroix, *Michelangelo in His Studio*, 1849–50 (Montpellier, Musée Fabre). Acquired by Alfred Bruyas, notable patron of Courbet, in 1854.

7 M I-167. Oil on canvas, 117 × 92. Private collection.

8 Indeed, it has a curious blankness to it, and Farrell Grehan (*op. cit.*) has even argued that this canvas is not by Daumier's hand, on the grounds that the 'copyist' has not understood the perspective of the easel in relation to the bottom of the back wall. However, Daumier was not above using the most mechanical methods to repeat a design in preparation for some further devel-opment – which in this case never took place.

9 For an extended analysis of this new phenomenon of dealing in contemporary art, see Nicholas Green, 'Dealing in Temperaments: Economic Transformation of the Artistic Field in France during the Second Half of the Nineteenth Century', *Art History*, 10:1, March 1987, pp.59–78.

10 'Mémoires de Paul Durand-Ruel', in L. Venturi, *Les Archives de l'impressionnisme*, 1939, II, p.164.

11 That is not to say that Daumier did not have a number of buyers from the later 1860s through to his death in 1879. The list of lenders to his 1878 exhibition reveals, however, that with a few exceptions none of his supporters owned more than a small number of his works. The exceptions were the family of Charles Daubigny, a successful landscape painter of the Barbizon School who owned twelve of his oil paintings, and M. and Mme Pierre Bureau, who had collected at least 25 drawings and watercolours as well as a couple of oils. M. le Comte Doria owned seven works, and Alexander Ionides of London three (obtained through Durand-Ruel), but with these exceptions the likelihood is that most of Daumier's patrons had quite modest incomes.

12 Bouvy 922, 930, and 928 respectively.

13 Bouvy 938–42. This was a large building flanked by the rue Drouot, not far from the Bourse. It contained several auctioneers' rooms, and they became known collectively as the Hôtel Drouot.

14 LD 3246. Jan Kist has suggested that the standing figure with arms outstretched represents the Barbizon painter Jules Dupré (who also happened to be the first owner of *L'Artiste en face de son œuvre*), and that the figure leaning forward with his nose almost touching the canvas repre-

sents Daumier himself. The cartoon would thus become an in-joke by a *farceur*.

15 Compare the lithograph 'Combat des écoles – L'Idéalisme et le Réalisme', LD 2629, *Charivari* 24 April 1855). Alison Garwood-Jones has suggested that such an artist might be the kind who 'deliberately commands public attention' and, by implication, who would be willing to accept the Legion d'honneur (unlike Daumier himself, as we know). Clearly this is mockery.

16 Surprisingly, Aubry did not lend this watercolour to Daumier's 1878 Retrospective Exhibition, but put in another drawing of a similar subject which he had more recently bought (see p.82). He did lend it to the 1888 *Exposition La Caricature* (398), before selling it to Durand-Ruel, who in turn sold it to the American collector Cyrus J. Lawrence, who bequeathed it to the Walters Art Gallery in 1910.

17 Compare the clothes worn by James Tissot in his portrait by Degas of *c.*1867–68 (Metropolitan Museum of Art, New York), and the similar way he exposes his long waistcoat. He is of course a younger dandy – Daumier invented one closer to his own generation! The subtle point of Degas's portrait is that his dandy was *another artist.* Could this have been Daumier's intention also?

18 This underdrawing itself was preceded by a try-out for the whole composition drawn in charcoal on another sheet (MD 382: Boymans-Van Beuningen Museum, Rotterdam), in which only the head of the artist and his friend were worked up a little in watercolour.

19 This is in fact the only version of *Amateurs dans un atelier* that could fit the dating requirements for such an exhibit, because the Walters version was owned by Aubry, not Court.

20 Alison Garwood-Jones points out that the walls of this room hung with pictures frame to frame, together with the book and statuette on the table, are in keeping with the contents of a 'cabinet d'amateur' rather than an artist's studio, notwithstanding the artist in the background holding a palette.

21 This resemblance was first noticed by Ms Gael May McKibbon, former Registrar of the Payson collection (now in Portland Museum of Art).

22 The Napoleonic legend reached its height when the Emperor's ashes were recovered from St. Helena in 1840 and brought back to Paris, to be placed in his new tomb at the Invalides in 1842– much to Daumier's disgust (see his cartoon, LD981).

23 A fine drawing in black chalk exists of the *Venus de Milo* by itself, probably made from a plaster cast, from exactly the same angle as she appears in *The Connoisseur.* MD 806 (Ordopsgaardsamlingen, Charlottenlund).

24 Herding, 'The Artist and the Connoisseur in Daumier's work', *Daumier Drawings*, Frankfurt-New York exhibition catalogue, 1992, p.57. One also thinks of the garden statuary figures in Watteau's *fêtes champêtres*, which would seem to be living if they had not been painted in monochrome.

25 *Two Amateur Print Collectors* (MD 376) in the Reinhart collection, Winterthur, should be added to their number. *The Connoisseur*'s first owner was the Barbizon painter Jules Dupré and at his sale in 1890, Maison notes, it fetched 1,250 francs, a good price for a watercolour drawing. Several preparatory drawings preceded this work, although not all those attributed to Daumier in this case are of certain authenticity. A small drawing of the seated *connoisseur* looking at sculpture, from the Fuchs collection (MD 368) and in reverse of the present composition, and a very broadly handled tonal study in charcoal and grey wash in the Boymans Museum, Rotterdam (MD 369) are certainly by Daumier in my view.

26 The early provenance of this work has not been discovered, if indeed it was ever sold in Daumier's lifetime. Maison catalogues its first provenance as Roger Marx, who is known to have bought a lot of Daumiers from his widow in about 1890. There is a possibility that the signature is a later addition by another hand.

27 MD 503 (Private collection).

28 A series of eight *Croquis pris au théâtre* (LD 3261–68), for example, appeared in *Charivari* between February 1864 and June 1865, two of which consist entirely of rows of goggling faces; another shows a free fight in an upper gallery.

29 For example, *Un fauteuil d'orchestre*, Washington National Gallery, Chester Dale Collection (M I-158, as *c.*1863).

30 See Laughton, 'some Daumier Drawings for Lithographs', *passim.*

31 A study of Daumier's lithographs over the same period, especially from 1868 onwards when censorship was slightly lifted under the more liberal government of Ollivier, shows that the artist was well aware of the aspirations of Prussia and the disastrous foreign policy of Napoleon III. His own titles for his lithographs in his account book, written before *Charivari*'s editorial staff invented legends for them, confirm his political awareness.

32 See Appendix, *Carnet V.*

33 The wood engraving is Bouvy 991; the watercolour is MD 501, *Pendant l'entr'acte à la Comédie Française* (present location unknown).

34 M I-133 (as 1858/62).

35 The Frankfurt-New York exhibition cataloguer writes: 'The painter's studio could just as well be the library of a collector, for what matters is that the painter has found his ideal audience'. *Op. cit.*, cat. no. 75.

Chapter 5 Daumier's Oil Painting Techniques, c.1850–1863

1 'Daumier the painter is born and grows alongside Daumier the cartoonist and draughtsman of everyday life', Eugéne Bouvy, *Daumier: L'œuvre gravé*, vol. 1, 1933, p.x.

2 See Appendix.

3 M I-174, now in the Ny Carlsberg Glyptotek, Copenhagen. Oil on canvas, 41 × 33 cms.

4 Barabbas is not present here, as he would be if the iconography followed the accounts in Matthew 27, Luke 23, or Mark 15, all of which imply that Christ and Barabbas were presented together for the crowd's decision. None of these, however, produce the phrase 'behold the man!' at this juncture. The mistake in title begins with Alexandre, p.373, who calls it *Nous voulons Barabas!* I am grateful to the students of my Daumier seminar of 1994 for raising this discussion, and in particular to Stephanie (Boughen) Dragonis.

5 Bartsch 77. Dated 1636.

6 Charles Blanc, *L'œuvre de Rembrandt*, Paris 1853. The etchings reproduced photographically. Copy in Cabinet des Estampes, Bibliothèque Nationale, Paris.

7 Clark, 1973, p.112.

8 K.E. Maison, I, p.193. It is true that the heads in question, when each is viewed in isolation, are curiously flaccid and expressionless, and the paint handling is coarse. Yet each time I have looked at this painting in the original I have been impressed by it, and I noted in 1990, for example, 'Not repainted much – the forms are just very large scale'. A very large brush has been used for the central figure, applied by what Maison called euphemistically 'a very able hand'.

9 See Adhémar, 'Les esquisses sur la Révolution de 1848', *Arts et Livres de Provence*, 1948, pp.42–5. He refers also to *Passants* (M I-114, Lyon) as 'appartiennent au même cycle' of the following works: *l'Émeute*, also known as *Scène de la Révolution* (M I-26, thought to have been lost in World War II but in the Pushkin Museum, Moscow, 1995); *l'Émeute* or *The Uprising* (M II-19, Phillips collection); the gouache called *l'Émeute* (MD 735, Ashmolean Museum); and *La famille sur la barricade* (M II-18, Prague, Narodni Galerie).

10 A. Boime, *Thomas Couture*, 1980, pp.436–7 and fig. XI.7.

11 Put very simply, an *ébauche* was the term applied to a preliminary sketching out of the main lines of a composition, together with the broad distribution of its tonal masses, on the full-scale canvas before proceeding to 'finishing'. (Constable's full-scale studies for his six-foot landscapes are in effect *ébauches*, except that they are on different canvases from the final works.) The core of

Couture's teaching was how to preserve the initial impetus, attack, tactile excitement or whatever, of the ground-layer *ébauche* into the finished painting, by allowing it to show through to the final surface in places.

12 Boime, *op. cit.*, p.437. Couture had been teaching his *méthode* since he opened his famous atelier in 1847, but it was adapted from quite traditional methods of tonal underpainting which he himself would have learned in the studio of Delaroche. After twenty years of teaching Couture committed his system to writing in a textbook for beginners entitled *Méthode et entretiens d'atelier* (Paris 1867) – too late for Daumier to have made any use of it, but the ideas would have been in the air much earlier. Couture's text contains some interesting details about how to prepare the first surface layer of a design: with pigments such as ivory black, bitumen, red-brown and cobalt. He goes on: 'Avec un ton composé de noir et de brun rouge, vous pouvez obtenir le ton bistre, ou bien: le bitumen, le cobalt et le brun rouge vous donneront à peu près le même résultat'. The introduction of black and cobalt as well as red-brown in the mixtures would allow for differentiation between cool and warm tints in the *ébauche*, in preparation for the colours to be laid over them.

13 Delacroix himself had been struck by the freshness of Constable's paintings at the 1825 Salon. Millet had been a contemporary of Couture's in the studio of Delaroche, himself a former pupil of Baron Gros and heir to the romantic tradition of relatively freer paint handling. Another contemporary and friend of Daumier's who regularly used a brown monochrome *ébauche* for beginning his Salon paintings was Théodore Rousseau, although in his case the execution of his early *plein air* oil sketches might have impressed Daumier more. The artist most famed for the free handling of his landscape *esquisses* in the 1860s was Charles-François Daubigny, a close friend and erstwhile neighbour of Daumier's when he lived on the Quai d'Anjou.

14 Boime, *op. cit.*, p.452.

15 In the discussion that follows I should make it clear that by the term 'ground' I am *not* referring to the priming layer of the canvas or wood panel, which would normally consist of some mixture of gesso with white lead, but to the final tone or colour of pigment spread over this surface before commencing the painting.

16 It is like looking at a painting by a member of *die Brücke*, painted in the wrong century.

17 Gustave Kahn, 'Daumier' (review of Daumier's 1901 exhibition at the Ecole des Beaux-Arts), *Gazette des Beaux-Arts*, vol. 25, 1901, p.490. He regretted that this picture (seen in the Exposition Universelle, #176, lent by Henri Rouart) was not included in Daumier's own exhibition.

18 These represent a selection of the colours recommended by Couture for the student to lay out on his palette *after* the *ébauche* in bistre and black has been executed and dried. Couture's full list of colours is given in this order: 'Lead White or Silver White; Naples Yellow "naturel"; Yellow Ochre; Cobalt; Vermilion; Brown-red; Lake (madder lakes are the best); Burnt Sienna; Cobalt [again!]; Bitumen; Ivory Black' (*Entretiens*, pp.34–5). By combining the effect of an *ébauche* with some of the colours used for a final painting, Daumier has developed a new, more spontaneous technique of his own. The one difference from Couture's list is that, whereas Daumier may well have used some cobalt blue, the more greenish tint of Antwerp blue can be more often identified by sight in his paintings.

19 See Chapter 3, pp.41–2. Daumier drew his longest series of 'Croquis dramatiques' for *Charivari* in 1856–57, and the compositional device of looking across a darkened auditorium to a lighted stage, seen at an angle, is first found in LD 2764 (published 22 May 1856), as Adhémar pointed out. It shows, however, a different theatre from the one in the painting.

20 'L'ACTEUR – Il était votre amant, Madame! (*Bravo! bravo!*) Et je l'ai assassiné! (*Bravo! bravo!*) Apprêtez-vous à mourir! (*Bravo! bravo!*) Et je me tuerai après sur vos deux cadavres! . . .

UN TITI – Ah! ben non, alors! qui est-ce qui porterat le deuil?' (Who will be left to go into mourning?) Two such urchins appear in the lower right foreground.

21 Laughton, 1991, pp.56, 142.

22 There is no smudging, therefore it was not drawn in chalk or charcoal, and the line thicknesses are too regular for a brush.

23 Compare Géricault's second oil *esquisse* for the *Raft of the Medusa*, which also employs a pen.

24 There are basically two types: (1) the woman and child walking along the street by the quayside wall (M I-37, 42, 43, 85, 86, 121, and M II-13); and (2) the washerwoman and her child emerging from the steps coming up from the quayside (M I-84, 159 and 160).

25 The configuration of the St Petersburg painting is very close to a small oil sketch on panel, M I-37 (coll. Frau Jäggli-Hahnloser) which Maison dates 1850/52 and which probably preceded it. An even earlier version called *on a Bridge at Night* (M I-9) in the Phillips Collection, Washington, could date back to the late 1840s.

26 The X-radiograph makes clear Daumier's method of execution, using long, curvilinear strokes with a large brush loaded with dense pigments. These are seen on the surface as whites, pinks in the flesh areas, yellow on the houses and pink streaks in the sky. A fairly large head of a young woman, with hair parted in the middle in a style reminiscent of the 1840s (not unlike Millet's early portraits of his wife), and

with a white collar, appears upside down below the washerwoman's skirt, to the left of the child's head. Further to the right, underneath the wall, is a vertical line of opaque paint about 30 inches long, which could perhaps have indicated a 'frame' for the portrait. I am grateful to Dr John Leighton and the staff of the National Gallery, London, for allowing me full access to the documentation concerning the condition of this painting. Since it appeared in a Sotheby's sale in 1993 it has been expertly cleaned and restored by an independent conservator.

27 'Dans les parages de l'île Saint-Louis, une femme du peuple passe le long des quais de la Seine, portant au bras un lourd paquet de linge qui fait gonfler sa poitrine dans l'effort et donne à son visage une expression comme angoisse . . . L'état d'inachèvement de certaines parties de cette tragique peinture la rend encore plus intéressante, car I'on voit, par exemple, pour la poitrine, comment le maitre cherchait, sculptait pour ainsi dire le nu, avant le vêtir. Comme dimension et comme sujet, ce tableau . . . peut être considéré comme une des pages exceptionnelles de l'œuvre de Daumier'. *Vente Collection Arsène Alexandre*, Galerie Georges Petit, 18 & 19 mai 1903, lot 15. The cataloguer is clearly describing the version now in St Petersburg.

28 The two nearly identical versions are M I-85 (fig. 89), and M I-86 (formerly Robin Howard collection); Sotheby's London, 26 April 1967, #2, and Christie's London, 5 December 1983, #5, repr. in colour in catalogue.

29 Maison thought the medium used might have been *essence*, that is, diluting the paint to a very thin and transparent consistency. K.E. Maison, 'Daumier's Painted Replicas', *Gazette des Beaux-Arts*, vol. 57, 1961, p.372.

30 *Salons de W. Burger [Thoré-Bürger] 1861 à 1868*, Paris 1970, pp.115–16 (my translation).

31 Poulet-Malassis, *A-Z, Ou le Salon en miniature 1861* (paintings that year were hung in alphabetical order), cited in Maison, I, pp.96–7. Hector de Callas, *L'Artiste*, vol. 69, p. 247 (June 1861), p.147 (my translation).

32 The versions are 1) Buffalo, Albright-Knox Gallery, oil on panel, 28.5 × 19.7, M I-84 (1861); 2) New York, Metropolitan Museum, oil on panel, 49.8 × 33, sgd. l.l. *h.Daumier 1863*, M I-159; and 3) Paris, Musée d'Orsay, oil on panel, 49 × 33.5, M I-160 (1864) (fig. 93).

33 Maison I, p.138.

34 Michael Levey, in Kalnein and Levey, *Art and Architecture of the Eighteenth Century in France*, Pelican History of Art, 1972, p.41. Another version of Daumier's *Watering Place*, unfortunately somewhat overpainted, which appeared in Sotheby's 1 April 1982 (305a) (M II-33), does have a group closer to the Marly formula, with a young man standing beside a rearing horse.

35 See chapter 2, p.29. Compare also the background of Goya's *A Plague Hospital* of *c.*1798–1800 (Marqués de la Romana Collection, Madrid). The misty background there is actually the cavernous interior of a vaulted room. The effect is achieved the same way: thin white and grey glazes over a warm brown ground. There is not much hard historical evidence for Daumier's liking for Spanish art (unlike the case of Delacroix, who had both copied Velasquez and recorded his admiration for Goya's prints), but the visual similarities between certain of Daumier's paintings and Goya's later style are too striking to be mere coincidence.

36 One interesting variant of this theme, which anticipates the night street scenes of Degas and Émile Bernard, is *un ételage*, a lighted shop window at night showing dresses and linens, with women peering in. M I-106, on Christie's New York, 15 May 1990 (1).

37 There are several variants of this design. The earliest may be *The Print Seller's Window* (M I-70) in the Fogg Art Museum, Cambridge, Mass. Another variant, with a provenance going back to Corot followed by Geoffroy-Dechaume (M I-138), which has the central group of figures shown half-length, should be contemporary with fig. 94 (M I-145). There are other 'versions' of this popular subject, one unfortunately considerably overpainted, and others which are not by Daumier's hand at all.

38 E. Fuchs, *Geschichte der erotischen kunst*, (Munich, Albert Langen, 1922–26), pp.152–3. I am grateful to Dr Helga Stegemann for this translation.

39 The Glasgow *Print Collector* was purchased by Sir William Burrell from Barbizon House in 1923. This was during his second phase of Daumier collecting. See Ronald Pickvance, 'Daumier in Scotland', *Scottish Art Review* 1969, vol. 12, 1, pp.13–16 and 29.

Chapter 6 Daumier and Dramatic Expression: Actors and Lawyers

1 See chapter 1, note 12.

2 Repr. in Farwell, 1989, p.118. Signed and dated 1860.

3 LD 2347.

4 The drawing has no provenance earlier than the 1901 Daumier Retrospective Exhibition (Paris, École des Beaux-Arts), to which it was lent by M. Cahen as 'Portrait d'Henri Monnier' (*sic*). Basically it is a sheet of miscellaneous studies: some relating to the dance of *Death and the Two Doctors* (see fig. 105); a little figure of Columbine (see fig. 167); and some heads drawn in pen including the inked-in head of 'Monnier' himself. The sheet probably hung around in Daumier's studios during the late 1850s and mid-1860s.

5 A minute vignette in the top right-hand corner has been noticed by the Frankfurt-New York cataloguers as related to *Paillasse* (fig. 175), *op. cit.*, p.72. If this is the case, since I think that the Paillasse in question is a very late drawing, this sheet must also have hung about in Daumier's studio for years.

6 This drawing, not catalogued by Maison, was published for the first time in the Frankfurt-New York exhibition catalogue (cat. 34).

7 Although the sheet has been cut, at the bottom right there is visible trace of a frame having been drawn round this preliminary design. This way of working when planning a composition is remarkably like the method of Daumier's friend and contemporary J.-F. Millet (1814–75), and I have argued elsewhere that their creative processes are comparable. *Cf.* Laughton, 1991.

8 'L'un disoit "Il est mort, je l'avois bien prévû" / "S'il m'eust crû" disoit l'autre, "il seroit plein de vie".' 'The Physicians', from *The Fables of La Fontaine* (V, 12) translated by Marianne Moore, New York 1954, p.111.

9 See chapter 5, p.77.

10 Charles Baudelaire, 'Some French Caricaturists' (1857), translated by Jonathan Mayre in *The Painter of Modern Life* . . . , 1964, p.179.

11 There is, however, a small drawing in Yale University Art Gallery (MD 485) which is closer to the text, in which Dr Diafoirus and his son simultaneously take the patient's pulse and pursue a ridiculous conversation.

12 There are paintings of the Diafoirus scene (with compositions different from this one) which Maison dates to *c.*1860–63, but the wrinkled face of the doctor under his conical hat here resembles a single head that Daumier painted in the 1870s, which he sold to M. Aubry on 20 April 1877 (*cf. Carnet V*).

13 LD 3133 ('Actualités', 29 March 1959).

14 For good reproductions and a complete account of all the plates, and a seminal essay on the subject, see Cain, 1971 (translated by Arnold Rosin), and the French text as *Les Gens de Justice* (Sauret 1954 and Éditions VILO 1974). Reissued by Tabard Press, New York, in 1994. The sequence in which Daumier drew these images can be established from his practice of numbering his lithographic stones as he sent them off to the press.

15 I am applying these generalizations to Maison I, I-18, I-19, I-65 to I-69, and I-90, to which he assigned various dates between 1846/48 and 1857.

16 The painting is on a reddish-brown toned ground which, as was noted in chapter 5, is often found in the 1850s but which Daumier also used later than that.

17 There is no exact precedent to be found for this grouping or these characters in any of Daumier's famous series of lithographs of *Les Gens de Justice*,

published 1845–48, nor in its sequel *Les Avocats et les Plaideurs* published in 1851, but the general characterization is similar in the watercolour, which I would date 1855–60.

18 At the 1878 Daumier Retrospective at Durand-Ruel's, the catalogue listed 31 *dessins* of advocates (the term includes watercolour drawings), and only seven *peintures* of advocates, all lent from private collections. 130 sheets of drawings concerned with lawyers are catalogued by K.E. Maison, of which about 55 employ watercolour to some significant extent. Some seventeen acceptable attributions of oils of this subject exist.

19 The tracing (MD 659) is now in the Boymans-Van Beuningen Museum, Rotterdam.

20 These features are difficult to verify now because the hall was reconstructed after being destroyed by fire during the 1871 Commune.

21 A further example of artistic license might be perceived in Daumier's representations of so many advocates apparently waiting to enter the courtroom at once. It could be a very complex case with each defendant represented by a separate advocate, or it could be outside the *Cour de cassation*, where appeals were heard on the basis of law and procedure only (jury verdicts of guilty or not guilty could never be reversed). In the latter case, the presiding judge would be the dominant figure holding his hat in the right foreground, and the crowd behind some of his *fifteen* counsellors (see Benjamin F. Martin, *Crime and Criminal Justice Under the Third Republic*, Louisiana State U.P. 1990, p.169). The fact that the present *Cour de cassation* is at the other end of the palace from the *Salle des Pas-Perdus* is of no significance: Daumier's comment here must be upon the mysterious workings of the law unto itself.

22 Bouvy 971, engraved by C. Maurand. The dramatic situation is the same, though the print is more like a vignette taken out of the more spacious format of the watercolour. The facial expressions of the lawyers are amusing rather than intense.

23 MD 676, in the Musée des Beaux-Arts, Marseilles; MD 677, private collection, exhibited at Frankfurt-New York 1992/93 (94) (repr.).

24 LD 1372, from *Les gens de justice*; M I, I-18 and II-38; MD 596 and 601.

25 Lilian M.C. Randall, *Diary of George A. Lucas*, Princeton 1979, I, p.40 and II, p.901 (entry for 18 June 1902). Prunaire was a very skilled engraver who produced large-scale prints of two of Daumier's oil paintings as well as this watercolour, which he copied approximately the same size as the original. Some prints were pulled in black and white and some were printed coloured, with a fair degree of likeness.

26 *Après l'audience* is on cream laid paper, bearing the watermark 'HALLINES' & initials 'H.P.' under crown & shield. It is probable that

Daumier was purchasing special papers for his watercolours, aimed at a 'quality market', at this juncture.

27 Margret Stuffmann, in 'Drawings from the Mind: Reflections on the Iconography of Daumier's Drawings', Frankfurt-New York exhibition catalogue, pp.23–4.

28 The versions are MD 661–664 inclusive. Their sequence is hard to determine, as none of them are the finished product. Also related in design, but showing the lawyer conferring with his client, are drawings MD 656 and 657, both of which indicate Prud'hon's painting *Justice and Divine Vengeance Pursuing Crime* hanging on the courtroom wall.

29 This was of the same dimensions, 20 × 27cms (taken as sight size). Auguste Boulard (1825–97) had been a neighbour of Daumier's on the Quai d'Anjou before 1860. He was a still life and flower painter who had his own works bought by George Lucas in the late 1860s and early 1870s (Randall, *Diary of George A. Lucas*, as cited in note 25, I, p. 69 and II, p. 296).

30 Nr. 144, entitled 'A la cour d'assises'. Its dimensions, too, were given as 20 × 27cms. M. Béguin lent a total of 4 oils and 4 drawings to the exhibition. This title is also found in a letter written by Daumier to the painter Jules Dupré in the late 1860s, which refers to it as needing a frame [Service de documentation des peintures du Louvre: facsimile of autograph letter].

31 Stuffmann, as cited in note 27.

32 Robert Herbert drew my attention to this last, barely visible detail, and speculated whether Daumier had deliberately suppressed it (were it more visible it would create a greater illusion of depth), or if it has been 'absorbed into the matrix of the watercolour and drawing'.

33 MD 642, National Gallery of Victoria. In all likelihood there was a painting of the *Crucifixion* in the old *Cour d'assises* in Daumier's time, but it would have been destroyed during the Commune in 1871, when the Palais was burned. It was replaced by a *Crucifixion* painted by Léon Bonnat for the new Cours d'assises, which drew much attention at the Salon of 1874. So gruesomely naturalistic was the cadaver of Christ that it was popularly called 'The Christ of the convicts' (Jules Claretie, *Peintres et Sculpteurs contemporains*, Paris 1884, II, 140–3).

34 Maison I, I-213, *L'avocat lisant* (as 1868/70). Coll. Dr Robert Bühler, Winterthur.

35 An entry in Daumier's *Carnet V* indicates that Aubry bought a *tableau* of an advocate on 28 April 1876, and a *croquis* apparently of the same subject on 12 May. Daumier may have found this watercolour a few days after he sold Aubry the oil painting. See Appendix.

36 This watercolour is not one of those bought by William Walters in the 1860s, but was acquired by his son, Henry Walters, early in this century

from the sale of another American collector, Cyrus J. Lawrence. Like certain other of Daumier's finished watercolours, this is on heavy laid paper watermarked HUDELIST, one of the two or three special papers which Daumier evidently chose to use for such works. Melanie Gifford of the Walters Art Gallery has suggested that the dark blue-black of the lawyers' robes is composed of a mixture of Prussian blue (very fine particles) and black paint. Unfortunately the sheet has been trimmed to its edges by a former owner.

37 Maison I, I-198 is in a very late style indeed; II-41 is so much altered as to be unrecognizable as by Daumier. In both paintings the figures are only half length.

38 'Ce n'est aucun des personnages que vous venez de nommer, pour la bonne raison que Daumier ne les connaît point et n'a pas mis le pied au Palais depuis plus de dix ans. Mais je vous assurer qu'il connaît les avocats, et surtout l'*avocat*, mieux qu'ils ne connaissent eux-mémes. De là cette ressemblance qui vous surprend'. (Alexandre, 1888, p.356).

39 *Galignan's New Paris Guide*, Paris 1870, p.301.

40 See René David, *English Law and French Law*, University of Calcutta 1980, pp.45–7, 66–8; and Benjamin F. Martin, *Crime and Criminal Justice*, as cited in note 21, pp.178–84. Professor David argues that these elaborate preliminaries are necessary, before a person should be 'exposed to the indignity of appearing before the *Cour d'assises*'. He goes on to say that to the English, perhaps, 'the appearance is given thus that the accused, frequently held in jail before the trial and sitting in a box between two gendarmes, has already been convicted and does not stand a minimal chance of being acquitted, except if the oratory gifts of his counsel move the jury to a verdict which is perhaps questionable from the point of view of strict law' (p.68). However this may not be an altogether true impression, given the differences in procedure in the presentation of evidence under French law. On the other hand Professor Martin points to the great powers of the *juge d'instruction* in the pre-trial enquiry (apparently these were even greater before a new law on criminal procedure, passed 14 July 1865, attempted to limit them slightly), and suggests that his recommendation to indict at all 'tends to make the court and the jury regard the accused as guilty until proven innocent' (*op. cit.*, p.145).

41 Martin, as cited in note 21, p.179. Interestingly enough there is only one instance of Daumier taking the interrogation by a judge as his subject: this is *The Interrogation of a Minor*, a pen-and-wash drawing in the Ny Carlsberg Glyptothek, Copenhagen (MD 645), for which two studies also exist.

42 'Les Têtes sont effreuses, avec les grimaces, des

rires qui font peur. Ces hommes noir ont je ne sais quelle laideur d'horribles masques antiques dans un greffe. Les avoués souriantes prennent un air de corybantes. Il y a du faune dans ces avocats macabres'. Edmond and Jules Goncourt, *Journal, Memoires de la vie littéraire*, ed. Robert Ricatte (Paris 1956), VII, 60, entry for 15 March 1865.

43 The watercolours which appear most directly related to the format of this group of lawyers are MD 606, MD 608, MD 609 and MD 610 (fig. 114). They all stand below the plinth of a huge pillar or pilaster, and the horizontal line of figures gets longer as the drawings become more elaborate. A small black chalk drawing, however, MD 607, which is only about 3½ inches square, introduces a figure on the left turning back into the group, as in the oil painting. As was common enough with Daumier (and parallel to the practice of Millet), this thumbnail sketch is enclosed in a rectangular frame, which indicates how the design might 'sit' on a canvas.

44 Maison's catalogue note (M I-140) is able to establish a provenance for this painting back to the artist Jules Dupré, its first owner (from the title given in the Dupré sale of 1890). See Appendix, *Carnet V*, entry for November 1875: If 'J.D.' was Jules Dupré, it is possible that this work was painted after Daumier retired to Valmondois in 1873. It is certainly later in style than M I-139, dated *c.*1860 by Maison.

Chapter 7 The People Transported, in Town and Country; and Some Outdoor Watercolours

1 *Cf.* Adeline Daumard, *La Bourgeoisie Parisienne de 1815 à 1848*, Paris 1963, p.617ff.

2 Extracts from *The Diary of George A. Lucas*, transcribed and edited by Lilian M.C. Randall, Princeton 1979, II, pp.174–6.

3 'Excursion train, 10 degrees [celsius] of boredom and bad temper'. Daumier had previously produced a series of 15 lithographs under the heading 'Trains de plaisir' in 1852 (LD 2325–2339). Provost has noted that an excursion train from Paris to Rouen cost 10 francs third class and 13 francs second class at that time.

4 *Diary* as cited in note 2, pp.177, 179.

5 See Appendix, *Carnet IV*, Page 1, 1864: *Lucas [un dessin]; Lucas 3 dessins*. Daumier's prices were average enough in the company of the relatively minor artists that Lucas was buying: this is evident from a perusal of Lucas's diary through the 1860s. In 1865 William Walters went into partnership with Samuel P. Avery to buy paintings and drawings in large quantities for export to New York, there to be resold. Lucas was employed as their Paris agent. After Daumier's death, however, Lucas also operated consider-

able deals on his own account, as is evidenced by this entry in his diary in 1881:

'[April] 11 . . . At Tripps & bought Daumier at 1000fs – to sell it @ 3000fs & they to have 10 per cent' (!) (*Diary* as cited in note 2, p.518.)

6 That we can judge this is due to C. Maurand's skill as an engraver.

7 This was noted by microscopic examination, and consultation with Abigail Quant at the Walters Art Gallery.

8 Abigail Quant says the pigment used for this must be manufactured ultramarine, in commercial production since 1830.

9 The date of these lithographs is determined by the numbered stones, 67–73, which are entered in his account book *Carnet III* in June 1864, although the series was not published in *Charivari* until August-September. On the inside cover of this particular account book Daumier wrote the address: *Mr. Lucas 41 rue de l'arc de triomphe*.

 Interiors of railway carriages had already been the subject of several of Daumier's lithographs in the 1850s: see for example *Impressions de voyage en chemin de fer*, a frontal view of a bench inside a railway carriage, published in *Charivari* on 9 November 1855 (LD 2640).

10 There exists a small oil painting on panel of the same subject but with a quite different group of figures (Maison I, I-109). Maison dates this by style as 1856–58, that is, as the earliest version. No drawings are known which relate directly to it.

11 I am grateful to Mr Michael Pantazzi, Curator of European Painting at the National Gallery of Canada, for allowing me to see the mounted X-radiographs and for discussing the whole history of the painting with me.

12 The drawing on glass, 72 × 108 cms, was exhibited at Ingelheim am Rhein, *Honoré Daumier*, 1971 (30) (German private collection). Not known to Maison. The two tracings referred to are MD 299 and 300 respectively. The only other evidence that I can find of Daumier possibly using glass as a means of tracing for transfer and reversal of an image is in two drawings of *Don Quixote and the Dead Mule*, recto and verso of the same sheet (MD 442 and 443), now in the Armand Hammer Daumier Collection. The squared up tracing on the verso was used as the basis for two oil paintings of the same composition now in the Kröller-Müller Museum, Otterlo and the Metropolitan Museum, New York, respectively. Maison calls it 'a tracing made against strong light', but this was achieved by literally pasting it to a sheet of glass – the wrinkled white marks of wet gouache/paste are still on the original charcoal drawing where Daumier pulled it off a sheet of glass before it completely dried. In the case of the Ingelheim drawing, he must have pasted the inverse tracing face down onto the glass and then drawn on the glass itself from the other side.

13 I am grateful to Barbara Ramsey, Paintings Conservator at the National Gallery of Canada, for making this photograph available to me and discussing it.

14 Linda Nochlin, 'Daumier's *Republic*; Delacroix's *Liberty*; Gender Advertisements in Nineteenth-Century Political Allegory', at Colloquium, *Daumier Drawings in Context*, New York, Metropolitan Museum 1993.

15 MD 301. Coll. Fritz Nathan, Zurich.

16 MD 302. Frankfurt-New York Exhibition 1992–93 (51), E.W. Kornfeld collection, Bern (reproduced).

17 MD 290. Frankfurt-New York Exhibition 1992–93 (52) (reproduced).

18 Durand-Ruel, 1878 (125). The dimensions given, 22˙ × 32 cms, would fit into a cardboard matt with an aperture roughly the size indicated by Daumier (or someone else) with brown chalk lines on the sheet of paper at the top and bottom edges.

19 LD 3302. This particular lithograph, published under the general category 'Actualités' in *Charivari* on 21 September 1864, was an isolated subject which Daumier had drawn six months earlier (*Carnet III*, stone number 12). His caption writers decided to make it refer to a day excursion to Le Havre, whence trippers could see a tidal bore in the Seine estuary at Quillebeuf (Provost, p.157).

20 See R.L. Herbert, *Impressionism: Art, Leisure and Parisian Society*, New Haven and London 1988, *passim*.

21 See, for example, Paul Mantz's essay on 'La Caricature Moderne', printed as an Introduction to the 1888 Exhibition Catalogue *La Caricature*, p.26. (Daumier's watercolour was lent to that exhibition by M. Paul David, cat. 414, as *Salle de départ d'une gare*.) On Gavarni, see also chapter 3, p.33 and note 4.

22 See Klaus Herding, 'Le Citadin à la campagne: Daumier critique du comportement bourgeois face à la nature', translated from 'Der Stadter auf dem Lande' (1974), in *Nouvelles de l'estampe*, 46/47 July–October 1979 (special Daumier number), 28–40.

23 The motif of beer drinkers seated at a table under trees occurs in two comic lithographs (LD 3250, 3287) published in 1862 and 1864 respectively, which are both sufficiently close to this watercolour in their disposition to suggest that time bracket for its date.

24 MD 361. Reproduced in colour in Laughton, 1991, p.135, fig. 8.31. On the verso of that sheet is a partial sketch of the subject in a horizontal format, closer to the watercolour reproduced here.

25 This watercolour, which appeared at the Hôtel Drouot on 10 Dec 1981 (20) (repr. in colour), seems to be less faded than the Metropolitan *Man Reading*.

26 The oil painting, known as *Les laveuses du quai d'Anjou*, is Maison I, I-40, of *c*.1857–60. (Repr. in Laughton, 1991, fig. 8.21.), now in Moscow.

 On the verso of *Dans la campagne* is a drawing of a man pulling a wheelbarrow, a theme associated with Millet's rustic images.

27 LD 3318, published on 30 July 1864. All the prints made for *le Petit Journal pour rire* have figures with enlarged heads, which demeans their good qualities as drawings.

28 George Lucas's diary shows that he continued his interest in Daumier's prints, drawings and oil paintings right through the 1890s, when Rudolph Bodmer (the son of the painter) kept bringing works by Daumier to show him. There is no specific reference to the acquisition of this drawing, however, and it is not one of the two which Lucas lent to the Daumier exhibition organized by the Galerie Rosenberg in 1907. He may not have valued it so highly as more finished works.

29 LD 784, published 30 July 1842.

30 The recto was exhibited at the Frankfurt-New York exhibition 1992/93, cat. 86 (repr.). The verso was chosen for illustration in the selection of Daumier drawings made in facsimile by Léon Marotte and Charles Martine, *Honoré Daumier, Cinquante Reproductions*, Paris 1924.

Chapter 8 Daumier's Life and Patrons (1864–1870), and his Saltimbanques

1 See Appendix.

2 Burty, 'Croquis d'après nature', an article in *Notes sur quelques artistes contemporains*, 2ᶜ série, 10 December 1862, cited in Jean Adhémar, *Honoré Daumier Dessins et Aquarelles*, 1954, p.9. Burty describes some of them as '[exécutés] à la plume, légèrement rehaussés de teintes plates . . .', which sounds more like pen-and-wash drawings, what Daumier would have called *croquis*, rather than highly finished watercolours.

3 Unfortunately, Jean Cherpin's calculations as published in 'Le Quatrième carnet de comtes de Daumier', *Gazette des Beaux-Arts*, 56, December 1960, pp.353–62, are incorrect. Daumier entered drawings as either *dessins* or *croquis*. He entered paintings as *Tableaux*, *esquisses*, *paneaux* or by title.

4 I suspect that they are notes of debts outstanding at the end of each month ('fin' is frequently used as a prefix), rather than records of how his total budget was spent.

5 Very closely, at least. The total receipts from *Charivari* in 1865, of 3,560 francs, would

account for 89 stones, and he lists a total of 92, which might include breakages or remakes.

6 '1866 à 1867 / de 8bre à fin avril sur mois 581 / 7 mois'. What is not listed here is the payments from *Charivari*, which would make up the balance needed to reach this figure.

7 For the significance of the 1847–48 inquiry, see chapter 1, note 23.

8 More significantly, perhaps, the number of *fabricants* or manufacturers in this trade category employing only one worker or working by themselves in 1860 had nearly doubled since 1848, from 769 to 1,387. This must reflect a typically bourgeois desire for independence – which no doubt Daumier shared, as an artist.

9 For Bureau, see chapter 4, pp.59–60; for Lucas, see chapter 7, pp.109ff., and index. Auguste Boulard (1825–1897) was a still life painter who was himself patronised by Lucas in 1868 and 1869.

10 Maison I, I-224, last seen at Sotheby's sale, 27 June 1977 (17). Its earliest provenance is given as de Bellio. Adhémar dated the picture 1862/65, and Maison thought it could be as late as 1870. The apparently very free handling of paint is partly accounted for by the size of a standard photograph, which is larger than the panel itself.

11 See Anita Brookner, *Watteau*, Feltham 1967, for an excellent short account of the relationship between the two types of theatre.

12 See Francis Haskell, 'The Sad Clown: some notes on a 19th century myth', in *French 19th century painting and literature*, ed. Ulriche Finke, Manchester University Press, 1972, pp.2–16. In the course of his argument, Haskell reminds the reader of Mrs Panofsky's researches which show that Watteau's famous picture of *Gilles* (Louvre Museum) was not originally received as an image of sadness, but shows us the setting of a *parade* – the free advertisement of the performance that was about to begin, which the actors gave on a raised platform outside the theatre or tent.

13 Maison I, I-144. The painting is inscribed *h.D. à Debureau*,and represents him as Pierrot. Maison says that his career as mime was marked by vicissitudes and that he repeatedly had to tour the provinces to survive.

14 See T.J. Clark, 1973, p.121.

15 Paula Hayes Harper, 1976, p.10.

16 LD 86, 'Baissez le rideau, la farce est jouée' (in *La Caricature*, 11 September 1834).

17 See, for example, the 1867 lithograph LD 3610, with the caption 'Charivari forced to re-draw the view of the place where they erected the Temple of Peace', where the scene is military manoeuvres on the fields outside the Invalides. *Charivari* wears the cap and bells of a clown, and holds an artist's sketching pad.

18 Harper, as in note 15, p.40.

19 Klaus Herding, *Courbet. To Venture Independence*, Yale University Press, 1991, chapter 2 *passim*. (Courbet's *Wrestlers* reproduced p.10.)

20 The subject of one of Delacroix's frescoes was Tobias wrestling with the angel, which may be significant in this context.

21 MD 525, black chalk, 30.7 × 25.8.

22 Three are in the Musée des Beaux-Arts in Lyon, on separate sheets. The first simply indicates directional movements (Inv. 941; MD 528). The second is a searching study of forms (Inv. 945; previously unpublished) (fig. 163). The third is in a much freer, kinaesthetic flow of lines, close in style to fig. 164 (Inv. 944; MD 527).

23 'Les Hercules, fiers de l'énormité de leurs membres, sans front et sans crâne, comme les orangs-outangs, se prélassaient majestueusement sous les maillots lavés la vielle pour le circonstance'. 'Le vieux saltimbanque', in *Le Spleen de Paris*, 1861. Baudelaire, *Œuvres complètes*, ed. Y.-G. Le Dantec, revised Claude Pichois, Paris 1961, p.248.

24 The top edge of the paper has been cut, so it is impossible to see the position of the raised hand.

25 MD 519 (French private collection).

26 'Les danseuses belles comme des fées ou des princesses, sautaient et cabriolaient sous le feu des lanternes qui remplissaient leurs jupes d'étincelles'. Baudelaire, as in note 23, *ibid*.

27 Dumas also owned a drawing of *La malade imaginaire*, MD 556 (Yale University Art Gallery) which he lent to the same exhibition. *La parade* was given to the Louvre by the heirs of another distinguished owner, Henri Rouart.

28 A very lively version with the same number of figures but no crocodile, not catalogued by Maison, is in the Armand Hammer Daumier Foundation in Los Angeles; the Szépmúveszeti Múzeum in Budapest has an upright variation in monochrome; and another horizontal version in watercolour (MD 555, location unknown) is apparently one lent to the 1878 exhibition by Mme Bureau, though its authenticity is difficult to verify from Maison's reproduction. An interesting related drawing of a strong man pretending to threaten a clown on the parade platform, with drummer, crocodile backcloth and audience in front, in red chalk and brown wash, was exhibited at the Frankfurt and New York exhibition, 1992/93 (cat. 100), together with a two-sided, partly traced drawing of the same pair of figures in the Louvre (MD 523 and 524, verso). A much smaller version in the Krugier Collection, Geneva (MD 552), is in pen and watercolour and seems considerably later than the others in style, like a remembered *reprise* at the end of the artist's life. Treatment of the subject in oil paint is rare: an exception is *Carnival Scene* (Joseph Mugrabi Collections, M I-126), exhibited at Frankfurt and New York (cat. 98, repr. in colour).

29 Harper, as in note 15, pp.165–7. Concerning her observation of the 'lawyer', however, if this parade of characters is still partly based on the old *Commedia dell'Arte* cast, the bewigged figure could equally well have been 'the Doctor', in Daumier's mind.

30 As Maurice Agulhon has expressed it, '. . . national unity was occasionally represented on its own account. It seems that the role sometimes fell to Hercules, and this secondary tradition never completely disappeared'. (That is, secondary to the symbol of *La France* or *La République* as a woman.) Maurice Agulhon, 1981, p.14.

31 The Burrell collection version is MD 533, on which Daumier inscribed *à mon ami Jules Dupré*.

32 The tracings are, respectively, MD 535 in pen, last seen at Sotheby's sale, New York, 27 Feb 1982 (10); MD 536, a tracing in pencil which was then reworked (Fogg Museum, Harvard University); and MD 537, a tracing in black chalk again reworked in conté-crayon and grey wash (private collection), exhibited at Frankfurt-New York 1992/39 (114) (repr). The pen drawing, which is what is known as a *calque* – a close copy made on tracing paper – appears to have been used to make the study in black chalk and grey wash. The pencil drawing, which is also on tracing paper, has undergone considerable modifications to the clown standing on the chair and to the background, now filled out with a distant crowd watching another parade which features a strong man. This version and the wash drawing were used as the basis of the watercolour, fig. 170.

33 'Il ne riait pas, le misérable! Il ne pleurait pas, il ne dansait pas, il ne gesticulait pas, il ne criait; il ne chantait aucune chanson . . . mais quel regard profond, inoubliable, il promenait sur la foule et les lumières, dont le flot mouvant s'arrètait à quelques pas de sa répulsive misère!' Baudelaire, as in note 23, *ibid*.

34 Veronika Kaposy, 'Remarques sur deux époques importantes de l'art de Daumier dessinateur', *Actae Historiae Artium* (Budapest) 1968, XIV, nos 3–4, p.296; and Harper, *op. cit.*, pp.183–9.

35 LD 3607. As it was not published, only four proofs are known. The one illustrated here bears a long manuscript legend, beginning: 'Le Phénomène – Regardez, mesdames et monsieurs, je suis la fameuse colosse prussienne . . .', which was not used. It suggests, however, that the script writer was trying to develop upon Daumier's own title which we find in his account book, 'prusse Colosse' (applied to stone 47 in mistake for stone 48) entered in September 1866. (See Appendix, *Carnet III*).

36 Mars occurs in several cartoons, but this reference is specifically to his pose in LD 3630, published on 28 March 1868. He is approached by a cherub bearing flowers, symbolizing spring, who asks (embarrassingly) in the caption, why 'papa Mars' perpetually stands at attention. In his

Carnet III Daumier simply described this as 'printemps Mars', presumably intending to contrast the two characters. See Harper, p.189.

37 Carle Vernet drew one very like this in a lithograph of about 1815 (no. 91 in his series) with the caption: 'La premier muscade, la voilà!'. The game was to guess under which cup the conjuror would conceal a ball. The origin of the game is much older, dating back to the seventeenth century. *Cp.* A. van Ostade's print of 'A Charlatan', with an audience of rustics, British Museum, de Hauke Collection, D 43, III.

38 The title *Le baiser de départ* is the one inscribed by Daumier in *Carnet III*, for stone 51 drawn in September 1870. On 2 September, Napoleon III and General MacMahon had surrendered to the German army at Sedan, a situation which provoked insurrectionary demonstrations in Paris and the proclamation of a Republic. From then on preparations for the defence of the city were made by units of the National Guard. On 18 September the Prussian armies surrounded Paris, and on 19 September the siege began. Daumier's lithograph was published on 20 September, but he may well have drawn it during the events of the preceding two weeks.

Chapter 9 Last Years (1870–1878), and Don Quixote

1 Chapter 8, p.127.

2 See Appendix, *Carnet IV* (page 16). This is the painting now in the Ny Carlsberg Glyptotek, Copenhagen (K.E. Maison, *Daumier Catalogue Raisonné*, I, I-174), a canvas of 41 × 33 cms. Brame, already a well-known dealer at that time, sold it to the collector Arosa. After Arosa's death it was bought at his sale of 25 February 1878 by Dollfus for 1620 francs – over double its original sale price.

3 See chapter 3, p.42 and note 31, for details.

4 See Alfred Cobban, *A History of Modern France*, vol. 2 London 1965 (1980 ed.), II, pp.210–15. Cobban points out that it is a mistake to regard the Commune as Marxist in inspiration, 'it was not a government of the working class' (p.213). It consisted of a mixture of divided political factions and different classes, including not only workers but also many lesser bourgeois or professional men. The business of the rents 'spelt ruin to the lower middle classes of Paris' (p.211). Eugene Schulkind, in *The Paris Commune of 1871*, London 1971, concurs: the battalions of the National Guard included 'large sections of the middle classes in addition to . . . the working class population' (p.18).

5 LD 3861 and 3862, both published on 3 April 1871. In *Carnet III* Daumier records them simply as 'Les Loyers'.

6 Many artists who had remained in Paris during the German siege – among them Corot, Manet, Degas and Berthe Morisot – left the city after the Commune was declared on 28 March, which effectively isolated the people of Paris from the rest of France. When Manet and Degas returned, however, they were deeply distressed by the events that had taken place. The story of the resilience of the younger Impressionists – including Renoir who stayed in Paris during the Commune – and their adoption of a whole new imagery of optimism, is well told by R.L. Herbert in *Impressionism: Art, Leisure, and Parisian Society*, Yale University Press, 1986.

7 See Appendix, *Carnet III*.

8 Specifically, the bombed-out or shelled-out houses in LD 3814, 'L'Empire, c'est la paix!', published on 19 October 1970. See Laughton, 1991, pp.161–2 and fig. 10.1.

9 See chapter 6, fig. 102 and note 5. Maison catalogues three other variants of this composition, all in a late drawing style (MD 544–546).

10 See Stuffmann, Frankfurt-New York exhibition catalogue, 'Sideshows and Saltimbanques' pp.202–4; also her paper 'Moments of Introspection in the Late Drawings of Daumier', at Colloquium, *Daumier Drawings in Context*, New York, Metropolitan Museum 1993.

11 Jacques Callot (1592–1635) of Nancy. Callot made a number of drawings in Italy of figures of entertainers at the court of the Medicis. He was also interested in beggars and peripatetic mendicants, which brings him close to the subject matter preferred by Daumier. His work was widely disseminated in France through the popularity of his etchings.

12 This drawing was discovered by Maison after the publication of his *catalogue raisonné*, and published by him in *Master Drawings* 9, no. 3 (1971) p.264, illus. 51.

13 Bouvy 937, engraved by C. Maurand.

14 On the verso is a pen drawing, also in a late style, of a lawyer in the assize court pointing to a picture on the wall by Prud'hon, *Justice and Divine Vengeance Pursuing Crime* (MD 656).

15 Maison's identification of this as M I, I-33 (Tokyo, Bridgestone Museum of Art) is unconvincing because the dimensions, 39 × 32 cm, are much too small for the size given in the *Enregistrement des Ouvrages* for the Salon (90 × 100 cm), unless it was exhibited in a frame a foot wide all round. There is nothing in this painting to connect it with Camancho's wedding feast as described by Cervantes.

16 MD 438 (Reims Museum), which has the same setting but the figures in reverse; MD 439 (Private collection); MD 440 (Rhode Island School of Design) (fig. 134); MD 441, Christie's sale New York 15 Nov 1990 (109) in monochrome. One or other of MD 439 or 440 was traced, squared up and enlarged for an oil painting, M I,

I-111, which remains, however, no more than an unfinished *ébauche*.

17 Catalogue nos 145 and 222 respectively. Sizes identical.

18 Concerning, *Carnet V*. This notebook was first published by Jean Cherpin as 'Le dernier carnet de comptes de Daumier' in *La Revue Municipale de Marseille*, 1956, 29 (mai-juillet), pp.34–42. Cherpin's analysis of the contents is not always convincing, but the transcription was reasonably accurate and the relevant pages were reproduced in facsimile. The whole point of Cherpin's remarkable discovery – that Daumier was not as blind during his last years as has often been said in the literature – has been rather overlooked by scholars, and even Maison, who certainly knew of this *carnet*, refused to date anything later than 1873.

19 A phrase *croquis divers* could mean three very small drawings sold for a total of 150 francs.

20 Alexandre, *op. cit.*, pp.357–60. Alexandre's inference seems to be that Daumier's sight became insurmountably bad as a kind of side effect of his 'illness', and that up to that time it had been getting worse for an unspecified period. But if the doctors only proscribed him completely from drawing from this point, the possibility remains that he might have gone on doing some work up to 1877. Philippe Burty's written statement on the verso of the late drawing *Justice and Vengeance Pursuing Crime* (MD 813) (a parody of a painting by Prud'hon) to the effect that Daumier was almost completely blind when he took the drawing, was signed nine days before Daumier's death on 10 February 1879, and therefore does nothing to counteract this theory.

21 M I, I-206. Canvas 40.2 × 33 cms. Provenance F. Roybet in 1880.

22 M I, I-213. 41.5 × 33 cms (a 'toile de 6'). Maison gives the earliest provenance of this as 'Corot (?)', but the uncertainty leaves open the possibility that Aubry was the purchaser of both this and the watercolour of the same subject two weeks later.

23 See chapter 6, note 35. Concerning the date of the watercolour and its relation to the oil, I am in disagreement with Maison who thought, together with Oliver Larkin, that 'several decades separate these two works' (Maison, I, p.168). I believe that they are both late in date.

24 M I, I-184 (p.152). Maison also lists a smaller scale trial piece now in the London National Gallery and Dublin's Municipal Gallery of Modern Art (I-182), a separate oil sketch for the figure of Sancho (I-183), and a drawing of the whole composition (MD 436). He assumes that the painting, which he dates 1864/66 must have been with Daumier for a period of about ten years before he sold it to Mme Bureau.

25 Hofmann, Werner. 'L'âme de Don Quichotte dans le corps de Sancho', (translated from the

German by Alain Ruiz), essay in *Daumier et ses amis républicains*, Marseilles (Musée Cantini) 1979, p.14. Retranslated into English here.

26 Cervantes, *Don Quixote*, translated by J.M. Cohen, London 1950, p.137.

27 Étienne Moreau-Nélaton, in *Histoire de Corot et de ses œuvres* (Paris 1905, p.266), claimed that it was painted directly on to the wall, but he admits in his later book *Daubigny par lui-même* (Paris 1925, p.89) that it was 'pillaged' from the house by Daubigny's daughter-in-law selling it after his death, so it would have been painted on canvas applied to the wall, which could be removed. Raymond Escholier, in *Daumier* (Paris 1923, p.171) already knew that the canvas was then in the possession of Baron Gourgaud, from whose heirs it was acquired by the Louvre in 1966.

28 Maison I-201 and 202. These are two versions of a nearly identical composition, horizontal in format, in which Don Quixote and Sancho ride towards us down a rocky mountain path, and the dead mule, in the same position as in Daubigny's painting, lies in the left foreground. The repetition of the design was achieved by using a squared-up tracing from a charcoal drawing the same size as the panel paintings, so that by the time Daumier drew his mule once more for Daubigny's house he had already drawn it four times previously.

29 Laughton, 1991, fig. 10.30.

30 Rey, 1966, p.140. If that were the case, however, a more likely product for the client would have been the slight pen-and-wash drawing now in the British Museum (Maison, MD 341), which is a rather mannered 'illustration' of a troubadour possibly drawn from memory after the performance. The oil painting could have evolved from that later.

31 Letter to the author, 16 March 1995. Kenneth Blé is Associate Conservator of Paintings at the Cleveland Museum of Art.

32 Specific examples are: *Le déjeuner à la campagne*, versions in Winterthur and Cardiff (fig. 149), M I-210 and 211; *Amateurs d'estampes*, versions in Ghent and in two private collections, M I-234, 235, and 236; and *Le peintre devant son tableau*, versions in the Barnes collection, Merion, in the Clark Art Institute, Williamstown, and the Phillips collection, Washington, D.C. (fig. 179), M I-220, 221, and 222.

33 See chapter 4, p.57.

34 Carpeaux's *Achille Flaubert* plaster head is illustrated full face in Anne Middleton Wagner's *J.-B. Carpeaux*, Yale University Press, 1986, fig. 264.

35 Four of these were from the famous *Association Mensuelle* prints of 1834 – see figs 10 and 11.

36 See Michel Melot, 'Daumier and Art History: Aesthetic Judgement / Political Judgement', *The Oxford Art Journal*, 11:1 1988, pp.3–24. In the course of this article, Melot gives a critical analysis of the way that the exhibition was organized and received, dwelling particularly on the difficulties that commentators at that time had in evaluating Daumier as a great artist when his principal achievement was still perceived, in most people's eyes, to have been his work as a cartoonist – by definition held to be a low level of art.

37 Melot, 'Daumier and French Writers', at Colloquium *Daumier Drawings in Context*, New York, Metropolitan Museum 1993.

38 M I-26. See chapter 5, p.69, note 9, and p.71 for discussion.

39 Cherpin, 1973, pp.205–6.

40 This evaluation reflects the emphases made on these two artists by J. Grand-Carteret in a long and serious study of French cartoonists in his book *Les Mœurs et la caricature en France*, also published in 1888 in Paris.

NOTES TO APPENDIX

Daumier's Account Books

1 I am grateful to M. Jean-Pierre Coddacioni, Bibliothécaire-Adjoint at the Municipal Library of Marseille, for allowing me to photograph Daumier's account books in their entirety; to Professor Barrie Ratcliffe of Laval University for advice on Historical sources concerning Parisian workers and bourgeoisie; to Dr Colta Ives, Curator-in-Charge of the Department of Prints and Illustrated Books at the Metropolitan Museum of Art, for inviting me to give a preliminary paper on this subject at the 1993 Daumier Symposium in New York; and to Professor David McTavish, Head of the Department of Art at Queen's University, for his comments.

2 See Jean Cherpin, 'Le quatrième carnet de comptes de Daumier', *Gazette des Beaux-Arts*, 1960, vol. 56, pp.353–62 (discursive article, only two pages published), and Jean Cherpin, 'Le dernier carnet de comptes de Daumier', *Revue Municipale de Marseille*, 1956, 29 (mai-juillet), pp.34–42.

Carnet I

1 The *Robert Macaire* prints were the first and most famous of the many subjects which Daumier's editors encouraged him to produce in series.

2 A series of 12 plates called *Cours d'histoire naturelle* appeared between December 1837 and October 1838. The first five plates appeared in *Charivari* in December.

3 A series of 30 odd prints called *Galerie Physionomique* was published in *Charivari* between November 1836 and December 1837. They comprise single figures with expressions which reflect their occupations, for example: yawning, shaving, spying through keyholes.

4 The *Croquis d'expressions*, a series of 100 prints, ran from 28 January 1838 to 7 April 1839. The heading was used generically to include a wide variety of social situations of the bourgeoisie, with emphasis on facial expressions.

5 These *bourdes* (blunders or gaffes) may have been intended for *La Caricature Provisoire*, but as that journal did not appear until November 1838, this and the following entry of *bourdes* more probably refers to the seven woodblock vignettes that appeared in the *Charivari* in June and July 1839 (Bouvy 100–106).

6 LD 537. *[Un] quiproquo* (unfortunate misunderstanding) in this case was the unwelcome interruption of a family meal by a pair of undertakers bearing a coffin.

7 LD 538. *[Le] père François* was a waiter at the Brasserie Anglaise. This cartoon of him was published in *Charivari* with a further legend turning it into an elaborate joke at Daumier's expense, about him falling in love with an English girl whom he had barely caught a glimpse of before her departure.

8 Evidently Daumier was paid 360 frs. for the preceding nine stones on 12 July, less 10 frs. withheld for some reason – perhaps for a stone that had to be replaced. ('1 pierre vente' would signify a stone sold rather than a title).

9 LD 539–544, a series of six 'Double Faces' (inverted double heads), published in *Charivari* with the disclaimer 'Malgré le titre, les scènes n'ont rien de politique'.

10 Bouvy 116. The first wood engraving recorded in this *Carnet*, engraved and signed LESESTRE and published in *Charivari* on 13 December 1838. The subject was the three editorial 'Hommes d'État' of *Charivari*, seated round a table as for a board meeting. This vignette was only worth 25 francs, and it is unusual to find the engraver's name included on a work of that scale: it suggests that the engraver was a person of equal importance to the artist who did the design.

11 The second appearance of the weekly *La Caricature* (following its suppression in 1835) began on 1 November 1838, under the title *La Caricature Provisoire*. Although Daumier uses the word 'gravé' here, he is in fact referring to a large lithograph drawn with a pen on the stone. The print in question was a 'titre-frontispice' (LD 545) which appeared on 11 November, to introduce a series of four more lithographs entitled *Mésaventures et Desappointments de Mr. Gogo*. This print has a very elaborate border with figures, which partly accounts for the exceptional price and the amount of time that Daumier spent on it.

12 This is the series for which Daumier drew the announcement in October (see previous note), LD 546–549.

13 These *titres* are lithographs in which the heading LA CARICATURE PROVISOIRE is writ large above Daumier's cartoons. Delteil records five such pieces, which were published between 30 December 1838 and 23 June 1839. Daumier's cryptic descriptions *tonture* (as rudely applied to family haircuts) and *métier* (for shopkeeper) barely identify LD 550 and LD 588 respectively from the other headpieces.

14 LD 554, *Parade du Charivari*. (See fig. 12).

15 A print 'Promenade du Bœuf Gras' was published in *La caricature* on 17 February 1839 (LD 555).

16 LD 557.

17 A suite of 12 pieces, *La Journée d'un célibataire*, appeared in *Charivari* from 14 April to 15 September 1839. ·

18 'Saltimbanques', on April 20 and 28, can be identified with LD 619 and 620 respectively. The second was published in *La Caricature* on the day that Daumier recorded his stone, so it was a rush job.

19 A cartoon about trashy posters, for *La caricature* (LD 621).

20 The first of the series, *Mœurs Conjugales*, which ran between May 1839 and September 1842.

21 The suite of 30 lithographs of male bathers appeared in *Charivari* between 11 June 1839 and 27 September 1842.

22 The first of this series of six appeared in *Charivari* on 19 June 1839.

23 This could have been LD 559, published on 23 June 1839, as plate 1 of a new series which became called *Types Parisiens* but which includes a large heading in capitals on the plate itself, LA CARICATURE PROVISOIRE.

24 *Coquetterie*: a series of ten plates on male vanity, published in *Charivari* from 7 July 1839 to 15 November 1840.

25 LD 594, the first of a new series, *Les Cinq Sens*, all five of which were later incorporated into the *Types Parisiens*. The four other named senses that follow in August 1839 are LD 595, 596, 598 and 597 respectively.

26 Page 17 was published by Jean Cherpin in 'Sur quelques documents nouveaux: 1. La production lithographique de septembre 1839', *Daumier*, Arts et Livres de Provence, 1948, pp.74–6. Pages 16 and 17 are reproduced in facsimile opp. p.73, loc. cit.

27 Probably LD 687, *Visite matinale d'un créancier*, published 17 September 1839.

28 'Emotion' number 6 is LD 639 – a dandy splashed with mud who gives up his dinner appointment in town.

29 'Emotion' number 7 is LD 690, *Monsieur est malade . . .* , published on 6 October 1839.

30 'Baigneurs' number 10 is LD 770 (a reluctant child being dragged into the water), published on 27 September 1839.

31 The first time that Daumier himself refers to this series by name. 'Types Parisiens' appeared in *La Caricature Provisoire* from 23 June 1839, or in some cases in *Le Figaro*, before being reissued in *Charivari* as a series of 50 in 1841–42.

32 Two identical 'Bathers' prints are illustrated by Delteil as his catalogue numbers 766 and 767. Both Delteil and Cherpin supposed that 'one bather redone' means that the stone probably got broken in the course of printing, and Daumier had to draw it again forthwith – at half price! However, this is not the first time that a subject was redrawn – see April 1839, '1 retouche de R.M.', and Jan. 1839, '1 Croquis d'Exp. replacé', also done at lower prices.

33 Cherpin identified this as LD 750, the last of a series of five lithographs, all published in September on the subject of sugar-beet. *Actualités* (events of the moment) became a general heading frequently used by *Charivari* to cover any cartoon not in a series.

34 Cherpin identified this with LD 752, 'Rentiers Espagnols' (*Charivari*, 13 October) which refers to the end of the 'carlist war' with Spain enabling Spanish stockholders to receive their profits. Parisian bourgeoisie are dancing in front of the Bourse. (Cited in Provost, p.134.)

35 Wood engraving(s) for *Les Français peints par eux-mêmes* (ed. Curmer) Afterwards referred to as *bois pour Curmer*.

36 Daumier designed 30 wood engravings for *Némésis médicale illustré*, by François Fabre, which was published in 1840 (*cf.* Bouvy 336–364). This is the first reference to that commission.

37 *Les Parisiens* was a new series of six plates published between 1 December 1839 and 26 June 1840 (LD 754–759). If the two noted here are the first in the series as published, they would be LD 754 *L'Equitation Boutiquière*, and LD755 *Les Badauds*. Daumier signed both in full.

38 Probably LD 791, 'Poids et Mesures' (two haggling shoppers), published in *Charivari* on 2 February 1840 under the heading *Actualités*. This heading was sometimes used interchangeably for similar subjects found among the *Emotions Parisiens*.

39 For some unexplained reason Daumier only got paid 25 francs for one of his three lithographs for *Charivari*.

40 The series *Sentiments et passions* (4 plates) appeared in *Charivari* from 5 June 1840 to 8 May 1841 (LD 799–802).

41 Probably LD 797, *Proverbes de famille* (*Oncle et neveu*) published on 31 May 1840. The second *Proverbes de famille*, LD 798, was published on 14 June.

42 *Ventre affamé n'a pas d'oreilles* (LD 803) was the first in sequence of the *Proverbes et maximes* (12 plates) published from 21 June to 20 October. He seems to have drawn ten of them in June.

43 'Sans asile' in the published text (LD 808).

44 Daumier's visualization is a sinister one: a prisoner in handcuffs is escorted by a gendarme (LD 806).

45 In view of the corrected total below, the wood engraving for *Némésis médicale* was an afterthought.

46 A suite of seven plates called *La Pêche* was published in *La Caricature* between June 1840 and January 1841. These two could be nos 2 and 3, published on 19 July and 1 August respectively (LD 816, 817).

47 The first print of a new series, *Les Bohémiens de Paris*, which ran to 28 plates, appeared on 4 September 1840 (LD 822). The title of the series must have been suggested by *Charivari*'s editorial staff after they saw what Daumier had produced: his first title was evidently 'Caractères [of Paris]'.

48 As the last in the series *Croquis d'Expressions* was published in *Charivari* on 3 March 1839, it is difficult to account for Daumier's use of the heading here, unless he was thinking of the old series and they used his drawing to fit something else, such as *Les Bohémiens*. (An article on *Carnet I* is in preparation).

Carnet II

1 Before the period covered by this notebook there had taken place the 'affair Branconnot [or Braconneau]', in 1841–2, in which Daumier had incurred a debt of 110 francs for the purchase of some new furniture, been taken to court, tried and failed to pay off the bailiff appointed by the court, and apparently had all his possessions sold except for his bed on 13 April 1842. The list of furniture seized appears to be far in excess of the value of the debt incurred, and the punishment for failure to pay Draconian. This incident is recounted by Howard Vincent in detail in *Daumier and his World*, 1968, p.84, and the evidence is partially available in documents published in *Arts et Livres de Provence*, 1948, pp.94–5, by André Quantaine. The present location of the documents cited is unknown. See also p.163.

Carnet III

1 There is no oil painting by Daumier known with a subject from La Fontaine with these dimensions, either in centimetres or *pouces* (inches, approximately). Of the two finished watercolours after La Fontaine subjects, the dimensions of *The Scholar and the Pedant* are closest to

22 × 27 cms, and more specifically the size of a preliminary sketch for it (MD 397a). (Had Daumier meant '22 sur 27' to be in *pouces*, the work would have been about 73 × 60 cms, but nothing known fits this size.)

2 This is the same address as that of the art dealer, Hector Brame.

3 This sequence of *Charivari* numbered stones was for lithographs published between 12 May 1864 (earliest) and, with a few exceptions that were held over, the end of the year. A wide range of subjects was covered, including the series 'Les Baigneurs', 'En Chemin de Fer' (67–73, drawn in June), and 'Croquis de Chasse'. A separate numeration system was employed for the *Journal Amusant*, which published its first Daumier lithographs on 19 November 1864.

4 *Charivari* stone numbers 9 to 24 (new series) included 'Croquis parisiens' and 'Croquis pris au Salon'. The *Journal Amusant* stone numbers 21 to 28 were concerned with the theme of outdoor fêtes, and were published from June through September.

5 *Charivari* stones numbered 93–97 were published on dates between 19 January and 12 May 1865. A new sequence was commenced at 1 in February: the earliest publication date was 16 March. Subjects included 'Les Hippophages'. The *Journal Amusant* stone numbers 9, 10 and 12 were all published on 4 February 1865 ('Croquis Parisiens'). Number 11, 'Les Cochers [cabmen] de Paris' was not published. Numbers 13 to 20 were published on 25 February, 11 March and 15 April 1865 ('Les Joueurs de Billard'), and 21 to 24 on 24 June.

6 *Charivari* stones numbered 25–32 were all 'Croquis d'Été', published from July through September. It may be significant, from the point of view of Daumier's other activities, that no stones are listed at all in the months of April and June, although he could simply have numbered batches as they arrived.

7 *Journal Amusant* stones numbered 33–36 were used for the series 'Régénération . . .par la Gymnastique' (4 Nov. 1865); 37–40 for the series 'Croquis musicaux' (9 Dec. 1865). (See also notes concerning Daumier's payment for these in *Carnet IV*, Nov. 1865 and Jan. 1866.)

8 This is the last reference to the *Journal Amusant* in this *carnet*. All the remaining *Charivari* stones come under the heading of *Actualités*.

9 LD 3500. All *Charivari*'s readers knew about the new alliance between the politician and the owner of the newspaper *La Liberté*, so the caption printed with this cartoon did not mention their names! Louis Provost's *Thematic Guide* to Daumier's *œuvre* is thus invaluable to the present-day reader.

10 LD 3503. Bismarck breaking eggs: as his way of unifying Germany.

11 *Charivari* stones 33–48 included 'Croquis d'automne'; 'Les Spirites'; and 'Croquis parisiens'. The *Actualités* series (a heading for all subjects) began at stone 49 (excepting 'Au bain' on stone 58, numbered twice).

12 This cartoon, which shows John Bull with two horses, carries the legend 'Changeant son cheval borgne pour un aveugle'. Provost (p.159) points out that the reference is to Disraeli succeeding Palmerston in Britain.

13 This stone cannot be LD 3413 ('Après le bain', for *Le Journal Amusant*, published 4 August 1866), as Provost lists it (*op. cit.*, pp.190–1), because of this quite unrelated title. 'Le tombeau de Mahomet', however, which is clearly what Daumier has written here, is not known as a published print.

14 LD 3515. M. Prudhomme (not named in the print) demonstrating military drill to a small boy, using a broomstick.

15 Apparently not printed.

16 This refers to a delivery of coke, which Daumier used to note carefully in *Carnet II*.

17 Apparently not printed.

18 Refers to the demolition of the debtors' prison in the Clichy district: two disgruntled creditors look on. Daumier's librettist devised the legend, 'Marius sur les ruines de Carthage'.

19 LD 3590. Death driving a steam locomotive.

20 LD 3607. Although given the legend 'TROP GROSSE', this print with its reference to Prussian expansionism was never published. (See fig. 171).

21 LD 3610. A personification of *Charivari* (wearing jester's clothing) looking over the former site of the 1867 Exposition Universelle.

22 LD 3603. Daumier mistakenly numbered this stone 11. It was not published, and Delteil mentions only one proof extant. It shows the fictive papal priest Bazile directing the battle of Montana.

23 LD 3599. The Prussian soldier is shown as a wolf rather than a shepherd, watching over the other states in Germany.

24 LD 3697. Emile Ollivier reading the electoral roll, his head hidden. His name is not mentioned in the caption to this print as published. In three cartoons immediately following this, however, his features would have been easily recognized by the public.

25 Louis Provost points out that the original legend for this lighograph, in manuscript, was refused by the censor. Its point would have been about a deputy who was confused whether the order of the day was Peace or War. But Daumier's own idea is evidently simpler: he draws a 'Deputy for peace' and shows him looking miserable about the outcome in parliament.

26 LD 3707. Since this was one of Daumier's most politically subversive lithographs, in which three bourgeois candidates bow humbly to a ferocious

looking man in worker's smock, it is perhaps surprising that the artist himself makes no indication of his intentions in his mnemonic for the print, in this case.

27 LD 3713. It is interesting that this lithograph, published on 25 May 1868, the day after the election in which a majority favourable to liberal forms was elected and the right wing defeated, was actually drawn by Daumier at the end of April. He does not indicate, however, which party he is representing so utterly knocked out – his image could have been used either way!

28 LD 3736. *Mât de Cocagne* is a greasy pole. The reference is to the elections of 24 May – 'liberty' is at the top of the pole.

29 LD 3784. Liberty on her deathbed, with doctor. Daumier gives a very ironic modern turn to La Fontaine's fable.

30 LD 3794. This drawing of two bourgeois men chatting in a café could be used for any topical caption that Daumier's editors chose to apply to it.

31 LD 3789. A return of Robert Macaire after nearly thirty years.

32 LD 3893. This stone was not printed until more than a year later, on 29 November 1871, with the caption 'Prenez garde, Madame la Majorité'.

33 LD 3900. Representing Bismark sighting an 'Empire Germanique' in the sky. Not published. Delteil mistakenly believed this to have been drawn in 1871.

34 LD 3804. Volontaires. Published with the caption 'Those who are about to die . . .' this piece revives the historical theme of 'The Departure of the Volunteers of 1792'. It appeared in *Charivari* on 2 September 1870, the day of the French defeat at Sedan. See also stone 51: Le baiser du départ. (fig. 173).

35 By analogy with stone number 47 on this page, 'mobile' must refer to a national guardsman, and number 55 therefore must be LD 3816, published in *Charivari* on 31 October 1870 (a 'Garde Mobile' spears a dead eagle like a turkey, while standing on other symbols of past sovereignty in France). Provost switched the identifications of stone numbers 55 and 56.

36 Stones 24 and 25 formed a double-page spread in *Charivari*, LD 3861 and 3862, 'Les Loyers' (published 3 April 1871). Provost points out that in a decree of 30 March 1871 the Paris Commune granted a general remission of rents from October 1870 to April 1871, while at Versailles the Minister of Justice was working on a system of 'amiable arbitration'. Daumier's second cartoon shows this proposal being presented to an incredulous group of lawyers.

37 LD 3814. Published on 19 October with the legend 'L'Empire, c'est la paix!'

38 Apparently no print was ever made of this subject.

39 No prints exist of stone numbers 2 (title illegible) or 3. The subject of 3 – the title implies shrapnel in a hospital – might have been judged unsuitable for publication.

40 Stone 4 must be LD 3842, captioned 'le rêve de la nouvelle Marguerite' [the new Germany], which Provost tentatively assigned to stone 2 of 1871. It was published on 30 January 1871.

41 LD 3843. This famous print was given the caption 'Pauvre france! . . . Le tronc est foudroyé mais les racines tiennent bon!' Daumier was obviously familiar with the symbol of the broken or stricken tree with one living branch as denoting hope.

42 Stone apparently not printed. The previous stone (LD 3846) shows 'La France' swathed in bandages, being robbed by her 'Heritiers' ('They think I am dead already!'). The resurrection of Lazarus might well have been intended as a sequel.

43 LD 3864. On 8 April 1871 the sub-committee of the 11th arrondissement (République-Bastille) ordered the public destruction of a guillotine, by burning, at the foot of Houdon's statue of Voltaire (Provost, p.164).

44 LD 3875. The ghost of Louis XIV, finding a Republican government installed at Versailles, cannot believe his eyes.

45 LD 3903. Drawing this in December, Daumier thought of the 'sweeper up of systems' (the Empire, Royalism, and the Commune) as cleaning up 1871. His legend writer, on 11 January, changed the date to 1872 to represent the new Republic.

46 LD 3925. This is the famous 'Republican' lithograph with the legend 'If the workers fight among themselves, how are you going to rebuild the edifice?' which many Daumier commentators have quoted as an example of his views. But again the legend was not Daumier's. His own description, 'masons fighting', is more cryptic and sinister.

47 LD 3921. The three 'bilboquets', or silly-headed fellows, are represented as reincarnations of Charles X, Louis-Philippe and Louis-Napoleon, looking at what they regard as an unclaimed trunk, labelled 'malle de la France'.

48 LD 3924. Daumier's last cartoon of Thiers, his old enemy.

49 LD 3887. Bismarck is represented with a pump on the globe, sucking gold out of France.

50 LD 3884. Daumier does not specify who is reading this eagle (imperialist) journal. His librettist evidently decided it was Robert Macaire, and wrote a suitable line for him as 'un gérant' (manager). The stones that follow, however, make it plain that Daumier had Ratapoil in mind, standing for the resurrection of Louis-Napoleon's ideas.

51 LD 3908. The cleric 'Basile' kneels in supplication before a donkey's head in a shrine labelled 'St Ignorance'. The association of 'Ignorance' with the church's interference in education had been in Charivari since 1849, when the ultra-cleric the Comte de Falloux was represented as a 'frère ignoratin' (LD 1848).

52 (LD 3937bis). Not in Delteil but retrieved by Provost. The reference is to the reelection of the old 'Second Empire survivor' Rouher, as member for Corsica. He had been caricatured by Daumier since 1850. Provost mistakenly gives this as stone no. 4.

53 LD 3936. Skeletons accusing Marshall Bazaine of war crimes (see fig. 168).

54 LD 9889. Daumier means the Aolic winds, here shown blowing reluctant Deputies back to Paris from Versailles.

55 LD 3892. The escamoteur or card sharper and sleight-of-hand artist were frequently represented in the series of popular prints known as Les cris de Paris, with which Daumier was fully familiar. In this case a call for 'la tour' refers to a plebiscite in which the Parisian citizens did not believe (Provost p.65).

56 This stone number was not found by Provost, and the subject cannot be traced.

57 LD 3912. This title typifies one kind of entry made by Daumier, where he describes the literal subject of the drawing – here a Representative driving a locomotive away from a horse pulling in the opposite direction – without any reference to its political content. (The horse, baring a flag with a fleur-de-lis, symbolized the monarchist manifesto of the Comte de Chambord.) Such a literal description may indicate a prior consultation here betweeen Daumier and his editors about the cartoon and the form it would take.

58 LD 3934. Daumier's title for his last lithograph is again on the cryptic side. The heads of these three sleeping parliamentarians with long noses are actually reminiscent of Daumier's grotesque 'parliamentary busts' made at the beginning of his career in 1830–32. The caption given to the published print, 'Vue prise à droite', makes it clear that Daumier intended here a visual pun on the phrase 'pulling long noses' to be applied to his lifelong enemies.

59 Messrs Ive and Barré were known as lithographers.

Carnet IV

1 This notebook is the subject of an article by Jean Cherpin, 'Le Quatrième carnet de comptes de Daumier', Gazette des Beaux-Arts, vol 56, 1960, pp.353–62. Cherpin summarizes the contents and identifies a number of the purchasers of Daumier's works, but unfortunately his attempts to calculate Daumier's average monthly income are incorrect. Six of the twenty pages are reproduced in facsimile.

2 The painter Achille Oudinot (1820–1891), pupil of Corot.

3 Charles-Edouard de Beaumont (1821–1888), lithographer whose popular series of prints of urban and rural genre scenes were published by Aubert etc., and painter patronized by George Lucas in 1864.

4 Auguste Préault (1810–1879), the well known Republican sculptor, friend of Daumier's since his youth.

5 M. and Mme Pierre Bureau, private patrons.

6 Auguste Boulard (1825–1897), painter and engraver.

7 George A. Lucas, agent for William Walters.

8 Mr Delisle's address appears inside the front cover of Carnet III, as 47, rue Taitbout. This is the same address as Hector Brame's, so Delisle could have been either an associate or an employee, and the activities of Brame's firm as an early purchaser of Daumier's drawings is thus made clearer.

9 The meaning of these two settlements of 500 francs each in May and June is not perfectly clear, but they do point towards some concluding transaction, after which Daumier must have left Paris to live permanently in his country cottage at Valmondois.

10 This is very likely Tête de Paillasse (fig. 159).

11 Cherpin, op. cit., has noted the addresses of three dealers on this page as: Beugniet, 10, rue Lafitte; Cadart, of Cadart and Luce, 58, rue Neuve-des-Mathurins; Moureaux, 5, rue Lafitte.

12 A page for L'Autographe au Salon, no. 11, 8 July 1865.

13 'Amusant' is Le journal Amusant, for which Daumier had begun to produce a separate series of lithographic stones in July 1864 (see Carnet III). He drew nothing for this journal in June or July 1865, but did four stones in August for the series Souvenirs de la Fête de Saint Cloud. In the same numeration he drew two subjects in the series Plaisirs de la Campagne, which were published in Charivari instead. Total six prints.

14 On 4 November 1865 the same journal published five prints in a series called La régénération de l'homme par la gymnastique (LD 3382–88). In the same numeral series there is a single print of Plaisirs d'Été, published in Le Petit Journal pour rire.

15 Five more prints were published in the Journal Amusant for 9 December 1865, under the heading Études musicales (LD 3388–92). From this point on the distinction between this journal and Charivari grows blurred, as far as payment was concerned; the proprietors were the same anyway.

16 The painting now in the Ny Carlsberg

Glyptotek, Copenhagen. (Maison, I-174, as 1864/66).

Carnet V

1 First published by Jean Cherpin in his article 'Le dernier carnet de comptes de Daumier', *Revue Municipale de Marseille*, 1956, 29 (mai-juillet) pp.34–42. The two autograph pages are reproduced in facsimile and transcribed.

2 Lefranc's complete table is printed in *Art in the Making: Impressionism*, by David Bomford et al., London National Gallery 1991, p.45. The dimensions of the canvases or panels mentioned by Daumier on these two pages are as follows:

Toile de 1:	21.6 × 16.2 cms	8 sur	6 pouces
Toile de 3:	27 × 21.6 ″	10 ″	8 ″
Toile de 4:	32.4 × 24.3 ″	12 ″	9 ″
Toile de 5:	36.9 × 28.8 ″	13½″	10½″
Toile de 6:	40.5 × 32.4 ″	15 ″	12 ″

None of these are very large, but if the item sold in October 1876, 'Don Quichotte courant sur les moutons', can be identified with Maison I-184, dimensions 56 × 84 cms), that would be a near equivalent to a 'Landscape' 'toile de 25', of about 21 × 30 inches.

3 References are to Volumes I and II of K.E. Maison's *Catalogue Raisonné of the Paintings, Watercolours and Drawings* (1968), as M I-[number] and MD [number] respectively.

SELECT BIBLIOGRAPHY

N.B.: The most comprehensive listing of books and articles up to 1980 is found in Louis Provost, q.v.

Monographs

Adhémar, Jean. *Daumier Drawings*. (English tranls. Eveline Winkworth.) New York and Basel 1954.

Adhémar, Jean. *Honoré Daumier*. Paris 1954.

Alexandre, Arsène. *Honoré Daumier – L'homme et l'œuvre*. Paris 1888.

Baudelaire, Charles. *Les Dessins de Daumier*. Ars Graphica, 1924.

Bouvy, Eugène. *Daumier: l'œuvre gravé*, 2 vols. Paris 1933.

Burty, Philippe. 'Croquis d'après nature. Notes sur quelques artistes contemporains', 2ᵉ série (10 Dec) 1862. On Daumier.

Cain, Julien. *Daumier: Les Gens de Justice*. Monte Carlo, Éd Sauret, 1971; Paris, Éd Vilo, 1974. Transl. by Arnold Rosin as *Daumier: Lawyers and Justice*. Boston 1971 (éd Sauret); New York 1994 (Tabard Press).

Champfleury. *Histoire de la Caricature Moderne*. Paris 1865. (On Daumier, Traviès and Monnier, with emphasis upon the first, and appendices on Philipon, Pigal, Grandville and Gavarni.)

Cherpin, Jean (ed.). *Daumier* (special edition of *Arts et Livres de Provence*). Marseilles 1948.

Cherpin, Jean (ed.). *Daumier* ('Bulletin Daumier N° 2'), *Arts et Livres de Provence*. Marseilles 1955.

Cherpin, Jean (ed.). *L'homme Daumier: un visage qui sort de l'hombre*. Marseille 1973.

Childs, Elizabeth C. 'Honoré Daumier and the Exotic Vision: Studies in French Culture and Caricature, 1830–1870'. U.M.I. Dissertation Services, 1989.

Courthion, Pierre (ed.). *Daumier raconté par lui-même et par ses amis*. Paris 1945.

Daumier. *Daumier* (special number of *Arts et Livres de Provence*). Marseille 1948.

Delteil, Loys. *Le peintre graveur illustré, XX–XXIX, Daumier*. Paris 1925/30.

Escholier, Raymond. *Daumier*. Paris 1923. (The best edition of his books on Daumier.)

Fuchs, Eduard. *Der Maler Daumier*. Munich 1927; 2nd edition (with supplement) 1930.

Georgel, Pierre, and Mandel, Gabriel. *Tout l'œuvre peint de Daumier*. (Transl. Simone Darses). Paris (Flammarion) 1972.

Hammer: The Armand Hammer Foundation. *Honoré Daumier 1808–1879: The Armand Hammer Daumier Collection*. Los Angeles 1982.

Harper, Paula Hayes. *Daumier's Clowns*. Ph.D. thesis, Stanford U.P. 1976.

Holme, Charles (ed.). *Daumier and Gavarni*, with critical and biographical notes by Henri Frantz (Daumier) and Octave Uzanne (Gavarni). Special number of *The Studio*, 1904.

Ives, Colta; Stuffmann, Margret; and Sonnabend, Martin. *Daumier Drawings*. London 1993.

James, Henry. *Daumier, Caricaturist*. London 1954. (New edition of an article written in 1890.)

Klossowski, Erich. *Honoré Daumier*. Munich 1923.

Larkin, Oliver. *Daumier Man of his Time*. London 1967.

Lassaigne, Jules. *Daumier*. Paris 1938.

Laughton, Bruce. *The Drawings of Daumier and Millet*. New Haven 1991.

Maison, K.E. *Daumier Drawings*. London and New York, 1960.

Maison, K.E. *Honoré Daumier: Catalogue Raisonné*, vol. I (Paintings), vol. II (Watercolours and Drawings). London 1968.

Marotte, Léon, and Martine, Charles. *Honoré Daumier, Cinquante Réproductions* (dessins de Maîtres Français). Paris 1924.

Mayne, Jonathan: see Baudelaire, under 'For Further Reference'.

Osiakowski, S. *Some Political and Social Views of Honoré Daumier as Shown in His Lithographs*. Unpublished Ph.D. thesis, London University 1957.

Passeron, Roger. *Daumier: Témoin de son temps*. Fribourg 1979 and New York (as *Daumier*, transl. by Helga Harrison) 1981.

Provost, Louis. *Honoré Daumier: A Thematic Guide to the Œuvre*, (ed. and introduction by Elizabeth Childs). New York (Garland) 1989.

Rey, Robert. *Honoré Daumier*. New York 1985 (2nd ed.).

Roger-Marx, Claude. *Daumier*. Paris 1969.

Vincent, Howard P. *Daumier and His World*. Evanston, Northwestern U.P. 1968.

Wasserman, Jeanne L. *Daumier Sculpture*. Fogg Art Museum, Harvard University 1969.

Major Exhibitions

Exposition des Peintures et Dessins de H. Daumier. Paris, Galeries Durand-Ruel 1878 (with biographical notice by Champfleury).

Exposition par les maîtres français de LA CARICATURE et de la Peinture des Mœurs au XIXᵉ siècle, Paris, École des Beaux-Arts 1888. Introduction by Paul Mantz.

Exposition Daumier, Paris, École des Beaux-Arts 1901. Preface by Gustave Geoffroy.

Exposition de dessins, aquarelles et lithographies de H. Daumier, Paris, Galerie L. et P. Rosenberg fils, 1907.

Aquarelles et dessins de Daumier, Paris, Galerie L. Dru, 1927. Introduction by Claude Roger-Marx.

Daumier: Peintures, Aquarelles, Dessins, Paris, Orangerie 1934 (ed. Charles Sterling). In the same year as the following exhibition.

Daumier: Lithographies, Gravures sur bois, Sculptures, Paris 1934, Bibliothèque Nationale, (eds. P.-A. Lemoisne, Jean Laran and Jean Adhémar).

Daumier. Philadelphia Museum of Art, 1937. (Introduction by Claude Roger-Marx, Technical Notes on Daumier by David Rosen and Henri Marceau.)

Daumier: Le peintre graveur, Paris, Bibliothèque Nationale, 1958.

Daumier. Paintings and Drawings (Catalogue by K.E. Maison, Introduction by Alan Bowness), London, Arts Council 1961.

Daumier: dessins, lithographies, sculptures, œuvre gravé. Paris, Musée Cognac-Jay, 1961.

Honoré Daumier. Lachenal, François. Ingelheim am Rhein 1971.

Honoré Daumier . . . Bildwitz und Zeitkritik [picture-punns and art criticism]: *Sammlung Horn*, Münster (Westfälisches Landesmuseum) 1978 & Bonn (Reinisches Landesmuseum) 1979. Major exhibition of lithographs, arranged chronologically and by types, with commentaries.

Daumier et ses amis républicains. Catalogue by Marielle Latour et al. Marseille 1979.

Honoré Daumier, Washington, D.C., National Gallery, 1979. Jan Rie Kist. Busts, lithographs (from Rosenwald Coll.) and watercolours from American Museums.

Daumier at the Royal Academy of Arts. London, Royal Academy 1980.

Honoré Daumier. Ed. Arnaud d'Hauterives. Paris, Musée Marmottan, 1989. (Major lithographs from Roger Passeron's collection).

Femmes d'esprit: Women in Daumier's Caricature. Middlebury College, VT (The Christian A. Johnson Memorial Gallery), Hanover & London, University Press of New England, 1990. Eds. Kirsten Powell and Elizabeth C. Childs. (Includes essays by Janis Bergman-Carlton, Elizabeth C. Childs, Lucette Czyba, Kirsten Powell, and Judith Wechsler).

Honoré Daumier Zeichnungen, Frankfurt, Städische Galerie im Städelschen

Kunstinstitut, 1992; and *Daumier Drawings*, New York, Metropolitan Museum of Art, 1993. Catalogue by Colta Ives, Margret Stuffmann and Martin Sonnabend, with contributions by Klaus Herding and Judith Wechsler.

Selected Articles

Adhémar, Jean. 'Les esquisses sur la Révolution de 1848', *Arts et Livres de Provendence*, 1948, pp.42–5.

Childs, Elizabeth. 'Big Trouble: Daumier, Gargantua, and the censorship of political caricature', *Art Journal*, vol. 51 (May 1992), pp.26–37.

Cuno, James. 'Charles Philipon, La Maison Aubert, and the Business of Caricature in Paris, 1829–41', *Art Journal*, Winter 1983, pp.347–54.

Duranty, Edmond. 'Daumier' (an important biography and critique in two parts). *Gazette des Beaux-Arts*, Series 2, XVII, May and June 1878, pp.429–43 and 528–44.

Geoffroy, Gustave. 'Daumier' (article on the occasion of the 1901 Daumier exhibition at the École des Beaux-Arts), *Revue de l'art ancien et moderne*, 1901, vol. 9, pp.229–50.

Herding, Klaus. 'Le Citadin à la campagne: Daumier critique du comportement bourgeois face à la nature', translated from 'Der Stadter auf dem Lande' (1974), in *Nouvelles de l'estampe*, 46/47 July–October 1979 (special Daumier number), 28–40.

Herding, Klaus. 'Daumier critique des temps modernes. Recherches sur "l'Histoire ancienne"', *Gazette des B/A*, series 6, 113 (Jan) 1989, pp. 29–44.

Hofmann, Werner. 'L'âme de Don Quichotte dans le corps de Sancho', (translated from the German by Alain Ruiz), essay in *Daumier et ses amis républicains*, Marseilles (Musée Cantini) 1979.

Hofmann, Werner. 'Ambiguity in Daumier (& Elsewhere)', *Art Journal*, 13, 4, winter 1983, pp.361–4.

Ives, Colta. *'Prometheus and the Vulture, Metropolitan Museum of Art Bulletin*, vol. 4 (Fall 1990), p.47.

James, Henry. 'Daumier, Caricaturist', *Century Magazine*, New York/London, 17 (new series), 1890, pp.402–3.

Jopling, Paul. 'Daumier's *Orang-Outaniana*', *Print Quarterly*, X, (September 1993), pp.231–46.

Kahn, Gustave. 'Daumier' (review of Daumier's 1901 exhibition), *Gazette des Beaux-Arts*, vol. 25, 1901, pp.463–92.

Kaposy, Veronika. 'Remarques sur deux époques importantes de l'art de Daumier dessinateur', *Acta Historiae Artium*, XIV, 3–4, Budapest 1968, pp.255–73.

Laughton, Bruce. 'Daumier's Drawings for Lithographs', *Master Drawings*, vol. 22, 1, 1984, pp.55–63 and plates 39–45.

Laughton, Bruce. 'Daumier's Expressive Heads', *RACAR*, XIV, 1–2, 1987, pp.135–42 and figs 94–107.

Maison, K.E. 'Daumier Studies – I: Preparatory Drawings; II: Various Types of Alleged Daumier Drawings; III: Cardiff Museum Paintings', *Burlington Magazine*, XCVI, Jan., March and April 1954, pp.13–7, 82–6, 105–9.

Maison, K.E. 'Further Daumier Studies – I: The Tracings; II: Preparatory Drawings for Paintings', *Burlington Magazine*, XCVIII, May and June 1956, pp.162–7, 199–204.

Maison, K.E. 'Some Unpublished Works by Daumier', *Gazette des Beaux-Arts*, Series 6, LII, 1958, pp.341–52.

Maison, K.E. 'Daumier's Painted Replicas', *Gazette des Beaux-Arts*, Series 6, LVII, 1961, pp.369–77.

Maison, K.E. 'Some Additions to Daumier's Œuvre', *Burlington Magazine*, CXII, 1970, pp.623–4 and figs 86–92.

Melot, Michel. 'Daumier and Art History: Aesthetic Judgement/Political Judgement', *The Oxford Art Journal*, 11:1 1988, pp.3–24.

Vial, M-P, 'Scène du prison ou scène de torture', *Revue du Louvre*, vol. 40, 5 (1990), p.417.

Wasserman, de Caso and Adhémar. 'Hypothesis sur les sculpture de Daumier', *Gazette des Beaux-Arts*, Series 6, vol. 101, February 1983.

For Further Reference

Agulhon, Maurice. Marianne into Battle, trans. Janet Lloyd, Cambridge University Press, 1981.

Baudelaire, Charles. *Œuvres Complètes*, ed. Y.-G. Le Dantec & Claude Pichois. Paris 1961.

Baudelaire, Charles, 'The Salon of 1845', in *Art in Paris 1845–1862*, transl. and ed. by Jonathan Mayne. London 1965.

Baudelaire, Charles. 'Quelques Caricaturistes', *Le Présent*, 1857; more fully published in *Curiosités Aesthetiques*, Paris 1868. Transl. Jonathan Mayne, in *The Painter of Modern Life and Other Essays*, pp.166–186, 'Some French Caricaturists'. London 1964.

Childs, Elizabeth C. and Powell, Kirsten. *Femmes d'esprit: Women in Daumier's Caricature*. Middlebury College, Vt, 1990.

Clark, T.J. *The Absolute Bourgeois: Artists and Politics in France 1848–1851*. London 1973. (Chapters on Daumier and Millet respectively.)

Daulte, François. *French Watercolours of the Nineteenth Century*. New York, 1970.

Daumard, Adeline. *La Bourgeoisie Parisienne de 1815 à 1848*, Paris 1963, p. 617ff.

de Banville, Théodore. *Mes souvenirs* [Daumier]. Paris 1882.

Farwell, Beatrice. *The Charged Image: French Lithographic caricature 1816–1848*. Santa Barbara Museum of Art, 1989.

Fournel, Victor. *Ce qu'on voit dans les rues de Paris*. Paris 1858.

Fournel, Victor. *Les Spectacles Populaires et les Artistes des Rues*. Paris 1863.

Grand-Carteret, J. *Les Mœurs et la caricature en France*, Paris 1888.

Green, Nicholas. *The Spectacle of Nature: Landscape and Bourgeois Culture in nineteenth-century France*. Manchester 1990.

Mainardi, Patricia. *Art and Politics in the Second Empire*. New Haven and London 1987.

Randall, Lilian M.C. *The Diary of George Lucas*, 2 vols, Princeton 1979.

Schulkind, Eugene. *The Paris Commune of 1871*. London 1971.

Sérullaz, Arlette, and Régis, Michel. *L'aquarelle en France au XIXe siècle: Dessins du Musée du Louvre*. Paris 1983.

Sérullaz, Maurice, et al. *Donations Claude Roger-Marx* [au Musée du Louvre]. Paris 1980.

Wechsler, Judith. *A Human Comedy. Physiognomy and Caricature in 19th-Century Paris*. London and Chicago 1982.

INDEX

PHOTOGRAPHIC ACKNOWLEDGEMENTS

In most cases the illustrations have been made from the photographs or transparencies provided by the owners or custodians of the works. Those for which further credit is due are: 5, 30, 43, 44, 48, 61, 73, 93, 99, 116, 168, 182: © Photo RMN; 14, 16, 46, 54, 63, 70, 76, 106, 125, 130, 153, 155, 178, 180, 184: Courtauld Institute of Art; 23, 60, 103, 151: © Christie's; 28: Photo Daniel Le Névé; 29: Photo Arrigoni; 36: Photo Brian Merrett, MMFA; 37, 100: © Frequin-Photos; 39, 80, 127, 169: Photograph © 1994 The Art Institute of Chicago. All rights reserved; 49, 104, 119, 170: Sotheby's; 50, 52, 57, 63, 165, 170: Caisse Nationale des Monuments Historiques et des Sites; 56, 62, 108, 110, 111, 118, 140, 176: Photographie Bulloz; 67: Musée des Beaux-Arts de Montréal; 87: Robert Schmit; 89: Photographie Giraudon; 139: Bequest of Mrs H.O. Havemeyer, 1929. The H.O. Havemeyer Collection. Photograph by Malcolm Varon; 162: © Ole Woldbye København; 183: Artothek.

DATE DUE

JUN 2 2 2003

~~JAN 3 0 1999~~

~~JAN 2 6 2003~~

AUG 2 4 1999

~~JUL 1 1999~~ ~~NOV 2 5 2003~~

~~OCT 1 5 2000~~

~~MAR 1 1 2002~~

~~OCT 3 0 2004~~

~~AUG 1 0 2009~~ APR 1 7 2005

~~MAR 2 1 2006~~